PRAISE FOR
Healing Trauma in Children with Clay Field Therapy

"In spending a fruitful day with Heinz Deuser discussing his Clay Field approach, it was clear there was a close 'bottom-up' relationship between his work and my work in Somatic Experiencing. Cornelia, a student of ours, has immersed her many years of expertise in somatic-based trauma healing and teaching of Clay Field Therapy into her new book, *Healing Trauma in Children with Clay Field Therapy*. I recommend her book not only to child practitioners but to therapists and body-workers of all kinds."

—PETER A. LEVINE, PhD, author of *Waking the Tiger* and *In an Unspoken Voice*

"Cornelia Elbrecht's extensive experience, life's work, research, and development of sensorimotor art therapy have been sophistically synthesized into this significant text. Considerable insights into the critical and transformative therapeutic work with children are elevated through a carefully constructed framework against the backdrop of active engagement and profound clinical case material. Achieving developmental milestones and healing from trauma through structured and supported engagement involves complex and intricate processes. The contents of this text will certainly equip and further inform practitioners at any stage in their career, including the most seasoned. An excellent addition to any professional, medical, institutional, or academic library."

—RONALD P.M.H. LAY, MA, AThR, ATR-BC, registered and credentialed art therapist, consultant, supervisor, and program leader of the MA in Art Therapy program at LASALLE College of the Arts, Singapore

"Elbrecht describes elegantly how interacting with a clay field can awaken our senses, particularly our sense of touch, thus facilitating a feeling of embodiment, agency, connection, and trust, functions that are sorely lacking in the aftermath of trauma. Through this unique, bottom-up approach, we are reminded how sensory input can have a transformative effect on how we interact with ourselves and the world. Working with the clay field, among other therapies focusing on sensorimotor input, has the potential to transform our understanding and treatment of trauma-related disorders."

—RUTH LANIUS, MD, PhD, professor of psychiatry, and director of the posttraumatic stress disorder (PTSD) research unit at the University of Western Ontario

"Too often art therapy focuses on emotions and emotional expression rather than engaging sensorial impressions. The discovery of interoceptive wisdom, especially for traumatized children, is the purpose of the Clay Field, so elegantly presented by Cornelia Elbrecht. She intimately understands the haptic vocabulary of clay as a language for supporting a traumatized nervous system. Elbrecht demonstrates through case-vignettes how clay is an ideal material for stimulating embodied joy while also developing sensorimotor-based ego strengths for repairing psychological injuries. So much of therapy happens while handling and working with art materials. With clay, as this book demonstrates, we can create our way through our suffering."

—MICHAEL A. FRANKLIN, PhD, ATR-BC, professor at
Naropa University, Boulder, Colorado

"Touch is an important sensory experience for children who have suffered complex trauma. For many of them, the very integrity of their bodies has been violated. It is why Cornelia Elbrecht has given us a gem of a book. It shows how playing, pushing, scraping, moulding clay can heal. It is meaning-making at its best."

—DR. JOE TUCCI, CEO of Australian Childhood Foundation

"Cornelia Elbrecht's depth and range of clinical experience, attuned sensitivity, and integration of varied theories (i.e., sensorimotor, developmental, art therapy, expressive arts, polyvagal, etc.) permeates her book, offering both new and experienced clinicians an excellent guide to understand this approach to trauma. Elbrecht's pioneering approach, Clay Field Therapy, adds fresh methods and insights for healing through trauma that meet the client where they are—whether needing to work at a sensorimotor level with the clay for safe contact or release, rewrite a trauma narrative using figurines with the clay, or integrate other arts therapies approaches to enhance the safety and processing of material. Elbrecht's approach powerfully demonstrates how to help clients find their body's innate wisdom toward healing—that unfolds within a safe therapeutic relationship and creative process."

—LAURY RAPPAPORT, PhD, MFT, REAT, ATR-BC, author
of *Focusing-Oriented Art Therapy*

"Cornelia Elbrecht's enlightening guide on the healing of trauma in children is a must-read for anyone interested in this salient topic. The Clay Field Therapy, described in detail, uniquely and importantly provides a nonverbal and noncognitive, haptic approach to the treatment of all trauma types, including the difficult-to-treat complex trauma of early childhood. Her work, spanning decades, shows time and again the real benefits to these children and corresponds beautifully with the neurophysiology of stress and trauma. In particular, I loved the way the work could be understood within the multiple vagal functions outlined in the polyvagal theory. This radical work has immense scope and opens the way for a deeper understanding."

—HEIDI CHAPMAN, BSc (psych), PhD, cognitive
neuroscientist

HEALING TRAUMA
IN CHILDREN WITH
CLAY FIELD THERAPY

HEALING TRAUMA IN CHILDREN WITH CLAY FIELD THERAPY

How Sensorimotor Art Therapy Supports the Embodiment of Developmental Milestones

CORNELIA ELBRECHT

FOREWORD BY CATHY A. MALCHIODI, PHD

North Atlantic Books
Berkeley, California

Published by	Cover photos by Jono van Hest, Cornelia Elbrecht, and Monica Finch
North Atlantic Books	Cover design by Rob Johnson
Berkeley, California	Book design by Happenstance Type-O-Rama

Printed in the United States of America

Healing Trauma in Children with Clay Field Therapy: How Sensorimotor Art Therapy Supports the Embodiment of Developmental Milestones is sponsored and published by North Atlantic Books, an educational nonprofit based in Berkeley, California, that collaborates with partners to develop cross-cultural perspectives, nurture holistic views of art, science, the humanities, and healing, and seed personal and global transformation by publishing work on the relationship of body, spirit, and nature.

North Atlantic Books' publications are distributed to the US trade and internationally by Penguin Random House Publishers Services. For further information, visit our website at www.northatlanticbooks.com.

Figures 4.1 and 4.2: Used with kind permission of the Natural History Museum, London

Figure 5.2: Courtesy of Beacon House Therapeutic Services & Trauma Team, 2019, www.beaconhouse.org.uk

Every reasonable effort has been made to obtain permission for reproduced materials.

MEDICAL DISCLAIMER: The following information is intended for general information purposes only. Individuals should always see their health care provider before administering any suggestions made in this book. Any application of the material set forth in the following pages is at the reader's discretion and is their sole responsibility.

Library of Congress Cataloging-in-Publication Data

Names: Elbrecht, Cornelia, author.
Title: Healing trauma in children with clay field therapy : how
 sensorimotor art therapy supports the embodiment of developmental
 milestones / Cornelia Elbrecht ; foreword by Cathy Malchiodi, PhD.
Description: Berkeley, CA : North Atlantic Books, [2021] | Includes
 bibliographical references and index. | Summary: "Treating trauma in
 children through creative play with clay"—Provided by publisher.
Identifiers: LCCN 2021019819 (print) | LCCN 2021019820 (ebook) | ISBN
 9781623176716 (trade paperback) | ISBN 9781623176723 (ebook)
Subjects: LCSH: Post-traumatic stress disorder in children—Treatment. |
 Clay—Therapeutic use.
Classification: LCC RJ506.P55 E43 2021 (print) | LCC RJ506.P55 (ebook) |
 DDC 618.92/8521—dc23
LC record available at https://lccn.loc.gov/2021019819
LC ebook record available at https://lccn.loc.gov/2021019820

1 2 3 4 5 6 7 8 9 KPC 26 25 24 23 22 21

North Atlantic Books is committed to the protection of our environment. We print on recycled paper whenever possible and partner with printers who strive to use environmentally responsible practices.

For Lachlan, Acacia, Jude, Leilani, Madeleine, Lucy, and X

CONTENTS

FOREWORD xi

PRELUDE xvii

INTRODUCTION 1

PART 1 THE FRAMEWORK

1 The Setting 13

2 The Somatosensory Foundation 27

3 Dual Polarity 35

4 Somatosensory Touch 51

5 Trauma and the Autonomic Nervous System 71

6 Traumatized Children 85

7 The Sensorimotor Cortex 105

8 Sequential Development 131

9 Expressive Therapies Continuum and
the Clay Field 137

PART 2 HAPTIC DEVELOPMENTAL BUILDING BLOCKS

10 Developmental Building Block 1: Skin Sense 149

11 Developmental Building Block 2: Balance 165

12 Developmental Building Block 3:
Depth Sensibility 173

13 Developmental Building Block 4: Vital
Relationship and Perception 185

14 Developmental Building Block 5: Balance in
the Relational Field of the Parents 205

15 Developmental Building Block 6: Departure
from the Relational Field of the Parents 235

16 Developmental Building Block 7: Centering as
Discovery of the Inner World 245

17 Developmental Building Block 8: Centering as
Search for Identity 253

18 Developmental Building Block 9: Centering as
Search for One's Own Base 261

19 The Five Situations for Children 273

PART 3 CASE EXAMPLES

20 Working in Different Settings 291

21 "I Love the Clay and the Clay Loves Me!" 297

22 A Case Study in Developmental Trauma 313

23 Combining Expressive Art Therapies and
Clay Field to Support Children 327

24 From Phenomenological Observing
to Accompanying 347

25 Developmental Trauma in the Psychiatric
Hospital Setting 363

26 The Healing Journey 373

ACKNOWLEDGMENTS 377

INTERNET RESOURCES 379

NOTES 381

BIBLIOGRAPHY 397

INDEX 405

ABOUT THE AUTHOR 425

FOREWORD

CATHY A. MALCHIODI, PHD

Wherever we touch life we form it…. If you really feel and internalize that knowledge, it is quite a thing to be a human being, to touch with the hands but also with a thought, a feeling, or a dream.

—M. C. RICHARDS, 1983

In *Healing Trauma in Children with Clay Field Therapy,* Cornelia Elbrecht brings to light a process of implicit communication like no other found in the field of art therapy or body-based psychotherapies—the presence of clay as the vehicle of reparation and transformation. When compared to many other forms of visual arts, clay is undeniably unique in so many ways. In most cases, it focuses on directly using one's hands as the major tool in expressive work. The sensory experiences of "touching clay" are direct and instant communication between the individual and the clay, unlike paint, drawing, and other image-based forms of expression.

This volume is one of a handful of published works that explains the use of clay in art therapy and its dimensions as a form of self-repair. There have been relatively few investigations of just how clay can support the recovery of individuals with mental health challenges, including trauma stress, attachment problems, and other disorders. Some, like contemporary researchers Nan and Ho, have added to our knowledge of what they call "clay art therapy" as a way to mediate a variety of challenges related to depression and major mood disorders.[1] Because clay is a three-dimensional material, there are also unique perceptual and decision-making responses that involve what Nan and Ho cite as "complex coordination of different cortical regions" of the brain. Overall, these types of studies underscore that clay does have some unique properties when it comes to decreasing symptoms and improving general health, a sense of well-being, and the ability to verbally communicate feelings. These applications and

xii Healing Trauma in Children with Clay Field Therapy

others form our growing knowledge of how introducing clay can be both a comple-
ment to existing approaches to emotional disorders, and also a primary and central-
ized way of working with people of all ages.

Tapping the Haptic Connection

Author Margaret Atwood writes, "Touch comes before sight, before speech.... It is
the first language and the last, and it always tells the truth."[2] Elbrecht, like other art-
based practitioners, has intuited that introducing clay in art therapy sessions cap-
italizes on these unique and powerful characteristics of this tactile, highly sensory
medium. There are a wide variety of sensory qualities of clay, including the prom-
inent experiences of touch and other physical senses and, like Atwood observes,
it is truly a "first language" that introduces us to both relationships and the world
around us.

Haptic is an adjective relating to the sense of touch, in particular relating to the
perception and manipulation of objects using the senses of touch and proprioce-
tion. When we talk about haptics, we generally mean any form of communication or
experience through touch. For example, haptic communication is the means through
which humans and other animals convey experiences and emotions via touching.
Haptic perception is the process of recognizing objects through touch. Similarly,
somatic senses are sometimes referred to as somesthetic senses with the understand-
ing that they include the sense of touch, proprioception (a sense of position and
movement), and haptic perception.

I first came across the term *haptic* as an art education student at Stanford Univer-
sity while reading about the work of Viktor Lowenfeld. His 1939 classic *The Nature
of Creative Activity* proposed two opposite types of perceptual orientation—haptic
and visual—as reflected in artistic production. Lowenfeld developed these ideas from
many years of observation of children's artwork in Austria and America. They are
opposite types, but most people will be on a continuum of visual to haptic percep-
tion orientation. Later, as a psychologist and expressive arts therapist, I returned to
this concept when thinking about how individuals with traumatic stress perceived
emotional and somatic sensations. As Lowenfeld observed, they often relied more
on kinesthetics and their bodies' experiences rather than images or cognitions. This
observation resonates with much of what we now are learning about trauma, partic-
ularly in regard to embodied memories and how we can effectively address distress
through implicit means in contrast to explicit communication, including talk-only
therapies.

Expression as a Historically Restorative Practice

The self-soothing characteristics of clay enhance self-regulation through what are developmentally grounded interactions with the medium. Smoothing, pounding, building, and shaping are among the many ways clay can be manipulated and experienced. The healing practices found throughout cultures around the world form a universal foundation for the process of the Clay Field that emerged and evolved in service of health and well-being over millennia and well before talk therapy appeared on the scene. Humans, in fact, historically have and continue to use these practices and variations of them to reach psychological and physiological stability, including self- and coregulation, self-exploration and understanding, and ultimately, restoration of self and community.[3]

The frameworks for art-based methods are now clearly in view in the form of brain-wise models that use "bottom-up" (sensory expression) or "top-down" (cognitive or language-based expression) as well as through the lens of cultural anthropology and ethnology.[4] When we look at contemporary psychotherapeutic methods via the latter, storytelling (talk therapy) and somatically resonant approaches (movement, gesture, enactment) are all derived from these historical approaches as well as iterations explained in numerous contemporary somatic and arts-based practices.

Within the currently exclusive narrative of contemporary psychotherapy is also the lost thread of the Indigenous contributions, art-based practices that continue to be used throughout the world for restoration, health, and well-being. We also know, again from thousands of years of human proclivity for self-expression, that nonverbal, embodied, and culturally resonant practices form a significant piece of any transformation, meaning-making, and healing. Even the ultimate god figure of talk-based psychotherapy, Sigmund Freud, said, "What the mind has forgotten, the body has not, thankfully."[5] He, in fact, knew that communication is not exclusively language-based, nor is it the only form of healing and transformation.

Breaking Apart, Putting Back Together

One of the fascinating and likely therapeutic characteristics found in clay is that it is malleable. That is, while other forms of art-based expression can be effective in expressing sensations, perceptions, emotions, and cognitions, clay can pretty much be reshaped, revised, and reassembled in infinite ways. For this reason, the use of clay in the context of therapy through historical psychology principles and the

neuroscience of trauma and attachment can be explained in a variety of ways, many of which are personal and even idiosyncratic. As an artist, while my experiences with clay are limited, the years spent exploring it introduced me to its potentials in ways that are not entirely driven by Western thought. In fact, as a student of Zen Buddhism, the principle of impermanence quickly emerges when interacting with clay as a medium:

> Everything is impermanent—flowers, tables, mountains, political regimes, bodies, feelings, perceptions, mental formations and consciousness. We cannot find anything that is permanent. Flowers decompose but knowing this does not prevent us from loving flowers.[6]

When I think of clay, I also am reminded of the Japanese concept of *wabi-sabi,* a principle that is often referred to in the field of art therapy as well as trauma. It celebrates not only the experience of impermanence, but also how everything is in process—that nothing lasts forever and nothing is ever finished. Work in clay often reflects these principles; working in clay can be rough and imperfect. It is authentic expression of one's being, and like existence itself, is transitory, changing over time. Those parallels have always struck me as a mirror of how we contact ourselves through the medium of clay, a material that embodies acceptance of who and what we are in the moment and the ultimately imperfect beauty of each individual we see in therapy and ourselves.

Conclusion

This book was written during a unique time period in global history—a worldwide pandemic. While it will take many years before we completely understand the impact of this collective experience on individuals and communities, it has undoubtedly been a time of disconnection, disrupted attachment, and traumatic stress. We have endured a loss of proximity to each other and, of course, a loss of connection via our senses.

Elbrecht's book comes to us at a time when both clients and practitioners need to reconnect to the source and core of what is soothing and reparative. This means reconnection through sensory-based, implicit experiences and the mind and body's imagination to something deeper. While we might find it through words or interpretations, we ultimately cannot find it from what is outside ourselves. It has to be found through inner intuited forms of knowing. For those of us engaging individuals, groups, and communities in the interoceptive and exteroceptive moments central to

expressive communication, we already know this—that implicit, sensory-based experiences really are at the core of all repair, recovery, and restoration. Working with clay with the context and container of therapy is undeniably one of those experiences.

CATHY A. MALCHIODI, PhD, FOUNDER OF THE TRAUMA-INFORMED
PRACTICES AND EXPRESSIVE ARTS THERAPY INSTITUTE
AND AUTHOR OF *TRAUMA AND EXPRESSIVE ARTS THERAPY*

PRELUDE

Cornelia and I have known each other for forty-seven years. We met when the major markings of postwar Germany had passed and we were looking for solutions to the past traumas as children of our parents. The "economic wonder" did not provide answers, and so we found ourselves on a quest, without knowing where it would lead. What we were searching for was a language and a dialogue in which we could be perceived. There were many like us. We experimented with creative therapies, and applied and discovered them. Truth was our truth, and we were challenged to find it. We explored preverbal communication with ourselves and others. Visions of a new world inspired a community. It was a time where therapy emerged before it had a language, yet it was solid enough for us to encounter ourselves through it. This is when I founded Work at the Clay Field.

Over time, everyone went their own way, but the shared basis remained. In Germany the Institut für Haptische Gestaltbildung (Institute for Haptic Gestalt Formation) was founded, and in Australia, the Institute for Sensorimotor Art Therapy; both remain in cordial and close exchange. I am delighted to welcome Cornelia's second book on the subject, which allows us to participate in human possibilities.

Trauma shapes how we move. Something has ruptured and requires repair. Due to the setting, our movement becomes perception, and based on our perception, we create ourselves through our movements. The basis is the connection with ourselves and the human relationship. This is how, as Cornelia shows in a multitude of ways, a vivid dialogue emerges, in which our hands find a language to understand ourselves.

This language is anchored in neurology and embodiment. Despite any traumatization, it offers real hope. Rather than being a victim, we can learn to be in charge of our life.

PROF HEINZ DEUSER

JULY 2020

It is with deep gratitude that I honor Heinz Deuser's life's work in this book. He is the founder and creator of Work at the Clay Field.

INTRODUCTION

Clay Field Therapy is touch therapy. The moment we touch the clay, it becomes relational and catapults us instantly into the present moment. As we touch the clay, we are simultaneously touched by it. We cannot distance ourselves from it the moment we engage. The creation of visual objects is not central to this approach, but rather how we perceive ourselves through the haptic connection with our hands. The large flat box filled with twenty to thirty pounds of clay provokes a relationship.

Virtually every art therapy approach to clay that I have witnessed over the years involves the figurative creation of an object and then invites talking about it. In all these cases, the therapeutic process relies on the cognitive interpretation of an image. However, there are many client groups, especially children, who confront in such a setting exactly the same upsetting difficulties they encounter at school and in social situations, where they are asked to understand something while their sensorimotor base and therefore their nervous system are in chaos due to past or ongoing adverse events in their lives. Many of these children are unable to create meaningful objects, or objects at all, even though they are of school age, and they are likely incapable of verbally explaining what they have done.

What the Clay Field offers such children is a safe and stable relationship. Due to the simplicity of the setting, a box filled with clay, the field is *there* for the child. It will not shout back, comment, punish, shame, or anything else, but simply reflect every imprint made into the pliable material. The field offers itself as an other-than-me that will reciprocate every communication impulse. Every time children reach out with a motor impulse and touch the clay, even with just a fingertip, they will receive sensory feedback from this action pattern. In this context, it is not the image, not even the imprint made in the clay, that gains importance, but the sensory response the child receives from this relational experience, which ultimately is a relationship with the child's mirrored self.

This sensorimotor feedback loop defines the essence of Work at the Clay Field. Of course, children will create landscapes and objects in the field, once they are ready, but they can just as well simply pour water onto the clay and watch it run, or lean with their full body weight onto it, or hide their hands in it, or rest their head on it while they gain trust, sometimes for the first time.

In a unique way, this sensorimotor art therapy approach is capable of gradually repairing interpersonal trauma. As the ultimate transitional object, the Clay Field offers responsive consistency for the relational needs of a child. Initially children will encounter their unfulfilled and unmet needs, just like they have learned them in the past. The clay may feel hard and unyielding, icy cold, or dangerous to the extent it might explode any minute. However, over time, the child also learns that nothing happens. And such nothing-happening comes as a blessing, as a realization that here, I am safe; here, I can learn a new way of being—with myself.

The focus in Clay Field Therapy is on haptic perception, which describes how we sense and perceive through touch with our hands. Touch and taste are proximal senses; they allow us to assess things close by, whereas seeing, hearing, and smelling deal with perceptions farther away. Apart from a few psychotherapy approaches to bodywork, touch is an underrepresented and little researched therapeutic tool. Art therapists tend to be widely unaware of its potential, including those who work with clay. They focus rather on image making, offering an optical experience. At the end of a Clay Field Therapy session, however, there will be no finished product, no artwork to show to friends, no sculpture to be fired in a kiln. Instead, intense body memories and updated belief systems will be taken home.

Due to the texture, weight, and resistance of the clay, the material demands physical effort. Clients are not offered a handful of clay, but a *field* filled with several pounds of it. Very quickly the head—and with it, our cognitive conditioning—has to make way for the more ancient urges of our libido. Our body has to become engaged. The dialogue between kinesthetic motor impulses and sensory perception has the therapeutic potential to heal developmental and traumatic experiences, in particular involving those formative experiences that have little or no conscious memories, because early childhood, sexuality, human closeness, and also accidents and medical procedures are dominated by touch. Most traumatic experiences involve interpersonal conflict and boundary breaches of our skin. Virtually all formative life learning involves haptic perception. "Touch is the first sense to become functional in utero, at about eight weeks' gestation."[7] We learn in the womb whether we are wanted in the world or not. Bruce Perry has researched how implicit memory from conception onward, for example, sets the baseline for nervous system regulation for the rest of our lives.[8]

Attachment as the essence of love, safety, and trust is communicated through skin-to-skin contact, how the infant is being held, hugged, and rocked. Babies' first explorations of their surrounding are dominated by touch; their grabbing and later sorting of objects prepares their brain for the development of language; objects later on become nouns, and what you can do with them turns into verbs.[9]

Clay Field Therapy addresses these implicit memory[10] systems, which shape our identity far more than acknowledged in most therapy settings. Implicit memory is body memory. The process of moving and lifting clay requires crucial proprioceptive action patterns we acquire in early childhood, such as being upright and organizing our muscles, ligaments, and skeletal build. Implicit memory is intrinsically connected to our survival impulses in the brain stem. It shapes our identity as an unquestioned felt sense based on how safe and loved we feel in our existential core, or how much danger and fear is continuously lurking underneath the surface, making us jumpy and easily triggered. Because we have always felt in a certain way, it feels *normal,* and therefore we do not question this embodied sense of self, even though our observable behavior might be the reflection of a highly disorganized nervous system. If a child has no other dominant experiences, chaos feels normal.

Importantly, the haptic therapy process is not symptom-oriented. The specific problem or crisis do not become the focal point, but rather the sensorimotor discoveries that lead to new answers and solutions. These solutions emerge from our universal, anthropological blueprint and are propelled forward by the body's felt sense. Ultimately, every child longs for goodness, safety, and the fulfillment of vital needs. Once new options to life have been discovered and become integrated, they are remembered, similar to learning how to swim or ride a bike. These are not necessarily cognitively conscious solutions, but implicitly learned, bottom-up achievements.

A recent review published by the Australian Childhood Foundation reveals that 75 percent of the children therapists work with experienced abuse in the first year of life, and for most, their opportunity to connect with a therapeutic intervention didn't arrive until they were age nine or over.[11] Many of these children have lived in continuous experiences of abuse and violence—experiences that have shaped their view of the world and formed templates through which they interpret the relationships that are core to their survival. While the Clay Field demands a relationship, it also offers a neutral container to relearn relational life experiences.

Many children, for instance, identify with *being bad* because they *feel bad* due to what has happened to them. At the Clay Field, a girl learns how to move all the clay, which makes her feel strong, and because she feels strong, she can be more confident. Or a boy creates a cave into which he can safely fit his hands. Feeling safe allows him

to downregulate his nervous system and be present instead of constantly on the run. These therapeutically supported haptic experiences are able to rewrite the procedural memory systems in the brain stem and midbrain. Such sensorimotor action patterns communicate directly with the autonomic nervous system, and even though they are widely unconscious, they influence all higher cortical brain functions.[12]

Hence, Clay Field Therapy is primarily nonverbal and does not need the story of what happened. Nonetheless, haptic touch is capable of addressing even the earliest developmental setbacks. When we see children in therapy whose early development has been compromised, talking therapies and sometimes even play therapies do not work because the cause for their disorganized behavioral patterns is locked in the earliest preverbal body memories. Touch, however, can reach these early needs. Once such children feel safe enough, they will inevitably explore the missing developmental building blocks at the Clay Field and attempt to repair them.

In the 1970s and 1980s, for eighteen years, I was a student and later worked as an art psychotherapist at the Center for Existential Psychology directed by Karlfried Graf Dürckheim[13] and Maria Hippius. Dürckheim was a professor of psychology and philosophy, and after he had spent ten years in Japan studying Zen Buddhism with the famous Daisetsu Teitaro Suzuki, he was one of the first lecturers in Europe to teach Eastern-Western spiritual practice, which was simply revolutionary in 1950s Germany. Dürckheim's late life work was based on a Buddhist-inspired mindfulness practice, including Zen meditation, martial arts, and bodywork as psychotherapy. Meanwhile, Hippius was a psychologist and Jungian analyst dedicated to the creative arts as therapy. It was a uniquely innovative place to train. By the 1970s their center became popular, meeting a deep need for an alternative pathway to therapy.

This was where Heinz Deuser[14] and I met, both in our twenties, keen to learn. In those days Deuser lived in a three-hundred-year-old Black Forest farmhouse designed for long winters with six months of snow. Double glazing in such houses was unheard of; instead we had two sets of windows. The winter ones were clipped on once it got cold. Over the summer, they were stored. When Deuser found one with a broken pane, he nailed a piece of plywood to the bottom—and that became the first Clay Field. The dimensions of that original window frame have never changed.

I was Deuser's guinea pig from the very beginning, when he started to experiment with clay, while I focused on developing Guided Drawing.[15] Right from the beginning it was the touch experience that interested him, working at all times with closed eyes. Initially I was given a lump of clay, and then asked to hold a rock in my hand and re-create that rock. Next, he presented me with the above-mentioned empty field. Then it became the filled field, and the clay limited to such an amount.

Even today I have vivid recall of the haptic sensation of touching this filled field for the first time. My entire experience changed from cognitive focusing about what I wanted to make to a relationship with my hands as haptic organs with a life of their own. I no longer had a mental focus and purpose. All of that was suddenly obsolete; instead I was confronted with an unspecific encounter. With my eyes closed, I remember how lost I felt in that first session. I had no orientation. The field felt huge, and after I had left marks from digging and moving the material, it felt chaotic. It was albeit a very familiar sensation, a state of terrifying loneliness in an overwhelmingly chaotic world, which had characterized my post–World War II childhood.

Next, my hands dug in with a firm albeit desperate grip, and they filled with a solid amount of clay. The sensation of this hold is burned into my implicit memory. At the time, I called it "horns of a bull," but it also felt like holding hands for support, something I had not known until then. Many times later, whenever I felt lost, I could remember this grip, and those horns became both a supportive hold and a steering wheel. They allowed me to find my way out of the chaos my life was in at the time.

I hope that my experience of that first Clay Field session is capable of illustrating one of the core differences this modality offers compared to other art therapy approaches to clay. It is not a visual but a haptic touch therapy. My hands in that first session could communicate with implicit childhood memories—memories that none of the other talking therapies, expressive therapies, psychologies, and bodywork had been able to address. This was a completely nonverbal felt sense memory, and finding an active response to a pattern of learned helplessness changed action patterns in my brain stem in such a profound way that still today I can call up this memory for support.

Over the following years I had well over one hundred Clay Field sessions, many as life-changing as that first one. In the 1980s, each of us having set up a center of our own, I trained with Heinz Deuser to be able to teach this modality. I have since gone through four more trainings with him because he kept furthering the method.

You will learn in this book, illustrated with many case examples, how the hands constitute a relationship with the Clay Field similar to the way the hands have developmentally gotten to know the world through diverse experiences, such as being weightlessly surrounded by water like in the womb, having our skin lovingly caressed, grabbing and having lots, lifting a heavy load, and delicately shaping a small detail—all of which reflect haptic object relations.

Simultaneously, my approach is deeply informed by Peter Levine's equally groundbreaking Somatic Experiencing,[16] which has proved that trauma activates ancient survival responses in the brain stem that do not respond to cortical processing.

Trauma is not undone through telling the story of what has happened; instead, we need to employ embodied, movement-based therapies to reach the autonomic nervous system. Only through finding implicit action patterns can we complete what we could not do at the time when we froze in fear.

In addition, when we work with children suffering from complex developmental trauma, their brains missed out on making the age-specific synaptic connections in the first place. Developmental trauma impairs the structure and functioning of a young child's brain.[17] Perry states clearly that the same event has a significantly different impact on a five-year-old than on an infant.[18] If the infant's nervous system shuts down in fear, all the following developmental stages will be impacted, whereas the five-year-old has the significant advantage of five years' worth of resources to deal with what happened. Developmental trauma can take years to heal, while a single traumatic event for an older child and an adult can usually be resolved within six to eight sessions.[19] Children suffering from complex trauma need to develop and restore the neurological skills that constitute a safe relationship. They need to reexperience the infant's dance of attunement with a secure caregiver who can provide them with the organizing principles of social and emotional learning.[20] Due to the unique relational setting of the Clay Field and its emphasis on healing unfulfilled touch experiences, it is one of the few therapies that can heal developmental trauma.

A traumatized seven-year-old boy may, for example, be unable to landscape the Clay Field and create a story that would be age-appropriate. Instead, he just hits the material in frustration. In such a case the therapist can address the inner two-year-old in him and support him with age-specific explorations such as pushing and pulling the material while paying attention to how this boy gradually learns to coordinate movements in his entire body, all the way down into his feet. Only now can he have an effect on the clay and shape it according to his ideas and make it do what he wants. Whatever happened to him as a two- or three-year-old may remain a mystery, but we can uncouple whatever trauma arrested his healthy development and support the latter. Whatever in him froze in terror and was dissociated can now continue to grow until he arrives at age-appropriate skills and behaviors.

I have witnessed children grow up several years within a few Clay Field Therapy sessions, because it allowed them to repair the necessary haptic developmental building blocks and neural connections.[21] Knowledge of these developmental building blocks is crucial also for those working with adults. Whenever adult clients connect with their childhood traumas, their hands will reflect this through haptic action patterns specific for their inner child's age. The language of the hands allows

diagnostic insights if the therapist is aware of the developmental stages when certain postures, haptics, and action cycles emerge in healthy children.

Complex trauma affects all those client groups who have grown up in an adverse, unsupportive, if not abusive environment in their early childhood. It causes developmental deficiencies as well as learning and behavioral problems, and it often makes them vulnerable to further trauma experiences later in life. Because their primary relationships were disorganized, they don't know any other way, and they will choose similarly chaotic, abusive relationships during their childhood, teenage years, and as adults.[22]

Peter Levine and Heinz Deuser met in 2008. While verbal communication was difficult, because they do not share a spoken language, they instantly recognized that they were both working on a similar, innovative approach to trauma. Peter made me promise at the time that I would bring Clay Field Therapy to the English-speaking world. This book on working with children includes the most recent findings and conclusions of Deuser's life's work on the subject. It is a project close to my heart, because in my experience it is the most effective therapeutic modality for children that I know of. I dearly hope that many children worldwide will benefit from this approach.

The first part of the book discusses the theoretical framework, embedding the approach into current findings of neurobiology, haptics, and somatosensory trauma therapy. Bruce Perry's Neurosequential Model of Therapeutics and the loosely associated Expressive Therapies Continuum provide a familiar framework to Deuser's unique discoveries of haptic development and diagnosis.

The second part is a step-by-step discussion of the developmental building blocks of haptic discoveries and perceptions. These should give therapists and educators insights into age-specific explorations at the Clay Field. Most traumatized children will not act their age, but regress to earlier developmental stages, usually to the time when something happened that arrested their healthy progress. Knowledge of the haptic stages will allow diagnostic assessment of a child's specific needs, and the support of the accompanier can be adjusted accordingly.

The last part of the book will illustrate the theoretical discussion with a number of case histories. The authors are Clay Field therapists, who work in a variety of settings: in schools, in private practice, and in Indigenous community centers. They include the Clay Field process of a woman in her sixties in a psychiatric hospital, who could finally and lastingly lay her childhood trauma of sexual abuse to rest.

Since publishing my first book on *Trauma Healing at the Clay Field*,[23] many therapists and educators worldwide have trained in this unique modality. It is well

established in Europe. I have introduced it to conference audiences in the United States, the Middle East, and China. Begga Hölz-Lindau recently completed her PhD on Clay Field Therapy for affect regulation with children diagnosed with attention deficit–hyperactivity disorder.[24] Elizabeth Antcliff is currently researching haptic perception at the Clay Field for her PhD at the University of Melbourne, and Cynthia Nasr completed her MA in psychology on the effect of Clay Field Therapy for children suffering from severe asthma in Beirut. The PhD research on Clay Field Therapy in the context of forensic psychology by Saba Basoglu in Istanbul has been approved.

The interest in this modality is global. Haptic perception is universal. The language of our hands, the developing building blocks beginning with sucking our thumb in utero, followed by the exploration of the world as a toddler, up to the development of language and cognitive processing, all have their origin in haptic experiences. Children in all cultures respond to the primal earth quality of clay as the ultimate creative material. But while many art therapists warn about the regressive qualities of clay, Clay Field Therapy views this regression as a necessity, as a relearning of developmental building blocks that remained unfulfilled during an unsupported upbringing. The modality teaches a framework of developmental haptic milestones that enable trained therapists to understand and encourage the nonverbal needs of their clients. What children could not learn in a coregulated relationship with their primary caregivers can now be postnurtured and resensed until a more fulfilling and satisfying relationship has been learned.

Over a lifetime I have trained in a wide range of therapeutic techniques. Initially I practiced as a bodyworker and naturopath while studying fine arts, martial arts, and meditation. I then trained in numerous expressive art therapies as well as Jungian psychology, Gestalt therapy, psychodynamic approaches, bioenergetics, and Somatic Experiencing. Yet, the most intriguing and effective modality of them all has been Work at the Clay Field. The embodied approach literally can change lives, especially those of children with developmental needs who do not respond to cognitive and image-based approaches but who need to be met at their sensorimotor base through touch, until they can gradually process and order incoming information in their lower brain. At the Clay Field they learn to organize their implicit motor and sensory divisions in the central nervous system in order to be able to adequately respond to relationships with friends, family, and their environment in a fulfilling way.

It is a bizarre coincidence that I am writing this book on haptic perception during the COVID-19 pandemic, where human touch has been forbidden for many months. I have now spent thirty-six weeks in self-isolation. It makes me wonder whether we are entering an information age where virtual contact is becoming the preferred

mode, where we spend our days on computers and in front of screens. I have been asked by childcare workers how to teach toddlers to pick up a wooden building block because all these children knew was the swiping motion needed for a touch screen. Their neural network had not learned a three-dimensional grip. The trauma of this global catastrophe ruled by fear of contagious human contact and requiring social distancing tells me that all the more we will need touch therapies fostering embodied connection with ourselves. I believe that therapies that stimulate the hands as a dual organ of perception will become an essential part of our future therapeutic tool kits to counterbalance information-age overload and a virtual lifestyle.

NOVEMBER 2020

PART 1

The Framework

1

The Setting

The Box

The setting is simple. The Clay Field is a flat wooden box, 18 by 14 by 1.5 inches, filled with ten pounds of clay for young children or up to thirty pounds for adolescents and adults. A bowl of water and a sponge are supplied. Especially for young children, half an inch below the rim is left unfilled to allow for water to be poured into the field without flooding the table and the floor.

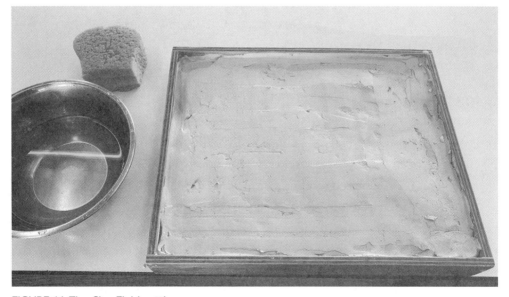

FIGURE 1.1. The Clay Field setting.

The entire approach would not be possible without the box. The clay being contained inside the field constitutes a fundamentally different relational impulse than a lump of clay without a box. The box too has an inside and an outside, just like we do; there is an inner world and an outer one on the table and in the art space. The boundary of the box is made from wood. It is solid, and unlike the clay, it does not move. Even primary school children can be observed holding on to the boundary of the box with one hand while the other explores the clay. The boundary gives a hold; it safely contains. Many therapists will hold the field with both hands while the child works inside the box as a nonverbal way of communicating: "I hold you in this endeavor of finding yourself." This holding of the box visibly makes children feel safe. The box contains the child, and so does the therapist. Children who lack boundaries and safety in their lives especially benefit from being held in this way.

Children's boundaries are still fluid. They do need adults in their lives to assure their emotional and physical well-being. Some may regard the field as a container and spread clay all over the table, themselves, the therapist, and the art room. The point where consciousness begins to distinguish between the inner versus the outer world is blurred for many and not necessarily limited to the field. It takes patience and skilled interventions to respond to sometimes chaotic efforts of children to communicate.

> A nonverbal nine-year-old boy from an abusive home spontaneously wipes his hands on the therapist's apron at the end of the session, leaving clay marks all over her front. She felt she had made some progress in this session to establish a glimmer of trust between them; however, it still takes her a moment to realize that this "caress" is his first effort to make contact with her, responding in the only way he is spontaneously capable of.

At times, the therapist can enter the field either to invite a child to engage, such as shaping a ball and rolling it across the field toward the client, or to support the process, when things get too hard or conflicting. A seven-year-old boy, for example, asks his therapist to shape the teeth for a crocodile he is making, thus assuring that his aggression becomes a shared responsibility, which makes it much safer for him.

The size of the box supports the projection of the body into the field. The left side corresponds to the left side of the body, and the right side of the field reflects the right side of the body. The top of the field is the head space, and the bottom third will relate to gut feelings. The center holds the heart and core issues. This is a natural projection of our physiology onto a mirroring object. For diagnostic purposes, it can at

times be insightful to be aware of the neurological correlation between the left hand and the right brain hemisphere, and the right hand's relation to the left brain hemisphere. Some children will display a significant imbalance in their landscaping of the field, with one side crowded and full of action and the other left bare. Such imbalance can reflect learned behavior due to the absence of one parent, or due to a significant power hierarchy at home, such as domestic violence, that the child witnesses on a regular basis. It is important to view such balance or imbalance not only as symbolic but also as an embodied state of being.

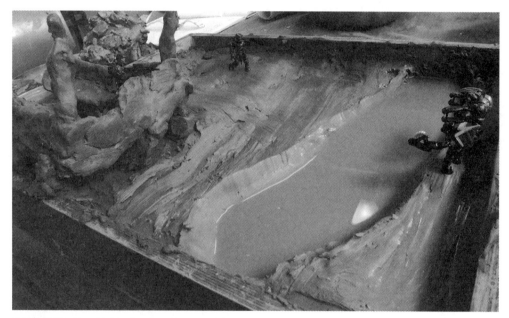

FIGURE 1.2. Clay Field of a boy from a violent home. He had planned this scenario and brought the action figures in his schoolbag to the session. The chasm in the field, which relates to an inner chasm in him, dominates the landscape he created. The power distribution is distinctly one-sided. Not only does the lonely figure on the right have less space, it also has no fort and no allies.

The Clay

In essence, clay is ancient. It is the material from which all life has evolved. Not only in the Judaic creation myths did God create man from clay and His breath. Clay is of ancient purity. No other material is as suitable for three-dimensional creations. It has been used for this purpose for thousands of years.

There needs to be enough clay to provide resistance, but no more than can be lifted. The clay needs to be as smooth as possible and contain no grit; it needs to have

a skin-like feel. The color of the clay can have cultural significance but is otherwise not important. Red clay stains more than white clay, if that is a concern. In Indonesia and Thailand, the volcanic origin of the clay makes it black, which was meaningful to the clients I worked with there. In some Indigenous communities, clay from certain locations holds spiritual significance and cannot be used except for ceremonial purposes, or cannot be touched by men or women, but it is rare that this becomes an issue.

The amount of clay offered is limited to what is contained in the box, but it is limitless in its possibilities. This means the clay will undergo infinite cycles of creation and destruction. Every impulse of creation is simultaneously an impulse of destruction. Every imprint changes the field irrevocably. Progress can only be made via creative "destruction as the cause of coming into being," as Sabina Spielrein put it.[1] Spielrein viewed destructiveness as a necessary aspect of the reproductive instinct. Children from violent homes, for example, who have been overwhelmed by destruction, have often lost their trust in the possibility of repair; they are frequently unable to create anything at the Clay Field because they do not dare to destroy the smooth surface of the field.

After the client has left, the clay may need drying out because a child has poured copious amounts of water into the field. It is then stored in airtight containers and presented anew as a smoothly filled Clay Field in the following session. Tea tree oil can be folded into the clay as a natural disinfectant. Objects are not kept unless a child insists that a specific small creation gain permanence. Photographs can be taken, if this is desired, but because a session is primarily an implicit haptic experience, the visual result does not necessarily reflect the process. I recall from my own Clay Field sessions that my body remembers with absolute clarity the blind touch experience even forty years after the session, but not the visuals; the image was not important, and the photographs I took at the end of each session remain quite meaningless.

Some therapists film every session as a record; a video camera can be introduced as part of the setting. This has proved valuable for supervision purposes. It is, however, also a safety measure, especially when working with children in certain settings, because the therapy involves a touch experience. This may also be relevant for adults, who work with closed eyes to reduce visual and cognitive stimulation. Children have their eyes open during the session. They are less inclined to overthink the process and are more used to relying on their body experience.

Working with clay is at times very sensual, but never sexual. Whenever I had clients who sexualized the experience at the Clay Field, they were actually dissociated from their hands-on touch perception and compensated with fantasies. For example, I recall an adolescent heroin addict who financed her addiction with prostitution. She masturbated the clay, her body leaning back, her face turned to the ceiling. Because

the actual touch connection was unbearable for her, she fled into her imagination, and dissociated from her body, just like she would have done in her working life. In all those cases I continued with less sensual art therapy modalities. This is different from the many occasions when penis shapes spontaneously emerge. Some clients will make the association, hesitate, quickly glance at the therapist or giggle, and squash it down, only then to re-create the shape, if it is needed, for example, as part of building a tree. Or they will deal with it as part of their active response to sexual trauma.

Laura is ten years old. She lives in foster care after her stepfather was convicted of sexually abusing her. For several sessions she creates a looming erect penis shape in a corner of the field, and then continues to ignore it, while she half-heartedly pokes around in the rest of the clay, landscaping some, until in the third session, she suddenly rips out the upright shape and declares it to be a "microphone." In the middle of the therapy room, she stands tall and blasts out her favorite pop song, thus completely reversing the trauma narrative and empowering her expression.

The Water

The water is an essential part of the setting. It can be used to make the clay softer, more pliable, and smoother, and to enhance contact with it. Landscaping the field with ponds and swimming pools brings life and vitality to creations, and as a cleaning agent, it not only cleans hands but also the soul from abuse. Water soothes when the clay is too activating. Warm water poured onto the surface is sometimes necessary to encourage full contact with the flat hands. Water easily surrounds the skin. It is the fluid opposite to the resistant clay. It invites skin contact, which can be reminiscent of early attachment needs. Water has a maternal archetypal quality, as opposed to the clay, which could be associated with the father archetype. The firmer the clay is, the more it invites building structures, whereas the liquid bog that many children like to create fulfills early developmental needs of creaming and nurturing skin contact.

Of course, water is poured into the field to fill rivers and lakes, to create swamps, watering holes, and oceans. It is poured in and dabbed out with the sponge. Dams are built to contain the water, then are opened up and flooding is witnessed, and next the water is sponged out again and the dam is rebuilt until a new cycle of flood and dry land is instigated. Water symbolizes the fluid quality of emotions, and children spend much time experimenting with the flow of water into certain areas of the field and keeping it out of others.

The holding of bodily fluids correlates with inner tension, even fear, and their release with the ability to relax. This manifests, for example, as bed-wetting. During their water experimentations in the field, children gain control over these patterns of retention and learn to control the flow. During puberty, these experimentations come into renewed focus, now as menstruation cycles and the flow of libido. Interestingly, these adolescents now build vertical structures such as water towers and investigate how water can flow from the top down.

Water has a symbolic connection with the libido, the flow of life and vitality. When water is added to a landscape, it enhances its potential for fertility and abundance, also psychologically. However, we can also be flooded with emotions and with libido.

Water cleans not just the hands. It can be applied to purge the soul from abuse. Sexually abused children engage in extensive purification rituals, washing the clay and cleaning the box with water and paper towels, sometimes for several sessions until the purging is done.

The size of the water container can vary. It should have a flat base so it cannot tip over easily. Children with perinatal needs like large vessels filled with water. For many the water needs to be bathwater-warm to become a nurturing resource. Others need smallish bowls to learn containment and boundaries. Some children enjoy a number of different-size cups and containers that they can fill with water, measuring how much can contain what. This is a Montessori exercise to learn containing fluids as symbolic emotions for affect regulation.[2] The sponge has a similar purpose. It can serve to bring water into the field, but also to dab it up and remove it, putting children in charge of their emotions.

Props

The table needs to be lower or the chair higher than normal to allow for the 1.5-inch extra height of the Clay Field. A chair that can be adjusted to the age-specific size of each child is ideal.[3] The top edge of the field should be at the height of the elbows in order to encourage free extension of the arms. If the art therapist's studio is carpeted, drop sheets are necessary to protect the floor. A sink needs to be available. Tissue paper sticks to wet fingers, so paper towels are a good option to wipe hands, tears, and snotty noses.

A sponge is always offered; it serves to move water into the field and to remove it from there. Sometimes the sponge is less confronting to touch and easier to squeeze than the clay. Sponges can be of different sizes and textures. In Italy I found the most fantastic sponges in fun shapes and colors. I should have bought a full suitcase of them. Other external objects easily become a distraction and encourage children to avoid

FIGURE 1.3. A fourteen-year-old is experimenting with vertical flow.

touching the clay. Such props can be on standby but should not be displayed. However, at times they are useful:

- spatulas, spoons, and ice cream scoops to dig and slice the clay
- pointy sticks to engrave and carve
- toothpicks, which may serve as fenceposts, spears, guns, or other spiky features
- glass marbles and crystals, which can introduce something solid and permanent when children do not know their way out of liquid muddy chaos, because they never experienced structure in their life. Marbles are also a great introductory hide-and-seek options to invite a child to enter the field.
- toy animals of good quality and small in size (I use the well-known Schleich animals) to act as symbolic protectors or helper figures that are able to dramatize particular story lines. Life in the Clay Field tends to be ruinous for the more fragile Sand Tray figurines; I do not recommend introducing them into the setting.

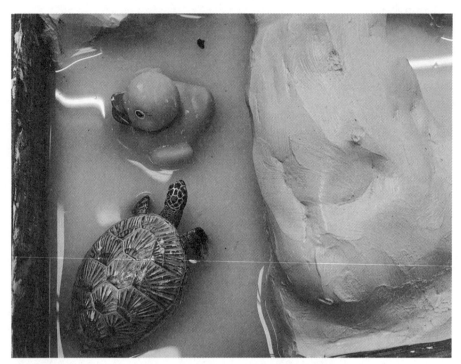

FIGURE 1.4. Small toy animals can help to tell a story, when landscaping in the Clay Field turns to symbolic play.

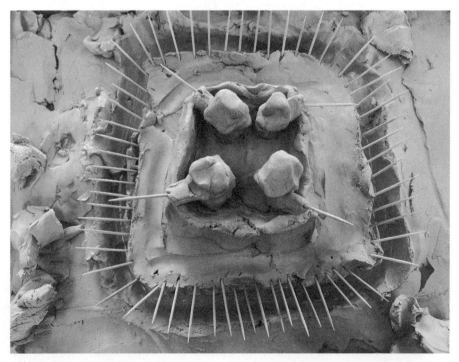

FIGURE 1.5. Toothpicks incorporated into a fort surrounded by a moat, guarded by four soldiers.

Lastly, it is necessary to provide protective clothing for each child in order to avoid school uniforms or other clothes getting dirty. At times this has caused negative feedback from caregivers, especially if they are unsupportive. Messy clothes can aggravate the situation and jeopardize an initial commitment to send their child to sessions.

Liam, a seven-year-old boy in kinship care, digs with one hand deeply underneath the surface of the clay into which he has also poured water. This is a playful, curious exploration. Suddenly he freezes. His whole body goes into immobilizing shock. Shortly afterward, when he emerges out of this overwhelming helplessness, he becomes enraged. His hand holds a penis-like shape, which he now hurls onto the floor and stomps on. Next, he begins to frantically lift out all the available clay, lump by large lump, and smash it into a bucket. While he makes these big splashes, he yells jumbled fragments of words and names, shaking with rage. After this purging of the field, he spends much time calmly and gently cleaning the empty field with a sponge and paper towels. The box is clean, but the art space and his clothes are a mess. His release and relief are palpable, and he makes sure he can come back the following week. When he climbs into the car, after his grandfather has picked him up, he wipes remnants of the clay that did not make the cleanup on the backseat of the car. For the boy this was a way of disclosing to his grandfather what had happened to him, but the grandfather was infuriated and discontinued the sessions, even though clay washes off easily.

The Framework

A child's session can last from thirty to forty-five minutes. Some sessions may involve shorter engagement at the Clay Field and include other activities such as painting, drawing, making a collage, or simply playing with dolls, teddy bears, and other toys. A cubby house, pillows, and blankets to hide can be valuable assets to learn about safety until the tolerance for explorations at the Clay Field has stabilized. Some children eye the Clay Field in the art space for several sessions, being well aware it is there, but they opt for more familiar activities until one day they come in and announce that they are ready to engage.

In schools the setting can at times be rather improvised, often without a dedicated therapy room and the length of the session being dictated by the bell ringing for the next class to commence. Children in these environments drop everything the moment the bell goes, wash their hands, and leave. This is possible because at the

Clay Field children work intensely in the present moment. If need be, they will pick up their story line or action cycles in the next session exactly where they ended the last one, often having planned the continuation of their clay project over the duration of the whole week. They arrive announcing: "Today I want to make ..."

Others can only engage for a limited amount of time with the clay. A ten-year-old boy with a highly dysregulated nervous system, for example, can tolerate about ten minutes at the Clay Field; he really wants those ten minutes, but he can't cope with more. The rest of the session he folds origami cranes with the therapist to downregulate his activation level. Through respecting his needs, he actually learns to regulate his autonomic nervous system responses to external stimuli.

Children do not *avoid* therapeutic interventions. They have in most cases a far more accurate inner radar than adults do to sense when they have had enough, and they usually continue exactly where they broke off a session, even if weeks have gone past in between, when they are ready to continue. Their nervous system regulation, however, happens through activities and modeling by the therapist, not through cognitive insight and verbal instructions. Spending a session building Lego or having a storybook read may have a purpose, if the child asks for it, even if the therapist does not understand why.

The scope and variety of approaches that the expressive art therapies offer allow children to pendulate between safe and activating expressions. Away from the Clay Field they can find comforting activities or ways to rewrite and integrate their trauma narrative. Cathy Malchiodi offers an abundance of insights into the options in her most recent book, *Trauma and Expressive Arts Therapy:*

> The visual arts, creative writing, and dramatic enactment are naturally conducive to storytelling, particularly declarative recollections of events as coherent narratives. But play, music, and dance also reveal stories through movement, sound, and rhythm. They convey the somatosensory nature of stories, because of the nonlinguistic nature of these forms of arts expression. This implicit, embodied narrative that is at the core of arts-based work goes beyond the limits of language when we consider communication of traumatic events and the body's memories.[4]

Play therapy, storytelling, and the Sand Tray[5] are particularly beneficial to support the cognitive integration of events as a "nonlinguistic narrative."[6] Symbolic play appeals to higher cortical areas without the need for words. Many children alternate their sessions with Sand Tray explorations. They will have one therapy session at the Clay Field, and the following at the Sand Tray. The image-based Sand Tray therapy is suitable to help integrate the sensorimotor discoveries in a symbolic way. Of course, many children will create symbolic landscapes in the Clay Field and develop their

story lines with their clay creations, but at times, if can be beneficial to find distance from the haptic experience and to review the narrative in a different context.

However, not all children are capable of symbolic play; many preverbal or non-verbal children are either too young or too traumatized to engage with the cortical areas necessary for symbolic play. They will, for example, use the small toy animals as tools to dig into the Clay Field, having no context they could *mean* something. These latter children benefit from body-based interventions if they cannot tolerate the clay. Blankets and cushions to cuddle into, teddy bears to hold, and cubby houses to hide in can provide sensory information of safety. Drumming, clapping, stomping, swinging, or jumping can allow release through rhythmic motor action patterns. I will discuss these sensorimotor approaches, especially how they relate to the Clay Field, throughout the book.

The Role of the Therapist

Recently an enthusiastic father sent me a photograph of a huge "clay field" he had constructed for his son's childcare center. It was triple the size and four inches deep, a well-meant offer, but no, this is not Clay Field Therapy. The setting does not depend on supplying a big box full of clay, which I am sure the children at the center will enjoy. Even a correctly sized box filled with clay will remain just that, a box filled with clay, unless an accompanier facilitates the process. The role of the therapist is, of course, crucial in this context. After all, it takes years of training to become a Clay Field therapist.

Art therapy in general is understood always to involve three aspects: that of the artwork, the client, and the therapist, or as Case and Dalley put it, "The art, maker, and beholder share the comprehension of an unspoken idea."[7] The therapist enters, with the client's permission, the inner world that is being revealed in the Clay Field. This is different from the dyadic setting of most talking therapies. Rather than the transference and countertransference happening between the therapist and the client, in the art therapy setting the therapist facilitates the transference between the client and the artwork.[8]

The therapist is the holder of the space, securing the environment. The therapist is responsible to provide whatever nervous system regulation is required for the child to be sufficiently regulated to be able to engage. With children this has to happen through body language, a calm demeanor, at times creative behavioral interventions, tone of voice, and modeling, because dysregulated children will often not be able to take in verbal instructions.

At times children need help. On invitation, the therapist may participate in the field, but always with the awareness that the session is about empowering the child. Of course, recognition and praise are important; acknowledging achievements makes them real. Many children, especially troubled children, live in an environment of endless "shoulds": "Don't do this; do that." Here they can make mistakes without being judged or punished. They can challenge themselves; things break, don't work, or collapse. Unless a child "employs" the therapist, the therapist's role is to be there with undivided attention. Such presence confirms the worthiness of the child.

The therapist also holds what could be called the auxiliary cortex, the thinking or awareness function, which enables clients to let go of understanding what they are doing and engage with implicit developmental needs from a much earlier age, where cognitive processing was not yet online. In his seminars, Deuser employs the image of deep-sea diving in this context; the therapist is the one in the boat, holding the lifeline, making sure the diving adventure of the client is as safe as possible. Clients, both children and adults, will simply not explore any issues of depth unless they feel implicitly safe in the setting. Once the client has surfaced and is "back in the boat," insights are shared and framed, whatever is necessary for the learning to become integrated. For children this might be praise and emotional confirmation; for others it needs naming and the raising of awareness of an accomplishment: "Look at what you have found!" Some school-age children who are nonverbal or have speech disorders benefit from the therapist commenting on every move the child makes like a radio broadcaster at a football game. This can strengthen the child's neurological pathways to connect action patterns with words.

My preferred role as a therapist is that of a midwife, assisting clients to birth and bring to light whatever they are carrying inside. If there is nothing to be born, even the best therapist will not succeed. With children and adults alike, it is a client-centered process and not one driven by therapy technologies; it is about supporting the emergence of an individual's potential.

Years of my supervision as a young therapist focused on learning to trust the deep knowing of the client, of being comfortable with *not doing*. This has helped me enormously throughout my career as a therapist. Many young therapists ask me: What do I do when this happens and a client does that? And every time I have to respond: I don't know. But what I know is the need to make a client feel safe and emotionally accepted. This needs to be authentic. I need to be in a space of not judging, staying open internally, and being able to deal with my own fears if they arise. We all respond with our mirror neurons far more to someone's body language rather than spoken words. This can be easily tested if you recall teachers you had in primary school. Most

likely you have no idea what they taught in any detail, but their physiological ticks and movement patterns, their empathy or critical disdain, their embodied communication will be remembered even decades later.

Somatic Experiencing teaches therapists to be aware of their own implicit reactions to a client's behavior. Do I hold my breath? Do I feel like crossing my legs? Am I afraid? If, as the therapist, I can track and respond to my physiological responses and respond to them internally, such as taking a deep breath or changing my posture, the client will instantly respond by also breathing deeply or being less afraid. Bruce Perry emphasizes that only a regulated adult can regulate a dysregulated child.[9] This is nonverbal, implicit affect regulation.

Art therapy is often misunderstood and infuriatingly devalued as art and craft or coloring in. However, even when the therapist plays with the child in this setting, if they build something with Lego blocks or create scribble drawings, in the context of therapy it is an act of building trust or downregulating anxiety.

For young children, the whole setting—the clinic, the art room, the art materials on offer, and the therapist—are one undifferentiated encounter they respond to. The therapist is the one who has to modulate the totality of this impression in order to turn it into a therapeutic experience. Turning the setting into a *temenos,* the Greek term for "sacred space," is the therapist's craft. After all, what we attempt in every session is soul retrieval, to repair and heal the broken, to call the spirit back. The therapist is the one who creates and holds the container to allow these small miracles to occur.

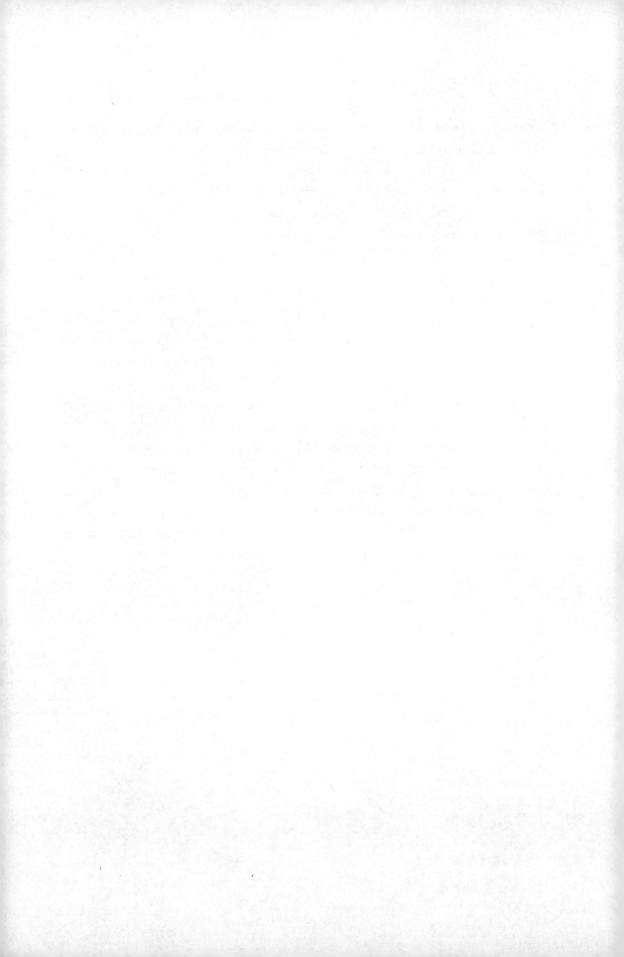

2

The Somatosensory Foundation

We carry within us an evolutionary human blueprint that comes online within a certain neurological window. Scores of scientists have studied the stages of human development from a multitude of different angles. In this context Deuser has focused on the haptic development, how the hands take information from the environment and process it according to age-specific stages of anthropogenic evolution.[1] He distinguishes between anthropogenic and individual development. Anthropogenic describes the universal human development from embryo to infant to toddler, preschooler, school child, teenager, and adolescent. We do not go to a crawling school as babies, but instead we are all propelled forward by a vital internal life-impulse of immense power. It is this anthropogenic impulse that drives our growth.

This growth not only entails physiological maturity and along with it the impulse to walk, learning a spoken language, and the use of tools, but also distinct stages of haptic development. We measure objective milestones such as when a child learns a pencil grip, or from when she can button up her pants, and we also notice when such milestones are not reached. The universal human haptic perceptions become modified due to individual, cultural, and biographical events that influence, support, and hinder a child's development. At the Clay Field we always work with both the anthropological blueprint and the individual biographical modifications this blueprint has undergone due to the client's life experiences.

In her doctoral research on Clay Field Therapy with children who have an attention deficit–hyperactivity disorder (ADHD) diagnosis, Hölz-Lindau investigates this

somatosensory foundation from the anthropological perspective. In utero and during the first months of life, the skin acts as a relational membrane that both separates us from and connects us with our immediate surroundings.[2] What we take in through being touched shapes our implicit sense of identity. At the Clay Field this same skin membrane now receives self-directed stimulation through the hands, and the skin membrane responds, as learned in the first months of existence, to such movement and perception. In addition to movement and perception, the dynamic-emotional quality is memorized based on the parental resonance and dialogue with their child. Hölz-Lindau calls this process *implicit resonance*[3] because as humans we are not an isolated monad but are designed to have immediate access through our body and its sensory abilities to participate in a psychoemotional way from conception onward. These resonating imprints shape our preverbal, implicit body-knowing.

The biological unit of survival for human beings is the clan. We are interdependent social creatures who need to synchronize our body rhythms with other humans. Bruce Perry explains this with the microarchitecture of our core regulatory networks. In utero, for example, the fetus has the formative experience of not being hungry, not being thirsty, and being warm. This baseline, where all survival needs are perfectly fulfilled, has the additional co-occurring event of three core sensory inputs: vibratory, tactile, and auditory.[4] The fetus will experience the mother's heartbeat, her states of tension and relaxation, and how she holds her child as somatosensory rhythms. The developing brain will take these rhythms as the matrix for "the world" and set the baseline of its autonomic nervous system accordingly—for a lifetime. Perry mentions a mother who was a professional athlete, with a really low resting heart rate, and how her baby's nervous system was coregulated to this calm baseline. Similarly, a baby with a mother suffering from high blood pressure had a significantly higher baseline of nervous system regulation, and the child of a depressed mother was born dysregulated.[5]

A fetus that has to endure chronic and repeated stressors will go into traumatic shock before the nervous system is fully formed. In Somatic Experiencing, this state is called Global High Intensity Activation (GHIA), shortened to "high global," and it affects the central nervous system as well as the skin, connective tissue, brain chemistry, organ systems, nervous and endocrine systems, and the immune system not only after birth but for the rest of the individual's life.[6] Some such babies who were unwanted or whose mothers endured existential danger are born with stress symptoms only otherwise observed in soldiers after years in open combat. Such stressors are also the basis from which Karr-Morse and Wiley explain the role epigenetics and childhood trauma play in adult disease—how our experiences of stress, insecure

attachment, abuse, and neglect become our biology.[7] The devastating impact complex trauma has on individuals' physical and mental health, and on their compromised ability to integrate into the social matrix, is passionately discussed in *The Body Keeps the Score* by Bessel van der Kolk.[8]

Resmaa Menakem certainly raised my awareness regarding the role transgenerational racial trauma plays in the context of epigenetics, where trauma becomes inherited. While this does not represent a change in the actual DNA structure, it changes how those genes get expressed; we implicitly learn what is and is not dangerous as a survival mechanism.[9] The *traumatic retention* of the experiences of generations of African Americans and white colonizers shapes the mostly unconscious implicit fear reactions of entire populations.[10]

When we work with traumatized children, we are working with their dysregulated nervous systems; we are working with their biology. Most of these young clients will not offer a cognitive narrative of what happened to them. Their therapists need to find ways to coregulate their nervous system, and through the *relational contagion*[11] of human contact make them feel safe and connected. One of the characteristics of developmental trauma is that coregulation with the child's primary caregivers was compromised, that rhythms were not attuned, that the somatosensory cues of safety and pleasure were not providing a dominant baseline. Such asynchronized rhythmic attunement teaches the developing brain: "You are not one of us," which is highly stressful for anyone, especially a child, because as humans our survival depends on being an interdependent part of a clan.[12]

None of this is conscious, but rather a felt sense based on movement and sensory perception mainly taken in through the skin boundary, which covers our entire body. Jean Ayres writes: "Sensory integration begins in the womb as the fetal brain senses the movements of the mother's body."[13] She defines her work around *sensory integration* as a stream of sensory information that continuously flows from contact with the world around us into our brain at every moment in time. When such sensations flow in a well-organized manner, the brain can use those sensations to form "perceptions, behaviors, and learning. When the flow of sensations is disorganized, it can be like a rush-hour traffic jam."[14] The need to integrate this flow of sensations begins in the womb, where the fetus is exposed to the mother's movements and emotions. It continues through the birthing and early attachment process, which is again based on sensing movements and the emotional affect regulation the mother's touch can provide. During childhood many adaptive responses become necessary to master challenges and to learn new things. There is learning involved when a baby crawls toward and then grabs a toy, and when children play. "Until a child reaches about the age of

seven, the brain is a sensory processing machine."[15] Like many other contemporary experts such as Perry, Levine, and Van der Kolk, Ayres emphasizes that all academic abilities rest upon a sensorimotor foundation.[16]

It is also known, at least in Somatic Experiencing and sensorimotor psychotherapies, that the implicit identity we extract from these earliest relational experiences remains vastly unconscious. Because we have always felt like this, we do not question these body sensations, but they shape what we will call "identity" later in life. Implicit memory is entirely body based; it is not cognitive, and it has no story to tell.

When individuals experience trauma, they feel *bad;* young children, in particular, think they *are* bad when they feel bad. Chronic bottom-up dysregulation and distress lead to negative identifications, beliefs, and judgments about ourselves. These negative identifications and belief systems in turn attract bad, dysregulated life experiences as well as complex and abusive relationships, which all trigger more nervous system dysregulation; over a lifetime, layers and layers of distress compound.[17]

Human interaction with others and the environment involves primarily implicit, nonverbal developmental building blocks we once learned. Our implicit and unquestioned sense of identity emerges out of the coupling of rhythmic patterns of movement, somatosensory perception, and the dynamic-emotional quality of the parental dyad.

And it is in this complex, often dysregulated state that troubled children arrive for their sessions. When these children now touch the Clay Field, their skin sense becomes stimulated. They experience touch. They can touch the clay, but they are also being touched by it. The haptic relationship with the clay will trigger all these internalized implicit memory patterns. This happens through the simplest touch, even the lightest touch with one finger. In the pliable material of the clay, these learned interaction patterns become visible, and they are being witnessed by a supportive accomplice, the therapist. The somatosensory process of movement patterns and their perception is now accompanied by a regulated adult who can provide physical safety, social support, and emotional resonance. And once children have gained trust in the relationship with the therapist, they have the opportunity to also gain trust in the relationship with the Clay Field, and thus with themselves.

Let me add one more puzzle piece to this discussion. Edward Tronick of Harvard University developed the now famous Still Face Experiment with babies and their mothers.[18] In the study, mothers were asked to hold all facial muscles as still as possible and not to engage with their infants while facing them. Within less than a minute these babies became very distressed because the coregulatory cues they need for their survival were amiss. Facial expressions such as smiling in response to the

baby's smile and making sounds in response to the baby's sounds wrap the baby into an implicit dyadic body of resonance, which communicates safety. It is the biology of what we call love, and what scientists call *mirror neurons.*

Neuroscientist Vilayanur S. Ramachandran considers the mirror neurons the basis for civilization, and that the discovery of mirror neurons is doing for psychology what DNA did for biology.[19] Mirror neurons are regular motor command neurons, which orchestrate a sequence of muscle twitches that allow us to move, to reach out, to pick up something, or to perform some other action pattern. A subset of these neurons also fire when I simply watch another person's motor action, when, for example, I watch you reaching out, and simultaneously in my mind my mirror neurons are performing a virtual reality simulation of your mind, of your brain. Mirror neurons are essential in transmitting skills from generation to generation. This might be as simple as eating with a spoon or with chopsticks, but also includes how to keep safe and how to interact with others, both loved ones and strangers. Adaptations through evolution may take hundreds of generations, such as how to adjust to a colder climate, whereas through our mirror neurons, we can learn to put on a coat within one generation.

Mirror neurons, however, not only transmit motor commands but also emotions. When I see you smile, or laugh, I respond. When I see your mouth signaling disapproval, I respond. Good actors, for example, are capable of manipulating our mirror neurons through facial expression and their embodiment of anger, grief, or love to the extent that we feel these emotions as if they were our own when we watch a movie. Mirror neurons are the empathy-glue of social interactions. Already babies in the crib "re-act" to facial expressions; they smile back, for example. We respond to loved ones by reading their facial and implicit cues for connection or stress. Our mirror neurons respond to body postures of danger and threat. And there would not be such deeply felt passion while we watch a football game if it was not for the mirror neurons, which allow us to actively participate even when we are watching TV.

Dyadic mirroring happens in all therapy sessions, and consciously applied, it can be invaluable in coregulating the client-therapist relationship. This is particularly necessary when working with children, who will not respond to verbal instructions, because they cannot take them in when afraid or activated. Instead, the therapist can use body posture, tone of voice, deep breathing, speaking slowly, positioning in the room, and intentional movements as a mirror neuron–informed language the child will implicitly understand. The moment, for example, the therapist crosses her legs and folds her arms, her body communicates to the child a defensive action pattern, being no longer "open" for the client's story. When the therapist exhales in a

pronounced way, the child's mirror neurons will prompt the same. Speaking slowly can slow down a child's hectic action pattern. Dan Hughes and Pat Ogden both train therapists in applied body language to regulate their clients' nervous system,[20] and so does Somatic Experiencing.

The Clay Field adds another intriguing dimension to the subject of mirror neurons, because the clay mirrors all action patterns projected into the field. The trained therapist is able to observe the interactions between motor impulses of reaching out into the Clay Field, the sensory feedback a child receives from this encounter, and how the child implicitly responds to this feedback. This is when videotaped case histories become valuable training tools, as they allow a slowing down of these feedback loops of behavioral interactions that the hands perform in contact with the clay. Observing even just the first minute of a child's encounter with the field can give profound insight into the vital needs and the relational conflict these young clients bring to the table.

Deuser defines the setting as a relational "us," a dual polarity, where I am the one sitting on a chair in front of the field, and I am also the one I encounter inside the field.[21] If the child is able to experience the therapist and the therapeutic environment as safe, there is the chance that with appropriate support the child becomes receptive to what Hölz-Lindau calls "corrections."[22] Such corrections are initially accidental discoveries of more fulfilling qualitative-emotional interaction patterns, which, with practice and repetitions, can become an integral part of an implicit new identity.

The improvement of the contact experience, through the skin as the body boundary and relational membrane, happens on developmentally increasingly complex and differentiated levels. Initially it is purely the experience of pressure, then it becomes contact, then implicit felt sense identity:

1. Pressure entails applying the body weight onto the field, making imprints; such mark-making is executed with motor impulses.

2. Contact begins when the client realizes the sensory feedback flowing from such an action pattern back into the body, such as the clay feels smooth, nice, or yucky, like a mountain, or something else.

3. Identity is a deeply human accomplishment; it emerges out of the insight that "I did this." No dog will turn around after having left footprints on the beach and say, "I made those."

These stages depend on the age and developmental maturity of a child. As a more conscious identity emerges, the dual polarity, the sensorimotor feedback loop, becomes intentional cause and effect: efferent and reafferent. As I project my motor

impulses and action patterns into the Clay Field, I receive sensory feedback from these connections. At the core, the Clay Field experience is always relational. I encounter myself in the other-than-me. The clay mirrors every imprint I make. Over time, learned biographical behavioral patterns are replaced by more fulfilling authentic ways of being without engaging in the story of what happened. This is partially because when we are dealing with developmental trauma, there is no conscious story to tell. But children are trapped in unfulfilling learned action patterns, dyadic misatunement, and a dysregulated nervous system.

This nonpsychological approach prompted Deuser to call the method an "education of the senses" rather than psychotherapy, even though the therapeutic benefits of this bottom-up approach are amazing. The process is not as such cognitive and not engaged in the trauma story. Work at the Clay Field puts the focus firmly on what movements were inhibited due to once experienced trauma, where development was arrested, resulting in the shutdown of certain parts of the brain. The therapeutic setting aims to create an environment of safety and support that allows these blocked, braced, dissociated aspects to be "re-membered" and reconnected with the child's life-stream.

Underneath all the individual dysregulation is the powerful anthropogenic drive. We would not be alive if we were not connected to it. If the therapist can align with this universal life stream and trust it, the child can learn to connect, align, and trust it as well. In my experience, this trust is more valuable than any therapeutic technique I have ever learned. Such trust needs to be authentic; it is an implicit, knowing calmness, and it is communicated through the mirror neurons. I learned this from becoming comfortable with not doing anything in sessions, rather just being present. I learned this from years of meditation practice and from sorting out my own issues in many different therapies.

While we all sit down in front of the field with our individual history, we also sit down in front of it with a *knowing anticipation* of who we are meant to be.[23] This urge could be described as an existential yearning toward the one we want to become. It is anchored in our anthropology. We all carry within us a blueprint of our human potential. Ayres describes it as a vital "inner drive so great, we take most aspects of sensorimotor development for granted."[24]

Feeling connected and liked or even loved will trigger an emotional response, just like being singled out and shunned. Which one would you repeat for more? We transfer our social relational patterns into the Clay Field with the promise of being able to fulfill unmet needs. It is this unfulfilled yearning that from now on drives the sessions and propels clients forward.

I am the one I want to find in this relational encounter at the Clay Field. When I sit down in front of the clay-filled box, I do not know who I am existentially meant to be. I will, however, undoubtedly recognize this essence of myself when I encounter it: when my hands, for example, connect with the clay and suddenly the material feels warm, solid, nurturing, and my entire body responds with tingling delight.

When this happens, it is a reunion with myself that will override any biographical traumas, setbacks, and detours as I connect with something that is genuinely identical with my essence. Levine calls this process "re-membering,"[25] as integrating the lost and dissociated aspects of oneself. One could call this the mystery of Work at the Clay Field, yet I have witnessed and experienced such unfolding hundreds of times. It is an existential force that drives us toward ourselves: "I am the one who did this, and I am the one who finds herself in what I did."[26] Adult clients will describe the attained state as wholeness, as oneness, as a coming home, and they feel filled with grace and gratitude. Quite often it is experienced as soul retrieval; something once lost or broken has healed and become whole. Children come to a point of deep satisfaction and satiation; some existential question or quest has been answered, a treasure has been found. They leave relaxed, when at the beginning of the session they were tense. They can settle, where before they were upset, and they become potent bright-eyed creators of their own worlds.

3

Dual Polarity

When someone sits down at the Clay Field, almost every individual will begin with a curious impulse and tap with one finger on the surface of the field. It's like a test, a checking in, the equivalent of a greeting, like saying "Hello." Next the flat hand will wipe across the field—and if we translate this haptic impulse, it would be the equivalent of asking: "How is this field receiving me? Does it tolerate me?" Some clients will add some water at this stage; others will simply repeat the wiping gesture across the field, but now with the question: "Can I tolerate this contact with the field?" And if these two questions, one directed into the field, the other directed toward the self, have been answered in an assuring manner, the hands will sink into the clay like teeth and grasp the material, which will provoke a sensory response. "Do I get enough?" "Does this feel nice?" "Do I want more?" "Do I want to get rid of this?" This will prompt further motor impulses. This is how we proceed in a sensorimotor dialogue with the Clay Field.

Dual polarity is a term Deuser created to describe the intriguing process that happens in the haptic relationship of the hands with the Clay Field.[1] Sitting on the table in front of the client, the Clay Field becomes the other-me. Every client works with a dual self-experience: I sense myself in my body sitting *at* the field, and I sense myself through my hands *in* the field. As an individual I am confronted with the encounter of an object in front of me, whereas my hands experience an intimate relationship with the clay inside the field.

In addition, there are two poles of perception. With a motor impulse I reach out into the field, and as I touch the clay, I receive sensory feedback from this encounter. This sensory feedback will inform my next motor impulse of reaching out. Will I now be shy or encouraged? Can I trust this or not? Will I get hurt here or am I safe? None of this will be conscious as our hands engage with the clay, but the encounter will be

informed by relational experiences we have had in the past, where we were encouraged or shamed, hurt or safe. Ultimately the clay is completely neutral; it unerringly feeds back to us what we project into it with our hands, and nothing else. This means the one I encounter in the field is always myself.[2]

The Clay Field as an Interspace

Some children hesitate to engage with the field, especially when they do not know the setting or the therapist. One way of inviting contact is for both to sit at the field, and the therapist might roll a small clay ball across to the child. The child might roll it back, and then the therapist returns it again. The Clay Field here has no other function than to be the space between the client and the therapist. It is a playful invitation to engage, to make contact, to build the therapeutic relationship. Many children, including those with disabilities, respond in a positive way to such an invitation. The welcoming ritual of a colleague of mine is to serve a cup of hot chocolate in the center of the field as an invitation that this relationship has the potential to nurture.

If the therapist wants to shift the focus from this interpersonal encounter onto the Clay Field, she might indicate that a marble has been hidden in the clay, and could the child find it? Not all children need this marble game, but some like to play hide-and-seek in order to build trust. Once the marble has been found, the child might hide the marble in turn, and the therapist has to find it.

In this context the Clay Field has primarily a social function: it connects the therapist and the client. It just happens to be the interspace between the two, where they engage. This changes significantly once the next step can be taken. From then on, the therapist steps back and supports the child's relationship with the field.

The Clay Field as an Opposite

When the Clay Field presents as an opposite, the child shifts the relationship onto the field, and the therapist becomes a benevolent bystander who can support, facilitate, and accompany this encounter, but who is no longer the focus of attention and trust-building. A world is on offer in front of the child. This can pose questions such as: How can I be in this world? How can I enter it? Do I have a place in this world? The field as an opposite reflects life experiences with other relationship-opposites in the past. Such biographical life experiences will determine how the child views this world at hand: it will be cold and unyielding, or it will be disgusting, or it will be forbidden, or it will be exciting. The field presents as an invitation but also as a

challenge. None of these reactions will be conscious and have a narrative. Rather, they will mirror the somatosensory dyadic relational patterns we learned to embody from conception onward.

At a primary school in a poverty- and crime-ridden neighborhood, several boys present with the inability to touch the field. They tell chaotic, murderous stories while their hands wave through the air, enacting noisy shootings, killings, and threats. Their nervous system has all the hallmarks of being chronically hyperactivated. Several have watched all-night R-rated thrillers and horror movies on television. All have witnessed violence at home. Most of their fathers are in jail or absent. When these boys touch the clay for a fraction of a second, they seem to flee in an instant. The relationship patterns they have learned in life are transferred onto the field. The world they know does not offer them refuge; their environment at home is not safe, and they live in constant stress. Hence, a relationship with the Clay Field is also deemed unsafe.

For the therapist, the challenge here is how to facilitate contact with an opposite-other that can be experienced as safe, and how to support their arrival in the "world." One useful intervention can be the suggestion to apply pressure: simple physical

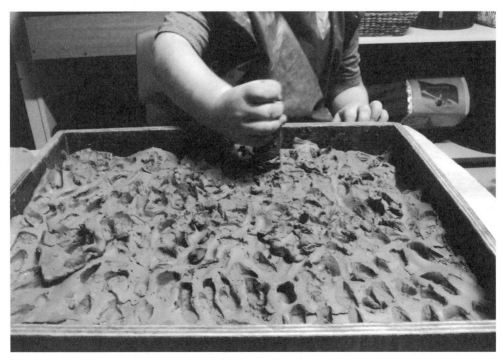

FIGURE 3.1. "Look how many footprints I can make. Thousands!" The child uses a kangaroo toy figurine to make the imprints.

pressure projected into the clay. Recall from the previous chapter that pressure is not yet contact; it is also not sensory, but pure engagement of muscles, ligaments, and skeletal build. As a transitional object, a boy may, for example, choose a totem or helper toy animal from the collection, and is then encouraged to make footprints with the animal on the field (fig. 3.1). The toy figurine ensures the sensory feedback loop is not triggered through touching the clay directly. In order to make increasingly deep footprints, the boy will have to exert pressure, because the clay is not like air, but resistant. The pressure will create a feedback loop, which here is not sensory, but it will provoke an implicit sense of presence. Applying pressure onto the field with the toy animal encourages the boy to come into existence; every imprint he makes into the clay confirms his being alive.

Emphasizing sensory feedback with questions such as "How do you feel?" would be way too much for these boys. Many do not feel "good" about themselves. All attention here is directed through motor impulses into the opposite-other through footprints, mark making, drilling with one finger, imprints with the hands, leaning on the forearms, or digging in with the elbows, whatever can be tolerated, until the child has an implicit felt sense that being physically safe in the world is possible. Some of these interventions may not work, but usually every child finds one posture that feels safe, calming, and comfortable. Even the choice of animal can become significant. Many boys, for example, choose the biggest one—an elephant. After all, they do want to make an impression. I recall some of these boys being so dissociated that they literally seemed to arrive from outer space, and I could almost hear the sigh of relief when they were able to arrive.

Pressure engages the physical body in a way that allows children to uncouple the trauma held in the body from their physiology. My muscles are not my trauma. My muscles have experienced trauma, and they have reacted to it; they are holding it in their bracing or collapsed patterns, but they are not identical with the trauma. Applying simple pressure onto a safe surface allows children to feel their body without the imprint the trauma left in their body-psyche. Making footprints enabled these boys to uncouple the trauma from their somatosensory experience of themselves. It allowed them to move away from fear and to reconnect with movement and flow.

If we apply the lens of dual polarity, here the opposite pole, the Clay Field, had to be made accessible in order to establish it as a safe, relatable object. In the following case, the world of the Clay Field also had to be made safe before it could be entered, but the session unfolded quite differently.

A four-year-old girl, Lara, refuses to be touched by her mother or anybody else. This onset is sudden and of great concern to the mother. When she comes into therapy Lara eyes the Clay Field with great suspicion. She is highly agitated and spends most of the time bum-shuffling on the floor in the therapy room. Eventually the therapist takes some clay and shapes a small goose. She places the goose on the edge of the box. Lara watches her intently with highly agitation. Next the therapist takes the goose and tips it forward, so the beak touches the clay. Lara freezes and waits, breathless. The therapist tips the beak again into the field, and after a while does it again. Lara has come closer the third time. After some time, the girl very tentatively puts one finger forward and touches the clay, just lightly, and waits. Nothing happens. Lara waits, and nothing happens. Next the girl begins to shake violently, and a flood of incomprehensible sounds erupts from her mouth. It takes almost twenty minutes of shaking and garbled words until the therapist can understand what Lara is saying. Having innocently entered a room at home, she came across her grandfather strangling his wife, the girl's grandmother, in a fit of rage. The grandmother survived, but the shock of witnessing such violence totally overwhelmed Lara. Unknowingly, the therapist had picked a transitional object that has a prominent neck. Over the following sessions, Lara acquainted herself with the Clay Field, creating simple age-appropriate landscapes. Her phobia of being touched stopped after the first session.

Also here, the polar opposite, the Clay Field as a relational object, was perceived as unsafe. It was not the clay as an art material, not the setting, but the relationship with the field that triggered Lara. However, Lara was quite safely attached to her mother prior to the trauma. Unlike the boys from the previous example, the girl was internally resilient enough to access the trauma and release it. This is possible when one traumatic incident happens for someone with an otherwise regulated nervous system. In Lara's case, for example, the mother noticed quite immediately that something was wrong with her daughter and sought help. The boys were sent for sessions as part of the school's counseling program due to their significant learning and behavioral issues. Their parents neither had the means nor the insight to send them to therapy. All boys lived in an environment of ongoing neglect and violence, and all suffered from complex trauma, which is far more difficult to treat. Especially if the child remains seven days per week in this abusive environment, one single therapy session is not much more than a drop in the ocean.[3]

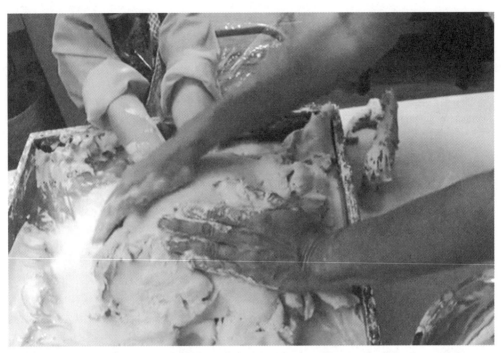

FIGURE 3.2. In order to communicate a sense of safety, the therapist may pack the child's hands into clay. Many children relish actual pressure, as it implicitly tells them that they are being firmly held. This seven-year-old boy from a violent home, diagnosed with ADHD, almost fell asleep. His nervous system relaxed to such an extent once he could feel viscerally safe.

While Lara was afraid of being touched, other children might be afraid of being seen. I have witnessed this most pronounced with girls in women's shelters. They have experienced a violent home, where the safest mode of survival was to be invisible. They have trouble engaging with the clay because it will make them visible. One way of successfully navigating this dilemma is by the therapist offering to pack in their hands. The girl will place her hands onto the field, and the therapist will firmly pack clay around her hands, creating a safe enclosure. This is different from when children do this themselves, or if it arises in the context of further sessions. Here the therapist models a safe relationship with the field. In the women's shelter this became a session ritual, where the majority of the children would arrive, once they had experienced this enclosure, and instantly place their hands onto the field, expectantly, waiting, until the therapist had packed in their hands. The ensuing clay shelter would become the base from which they could safely venture out into the field, beginning to landscape it according to their needs.

Less acutely troubled children will engage in landscaping the Clay Field. They will build worlds and attach stories. The narrative is frequently a problem-solving effort. The nine-year-old girl (figs. 3.3 and 3.4), for example, creates enclosures for

mothers and babies that are policed by dogs. As an infant she had been abducted by her father, and the threat of this happening again still remains. Here she is securing the relationship with her mother, creating the narrative for a safe world. This is her second session, and she arrives with a plan. She collects several mother-and-baby pairs of animals for which she intends to build the enclosures.

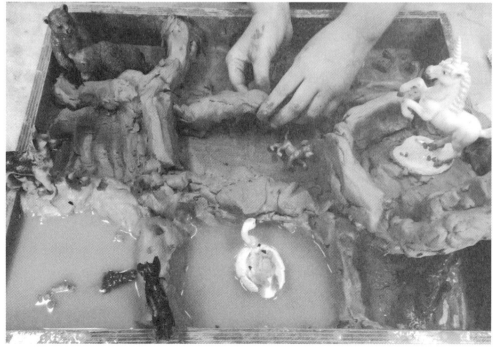

FIGURES 3.3–4. This nine-year-old girl maps out a zoo for mothers and their babies, a story that repairs the destructive narrative of her upbringing.

Many such children will actually arrive at the session stating what they want to make today. They have planned action scenarios and are looking forward to building a meaningful world of their design.

On the other hand, children who ask the therapist, "What do you want me to make?" really are saying, "I'm not safe here." When a child feels safe in the setting and they are put in front of a box full of clay, they will engage with the material, even if they have no idea what they want to make, which is the case in the following aspect of the work.

The Clay Field as a Self-Generating Experience

Here the field acts as an invitation for an open psychodynamic process. It offers itself for a rolling-forth sensorimotor experiment. The outcome is unclear. There is no pre-conceived plan. Such an attitude requires a lot more trust than the previous setting. Children here are willing to get lost in the experience in order to find themselves. Each motor impulse projected into the field will give sensory feedback, which will resonate in the child's body. This is an unfolding dialogue between the field and the child. However, while the field is the other-than-me, the one I encounter in the field is no one else but myself. What I encounter are the imprints my movements have made. I express myself, and the field receives my expressions as indentations, as buildups, as material being pushed away or pulled toward me. Every time my hands reach out again into the field, they encounter these marks, crevices, piles, and imprints. In this way, I enter a dialogue with myself: an experience that provokes a continuously changing unfolding of events and discoveries.

The open-ended process requires the child to feel relatively safe in the setting, which manifests in the field as what Deuser calls *finding a hold,* which is literally quite often something the hands can hold on to, a place of safety that gives orientation or steadfastness. One can observe the hands returning to this place to rest, or to reorient, and then set off again to explore. The therapist's role is to provide resonance, presence, and if need be, nervous system regulation.

Safety in the setting, safety in the relationship with the accompanying therapist, and object constancy in the field through a "hold" make it possible to break away from old patterns of behavior and explore new ways of being. The questioning of limitations learned in the past happens through movement and perception, not through cognitive insights. A space in the field may now feel too small, and the impulse is there to make it bigger. This will give sensory feedback and the implicit embodied

experience of how it feels to have more space. If it feels good, we can just create a bit more space and check it again, until it feels just perfect and we have arrived at a whole new life experience in the world—a world where I can have space and be safe and feel good about myself.

The same process could be driven by emotions or by taboos. It might just feel really good to push the clay away in anger, or to hit it with my fists. And if it is safe to do that, it allows me to actually feel the liberating resonance in my gut. I can add a sound and hit or push a bit more, and feel myself in an exhilarating new way of empowerment. I can do this! I can deal with this, where before I did not know I could.

The process is a shedding of old layers, a step-by-step liberating of myself from biographical limitations and restricting ways of relating. What I discover is my place in the world and my relationship with it. This is a continuous reciprocal experience, an externalizing of myself into the Clay Field—and how it feeds back who I am. The process is driven by a passionate longing to be myself.

A Lake Full of Chocolate Milk

Jason's first session was forty-eight minutes in duration. Jason is an intelligent small-framed boy. He is five and a half years old. His family very recently moved from London to live in Australia. He has mentioned on numerous occasions to his mother that he misses their home in London. Since immigrating, he has developed a facial twitch, and he drools occasionally. He has also begun to wet the bed at night.

He was brought willingly by his mother. His twin sister stayed at home. The sister is taller, competitive, argumentative and (as described by their mother) controlling. She is less confident socially than him, although she is able to articulate her needs. Both children attend preschool.

Jason is looking forward to his session and comes in joyfully, touches the clay with his finger, and as we put on the apron, he notices the animals, and describes how he is going to put their prints into the clay. He does this later on.

The therapist had hidden marbles in the clay to assist him with transitioning, because it is his first session. His motor impulse to find the marbles (fig. 3.5) is full of vital intention. He not only wants to find the marbles, he is definitely looking for more, even though he does not quite know how to go about it. Once the marbles are found, he begins to mark tracks with one finger, and fills these with water to create a river. Encouraged by the therapist to dig with all his fingers rather than one or two, he makes a lake for the duck (fig. 3.6).

FIGURE 3.5. Searching for marbles.

FIGURE 3.6. Digging with all his fingers.

He moves the water from the bowl into the field quite quickly with the sponge, using his fingertips. On being shown how to hold the sponge with his whole hand, he follows accordingly, moving the water back and forth between bowl and Clay Field, referring to it as "chocolate milk." It is quite visible how he gains vitality, having lots and lots of chocolate milk, lots of material, being fully engaged (fig. 3.7).

FIGURE 3.7. A lake full of chocolate milk.

At thirty minutes into the session, Jason spontaneously packs his left hand up to the elbow in clay (fig. 3.8), and it remains there for eight minutes while he packs the bear into the clay with his right (fig. 3.9). He pushes his hand through and out the far end and is delighted that he can "see out" through the window. He closes it up. He opens it again and closes it again (figs. 3.10 and 3.11). On withdrawing his arm from the "cave," he places the duck within it (fig. 3.12). He creates a bed for the bear in the center front of the Clay Field using the sponge for the bear to rest on (fig. 3.13). Later he creates a cave for the bear just behind it (fig 3.14). It is visible how much confidence he is gaining. He is increasingly certain of his actions, which in return reaffirms the acquisition of his own vitality. In an implicit way, he understands what he is doing and what he is gaining. All of this is spontaneously unfolding. It is unplanned, and yet he finds himself in these actions, driven by curiosity. Jean Ayres writes: "Children are designed to enjoy activities that challenge them to experience new sensations and develop new motor functions. It is fun to integrate sensations and to form adaptive responses."[4]

FIGURE 3.8. Packing his arm into clay.

FIGURE 3.9. Burying the bear.

FIGURE 3.10. Nurturing the bear.

FIGURE 3.11. A cave for the bear.

FIGURE 3.12. A cave for the duck and his hand.

FIGURE 3.13. All have a new home now.

FIGURE 3.14. His hand reemerges.

Having surveyed the landscape, he states that the duck was safe, and he places the bear at the highest point of the cave and indicates he is finished. He will return the following week. He enjoyed it and says it was fun, and he explains what he has made to his mother.

We can view this process as a continuous dialogue between the polarities of Jason and the Clay Field, as a dialogue designed to liberate our true needs and dormant potential. This is executed as a dance between movement and perception. Jason did not consciously know what he needed when he came to the session, and yet he found exactly what he was searching for, appropriate for his age and addressing his anxiety concerning the loss of his familiar base back in England. The Clay Field made it possible to experience himself in an empowered, competent way.

Initially Jason's Clay Field is an interspace with a marble hidden inside, simply designed to invite him to engage. He is confident enough to quickly progress to the field as an opposite into which he projects his purely sensorimotor exploration—digging and pouring water into rivers and lakes full of chocolate milk, which deepen when they gain an emotional and vital quality. Increasingly we can observe the self-generating experience when he turns to role-play with the two symbolic parental figurines of duck and bear. These two toy animals, which can be supplied or chosen, allow children from

approximately five to nine years of age to express the relationship with their parental caregivers in a symbolic way. In Jason's case, there are no apparent stressors concerning his parents, except that he wants them to have a shelter. His fears are around his safety, having lost his familiar home. It is interesting that during the entire second half of the session, he keeps his left arm securely packed in to consolidate his visceral need for being securely held. The therapist had neither suggested he pack in his arm nor mentioned this as an option; it was an entirely self-directed impulse, and obviously something he really needed. In the end both his animals acquire a safe home: the duck in the cave and the bear on top. The bed-wetting stopped after this session.

—PHOTOGRAPHS AND CASE NOTES CONTRIBUTED BY JOCELYN CAMPBELL

Dual polarity is a continuous cycle where we are actively doing and passively receiving. In all movements we reach out, externalizing ourselves—only to return to ourselves enriched with an experience. Deuser calls this motivation an *intention toward ourselves*,[5] driven by our vitality, our desire to touch, the lust to grab, provoked through the resistance we encounter in the clay. There is a vital urge to "make this experience work for me." How did Jason know he needed to pack his arm into clay in order to feel safe? What moves us is projected into the field. The resistance of the clay will provoke memories from other experiences where we encountered conditions that blocked and hindered us. If you watch Jason's body in the first photograph, it is visible how much he strains, his entire body being twisted with effort (fig. 3.5). There is frustration, but simultaneously we imagine in this situation virtual movements of what we want. These *movement fantasies*,[6] as Deuser calls them, act as motivation to continue. Such impulses can be observed as the hands move in the field. Jason's hands wanted more but didn't know how to. The therapist noticed this and showed him how it was possible to dig with all the fingers instead of just with one. A little later, she supports him again by showing him how to use his full hand to squeeze the sponge. These are minimal inputs, but they matched Jason's desires in that moment and empowered him to fulfill his needs. Such movement fantasies are driven by our potential, and clients benefit if the therapist can read these desires and verbally encourage their exploration. Their realization is not ego-driven but has its basis in our anthropological-evolutionary urge for life, modified by individual history.

We encounter the limitations of our history through habits and learned ways, but deep inside, we long for more. The continuous sensorimotor feedback loop enables us to increasingly respond from the perspective of our more authentic, individual core—simply because it feels so much more satisfying when we connect with it. Once we know we can have a lake full of chocolate milk, there is no going back. And in the process, we taste our wholeness and connect with an increasingly authentic sense of self.

4

Somatosensory Touch

While haptic perception has been a neglected, seemingly unimportant sense for centuries, it has emerged as a modern solution to counterbalance our visually over-loaded, internet-dominated contemporary environment. According to Martin Grun-wald and his faculty at the Haptic Institute in Leipzig, we have entered the haptic age.[1] Current research focuses primarily on design, computer games, and robotics, enabling a surgeon, for example, to perform surgery on a patient via a computer that can translate his hand movements into a machine holding the scalpel five thousand miles away. Suddenly the human hand has emerged as a sensory double organ of extraordinary capacity and ability.

I personally believe that Clay Field Therapy is one of the approaches needed for a society where individuals spend increasing amounts of time online, and children no longer play much outdoors but instead press keyboards to engage with virtual worlds in computer games. The need for psychological answers to this lack of embodiment is apparent in the growing importance of body-focused approaches, and I am sure haptic perception will increasingly find recognition as a valuable therapeutic tool.

When we sit at the Clay Field, we work with the sense of touch. In his book called *Touch,* neuroscientist Linden calls the skin a social organ through which we develop trust and bond with our caregivers.[2] Safety and love are communicated through touch. Sexuality knows erogenous zones most susceptible for touch. We have *passive sensors* for pain, itching, temperature, and certain chemicals, and *active sensors* that are capable of finding a specific coin at the bottom of our handbag.

Our touch circuitry permeates every aspect of life. It literally makes us feel con-nected with family and friends. Linden even points out that doctors who touch their patients get higher health care ratings and waiters get higher tips when they physically

connect with their patrons. Children can develop normally without a sense of sight, sound, or smell. Yet without touch they grow up to be emotionally and socially dysfunctional; we could witness distressing evidence of this when images of the Romanian children raised in severely understaffed orphanages during the 1980s reached the Western public.

Neonatal wards have discovered that providing "kangaroo care," meaning the mother holds her premature infant against her chest to keep the baby warm and close to her heartbeat, can reduce infant mortality rates while also decreasing the babies' stress levels and improving their sleep and cognition—benefits that remained at age ten.[3]

Emotional pain triggers some of the same neural pathways as physical pain.[4] Neural circuitry and psychology reveal that the sensory system and the brain interact; emotion and tactile sensation are physiologically linked. Pain, a caress, proprioception, and itchiness all have their own neural pathways, even though they also connect at times. These somewhat independent pathways can result in intriguing disorders. People with impaired pain sensors can still feel a caress; the reverse is true as well. All these pathways are not completely separate. Some overlap, and the brain hubs they activate communicate with one another, all of which is under sensory and emotional modulation.

While a life without physical pain sounds ideal, those who are unable to feel pain because of a mutation in their genes often do not live beyond their teenage years. Even ordinary cuts and abrasions become a threat because the bacterial infection remains unnoticed, and this lack of perception can render injuries fatal.

Our mechanoreceptors convert touch, which they perceive as a mechanical energy delivered to the skin, into electrical signals.[5] These electrical signals then travel at the relatively slow speed of approximately 150 miles per hour up the spinal cord to the brain.[6]

Linden identifies two separate touch systems in the skin, operating in parallel, that report fundamentally different aspects of our tactile world. The fast A-beta fibers convey touch information with *high spatial* and temporal resolution, which allow us to discriminate between subtly different stimuli away from the body. Through them we can perceive our body in space, called proprioception. The A-beta fibers enable us to position an arm even with our eyes closed.[7] Without being able to locate above and below, and orient our body, we are actually unable to move. Rothschild describes a patient whose brain region that processes proprioception had been damaged, and who was unable to get up from bed, even though he looked perfectly healthy, because his brain did not know where "up" was.[8]

The slow C-fiber caress system produces a diffuse, *emotionally positive* sensation on only the hairy skin.[9] It responds to slow, light touch. The caress system can even be activated through watching an erotic movie. Hairy skin has a different function than glabrous hairless skin, such as the inner hand, the lips, and parts of the genitalia.

Then there is the so-called Meissner system, with about 350 Pacinian corpuscles per finger, which allows us to handle tools as a sensory extension of the body.[10] This is how we play the piano or use a screwdriver, how we chop vegetables, and how the blind read Braille with their fingertips.

There are many more highly complex aspects to the neurobiology of touch, but discussing them would be beyond my knowledge and the purpose of this book. I would like, however, to look at a couple of other systems that are just as important when we work with a tactile medium such as clay.

The Fluid Network of the Fascia

So far we have looked at the mechanoreceptors. What we also stimulate, however, even with the lightest pressure, are the fascia, also called the connective tissue. It is commonly believed that touch is communicated through the skin, and that the skin communicates the contact experience through the peripheral nervous system to the brain. "The nervous system is widely regarded as the fastest, working in milliseconds to seconds at speeds of 7 to 170 miles per hour."[11] In evolutionary terms, the nervous system and the fluid systems, such as the fascial system, developed in tandem. The fascial network is the largest and medically most underappreciated organ in the human body. It is a fascinating holistic system that holds our entire body together. All our bones, muscles, ligaments, and organs *float* in a myofascial web.

Structural Integration expert Thomas Myers explains the fascial system with the example of a grapefruit. Within the skin of the grapefruit we find each fluid-filled segment consists of a double-walled membrane. Each slice is filled with many more tiny, softer double-walled membranes, each of these filled with juice.[12] In the human body, "the fascial bags organize our 'juice' into discrete bundles, resisting the call of gravity to pool at the bottom."[13] Sixty to sixty-seven percent of our body weight is fluids; without these fascial bags, our fluids would form a huge puddle around our feet. Our bones float inside this fascial web, similar to the pips inside the grapefruit. What structurally holds us up is not the skeleton and the muscles and ligaments but this intricate fascial net that encases everything in our body. We can easily prove this by trying to make a skeleton stand up. It won't. The fascial web is a network of membranes, some soft, some multi-layered for structural stability, and others flexible or firm.

The elasticity of our skin depends on the fascia. In old age it loses this elasticity, for example compared to a baby's skin, which is equally soft and firm. Even light pressure on the fascial net is communicated across the entire system at lightning speed. All injuries are stored in the fascia and leave imprints or even tear the membranes. The membranes respond to trauma and injuries by becoming stiff and contracted, which we then witness as bracing patterns, such as a frozen shoulders and scars.

The fascia network reacts to touch through a variety of sensors that are located in a relatively shallow layer of the skin, and they answer to even tiny indentations produced by textured surfaces. The fascial network is likely to be the most under-researched organ in the body. Surgeons mostly regard it as the stuff they have to cut through before they get to the real body parts. However,

> the fascial network is the largest sense organ in the body, dwarfing the eyes or ears in its rich diversity and proliferation of primarily stretch receptors. These sensory nerves frequently outnumber their motor compatriots in any given peripheral nerve by nearly 3:1.[14]

This means the sensory facials network communicates three times faster with the brain than the motor mechanoreceptors Linden mentions. The fascia pass on touch information through electric vibratory signals in their fluid network.

I am quite sure that the somatosensory rhythmic blueprint a fetus's neurobiology receives in utero is communicated through this fascial web. The fluids in the fascia communicate and store memories; these are both physiological and emotional memories. Epigenetics as a transgenerational information system is able to adjust the very cell structure of our being.[15] To which Perry adds: "Genes are mere chemicals and without 'experience'—with no context, no microenvironmental signals to guide their activation—create nothing."[16] Experience becomes our biology. One of the core networks to communicate these experiences is the myofascial web.

Body therapies using touch aim to redistribute the fluids in the fascial system in order to reduce stress. In our case it is not a therapist who touches the client, but the client who touches the clay. The clay as such is neutral; it feeds back whatever the hands project into it. The pressure marks the hands leave in the material remain. My hands can revisit these. They can recognize them as mine. What the clay feeds back is myself, my learned biology of making marks, including all the stressors I experienced and stored in my implicit memory. Our somatosensory self, however, has no interest to linger with pain and braced freeze states once we deem we are safe and have more appealing options at hand. These may not be conscious decisions, but

if the accompanier is able to communicate safety, the child's hands will gradually relax and search for a better, easier, or more fulfilling way of connecting.

The Evolution of the Hand-Brain-Language Connection

Neurologist Frank Wilson has traced the evolution of the hand in correlation to the development of the prefrontal cortex, beginning when our ancestors were still apes. His research states that the cortex more than doubled in size, from 400 to 600 cc to an average of 1,000 cc, once we began to walk upright and use our hands for tool use and communication rather than locomotion.[17] The transition from *Homo erectus* to *Homo sapiens* happened around two hundred thousand years ago. Wilson quotes Merlin Donald's findings that the initial accidental discovery of tool use for hunting required a place in the brain where such a discovery could be stored, so *Homo erectus* could remember it for the next time.

> Innovative tool use could have occurred countless thousands of times without resulting in an established toolmaking industry, unless the individual who "invented" the tool could remember and reenact or reproduce the operations involved and then communicate them to others.[18]

Our neocortex developed because it needed to compute the skilled hand movements we wanted to learn for our survival. The fact that we have developed a left and a right brain hemisphere is also due to both hands engaging in different tasks when they are no longer used for moving on all fours.[19] This skill would have already been rudimentarily developed in apes, but became pronounced once *Homo sapiens* began to use weapons, tools, and sign language.

When I want to open a coconut, for example, my left hand holds the nut in place while the right hand applies a learned motor impulse to open it to get to the juice. Each hand performs quite a different task. My left hand needs to be aware of the present surface on which I place the coconut and make sure it does not wobble, for example. My left hand needs to deal with a present situation here and now. This is the function of my right brain hemisphere, which is known to be able to connect and communicate with a multitude of impressions and inputs in the present moment. Different from my left hand, my right now applies a movement I have learned in the past and applies it to the coconut in order to open it to get to the juice, which at this stage is just a promise. This is how our left brain hemisphere works. Bolte-Taylor describes the left brain as a serial processor sorting past learned experiences with the prospect for a future outcome.[20]

Psychiatrist Iain McGilchrist, a specialist on the *divided brain,* is quite critical of our modern data-driven, computerized, left-brain dominance, which devalues the creative, relational being quality of the right brain:

> One of the interesting elements that comes out in research into the "personalities" or the "takes" of the two hemispheres is that the left hemisphere thinks it knows it all, and as a result is extremely optimistic. It overvalues its own ability. It takes us away from the presence of things in all their rich complexity to a useful representation— that representation is always much simpler. And an awful lot is lost in it....

> Clever guys with techie minds sold the idea that these things would work, and they now administratively run all the professions. Teachers used to create a relationship with their students by using the richness of their experience and knowledge of the world, often in idiosyncratic ways, with their infectious enthusiasm to fire up their students. Instead, it's [been] replaced by, "You must do this curriculum, and you must escort so many on this, and you must have so many of the following." That is death to the mind, to the imagination, in fact to our civilization. I would like to alert people to that.[21]

Wilson emphasizes that this left- and right-brain connection does not change depending on an individual being dominantly left- or right-handed, but the ability of both hands cooperating is essential. If they do not, the brain hemispheres are also not connecting; there needs to be a left-right complementarity in the brain *and* the hands.[22]

In addition, back among the Neanderthals, the most effective way to communicate how to open a coconut to others in my tribe would have been by showing them the movements I make. In those days, this would have been through mimicry, hand gestures, and being perceived through the mirror neurons, all of which required the cortex to grow in order to store this new knowledge communicated through the hands of others. Speech as we know it today would not have existed then; rather, language was based on hand signaling and mimicry. Sign language is actually the predecessor of spoken language.[23]

According to Wilson, every child today retraces these evolutionary motor skills in order to develop language. The baby's signaling becomes a signifying function. As children begin to walk, they discover that they can attach a sound to all objects around them. They use their hands and arms to point and balance. Gradually, signaling becomes actual words. The verbal behavior in the child undergoes a long metamorphosis during which children discover that objects can be manipulated and combined. They will begin to experiment with logical connections such as creating piles of things the same color, fitting objects of a certain size into a matching container, or lining up small items in rows. It is in this way that objects become nouns and what one can do with them turns into verbs. Connecting Brio railway tracks or building a Duplo tower teaches children language. "The attainment of early language milestones in the child

always takes place in company with the attainment of very specific motor milestones."[24] Children who do not complete these haptic motor milestones will also have trouble to cognitively process events occurring in their environment. Clay Field Therapy's focus is on these haptic motor milestones in the trust that once achieved, they will then trigger synaptic connections the neocortex needs to make.

When a child piles clay on top of another pile, groups small created balls in a cluster, or connects one place in the field with another through drawing a line with a finger, it exercises the cortical area that will later line up words like objects and group them into clusters, describing what one can do with these, as the foundation for constructing sentences. Hearing will only ensure that the child of Chinese parents will not communicate in Italian, but the ability to form language skills depends on the child's haptic motor skills. Sign-language communicates with the same part of the brain as spoken words.[25]

Child's play is serious cognitive business. I cannot help finding these neurological insights extremely exciting and of utter importance for art therapists. As art therapists we engage our client's hands and encourage metacommunication through play, paint, drawing, clay, and sorting and placing objects into collages. Especially since art therapy is frequently dismissed as mere art and craft activities, I find it significant that we become aware of how essential our understanding of the hands-brain-language connection is when we are working with children.

The somatosensory and motor cortices are collectively referred to as the *sensorimotor cortex*. Our human hands and mouth are disproportionately represented in the precentral and post central gyri of the brain, much more so than other parts of the body. Neurosurgeons Wilder Penfield and Theodore Rasmussen designed two homunculi to demonstrate how large sections of the primary somatosensory and motor cortices are dedicated to the hands and mouth, and they show with clarity how strong the hand-brain connection really is (figs. 4.1 and 4.2).[26] Two sensory and motor homunculus models exhibited at the Natural History Museum in London depict gigantic hands and mouths. The hands of the sensory figure are larger than the figure itself, and the lips are enormous in size. The motor model's hands are almost ten times the size of its body. If we consider the "real estate" the hands take up in the neocortex, we find that the human hand and the mouth receive disproportionate representation in the brain. Looking at those giant hands, it becomes apparent how significant sensory and motor impulses are as perception tools. Penfield and Rasmussen show in their research that we use an enormous amount of our brainpower for motor dexterity, represented in the huge hands, and in our speech, pictured in the big lips and tongue. Smell and sight are of lesser importance, and we don't have much brain space devoted to the rest of our body.[27] Linden calls this phenomenon a touch map: a "map of the body surface exists in the somatosensory cortex."[28]

FIGURE 4.1. Motor Homunculus. This model shows what a man's body would look like if each part grew in proportion to the area of the cortex of the brain concerned with its movement.

FIGURE 4.2. Sensory Homunculus. This model shows what a man's body would look like if each part grew in proportion to the area of the cortex of the brain concerned with its sensory perception.

What would it be like to imagine our clients connecting with the Clay Field with such huge hands? It illustrates so vividly how important haptic perception is, and at the same time it is astounding that we have researched this sensorimotor brain hand connection so little. Jean Ayres states: "As you watch your child struggle to learn how to tie his shoelaces, remember the countless streams of electrical impulses that are generating what you see."[29] The brain is not a passive witness to the expansion of these mechanical and sensorimotor explorations and accomplishments. It sweeps the process forward, and as it does so it defines its own procedures for regulating the flow of information generated by all the interactions that are taking place, and it models its processes and its formulations of the world on the narrative principle.[30]

Kiese-Himmel, a researcher at the Haptic Institute in Leipzig, investigated the correlation between haptic perception in infancy and the first acquisition of object words. Her findings suggest that many language-impaired children fail to organize their haptic experiences of the world and have basic perceptual deficits, which are related to higher-level language processing.[31] Poor tactile and haptic performance in children can be associated with disordered language development and behavioral difficulties. Clay Field Therapy has actually proved to be of enormous benefit for disabled children, as the touch experience with the clay enables them to activate, exercise, and reorganize the developmental haptic building blocks that have remained understimulated.

The Body Map of the Hand

As a last addition to the theme of touch and the hands, I would like to add the more unscientific aspect of acupressure, acupuncture, and the system of meridians in Eastern medicine. Thousands of years of empirical knowledge have shaped this system. And I have experienced the application of this knowledge as a shiatsu therapist over many years of practice and in hundreds of Clay Field Therapy sessions. As shown on the simplified acupressure map (fig. 4.3), the base of the hand relates to the pelvis, the pelvic floor, and the abdomen; the middle of the hand corresponds with the lungs and the heart. The fingers are not mapped here, but they relate to the five senses and cognitive processing.

While this chart can be dismissed as pseudoscience, it can, however, easily be tested with some simple exercises. Whatever the hands do in the Clay Field has its embodied equivalent and will also appeal to particular regions of the brain.

For example, the base of the hand relates to the pelvis and abdomen. If you attempt to push thirty pounds of clay away, you will easily discover that doing this with your fingertips will not be very successful. Using a flat hand also has no power, but the base of the hand will be able to move the clay. It will instantly engage the core strength in the

FIGURE 4.3. Acupressure maps the hands into regions that correlate with the body's organs.

lower abdomen, the legs, and the feet. Even when sitting in a chair, the feet, legs and abdomen get organized to be able to apply counterpressure that reverberates through the entire body. The base of the hand is in charge of all gross motor impulses involving pressure. The thumb in this context is technically not a finger but an extension of the base of the hand, necessary to apply counterpressure through a variety of grips.

The flat hand has the highest sensory abilities. The moment the inner hand comes in contact with the clay, it will communicate qualities to the entire body, such as warm or cold, soft or hard, pleasurable or disgusting. Our key relational capacity lies in the inner hand. When we caress or hug someone we love, we engage with an open hand. When the hand grabs a lump of clay and squeezes its grip to the extent that the clay arrives in the inner hand, especially the part of the heart-lung region, clients *feel* the material, which can be both sensory and emotional.

Clients who have been hurt in relationships will frequently brace away from coming into direct contact with the clay through the flat hand by only using their fingertips or the base of their hands (fig. 4.4). They will go to great lengths in order not to be fully touched. The relational center in our physiology is the chest and heart area, which becomes stimulated through the flat hand. Contact with the flat hand can easily become emotional. If too much emotion is feared, the accompanier can encourage motor impulses, which will shift the focus away from overwhelming sensory

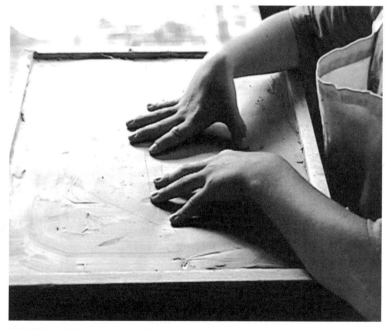

FIGURE 4.4. This ten-year-old girl does everything to avoid contact. Her forearms rest on the edge of the box, and her hands arch away from the clay. Her hands have minimal connection.

information, through encouraging pushing with the base of the hand or applying pressure with the elbows or forearms, such as I discussed in connection with the traumatized boys in chapter 3. These are simple yet effective trauma-informed haptic interventions.

The index finger that sneaks forward to tap onto the field is cognitively curious; it wants to know what this object in front of me is like. Sometimes the index finger almost seems to have an eye and the ability to look into the spot it is poking into.

The fingertips can act like virtual sensors: not only able to touch, but also to see, hear, smell, and taste. Along with their fine motor skills, they have an astounding perceptual capacity. They are the ones who see images in the clay: colors and landscapes. The fingertips engage our cognitive abilities; they recognize shapes in the clay and are able to name them. It is the fingertips that will give meaning to creations in the Clay Field. They can generate insights. When we want to shape a particular detail of a figure, we apply the fine motor skills of the fingertips.

Some teenagers may primarily work with their fingertips when their key developmental need is the cognitive integration of their emerging identity. They usually also talk a lot in that case. However, clients who hold unprocessed trauma in their body may avoid full touch and stay as much as possible in the head, working solely with their fingertips; they avoid the impact of full touch just as they avoid full contact with their body. An example is the anorexic girl who spends session after session picking around in the clay with her fingertips, too afraid to come into contact with her body. Such clients literally walk on tiptoes through life. It is a relief to witness when they can finally relax to the extent that they can "come down" and apply pressure, which will eventually connect them with the full hand, equaling full body-contact.

Anyone who has ever visited a Chinese, Ayurvedic, or Tibetan doctor would have experienced the pulse diagnosis. We have six yang and six yin meridians. The yin meridians flow from the feet up, and the yang ones from the head down. All twelve meridians flow through the wrists and end in the fingertips. Each one represents the flow of chi in a particular organ.[32] The Eastern medicine practitioner is able to read the various pulses in the wrist in order to diagnose the state of the client's liver, heart, lungs, or spleen. In my application of Clay Field Therapy, this knowledge has become helpful, because clients who have trouble coming into contact with their body, or are stressed and very activated, can be asked to connect their wrists with the clay, or make themselves bracelets of clay, or rest their forearms and wrists on the field, which helps them to be more embodied without connecting with the trauma memory held in the hands (fig. 4.5).

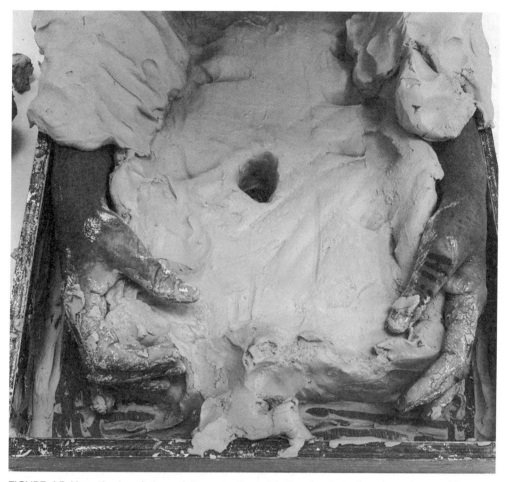

FIGURE 4.5. Here the hands have full connection with the clay, including the wrists and fore-arms, which would equal full body contact. The young woman wanted her elbows packed into clay by the therapist for an intense experience of being connected and supported.

It is clearly observable when the hands are comfortable to connect and when they avoid contact with the material. A girl may push the clay away with the base of the hand, but be careful not to touch it with the middle of the hand, and keep the fingers overstretched, away from the material. When I then look at the girl, I find that her head is turned sideways, not wanting to know what she is doing, or touching in the same way as her fingers, avoiding witnessing what she is compelled to do.

We can observe the hands as a mirror of the body. The haptic engagement of the hands with the clay mirrors the physiology of the client: the part of the hand that can connect and the part that is dissociated. Whichever part of the hand is straining, or collapsed, or rigidly frozen in fear will correspond to implicit postures of bracing, straining, dissociation, and collapse.

FIGURES 4.6–7. Jason's first tentative contact with the Clay Field, and thirty minutes into his session the impulse has been fulfilled.

If we revisit Jason's session from chapter 3 in this context, it becomes obvious how he is straining to drill one finger into the material (fig. 4.6) at the beginning. His body leans back and twists with the effort, and his left arm supports him on the edge of the field. Thirty minutes into his session (fig. 4.7) he is leaning into the field, his left arm now fully encased with clay, his right arm supported by the field and in full contact with the material. Both his hands are engaged. They visibly communicate with each other in both images. However, while the first move is one of stress and albeit curious tension, the second image is one of fulfilled connection. His posture and his hands have arrived at a polar opposite of his initial movement. The left hand that could not get into the clay at all is now full encased, and the right hand, which was straining to get anything, now has all the material available.

When we work with clients, we are looking for these states of sensorimotor fulfillment. After Jason's stressful experience of migration to a foreign country, the experience of connection and contact in the Clay Field gave him a renewed sense of safety and the assurance of his place in the world. That embodied experience, for example, instantly stopped the bed-wetting.

If you once more visualize the homunculus models from the Natural History Museum in London and then project those huge sensory and motor cortex hands onto Jason's experience, it might become obvious that even though for the five-year-old there was no verbal cognitive integration, except that he stated his satisfaction as "fun," the shifts that will have taken place in his entire being during this therapy session will have been significant.

The Language of Haptics

Developmentally the mechanoreceptors in the hands undergo a number of key stages that all occupational therapists are well aware of. The baby's hand is soft and "round." The inner hand connects to the mother's skin. Within months the infant is also capable of grasping objects employing the fingers, but not the thumb. A baby starts to use one hand then the other. From about four months onward, they begin to move both hands together in a symmetrical movement such as clapping. At about one year of age, one hand assists another, objects can be passed from one hand to the other, and they can hold small objects between the thumb and one finger. Children can now pick up an object, bang with it on the table, and then let it go. Sounds are being attached to such objects.

Over time a child's body awareness and gross and fine motor skills increase. The three-fingered grasp of being able to hold a pencil between two fingers and the thumb is a relatively late and crucial discovery at around the age of four or five.

In order to be balanced and connect the two brain hemispheres successfully, three main stages of development need to be experienced and developed:

1. Symmetrical movement, where both hands and feet move together, such as clapping, jumping, and double hand grasping, as we can observe it in babies and toddlers.

2. Reciprocal movement, where both sides of the body work together, such as crawling, walking, running, and climbing. Crawling has an important role in a child's development: it prepares an infant for bilateral coordination of the hand-brain connection and thus the entire body.

3. Asymmetrical bilateral coordination, where both sides of the body work together doing different things, develops next. Here children can kick a ball, use scissors, or play a musical instrument. As a child starts to use both hands in this asymmetrical, complimentary way, the ability to cross the midline, such as taking, for example, the left hand across to the right side of the body and vice versa, begins to emerge. It is important that a child can cross the midline as a comfortable and spontaneous action. A three-year-old child, for example, begins to use one hand to stabilize an object, while the other acts upon it, but is not consistent in hand roles. A child may use the left hand to pick up or do activities that are on the left side of the body and then swap to use the right hand for those on the right. A child begins to prefer to use one hand over the other when tackling tasks most of the time. Particular hand dominance is usually developed by the time they are of school age, but not in all cases. The mature stage of development in hand dominance is to establish at least one hand for skilled work and for both hands to work together in a complementary way so that a variety of tasks can be accomplished effectively.

The following chart marking haptic milestones in children's development was published by the Paediatric Occupational Therapy Association in South Australia. While children younger than four years old rarely show up in Clay Field Therapy sessions, this map is still useful because we see children who have not been able to achieve these milestones due to adverse events during their earlier years. While these delays can be caused by illnesses, children's sensorimotor development will also arrest when they experience ongoing neglect or abuse. Because of the intricate connection between cognitive development and the attainment of very specific motor skills, it is possible, when we support children in gaining appropriate motor skills, that their learning and behavioral issues tend to improve, usually in significant and noticeable ways.

This list may serve as a handy guide for age-appropriate achievements.

Fine Motor Development Chart[33]

AGE	DEVELOPMENTAL MILESTONES	POSSIBLE IMPLICATIONS IF MILESTONES NOT ACHIEVED
0–6 months	reflexive grasp (at birth) global ineffective reach for objects (3 months) voluntary grasp (3 months) 2-handed palmar grasp (3 months) 1-handed palmar grasp (5 months) controlled reach (6 months)	poor muscle development and control delayed ability to play independently delayed sensory development due to delayed interaction with toys and other sensory objects
6–12 months	reaches, grasps, puts object in mouth controlled release of objects static pincer grasp (thumb and one finger) picks things up with pincer grasp (thumb and one finger) transfers objects from one hand to another drops and picks up toys	poor development of hand and finger strength poor manipulation of objects resulting in delayed play skills delayed sensory development due to lack of sensory play experiences
1–2 years	builds a tower of three small blocks puts four rings on a stick places five pegs in a pegboard turns pages of a book two or three at a time scribbles turns knobs paints with whole arm movement, shifts hands, makes strokes	poor development of hand and finger strength delayed independent play skills delayed development of self-care skills (such as eating) delayed manipulation skills

AGE	DEVELOPMENTAL MILESTONES	POSSIBLE IMPLICATIONS IF MILESTONES NOT ACHIEVED
1–2 years	self-feeds with minimal assistance able to use signing to communicate brings spoon to mouth holds and drinks from cup independently	
2–3 years	strings four large beads turns single pages of a book snips with scissors holds crayon with thumb and fingers (not fist) uses one hand consistently in most activities imitates circular, vertical, and horizontal strokes paints with some wrist action; makes dots, lines, circular strokes rolls, pounds, squeezes, and pulls play-dough eats without assistance	delayed self-care skills (such as eating) delayed prewriting skill development delayed manipulation of small objects such as toys, pencils, and scissors frustration when manipulating small toys and objects
3–4 years	builds a tower of nine small blocks copies a circle imitates a cross manipulates clay material (rolls balls, makes snakes and cookies) uses nondominant hand to assist and stabilize the use of objects snips paper using scissors	delayed prewriting skill development frustration and/or avoidance of pencil-based tasks poor pencil grasp and pencil control poor self-care skills (such as eating) delayed drawing skills
4–5 years	cuts on a line continuously copies a cross copies a square writes name writes numbers 1 to 5	difficulties holding and manipulating a pencil difficulties learning to write name and other letters of the alphabet

AGE	DEVELOPMENTAL MILESTONES	POSSIBLE IMPLICATIONS IF MILESTONES NOT ACHIEVED
4–5 years	copies letters handedness is well established dresses and undresses independently	dependence on caregivers for everyday activities such as dressing frustration and/or avoidance of pencil-based tasks
5–6 years	cuts out simple shapes copies a triangle colors within lines uses 3-fingered grasp of a pencil and uses fingers to generate movement pastes and glues appropriately can draw basic pictures	difficulties learning to form letters and numbers correctly poor handwriting difficulties demonstrating academic ability on paper fatigue during pencil-based tasks frustration and/or avoidance of pencil-based tasks
6–7 years	forms most letters and numbers correctly writes consistently on the lines demonstrates controlled pencil movement good endurance for writing can build Lego, K'nex and other blocks independently ties shoelaces independently	difficulties getting ideas down on paper fatigue during handwriting tasks difficulty keeping up in class due to slow handwriting speed poor legibility of handwriting may impact self-esteem when comparing work to peers possible frustration and/or behavior difficulties due to avoidance of pencil-based tasks
7–8 years	maintains legibility of handwriting for the entirety of a story	difficulty completing handwriting tasks in a timely manner fatigue during handwriting tasks poor academic achievement due to difficulty getting ideas down on paper difficulties due to avoidance of pencil-based tasks

5

Trauma and the Autonomic Nervous System

Our Many Brains

In the past decades, trauma-informed therapies have significantly shifted toward an approach informed by research into human neurobiology. Therapies are more focused on nervous system regulation, away from exposure therapy, and from narrating the events that happened. Peter Levine studied how animals cope with life-threatening stress on a daily basis with the question how we as human animals could learn from their approach.[1] A deeper understanding of developmental trauma has led to insights that stress responses may be held lifelong in the body, sometimes from conception onward, causing complex physical and mental health issues without there ever being a "story."[2] Bruce Perry has made it very clear that when we work with developmental trauma, the focus needs to be put on nervous system regulation, especially since many children have actually never experienced what a regulated nervous system might feel like. Their mothers were stressed during the pregnancy, hence the baseline of their nervous system is set to stress for the rest of their lives, unless we can facilitate embodied, felt-sense downregulated experiences for these clients.[3]

In this context it helps to understand some of the basics of neuroscience and the core brains we have as humans (fig. 5.1): the brain stem, the midbrain cerebellum, the limbic system, and the cortex.

ANATOMY OF THE BRAIN

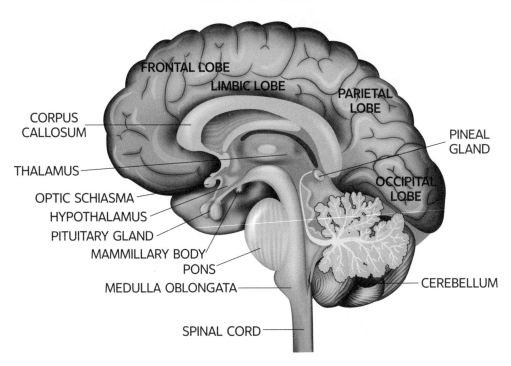

FIGURE 5.1. The anatomy of the human brain.

The oldest part of the brain, our brain stem, developed millions of years ago. It plays an important role in maintaining homeostasis by controlling autonomic functions such as breathing, heart rate, blood pressure, digestion, and perspiration. The implicit perception of these functions with our internal sense is sensory. We share the brain stem's origin even with fish. It operates in a relatively simple on-or-off fashion: Am I safe? Or not? It is here where trauma responses trigger the autonomic nervous system into action affecting our sleep, state of alertness, and sense of safety. Such responses are involuntary, and we have little conscious control over these survival impulses. If I am safe, I can enjoy life, swim, and move, if we stay with the image of the fish. I can hunt, eat, and digest food. If there is danger, however, all movement will freeze, peristalsis will seize, and my entire organism will go into energy conservation. Animals play dead, and they dissociate from their bodies, which will make it less painful if they become prey and die. Levine realized that even though, as human mammals, we have developed a complex neocortex, we are still ruled by the same ancient survival responses we share with the entire animal kingdom.[4] When we are in fear for our life, all higher

brain functions are widely turned off. There is no reasoning with someone in a panic or metabolic shutdown.

Levine's core discovery was that animals recover, once they are safe, through completing active defense responses such as fighting or fleeing, and resume whatever they wanted to do before they froze involuntarily in fear. Such a response needs to be a felt-sense, embodied response with the aim of reconnecting us with the flow of life. The Clay Field, for example, is well designed to complete especially the fight action cycles because the weight and resistance of the clay require physical effort to move it. By pushing it away, or throwing the clay onto the floor, or punching it, clients can purge themselves from unwanted touch and boundary breaches. Such an active response can reset the amygdala in the brain stem on the basis of an embodied understanding: "I have dealt with this danger successfully, and I am able to move on now." The three alarm settings in the brain stem are: fight, flight, or freeze—or I am safe.

The midbrain, the cerebellum, monitors and regulates motor behavior, particularly learned movement patterns. Here we learn to coordinate our voluntary motor functions, reflex memory, motor learning, balance, posture, and sequential learning. It is important to the timing of rhythmic movements such as dancing.[5] One of the effective elements of Clay Field Therapy is the fact that it appeals to these very early sensorimotor structures in the brain.

Only when we feel safe in our basic survival needs will the limbic system, our mammalian brain, come online. This is our social brain, in neurobiology referred to as the social engagement system. The limbic system is in charge of our emotions and feelings as well as how we relate to others. Where I live in Australia, I am surrounded by horses and kangaroos, which give me plenty of scope to study herd behavior. Our mammalian brain developed over millions of years. In the mammalian world, infants' lives depend on the care they receive from their mothers. Without being held and nurtured, their offspring will die, which is quite different from the world of reptiles, who develop on their own from the moment the egg is fertilized.

The last and most recent development of the human brain is the neocortex, which has been shaped over the last two hundred thousand years. It is here that we can perform the amazingly complex tasks that are essentially human, such as abstract thinking, cognition, language, sensory perception, and spatial reasoning. I have mentioned in the previous chapters how instrumental the hands and tool use were in developing the neocortex. Eighty percent of the real estate in the neocortex is connected to our hands and mouth; thought processing and language are dependent on widely haptic stimulation, which children do through playing with objects.

Neuroscience regards these and the more complex substructures of these brains as interrelated. They certainly do not neatly wrap one evolutionary layer around the next like geological strata. Our brain is not an onion with a tiny lizard inside.[6] Instead, the most recent view of evolution is that animals radiated from common ancestors. Within these radiations, complex nervous systems and sophisticated cognitive abilities evolved independently many times. Fish and birds also have a cortex, even though it is smaller in size than the human one, and they are equipped with modified abilities according to the needs of their species.

The prefrontal cortex, a region associated with reason and action planning, is not a uniquely human structure. Animals are also able to exercise some control over their emotions, if they deem such decisions to be beneficial trade-offs. This is something every dog owner will confirm, and what, for instance, thousands of experiments with mice and rats have shown.[7]

The different regions in the brain have different functions and priorities. These regions can be aligned and operate as one when we feel good about ourselves and feel safe, but in crisis, the communication between them becomes compromised. Sarah McKay argues that our brains are not preprogrammed into a particular set of emotions such as fear; rather, we interpret our body sensations to construct "consciously experienced feelings in the moment."[8] This correlates with Levine's view that traumatic overwhelm does not necessarily trigger the same reaction in every child. For one girl, a vaccination might barely be registered, whereas another child of the same age might experience the intervention as a terrifying boundary breach. How the girls will interpret body sensations of fear depends on how well they are held by family and friends and how resilient their nervous system was in the first place. Stephen Porges's term for such resilience or reactivity is *neuroception.* It triggers without conscious awareness what we perceive as either threats or safe cues.[9]

A nervous system set to chronic hyperactivation due to ongoing unsupported events in a child's life will tend to apply black-and-white thinking with a limited ability to modulate experiences. Fear and excitement, for instance, are based on virtually the same body sensations as higher heart rate and a wave of hot libido rising from the gut, but the cortex of different individuals will interpret these sensations in accordance with the situation they are in, the people they are with, and previous experiences they have had. We know that context matters. If fear sensations were programmed to be nothing but fear, roller coasters in amusement parks would not make any money; we do enjoy the thrill of a bit of fear. If the roller coaster breaks down and causes a life-threatening accident, however, we would respond differently.

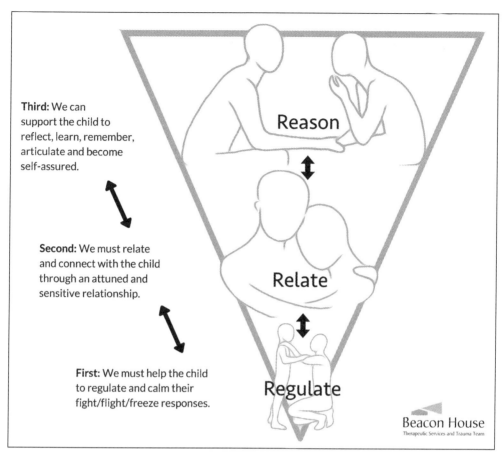

Third: We can support the child to reflect, learn, remember, articulate and become self-assured.

Reason

Second: We must relate and connect with the child through an attuned and sensitive relationship.

Relate

First: We must help the child to regulate and calm their fight/flight/freeze responses.

Regulate

Beacon House
Therapeutic Services and Trauma Team

FIGURE 5.2. Bruce Perry's map of the three R's.[10]

Child psychiatrist Bruce Perry has developed an easily understandable chart called the three R's: regulate, relate, and reason (fig 5.2). *Regulate* describes the brain stem and midbrain; *relate* is the limbic system; and *reason* is the neocortex. He developed his neuroscientific research into the Neurosequential Model of Therapeutics as a bottom-up approach for children. Bottom-up in this context means that we need to address the brain stem first, regulate a child's nervous system based on a trusted relationship with the child, and only then can reasoning begin. A child who is upset and scared will not be able to think. The survival systems in the brain stem will highjack all higher brain functions.

Dan Siegel employs the terms *upstairs* and *downstairs* brain. If the downstairs brain is dysregulated due to fear, the upstairs brain will be offline, and no reasoning will bring this child back to her senses. What is required is safety and a secure relationship before the *reason* part, the upstairs brain, can become reengaged.[11]

Children learn to regulate their nervous system through their primary care-givers in the first years of life. Up to thirty-six months of age[12], children need external stress regulation through the same trusted adults. Only then have they learned to apply such regulation themselves. Insecure attachments and accumu-lative stress cause structural impairments to the developing brain, in particular to the neural networks that establish the capacity for social and emotional func-tioning in the limbic brain. Perry and many others have researched how a trau-matic event will impact a child. "While experience may alter the behavior of an adult, experience literally provides the organizing framework for an infant and child."[13] The younger a child was when an adverse event happened, the more pro-found the impact on every higher brain function is. If the developing brain stem is affected by trauma, the *regulate* function that processes somatic input from inside the body and sensory input from outside the body becomes asynchronous and unable to process events.

Bruce Perry emphasizes that it is of utter importance that the therapist remains regulated and calm, and that a dysregulated caregiver cannot regulate a dysregulated child.[14] Dan Hughes describes the same in the context of his dyadic developmental psychotherapy.[15]

We know that each brain area has its own timetable for development and that impairment in the organization and functioning of the sensorimotor base will trigger a cascade of dysfunction in all higher cortical networks of the brain. While many still believe that trauma during the pregnancy of the mother or in the first years of life will go unnoticed, because the child is still preverbal, we know today that rather, the reverse is true. The same event will impact an eighteen-month-old child much more severely than a five-year-old, as the five-year-old has developed a number of coping strategies the toddler will not be able to access. The reverse is also true: "Somatosen-sory nurturing, for example, will more quickly and efficiently shape the attachment neurobiology of the infant in comparison to the adolescent."[16] It is hard to repair the broken trust circuitry in a teenager.

If the infant has not learned to regulate his nervous system due to attachment trauma, he will not know how to soothe and settle when he feels upset as an older child or adult. The upset will remain and affect all higher brain functions, how he relates to others and himself, and his ability to reflect on his actions and those of others.

Psychoneurologically, abuse and trauma create a hyperalert status of flight or fight or partial shut-down, and impair the developing connection between the right and left brain hemispheres; the rational brain lacks proper control over the emo-tional brain.[17] Control over certain behaviors is blocked out to the extent that such

children will actually not remember when they hit or kicked someone; they are not lying when they claim, for example, in the subsequent therapy session they had no meltdown this week.

It is usually when children start school that it becomes noticeable that they cannot focus and begin to act out in frustration. Their seemingly bad behavior is, however, largely beyond their control. Because of their disorganized sensorimotor base, their conscious capacity to control affect, to feel safe in peer groups, to be able to read the social engagement system, and to act rationally is beyond their capacity, even if they try really hard.

In his book *Trauma and Memory,* Peter Levine explains the different memory systems and how they regulate our nervous system bottom-up (fig. 5.3).[18] Also in developmental terms, bottom-up means we are moving from the least conscious memory system up to the most conscious.

These memory systems develop chronologically but are simultaneously interdependent. The somatosensory baseline is set in utero, informed by safety or threat. Attraction or repulsion become survival responses from dyadic atunement onward. The more regulated this base is, the easier the following building blocks will be acquired. If this base is dysregulated, all following steps will be compromised.

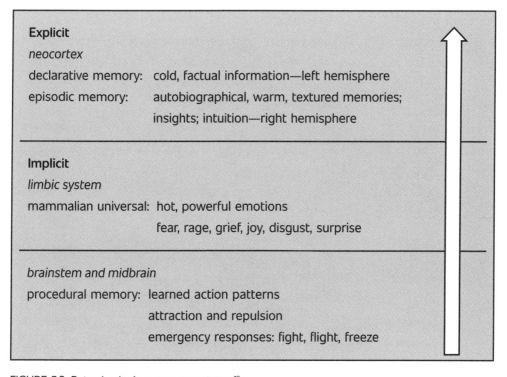

FIGURE 5.3. Peter Levine's memory systems.[19]

Next comes the patterned learning of crawling, walking, riding a bike, getting dressed, and holding a pencil. Once we have integrated these action patterns through many repetitions, we will remember them for the rest of our lives.

Through the limbic memory system, which in Perry's graph (fig. 5.2) is pictured as the *relate* section, we learn attachment as infants. Later in life these become more interdependent relationships, interwoven with feelings and emotions over which we have little conscious control. All these limbic emotions are implicit; they are gut-wrenching, break our heart, make us jump with joy, fall in love, bend us backward, crush our hopes, or make us blind with rage. Emotions are felt-sense states we experience in our body. The stronger the emotion, the more we are lost for words. We have no control over our heart beating faster and blushing when we are attracted to someone, for example. Intense levels of fear, rage, and grief can push us back into the brain stem's survival mode. All traumatic stress is characterized by these more primal emotions connected to fight, flight, or freeze. I find the image of an iceberg can illustrate these memory systems quite well (fig. 5.4). Only the neocortex, as the smallest part, is visible above the waterline, whereas the implicit memory systems are all body-based.

Only now the tip of the iceberg becomes visible as our explicit, conscious, and in Perry's terminology, reason-driven memory systems emerge. Levine calls the

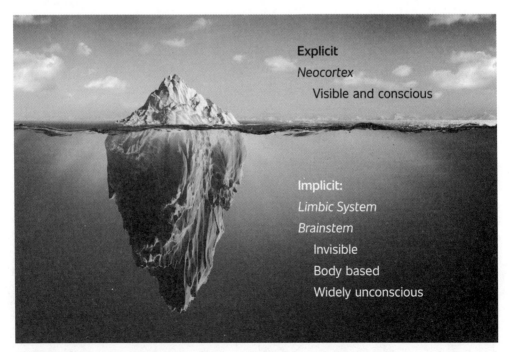

FIGURE 5.4. An iceberg illustrates explicit, conscious memory systems above the waterline, and the vast implicit memory systems that are unconscious.

memory system dominated by the right brain hemisphere *episodic memory.* Episodic memory is autobiographical and filled with warm, textured life stories. Here we remember events and dreams and apply symbolic thinking. Intuitive ways that enable us to weave in and out between conscious and unconscious memories allow us to dip below the waterline into the limbic and implicit memory systems. The majority of psychotherapies work with the client's episodic memory system. McKay suggests the expansion of an emotional vocabulary similar to a "mental well-being thesaurus" to give clients a sense of agency over situations and their responses to inner experiences.[20]

Processing information, abstract thinking, and dealing with facts are features that characterize the *declarative memory* system, which Levine allocates more to the left brain hemisphere. This memory system prides itself on being objective and devoid of feelings. It has some function in the world of psychology in the context of ego-strengthening, analytical, and behavioral approaches, but most therapists will be more familiar with engaging in autobiographical episodic memory.

The Polyvagal Theory

Peter Levine and Stephen Porges both place their trauma-informed insights on understanding the polyvagal system in the body. Porges's book on the polyvagal theory[21] was one of those that was on the table next to my bed for a long time in the hope I would assimilate the text in my sleep. I found it too medical to read. However, I then attended a master class with Porges during the Australian Childhood Foundation Trauma Conference in 2014, and he turned out to be a clear, simple, and engaging speaker. Finally, I understood his important research. During his master class, Porges used the image of traffic lights to explain his polyvagal theory in a way that I found even children and parents could easily comprehend. It is one of the printed resources I keep on my desk and show to parents and children alike to assist them in understanding what is happening inside them.

The polyvagal theory focuses on how the autonomic nervous system impacts every somatosensory system in our body. It details Perry's *regulate* section in the brain stem; what Levine calls the emergency responses of fight, flight, and freeze in the reptilian part of our brain stem; and what in Clay Field Therapy entails the sensorimotor base we acquire in the first four years of life. If we perceive ourselves in danger, all higher explicit brain functions are overridden by physiological sensations arising from the autonomic nervous system, which are involuntary. We have little conscious control over these reactions. Hence let's zoom into Perry's *regulate* window in the brain stem and look at Stephen Porges's traffic lights.

Shutdown and Dissociation

When we fear for our life, we freeze in terror and everything shuts down—we become unable to move and we disconnect from ourselves and others in order not to feel what is happening. Animals play dead at this stage. We appear absentminded and avoid eye contact. The voice is a bare whisper, and our facial expressions are lifeless. Such shutdown masks unbearable activation levels of intense fear that have been numbed by dissociating from them. Our body either becomes rigid and immobile or at times collapses and slumps over to the extent that we cannot even walk upright anymore.

Sympathetic Arousal

When we perceive danger, we become tense, jumpy, alert, and easily triggered. Every system in the body gets ready to fight or flee. Emotions can quickly escalate into rage. We are crying on the inhale. Children will kick, hit, or run and hide.

Parasympathetic Settling

Once we perceive the danger as over, we calm down and our peristalsis begins to move again. We exhale and cry on the exhale. Sometimes we shake, releasing the excess stress hormones and tension held in the body.

Social Engagement System

We feel safe. A calm state describes the so-called social engagement system, where we are able to connect with our surroundings. We feel a relaxed alertness, can be present in the here-and-now, make eye contact, have a clear voice, and our face is alive with expressions. All higher brain functions are online—we can relate and reason; we can interact with others and our environment; and we are capable of reasoning, verbal communication, and learning new skills.

FIGURE 5.5. Stephen W. Porges's polyvagal theory.[22]

Red: Shutdown and Dissociation

Children in the red *fear* traffic light section are almost incapable of dealing with any external input. Their prefrontal cortex has widely shut down. Parasympathetic shutdown masks extremely high and unbearable sympathetic activation that leads to tonic

immobility: the freezing reflex kicks in, and individuals become either rigidly stiff, literally as in the freeze response, or they collapse and lose all tonus, becoming floppy. This state is marked by simultaneous signs of high sympathetic (freeze) or parasympathetic (collapse) activation. Many sexual abuse victims experience such dissociated states, which are involuntary. Their autonomic nervous system has decided that no active response will be successful, and they surrender to imminent "death." Even if they wanted to run away, they would not be able to, because their muscles have collapsed into tonic immobility.

Dan Siegel describes it as the downstairs brain becoming so upset that the upstairs brain, the neocortex, is no longer able to take anything in.[23] The brain stem holds the cortex hostage. The child is flooded with fear-driven physiological responses to such an extent that the nervous system has shut down and the body has become numb and collapsed. During such episodes, children can't hear and process what others are saying. If they get reprimanded or punished for what they have done, they will withdraw even more—it just increases their stress levels, while they have no way of cognitively processing what someone is saying. Whatever they did was a survival response where they were literally on autopilot.

Such panicked children need only one emergency response, and that is safety. Such safety needs to provide an *embodied* experience of being held and feeling secure. Parents downregulate their terrified child in this state with a hug to help him to breathe again, cry on the exhale, and maybe shake until he can settle. However, mental health professionals are not allowed to hug children, and children who have experienced caretaker abuse will not necessarily find physical contact or any contact with another human comforting. This is when orienting in the therapy room becomes important, when blankets, weighted blankets, places to hide, and cushions to hold become useful—whatever the child can perceive as protective, surrounding his body with warmth and shelter.

Yellow: Sympathetic Arousal or Parasympathetic Settling

Most therapy sessions happen within the boundaries of the yellow *danger* section. This is where children can learn, with the help of the therapist, how to downregulate when they are upset, or that they are safe enough to process what has happened. Sessions oscillate between sympathetic activation and parasympathetic calming. At the Clay Field, this can be done with simple instructions to add more pressure or to bathe the hands in warm water, whatever brings movement and rhythm back,

because rhythm is a sign of feeling alive. Our living body is filled with rhythms: that of our breath, our heartbeat, of every cell pulsing. In addition, any activity that makes a child feel safe can act as a resource. Children regulate their nervous system through activities; they jump and run when they are excited, and they hide underneath a blanket cuddling a teddy bear when they need calming down.

In the context of trauma therapy, children explore action cycles at the Clay Field that will consolidate skills they did not learn in earlier developmental stages due to life experiences. They naturally oscillate toward such experimentations if they feel safe in the setting and unconditionally accepted, different from school, where academic and peer pressure forces them to hide or overcompensate for their deficits. Along with the acquisition of age-specific developmental stages, they will rewrite their trauma narrative by finding storied solutions and endings to what happened to them. This frequently involves the repair of the parental archetype. Hellinger's work on family systems, for example, is based on the notion that we do implicitly know the orders of love[24] and that every child existentially needs the mother-father-child triad, independent of divorce, absence, or death of a parent. Part of the healing narrative for many children involves the restoration of this order of love through creating balanced landscapes and homes in the Clay Field, where the insufficient parent is symbolically nursed into existence or banned to a safe place.

> Six-year-old Tracy has never met her father. In the Clay Field she creates an island onto which she places a bear she has shaped. A boat transports an endless supply of food (little clay balls) and gifts onto the island.

> Kieran is seven and stays in a women's shelter with his mother and siblings. The field is filled with water and full of fish. Next to the field, he creates a separate pool on the table, connected to the left side of the field, but in separate waters, in which he places the shark. The shark gets food and is covered with clay sunscreen but is not allowed into the big pool, where he could hurt the other fish. The sunscreen is his expression of love for his father despite him being too scared to live with him.

Pat Ogden speaks about the need to "ride the edge."[25] If a therapy session is too toned down into parasympathetic settling, clients will not have the sense of proper work done and cannot discharge enough of their inner tension. However, when they release their fear, rage, and frustration, it needs to be done in a safe way, so that it

may touch the red zone, but never crosses over into shutdown and dissociation. Jean Ayres states: "Fortunately children are designed to enjoy activities that challenge them to experience new sensations and form adaptive responses."[26]

Sympathetic arousal states are characterized by a number of observable physiological signs: Faster respiration, quicker heart rate, increased blood pressure, dilated pupils, extremely pale skin color, and being partially flushed are all signs of sympathetic activation. Clients feel hot and cold; experience increased sweating; have cold, possibly clammy skin; experience decreased digestion and peristalsis; and often have dry mouth.

Emotionally here we have anger increasing actions and crying on the inhale. Both can be easily observed as well. Upset children can cry dramatically on the inhale, gasping for breath, and as soon as a caregiver hugs and soothes them, the crying switches to a trembling exhale.

During an actual traumatic event, or with a visual, auditory, or sensory flashback, we have to be prepared for quick movement leading to a possible fight-or-flight reflex; children bolting out of the therapy room, for example, or even attacking the therapist or objects in the therapy room.

Parasympathetic states are characterized by slower, deeper respiration; slower heart rate; and decreased blood pressure. The pupils constrict; the skin is flushed and dry (not sweaty) and usually warm to the touch. The stomach begins to rumble because digestion and peristalsis increase. Some children may express the need to go to the toilet at this stage, which can be a most positive sign of them having begun to relax. Emotionally we find anger decreasing actions, and clients cry on the exhale.

Green: Social Engagement

Once we are back in the green, we are OK. Now we can fully engage with our senses, we can orient and make eye contact, and our face communicates vividly how we feel. We have a voice. Dan Siegel's *upstairs brain,* the prefrontal cortex, is back online.[27] We can think and communicate and engage with others without feeling threatened. With clients where trust has been established, greeting rituals take place at the beginning of the session, and at best we can say farewell to clients with a smile, eye contact, and a sure sense that they have relaxed into an alert presence, being fully in the here-and-now.

6

Traumatized Children

Children do not come into therapy because they are happy, relaxed, and well adjusted. Rather, they see a therapist because they have stress responses that interfere with their social engagement, learning, and behavioral abilities. At the same time, because most children's trauma is implicit, they will not be able to verbalize their distress. It is up to their caregivers, teachers, and therapists to read the warning signs and intervene with appropriate measures. Usually their dysregulation becomes noticed once they enter primary school.

Van der Kolk speaks about the hidden epidemic of child abuse:

> In today's world, your zip code, even more than your genetic code, determines whether you will lead a safe and healthy life. People's income, family structure, housing, employment, and educational opportunities affect not only their risk of developing traumatic stress but also their access to effective help to address it. Poverty, unemployment, inferior schools, social isolation, widespread availability of guns, and substandard housing are all breeding grounds for trauma. Trauma breeds further trauma; hurt people hurt other people.[1]

Child abuse is far more common than anyone wants to admit. The mental health responses by most governments are inadequate. The best programs I know of focus on supporting the parents financially and emotionally as well as providing psychoeducation because the children are dependent on their caregivers. If the caregivers hurt less, they will hurt their children less.

Levine reminds us:

> It is important to remember that some trauma symptoms are *normal* responses to overwhelming circumstances. The heightened arousal energy together with

shutting down (when there is no escape) are biologically hardwired survival mechanisms. *However,* this protective system is meant to be time-limited; our bodies were designed to return to a normal rhythm soon after the danger ends.[2]

When children find themselves in ongoing abusive stress situations, their bodies adjust to chronic trauma.[3] This is when experts speak about *complex trauma.* Many of the children I describe in the examples in this book have not just experienced one single frightening event but have been exposed to prolonged chaotic and abusive environments. They are not supported in recovering from one single event, but rather are forced to accumulate layers and layers of unresolved stress. In the following sections, let's look at how Porges's polyvagal theory manifests in action. I have divided the groups into primary school children and adolescents.

Primary School Children in Shutdown

Primary school children will likely be the main client group for those working as Clay Field therapists. It is also the time when traumatized children are being noticed due to behavioral and learning difficulties. In the red freeze state, those kids present in a masked hyperaroused state. Such children will appear disengaged, distracted, bored, or to be daydreaming. Levine calls them "acting in" rather than acting out.[4] When addressed, they appear confused and forgetful, or slow, as if they had to arrive first before they can focus on anything; they have obviously not been listening, and they may try to change the subject. Their movements can appear clumsy and uncoordinated.

From the child's perspective, they often feel anxious, as if under attack, and while they are unable to think and listen, their hearing becomes hypersensitive. Some believe in magical thinking, such as: *If I don't move, you can't see me.* In the imagination, they may go to a nicer place than the here-and-now, playing with imaginary friends. Many feel ashamed, rejected, or scared of something that happened, believing that if others knew, they would no longer want them around. They find it hard to trust anyone.

In extreme cases, children are so braced that they are literally scared stiff. They are in a masked, high sympathetic nervous system activation state. With their upper arms clamped to their chest, they barely breathe, even though they feel very upset. They "hold themselves together" because they cannot access a reliable inner core or external support. Many brace themselves against touching the clay because they fear being reminded of past relational experiences where they did get hurt. It is important to know that these responses to the clay are rarely experienced as emotional, but are learned action patterns stored in the procedural memory of the autonomous nervous system.

While the braced child is hyperaroused and feels anxious, the hypoaroused school-child in shutdown has a low heart rate and no energy. The muscles are floppy. Their body posture is slumped over, with the head hanging down. They appear socially withdrawn and compliant, trying to be invisible, and unfortunately they are easily bullied. They give flat yes or no answers and present as passive, silent, and resigned. They may complain about tummy aches, feeling tired, sad, tearful, and lonely. Many believe themselves to be useless and unlovable, all by their own fault. Nowhere is safe, and wishing to be dead is not uncommon.[5]

It can be hard work to gain the trust of such a child. Most need one-on-one time with a trusted adult. Some of the Indigenous children we worked with would not trust any adult, especially a white woman, but they would come with one or two friends for support. Once some sense of safety has been established, engaging with rhythmic patterned movements in order to reconnect with the life force is the next priority. These can initially be tiny rhythmic movement patterns such as squeezing a sponge in warm water.

> A six-year-old boy in a psychiatric hospital has been tormented by his mother with severe physical abuse. His body is covered in scars and burn marks. He develops a knocking ritual with the therapist. He knocks on the door; the therapist answers with knocking on the table; he knocks again; the therapist answers. The game is extended by the boy leaving the room, knocking, and entering; the therapist responds to the knocking. This goes on for several sessions until he has gained enough trust to come closer. The first time he sits down at the table, he turns his back to the Clay Field. It takes another couple of sessions until he dares to turn around. Over time, his therapy was successful to the extent that he could engage with the clay and learn to complete essential milestones he had missed out on before. Parallel to the Clay Field sessions, he learned getting dressed, tying his shoelaces, finding friends, and riding a bike.

Rhythm is life. To connect to rhythm is essential to come out of metabolic shutdown. Such rhythmic stimulation could be extended to drumming, swinging, bouncing on a trampoline, running, stomping, dancing, hammering, and punching into the Clay Field. A relationship can be built through simple shared tasks such scribble drawings, coloring in, playing Lego, and reading a story book with a calm, regulated adult who does not get frustrated or impatient with the child. Malchiodi describes a number of easy-to-follow deep breathing exercises for children.[6] Wrapping blankets around the body, holding cushions, and hiding in cubby houses all can give an embodied sense

of safety. Stimulating the senses through smell with essential oils, crunchy food, or rhythmic music can give a taste of life.

Collapsed children are far worse off. They are in dorsal vagal shut-down. They "hang" in the chair, barely able to hold themselves up. They are dissociated from their body in varying degrees and feel without hope. Many are ashamed to be seen, ashamed to be witnessed in their actions because they do not expect kind feedback. Their inner structure has broken down. Many have dissociated from their body to such an extent that they no longer feel themselves or are numb from the waist down, for instance. Such children usually have a complex abuse history where they lacked reliable trustworthy relationships from an early age onward. They have basically given up on expecting anything positive from any contact in their life. Again, this is not necessarily an emotional response, or one with a story, but an implicit survival pattern.

We have looked before at the language of individuals in a freeze state of metabolic shutdown and how it is characterized by "I can't": I can't move, I can't breathe, I can't think, I can't do anything, I can't feel anything; this is impossible. Individuals have disengaged from life. Once these children gain some sense of safety and trust, movement will bring them back into the "I can" yellow zone—in particular, simple rhythmic movement to reconnect with a sense of feeling alive. However, it is important to be mindful that shutdown masks high activation levels that were unmanageable for the child. These will inevitably erupt once the child comes out of the metabolic immobility state. When therapists do not know this, it can be shocking to experience a virtually immobilized, withdrawn child exploding into kicking rage without any warning. And should children not feel supported in the expression of such distress, they will withdraw very quickly and shut down again.

Collapsed and braced children tend to avoid direct sensory touch of the clay with the hands, because this would provoke an increase in emotions, usually fear, associated with past experiences. In this case the therapist may encourage them to work with pressure. Braced children in particular benefit from toy figurines making footprints, or their elbows pushing into the clay in order to find a hold. Collapsed children can be encouraged to lean on their forearms to find support. In all of them it will eventually provoke a sense of "I am here!" As they push into the clay, the resistance of the clay will give these children a sense of self in a vital encounter; the Clay Field becomes an opposite other that actually responds to their needs. Through pressure they can find a reliable hold within themselves. It could be translated into being listened to, but here we do it with the entire body involved. Only when clients have gained this vital trust within themselves, and into the potential of the encounter on offer, will they be able to act and say "I can."

Primary School Children in Sympathetic Arousal

Children in the yellow traffic light section present in a sympathetic arousal state. They appear hot and bothered. They can be aggressive, shouting and demanding while being inflexible; they may resort to equally inflexible blaming or lying. Many are unable to complete tasks. They don't fit in and are loners, disruptive, and immature. However, they act in this way because they feel scared, unlovable, worthless, and in danger. They may have a need to be in control of everything to make it predictable.

This is the group of kids most likely to be diagnosed with ADHD. They are hyperactive, ready to bolt at any time or to lash out; they are jumpy and tense. Some need to go to the toilet a lot, or they hide under tables and in cupboards. They walk around with clenched fists, bumping into people or avoiding them. Others resort to baby talk and silly voices.

From the perspective of these children, others are bigger or stronger and not necessarily benign. Unable to focus, many feel lonely, ashamed, trapped, and overwhelmed. They feel less bad when keeping busy. Physiologically their joints hurt, they feel sick to the stomach, and they have no appetite.

Because many deem it unsafe to express what they are feeling and that adults can't be trusted, they need patience until they can feel sufficiently secure to engage. They need to be able to name and connect with at least one trusted adult, and also know and name places where they are safe.

Cathy Malchiodi developed a circular chart that I find useful. Children can draw themselves in the center, which is then surrounded by four or six sections to be filled in, asking for preferred food, favorite place, favorite people, and what I'm scared of. Such drawings give insight into who the most trusted adult in the child's life is and where the child's resources are, rather than drawing the entire family, which may trigger a loyalty conflict and often does not disclose much.[7] Shirley Riley teaches similar exercises in her approach to family art therapy.[8]

Some children feel safer if they get a tour of the clinic or therapy room to get oriented and know where things are and what they can be used for. If noises or voices outside the therapy room can be heard, an explanation with regard to the source may assist in settling hypervigilance. They benefit from clear and simple explanations—anything that makes a session or life predictable. Predictability is safety in the neuro sense. They might want to choose where the therapist sits, know where the door is to get out, and where to find the toilet. A drink or crunchy snacks served on top of the Clay Field are popular and suggest that this setting can be nurturing.

The therapist may engage in art activities: shared scribble drawings, drawing herself for or with the child, or invitingly working the clay to reduce shame and embarrassment or the fear of doing something wrong.

> Kevin is eight and has been diagnosed with ADHD. His parents do not want to put him on medication. The therapist engages with him in a visualization exercise, where he puts one hand on his tummy with the intention to find a power animal there to help him cope better at school. He "sees" a bear, whom he claims is very strong. With this pleasing image in mind, they proceed to his heart to find the next power animal. He becomes very distressed and shares that a baby fox lives in his heart, and it has been burned to the extent that it has no fur left. Kevin refuses to engage in any further imagery and is afraid to focus on his body. The therapist decides to switch to narrative therapy, asking Kevin what the fox might need to get better. Together they cocreate a story, which Kevin illustrates and the therapist writes down in words. In their story the fox comes to a house in the middle of the forest where an old woman lives. She takes the fox in, makes him a bed, and uses a tincture she has in her kitchen to create a special balm. Kevin mixes the balm from paint and liquid clay, and in his drawing, he puts it onto the fox's skin. The woman cooks him all his favorite foods while the fox's fur regrows. When he is ready and strong, he leaves the woman's house and goes back to his forest, but he may come back for visits.

While we will never know what happened to Kevin, his story points toward infant trauma involving his skin and sensory contact. Maybe this is how his body remembers his birth. Kevin came from a loving, caring home, which enabled him to apply age-appropriate problem-solving through imagery, role-playing, and story. The therapist compiled the fox story into a picture book for Kevin, which he took home.

At times such engagement needs to be simple, such as hiding marbles in the clay, playing hide-and-seek, or rolling a small clay ball across the field with the invitation to roll it back.

> Tommy, an eight-year-old boy diagnosed with ADHD, responds, according to his parents, with "unmanageable" temper tantrums to any change of location, such as going from home to swimming lessons. His outbursts last for up to forty minutes. He spends six sessions at the Clay Field poking one finger into the material and pulling it out again, over and over, over and over, for six one-hour-long sessions. He loves coming for these sessions. The therapist is engaged throughout, animating each drilling venture as if it were the most interesting event happening in the world.

Tommy almost died during his birth due to being stuck in the birth canal. He needs to experience on all implicit levels that he can enter something and then get out of it. Finger in, finger out. Once he has gained this certainty, it takes just two sessions where he reenacts the birth in a symbolic way. In the seventh session he pushes a small toy duck vigorously into the clay, buries it, and then births it. He then repeats the same with the bear, virtually bashing the bear into the clay, vigorously pushing it in, next turning over the entire mass of the clay to check whether and how the bear will come out at the other end. In the following session he puts his entire arm through a clay tunnel he has built from all the available material. Interestingly, most of his dysregulated outbursts at home are reduced from the first session onward, ceased entirely after the last one, and they did not reoccur.

His mother writes to the therapist after the eighth session: "Just thought I would let you know that this is the first holidays ever that my boys have not been at each other's throats all day. I'm sure the art therapy has a lot to do with that. They have been playing with each other every day. Of course, they have had their moments, but nothing compared to what they are normally like! It's making a lot of difference to all our lives."

Both Kevin and Tommy came from caring homes but held infant trauma in their bodies that troubled them, affecting their emotions and behaviors. Both needed to complete their unfinished story in order to settle. Levine is adamant that we need to "use up" the intense survival energy that was summoned to survive, as otherwise "we continue to experience life as if the threat is still present."[9] We need to complete the outcome of the trauma narrative in an embodied way for the brain stem to understand: "It is over now. You are now safe." This can be done, as demonstrated in both cases, without knowing for sure what has happened and without addressing actual biographical events with the child.

The Clay Field is extraordinarily suited to offer a relational setting that allows the fulfillment of earliest sensorimotor touch needs. It appeals to and challenges the sensorimotor base that all individuals need to integrate as a solid foundation. Only once this base is established in a functional, regulated way can the higher relational and cognitive brain functions operate in an organized fashion.

When children freeze in fright, are overwhelmed by chaos, or lack nurturing due to neglect, they will arrest in their development, because their brain has lost the necessary plasticity to absorb and integrate new information. As children grow older, necessary building blocks are increasingly amiss, which compromises all further

learning. They find themselves in a situation similar to being thrown into a pool without ever having been shown how to swim, or even how to be comfortable in water, how to ask for help, or to believe help is available. Of course, they will react with distress. Many children enter kindergarten and school with such deficits. These are then the ones who are singled out for learning or behavioral difficulties or are diagnosed as being "on the spectrum." They act out in frustration or shut down because they cannot adequately process the avalanche of impressions and expectations their environment bombards them with.

Independent of their age, at the Clay Field children will go to exactly those stages that challenge them. There, they tend to hover with a mixture of curiosity and inhibition, torn between the urge to move forward and their old fears. Perry's account of severely abused children in *The Boy Who Was Raised as a Dog* describes passionately how children need firstly to be safe, that no lasting therapeutic change is possible without a safe interpersonal base.[10]

Then, secondly, children seek out exactly those developmental building blocks they missed. The same applies to adolescents suffering from complex trauma, or traumatic events that occurred during their formative childhood years. They will also need time to reconnect with their early years in order to integrate and heal fragmented or missing building blocks.

Adolescents in Shutdown

While the physiological symptoms for adolescents might be similar to those of primary school children, teenagers are now far more aware of not fitting in, having to hide what is happening at home or inside them. As peer pressure and the need to have friends increases, their lack of social skills becomes painful. Some hide away and chill out as nerds, losing days and weeks playing computer games. Many disappear in their own world, earphones plugged in, listening to music while blocking out the external world. Others numb their pain with food, drugs, and alcohol or boost their self-esteem with it. Drugs and alcohol can now become an attempt to self-medicate the dysregulated nervous system.[11] The physical pain of self-harming may reduce unbearable tension and emotional pain that has no other outlet. Anorexia may become a way of controlling at least their own body when everything else feels out of control. Bullying on social media is a problem that still mostly flies under the radar of parents and teachers; and so does the accessibility of pornography, with its soulless hidden or overt sexual violence. Both have a tremendous impact on the lives of insecure teenagers. "Testing and pushing the limits is part of adolescent behavior. However, in trauma reenactment, it takes a further escalation."[12]

Adolescents in the red freeze section present in a masked hyperaroused state. They may appear bored, distracted, almost appearing drugged or zoned out while not listening, not going where they are supposed to be, and just "hanging around." They are hypervigilant to sounds and the tone of voices, scanning the room for threats, looking for cues as to where the attack may come from and where the escape route is.

They feel scared and defensive, their entire body bracing against a hostile world. Their hands usually show their inner tension with white knuckles or clenched fists. Many believe they are a failure, unworthy, and nowhere near as good as others. They hate themselves, feeling like outsiders, not belonging. Their fear of being laughed at, humiliated, and embarrassed is acute.

Adolescents in the red collapse section experience a masked hyperaroused state that is characterized by slouching body posture, the shoulders and head hanging, the body having no tonus. Hair or a hoodie covers their face. They tend to be unhappy, anxious, fidgety, and withdrawn teenagers who are trying to fly under the radar in order not to attract attention. Many describe feeling exhausted but are unable to sleep, unable to relax or enjoy anything, unable to care about anything. They have no energy, are depressed, and feel worthless or guilty. Many wish they could cry or scream. Feeling dead on the inside, they are putting on a brave face for the world. They believe that no one cares about them: "Leave me alone" is a mantra, while they desperately try to fit in and be like others.

Dissociation can be as simple as daydreaming, but it can also result in long periods of amnesia or assuming various "sub-personalities." Such alters begin to have a life of their own, not recognizing each other while they attack each other. Such states of dissociation frequently occur following a flashback or at the beginning of a terrifying thought, image, or feeling. More often, dissociation is felt as not being in one's body, "feeling like I am looking down at myself" from the ceiling,[13] or just being used to not feeling certain body parts. I have worked with hundreds of women who had no felt sense in their pelvis and abdomen: everything from the waist down was numb and "black." Rather than being overly concerned about what had happened to these girls, my foremost thought has always been that these clients feel existentially unsafe. It is important to create an embodied sense of safety in whichever way feels attractive to the adolescent.

Adolescents in Sympathetic Arousal

Secondary school children in the yellow flight section present as hyperactive, even manic, aggressive, and braced. They tend to feel ugly, unworthy, and alone, and they are unable to tell anyone how they feel. Their behavior may be disrespectful, loud, immature, or clumsy, and many are unable to follow rules. Their antisocial attitude

can appear threatening when they feel threatened. This happens when they get over-whelmed by too much going on or by feeling outnumbered. In such cases, they want to flee, to just get out of wherever they are. They may run away, trying to escape or to disappear to be safe, which also makes them skip school. They tend to be hypervig-ilant, responding especially to noises. Physiologically they have a fast heart rate, the pulse ringing in their ears, their breathing is quickened, and their muscles are tense. They may feel nauseous and sweaty. Again, their hands often reveal the intense stress they are experiencing, showing clenched fists or white knuckles.

The nervous system of such teens is set to flight. Different from adolescents in the red shutdown, who are immobilized, braced, or collapsed, these kids are mobile. They can respond to a perceived threat, and their entire being is wired to danger.

Aboriginal boys at a school in the Northern Territory of Australia will only come to a session if the therapy room has doors open to the outside and they can sit right next to this exit. They come in groups of two or four, never alone, and if there is one wrong move, any unpredictable occurrence, they will all bolt.

Adolescents in the yellow fight section present also in a sympathetic arousal state, but they will fight rather than run. They present as argumentative and aggressive, often confrontational. They almost thrive on being antisocial, disrespectful, and dis-regarding others. They have obvious behavioral problems, are unable to concentrate, unable to fit in, unable to follow rules, and unable to get along with their peers.

They may find themselves in constant inner tension, feeling nauseous, faint, or dizzy, occasionally with the urge to cry or laugh hysterically. Because they may feel under threat from multiple sources, they attack in the hope of surviving. Belief systems involve: no one likes me; everyone hates me; I am not good enough; no one wants me; I am ugly. This goes along with feeling worthless and not belonging, having no real friends, and distrusting everyone. Yet these adolescents wish more than anything else to be liked, to have friends, to be popular, to have someone to talk to—and to be safe.[14]

Jayden is fourteen. He enters the therapy room for the first time. Along the wall is a shelf on which small sculptures of other children's safe places are lined up. Jayden walks along this shelf and with his outstretched arm swipes all the sculptures onto the floor, where they shatter. The male therapist, fortunately, does not confirm the expected rejection, but instead goes to the table on which

the Clay Field is placed, lifts up the table and smashes it down, lifts it up again and drops it down, and then moves the table with as much noise as possible to a different place, and sits down and begins to work the clay. Jayden is stunned and just observes. After a while the therapist says: Aren't you going to join me? Jayden does. At no point was it mentioned how "bad" Jayden had behaved, which was his expectation, but instead he was met in his need to be loud, disruptive, and pushed around; he had been understood in an embodied way that he could relate to. Jayden continued exploring the clay like the little boy he really was. He never smashed any of the others' artwork again.

Those in red shutdown easily become victims of those trapped in yellow fight-flight mode. The overwhelmed and immobilized adolescents are unable to defend themselves, don't know how to ask for help, and have no reliable friends to keep them safe. The ones in sympathetic arousal states can boost their fragile self-esteem by feeling strong and powerful as they violate more vulnerable peers. This applies to sexual, physical, and emotional violence, including bullying, face-to-face or online. Adolescents are facing a social minefield at school at the best of times, but those with unsupported childhoods will struggle even more.

Of course, teenagers also experience single traumatic events, such as the divorce of their parents, death, accidents, illness, or something frightening; however, by now they have also developed inner resources, particularly if they have grown up in relatively structured and caring homes. Often close friends, family, or a few therapy sessions will help them to work through issues to get back on track.

It is an entirely different story for adolescents with complex trauma issues. The latter become increasingly hard to reach and engage. Their developmental deficits are at times unmanageable for themselves and for caregivers, teachers, and therapists alike. Their chronic distrust of adults prevents them from getting help and accepting support. The harrowing statistics speak for themselves: Almost 80 percent of inmates incarcerated in U.S. prisons have spent time in foster care. Forty to fifty percent of former foster youth become homeless within eighteen months after leaving care, and 65 percent of children in foster care experience seven or more school changes from elementary to high school.[15] And foster care is just the tip of the iceberg. Bessel van der Kolk's book *The Body Keeps the Score* is packed with examples of the destructive effect of complex developmental trauma.[16] Crime, violence, and risk-taking may lead at times to severe accidents, if not death; drug and alcohol abuse, suicide, and eating disorders such as anorexia, bulimia, and obesity as well as diabetes and heart

disease are all linked to childhood trauma and neglect. The statistics are disheartening. Sexual, physical, and emotional abuse in families is not a rare occurrence, but a high percentage of all children worldwide are being abused, and the abuse is overwhelmingly caretaker abuse. "The consequences of caretaker abuse and neglect are vastly more common and complex than the impact of hurricanes or motor vehicle accidents."[17] Those young people identify with being bad because they have felt bad from a very young age onward.

In therapy, adolescents need a variety of options. Some teenagers respond well to group therapy without it being named "therapy." Others crave one-to-one contact to be able talk things through, or they feel safer this way. Van der Kolk mentions a whole range of group options, such as ballroom dancing classes for teenagers in order to heal attachment trauma; in the process they learn dyadic synchronization in a structured environment, where everybody is doing the same moves, and it is fun. Drumming circles encourage nervous system synchronization and regulation. Shakespearean drama groups enable adolescents to pour their emotions into an archetypal framework, which is able to mirror their own existential struggles. Martial arts or capoeira hone physical and defensive skills within a disciplined framework of rules. Outdoor adventure programs, taking adolescents on lengthy boating trips or into remote wilderness areas for camping trips, including rappelling, canoeing, and other manageable risk-taking, are popular and successful in teaching adolescents teamwork and survival skills, which challenge them to connect to a different, healthier identity than the known.

Cathy Malchiodi's book *Trauma and Expressive Arts Therapy* bursts with ideas and her scope of experience and knowledge. Her approaches include art, music, drama, dance, play therapy, poetry, and bibliotherapy; they cover body-based, cognitive, narrative, and mindfulness exercises. It is a culturally resonant four-part model for the expressive arts working with trauma, discussing:

- movement: dance, energy arts such as tai chi and martial arts
- sound: music therapy, drumming circles, working with the voice
- storytelling: drama and narrative therapies
- silence: mindfulness, meditation, contemplation, and self-regulatory exercises

Therapists need to offer teenagers multiple options to allow different pathways of healing and exploring. I would like to add equine therapy to this list, which I have found beneficial particularly for fearful dissociated individuals. And, of course, Clay Field Therapy is part of this list, but not necessarily the only option.

Teenagers want to be seen, even if they do not quite know how to be visible, resulting at times in bizarre contradictory messages they send with their hair color and choice of clothes and accessories, while their body is still trying to be invisible. They also want to be heard, even though many do not know how to express themselves. It is hard to gain teenagers' trust, hard to keep their interest, hard to get the balance right between being authentic and maintaining firm boundaries. Sometimes it is hard to hold the chaos and to allow meaning to emerge, but it is the only way to give clients the mastery over what happened to them.

Trauma therapy has been applied in Indigenous cultures for thousands of years; they have used rituals and ceremony to repair trauma and loss involving music, dance, drama, rhythmic embodiment, spirituality, and community. *Coming to our senses* is the most effective component of trauma therapy, and all the arts, including the clay, help us to do so. Deuser calls Work at the Clay Field an "education of the senses."[18] Our senses are the starting point for trauma repair and recovery. At the core of all these approaches is a creative, body-focus that aims to lay

> the frozen shame, grief, rage, and sense of loss to rest by helping trauma's explosive assault on the body to become complete and resolved. Peter [Levine]'s work helps us to transcend what he calls the "destructive explanation compulsion" and to create an inner sense of ownership and control over previously out-of-control sensations and reactions. In order to do that, we need to create an experience of embodied action as opposed to helpless capitulation or helpless rage. Only after we become capable of standing back, taking stock of ourselves, reducing the intensity of our sensations and emotions, and activating our inborn physical defensive reactions can we learn to modify our entrenched maladaptive automatic survival responses and, in doing so, put our haunting memories to rest.[19]

Hopefully our parenting styles and education system will increasingly become more trauma-informed. Rather than punitive measures for traumatized children who are acting out, we need to understand that when children have lacked secure attachment with their primary caregivers in the past, the last thing they need is to be excluded, expelled, or even incarcerated. Rather, they need to learn how to be safe, how to downregulate, and how to engage.

From Red to Green in Forty Minutes

Joel is ten years old. His parents went through a very public and acrimonious divorce a number of years ago. His father moved away but recently returned to have contact with his children. Joel is a skinny, awkward boy. He has no friends and is easily triggered into high stress responses, be this through teasing and bullying or because he cannot deal

with a certain task. For the last year, he has been regularly seeing an art therapist who works at his school. He trusts her; she may be the only adult he actually trusts.

When Joel gets stressed, he climbs high into a tree in the yard at the school, and the only sound he will make is meowing like a cat. When he dissociates, he is unable to speak. In this particular session, it takes the art therapist about twenty minutes, sitting underneath the tree, quietly talking to him, until he climbs down. She is known to be the only staff member who can talk him out of the tree. She takes him to the art room, where he sits collapsed on the chair with his hoody drawn deeply over his face. The therapist places the Clay Field in front of him.

This is the phase where Joel oscillates between shutdown (red) and rage (yellow). When a child comes out of dissociation, like Joel at this stage, he will internally be confronted with all the emotions he could not cope with and that drove him into shutdown in the first place. It is important to create sufficient safety to allow these emotions to surface and to allow them to be expressed without harming himself or anyone else. Having hit the Clay Field hard several times, it is obvious that Joel's right hand hurts from the impact. In response, the therapist moves the bowl with water closer to him. The water can be a resource to allow pendulation toward a softer, warmer place than the clay.

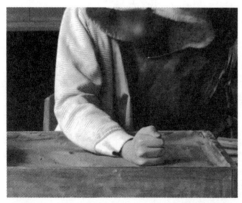

FIGURE 6.1. After initially sitting mute and hunched over in front of the field, Joel proceeds, once every minute or so, to raise his right arm and smash his fist into the field with all his might—and then collapse again. The therapist holds the box, signaling to him that she is holding him in his rage. His fist hurts. His left arm is collapsed. The therapist is gently but firmly present even though he does not respond. At one stage she points out the marks his fist has left in the field. Then Joel hits the clay again.

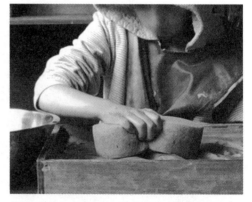

FIGURE 6.2. Joel responds and places his right hand into the water, beginning to tentatively squeeze the sponge that floats in it. It is a carwash sponge and quite large. Next, he brings the sponge onto the field and rhythmically squeezes the sponge in tiny bursts. He has found a rhythm, which can reconnect him to life. The most important step has been achieved, even though his left arm is still collapsed.

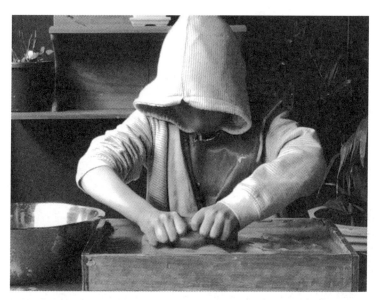

FIGURE 6.3. Joel's left hand has become included as he rhythmically squeezes a large, waterfilled sponge.

His left hand emerges and engages for the first time. He squeezes the sponge with both hands and lots of pressure in rhythmic repetition (fig. 6.3). The white knuckles reflect his inner tension. Such a rhythm of contracting and expanding is able to connect us to the most basic life impulse, a pulsing movement every cell in our body knows as a signal of being alive. Rhythmic pressure as a movement translates into tension and release, tension and release, which can always be welcomed as a sign of coming out of metabolic shutdown. Next, Joel picks up a toy elephant and makes it walk over the field, increasing the depth of the footsteps, which means the pressure applied onto the elephant will feed structure and muscle tension back into his body (fig. 6.4). He can begin to feel himself and reconnect with the structural build of his body.

Applying pressure in this way can uncouple the trauma held in the body from Joel's physiology. Our muscles and skeletal build hold the trauma when we get hurt through the way the body contracts, braces, and freezes in fear.

FIGURE 6.4. Downward pressure allows Joel to feel himself and come out of shutdown.

However, the muscles and skeletal build are not identical with the trauma. Pushing the toy elephant down into the field will stimulate Joel's body into experiencing his strength and empower him with a focus away from the implicit trauma memories. In the process, Joel can connect with a different embodied identity than that of the overwhelmed victimized kid.

Next Joel jams the elephant headfirst into the clay and makes the elephant splash. With the help of the elephant, he begins to dig deep and then slips his hand underneath the clay. The left hand follows. He makes sounds while he lifts all the material up from the bottom of the box at one time (fig. 6.5). It is such a metaphor for the upheaval he is experiencing and also in how much opposition he is with the world. It is visible how firmly the therapist needs to grip the box in order to support him. Especially when children feel angry and in opposition with the authority figures in their life, in particular their parents, they relish resistance from the clay. The haptic aggression here is oppositional and about tackling an opponent—in this case the clay—to gain a vital, embodied sense of self and identity.

In fig. 6.6 Joel drops all the clay into a bucket underneath the table. Both his hands are now engaged. He is standing and actively involved. The last bits are shaped into balls and smashed into the bucket. Making the balls gives his hands full sensory contact with the clay. The last ball is fired into the field, which holds some water that splashes the table and the therapist. Now he begins to get material back out of the bucket for more splash-balls into the field. He modulates his force when the therapist asks him to due to the mess it makes. He can listen and take that in. The therapist

FIGURE 6.5. Active trauma response by lifting all the material out of the field.

FIGURE 6.6. All the clay is now shaped into balls and smashed into a bucket.

does not stop him but just asks him to apply less force. Joel is moving. He is no longer stop (red) and go (yellow), but firmly in the yellow danger zone. He can! He is able to actively deal with the situation he is in.

Next, Joel lifts the twenty-pound bucket full of clay onto the table and vigorously pummels his right fist into it, now in a rhythmic full-body movement similar to what we would apply to boxing a punching bag (fig. 6.7). This is an active fight response, where he is completing a defensive action that he could not execute before, when he was too overwhelmed, and therefore dissociated and fled into the tree. Discharging his inner tension and completing the previously held, incomplete action cycle can signal to the brain stem and all implicit systems: "I am safe now and can deal with it." In the process, his language comes back, and he communicates in short sentences with the therapist.

FIGURE 6.7. Joel vigorously pummels the clay in the bucket with his right fist.

Joel is up to his elbows in the bucket when he declares, in full speech, he has reached the bottom. He lifts the bucket and tips all the stomped clay back into the field. The clay is shaped like a cake when it slips out of the bucket mold. He spends a number of minutes repairing all the gaps and continues until he has one smooth

FIGURE 6.8. As Joel caresses his new self-world, he repairs his emotional injuries, while receiving sensory feedback of a new state of being.

surface, as if repairing his own emotional injuries (fig. 6.8). Both hands are engaged, and he hums as he caresses the clay with his flat hands. Twenty minutes into the session have gone by. The hoodie has gone.

He places the elephant, a shark, and a lion on top of the cake, then digs into it, quickly forgetting about the animals, and spends the next ten minutes working the clay by literally chewing it with his fingers (fig. 6.9). Such processing is equivalent to mastication; Joel is processing and digesting with his hands what has occurred. He is standing up. His hands have tonus but are no longer tense. He begins to claim every aspect of the clay in the field and makes it his own. He digests his experience, which before he could not process, when all the material came out in one large chunk. While he works the clay with full contact of his hands, he softly sings a made-up song, "Everything is possible," in repeated loops.

Toward the end of the session, he singles out a special portion of the clay and places it into the water bowl. We could look at this special portion as identical with him, the self he is able to extract from the chaos. On a shelf in the art room, he has found a watering can and squeezes every available bit out of the sponge into the can and then waters the clay in the bowl. We can regard this as his effort to nurture and "feed" his self.

Lastly, he invites the therapist to connect with and admire his clay in the bowl. She moves over, and together they touch and bathe the "special" clay in the bowl (fig. 6.10). Joel is fully relaxed and present. He makes eye contact. He speaks, and his social engagement system (green) is back online.

FIGURE 6.9. Chewing the clay with the fingers is equivalent to the digestive process of mastication. It is implicit processing of what has occurred.

FIGURE 6.10. Social engagement: Joel invites the therapist into his new space in the bowl. He has gained sufficient trust to connect and share his experience.

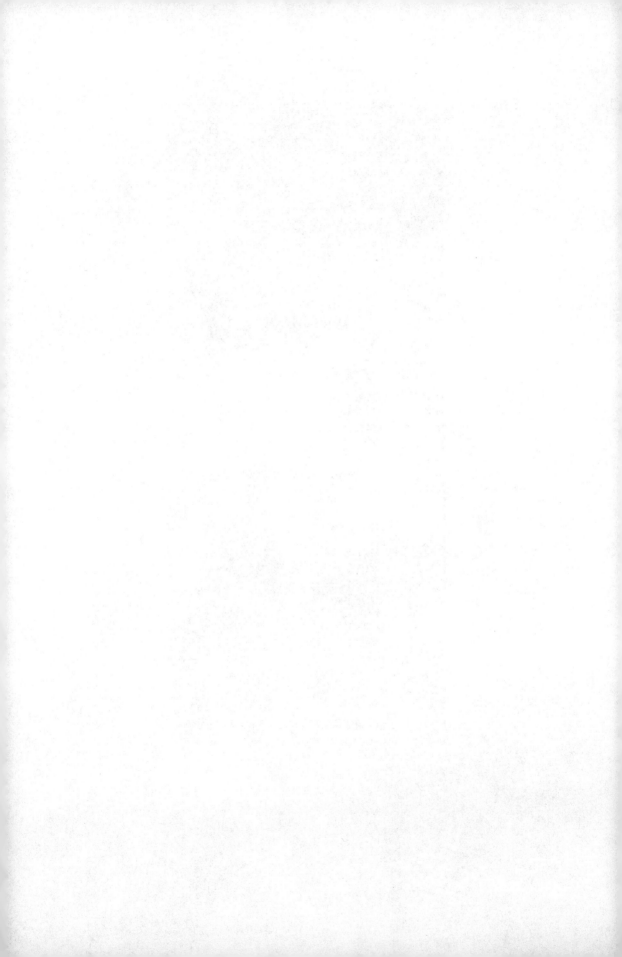

7

The Sensorimotor Cortex

I have mentioned the dual polarity of sensory and motor impulses and how they each play their role in the interactions at the Clay Field. Clay Field Therapy is a sensorimotor art therapy approach. The stress-responses arising from the autonomic nervous system instantly impact on the somatosensory and motor cortices in the peripheral nervous system. Children who are relaxed can be in their body without paying too much attention to it, while all their focus is on improving their voluntary motor skills, such as kicking a ball, drawing, or fitting a particular Lego block into the right place. At the same time, they have all their senses available to take in their environment, observe it, learn from it, orient in it, and express themselves in it. It is incredible how much relaxed and safe children see, hear, and smell, and how their sense of taste and touch is intensely alive. Let's look at bit closer at the neurological network in the body. Understanding the somatosensory and motor cortices in the peripheral nervous system has much to do with a trauma-informed therapeutic approach.

Traumatized children present in predominantly two groups. There are the ones acting out, and the ones who are almost invisible, "acting in," as Levine calls it. They are either hyperaroused or hypoaroused.

Van der Kolk and others state that developmental trauma is caused by ongoing, repeatedly overwhelming events that happened in a child's life.[1] Young children growing up in chaotic, violent, and abusive homes have no option to fight or flee; all they can do is dissociate parts of their nervous system in order not to feel so much pain and fear.[2] These are not conscious decisions but implicit trauma responses to hugely stressful life experiences. The nervous system is able to recover from a single traumatic event with adequate support from family and friends or with therapy, but ongoing stress, threat, and violence, in particular caregiver abuse, actually alter the pathways in the brain.

The hyperactive ones are mostly boys, frequently labeled as having ADHD. I am not talking about healthy active boys, who need lots of time for physical activities; hyperactive children on the spectrum are always "on." They cannot settle, cannot focus, cannot concentrate on any task at hand. They have learning difficulties, and their behavior is disruptive. They are the hyperaroused ones in chronic fight-or-flight sympathetic arousal. These boys, but not exclusively, have usually numbed essential parts of their sensory function. They have been so overwhelmed by fear and violence that parts of their peripheral nervous system had to shut down. They are kind of OK now because they feel less. However, this lack of sensory feedback to their brain gets them into endless trouble with peers, teachers, and society at large. They tend to appear for Clay Field Therapy sessions at primary school age, when their learning and behavioral issues become disruptive in the classroom and hard for teachers to manage. Millions of such children are currently medicated with Ritalin rather than receiving trauma therapy. If they do not get psychological help, however, the likelihood is high that they will become part of the criminal justice system once they hit puberty or suffer a lifetime as dual diagnosis clients who present with drug and alcohol addictions and mental illness. Van der Kolk discusses the hopeless health, mental health, and social outcomes for clients suffering from complex developmental trauma that remains underdiagnosed and untreated.[3]

The other group are the quiet ones, the hypoaroused ones, who act in and are either in braced or collapsed metabolic shutdown. They sit in the back of the classroom and never speak up. They are awkward, have few friends, and are often regarded as weird or as freaks by their peers. We find more girls in this group. They have learned to hold back, to sit back, to inhibit their motor impulses because speaking up, acting out, and being seen and heard would only get them into more trouble. Living with a sexual predator or a violent family member, the safest way to survive is by being as invisible as possible.

Over time the body adjusts to chronic trauma. One of the consequences of shutting down is that teachers, friends, and others are not likely to notice that the girl is upset; she may not even register it herself. By numbing out, she no longer reacts to distress the way she should, for example by taking protective action.[4]

At home the active presence of such children is likely to attract violence or sexual abuse, so they try to fly underneath the radar as much as possible in order to stay safe. Because these girls are quiet, they tend to go unnoticed throughout primary school. Only once they reach puberty do they become very vulnerable, because they have little self-esteem, they have no friends to keep them safe and to teach them about sexual predators, and no social strategies of self-preservation. They have never acquired the ability to say no and defend themselves. They become easy prey for sexual violence, including grooming online and abuse on social media. According to

Van der Kolk, girls with incest histories also sexually mature earlier than their peers, increasing in them the hormones that generate sexual desire.[5]

The latter is also the group prone to self-harming as a way of internalizing actions and emotions they cannot express. How much rage and pain does it take to cut through the numbness to feel at least temporary relief?

According to Van der Kolk and many other mental health specialists, caretaker abuse and neglect are far more common and complex than the impact of natural disasters and motor vehicle accidents. On average it will impact 10 to 20 percent of all children in every classroom, and the ratio will be much higher in socially disadvantaged neighborhoods.

If you recall the dual polarity in the Clay Field, it takes a motor impulse to reach into the field, and then the hands receive sensory feedback from the encounter. In traumatized children, this feedback loop is dissociated, or disorganized, or both. At the Clay Field the first group will engage in huge action cycles, pushing all the clay out, then lifting it all up, smashing it back down on the table, but they will not feel themselves. They do not receive any or reliable sensory feedback from their actions.

The children from the second group will barely engage with the clay. They will draw with one finger or roll tiny balls between two fingertips. Some of them feel a lot but are paralyzed when it comes to expressing themselves. They are crippled mostly by shame. They will avoid eye contact, barely whisper, and feel painfully awkward. One girl almost disappeared underneath her hoodie; another had all her hair brushed forward so her face was not visible; another could only engage when she was fully covered underneath a large shawl, which acted like a veil hiding her entire body. It takes time to gain the trust of these children, especially once they have hit their teenage years. So how do we work with these troubled children at the Clay Field?

Jake is seven years old and is staying in a women's shelter. He has witnessed his mother almost get killed by his father on more than one occasion. As he smashes his fists into the clay, pummels and hits it, he tells the therapist that one day he wants to be as strong as his father, because his father is the strongest man on earth. Jake's hands obviously hurt from all the hitting, but It still takes a number of quiet prompts before his hands can take a bath in a bowl filled with warm water. Initially the therapist words it quite intentionally that his hands might need the warm bath to have a rest, rather than him, because Jake is not sure at all if feeling warmth is safe. With the assurance from the therapist, he enjoys floating is hands in the warm water. Gradually Jake creates a new connection between warmth as pleasure and safety, different from his implicit (not verbalized)

assumption that vulnerability will get you hit and hurt. He has witnessed his mother's pain and distress, and something in him decided never to be in her role. With his hands floating in the warm water, he could tentatively restore the sensory feedback loop that had been dissociated.

Jake is a textbook example for a hyperaroused boy who has his sensory function dissociated. His session also illustrates how simple effective interventions can be if the therapist is granted some basic trust and gets the timing right. Let's look at Katie, who could be Jake's little sister, but with a very different response.

Katie is five years old and is also staying at a women's shelter. She sits at the Clay Field, barely daring to move. She only whispers, while leaving almost invisible marks with one finger in the field. The therapist notices that one foot has slipped out of her sandal and is secretly enjoying a puddle underneath the table left behind by a child in the previous session. The therapist offers to place the Clay Field on the floor, and Katie carefully puts her feet into the clay. Next she stands up and begins to "walk" in the box, noticing that she is gradually creating a "mountain" between her feet. As the walking gets more rhythmic, even dynamic, Katie watches her mountain grow with amazement. A bit later, Katie begins to cream her legs with liquid clay, then her face and her hair. When she is fully covered in clay, she stands in the field, with her arms up in the air, roaring and stating that she is a "monster."

Katie is an example of a hypoaroused child, who is so overwhelmed and afraid that her motor division is virtually shut down. Almost by accident, the therapist discovered her foot in the puddle underneath the table. By diverting Katie's attention to something that was unexpected and not deemed threatening, Katie's feet could explore the clay in a way that Katie herself would never have dared. The rhythmic movement of the walking in the field was sufficiently able to ground and encourage her to find an active response that virtually brought her back to life.

If we compare the two case histories, Jake was overactive and needed down-regulating and sensory stimulation, whereas Katie was immobilized and needed movement. Jake was acting out, and Katie acting in. In both cases the therapist also applied a Somatic Experiencing technique that Levine calls *pendulation*.[6] Pendulation assumes that we have a trauma vortex on one side and a healing vortex on the

other. It is essential to divert a child's attention away from the overwhelming trauma vortex toward the healing vortex in order to build resources. Jake could have gone on pounding and hitting the clay, but while having worked really hard, he would have left empty-handed, and to keep sitting with Katie in front of a field that she does not dare to touch would just confirm her disempowered, overwhelmed state of being. Yet Jake's hands could enjoy the warm water, and Katie's feet did know how she could stand up. Pendulating to an alternative pathway enabled both children to experience an embodied and renewed sense of self.

Child psychiatrist Bruce Perry relates the sensorimotor cortex to the foundation of a house. If this base is constantly moving and shifting due to feeling existentially unsafe, every higher brain function of behavioral and cognitive development will be impacted and compromised. This is why these children, once they commence primary school, have learning and behavioral problems—not because they are naughty, stupid, or have "bad" genes, but because their nervous system is easily triggered into chaotic upheaval, eliciting chaotic responses.[7]

The map of the sensory and motor divisions in the central nervous system illustrates the relationship between the sensorimotor cortex and the autonomic nervous system. We have already looked at many of the aspects described. You will remember the homunculi in the Natural History Museum in London, depicting the relationship between the sensory and the motor division and its hands-brain connection. Also familiar is children's trauma responses in the autonomic nervous system. The aspect I would like to discuss here is how knowledge of the sensory and motor division's functions allows trauma-informed interventions in therapy, in particular at the Clay Field, in order to bring the dissociated sensory or inhibited motor function back online.[8]

If we travel from the central nervous system down along the spinal cord, we reach the peripheral nervous system, which we have already discussed in chapter 4 through the lens of Linden's touch research.

The peripheral nervous system's main function is to connect the limbs and organs to the brain via the spinal cord. It consists of nerves and ganglia outside the brain and the spinal cord. In the diagram (fig. 7.1) you can see that it has two divisions: a sensory and a motor one:

- The **afferent sensory division** is responsible for the detection of information in our external environment and in the internal organs. This division relays the detected information to the central nervous system. The brain then integrates and organizes information in preparation for appropriate action.

- The **efferent motor division** sends motor information from the central nervous system to various areas of the body so that we can act.

FIGURE 7.1. Map of the central nervous system, depicting the somatosensory and motor cortices and their relationship with the autonomic nervous system.

In short, when we sit down in front of the Clay Field, there is a sensory message delivered to the central nervous system stating "This is safe" (or not), and accordingly the brain will send a motor impulse to the hands, prompting them to act. Touching the clay will again feed back to the nervous system that the clay feels cold or soft or disgusting, including the responses of the internal sense, such as that I am feeling excited and my heart is beating quite fast, which prompts another motor impulse, and so on. The afferent and efferent feedback loops communicate with each other. In Katie's case, her sensory division was clearly sending messages saying, "This is not safe, I'd better not move." And Jake acted out, but he had dissociated the sensory feedback loop.

The sensory division has two subdivisions:

- The **exteroceptors** are the five senses of touch, taste, smell, sight, and hearing, which all orient in the outside world. Touch and taste are proximal senses, dealing with things close by, whereas sight, smell, and hearing relay information from farther away.

- The **interoceptors** are proprioception, the vestibular sense, and the internal sense. All are designed to communicate information from our internal organs to the central nervous system.

 - Proprioception deals with the body's location in space.

 - The vestibular sense allows us to be upright and in relation to the earth's gravity. Located in the middle ear, it can cause dizziness, vertigo, motion sickness, and loss of balance.[9]

 - The internal sense deals with the felt sense, how we perceive our body on the inside, such as our heart rate, breath, and digestive system. The interoceptors receive their information from the autonomic nervous system, which is involuntary and mostly beyond conscious control.

The motor division has two subdivisions:

- The **somatic nervous system,** whose voluntary motor functions are under conscious control. This system takes impulses for action from the central nervous system and communicates them to the skeletal build, the muscles, and the skin. It allows me, for example, to act upon the need for a glass of water and walk into the kitchen to get one.

- The **autonomic nervous system,** whose involuntary functions cannot be consciously controlled. It oversees largely unconscious bodily functions such as

heart rate and respiration, but also hormonal and endocrine stress responses, and it mediates, through Porges's vagal system, our capacity for social engagement, trust, and intimacy. This system also relays impulses from the central nervous system to the smooth muscles, cardiac muscle, and glands. Its two divisions—the sympathetic and parasympathetic branches—respond extremely rapidly to signals of threat received from the central nervous system.[10]

If you recall the iceberg from the previous chapter, we can be explicitly aware of our five senses and our voluntary motor division. We can orient in the world with our eyes and ears, and we can decide to get up and go for a walk. Both the exteroceptors and the somatic nervous system are above the waterline of the iceberg. The interoceptive system, how we feel in our body, and the autonomic nervous system are below the waterline.

When clients experience a traumatic event, or children live with a nervous system that is set to chronic stress, the interplay between the sensory and the motor division becomes imbalanced. We have all experienced the moment of fear when we walk down a dark alley and hear footsteps behind us. Suddenly our interoceptors take over and we can barely think while our heartbeat rings in our ears. We sweat and run without hearing or seeing much else. Van der Kolk states that during a traumatic event and during states of post–traumatic stress disorder (PTSD), the exteroceptors are held hostage by the interoceptors. Our ability to orient in the world is overpowered by reflexes arising from the yellow and red traffic-light zones.

The exteroceptors are crucial for safe orientation in the world; they also make life richly textured and give us a sense of feeling alive. Fear, on the other hand, triggers the instinctual survival responses of the autonomic nervous system in the brain stem into fight-flight or shutdown. In order to save your life, all higher brain functions are shut down. We can no longer think straight; we can no longer put words to emotions, and external sensory perception is turned into the blind tunnel vision of "run for your life."

When we work with overwhelmed children, it is important to stimulate as many of their five senses as possible, to stimulate their external sense of orientation so they can actually objectively check whether they are safe. Rothschild calls this *dual awareness;* it buys client's time to emerge out of their internal turmoil, and even though they feel anxious on the inside, they can also become aware that they are safe in this particular situation.[11] It gives them an informed choice. This is why the tour of the clinic is so important: so they can orient, and in the process engage their five senses. Whatever a child is curious about, we can inspect; it does not matter if this involves the door handles, or finger-painting with essential oils mixed into the paint. It could be crunchy food, checking out the toys that are available, and explaining the noises

the hypervigilant child can hear. Zooming into details will confirm that the child's social engagement system is online.

All of us experience sensory recall quite frequently. The smell of the ocean might trigger a relaxed beach holiday, or a particular song on the radio might make you remember a dance with a romantic interest. In the same way, negative memories might be triggered. However, because of the shutdown of the exteroceptors during a traumatic event, the recall of events will be incomplete, distorted, or completely missing. The interoceptors, however, do react with the same amount of distress as they reexperience the memory. Many clients, for example, are triggered by the smell of alcohol, because that was the scent of their abuser's breath. Yet, while they have this reaction to alcohol, they may not consciously remember the abuse.

We can bring relief to such clients by:

- calling the exteroceptors back online to strengthen the sensory division
- emphasizing voluntary control of the striated muscles to stimulate the motor division

The following section will discuss a number of trauma-informed interventions particularly suitable for children.

Trauma-Informed Interventions to Strengthen the Sensory Division

My first intervention, when I see clients experiencing high stress and internal fearful overload, is safety. How can they regain an embodied sense of safety? The following interventions are particularly beneficial for clients in shutdown, who are hypoaroused.

Stimulating the Five Senses

The first step is to orient in the room. Where would the child like to sit? What art materials are available? What is possible to do in this setting? Where is a place that feels safe? What is familiar, and what have you never seen before? It can even just be something the child can look at and describe. This can be talking about the sink, about crayons, or about a tree outside in the yard. It is whatever a child finds interesting, to make sure the child is able to arrive and be present, away from the inner turmoil. It is anything that will engage the exteroceptors into perceiving the outside world. At times this requires clear and very directive interventions. A stressed and nervous child may like to know where the bathroom is, what art materials are on

offer, where the exit is, and why someone is coughing in the clinic's waiting room. The child needs clear and honest messages concerning the safety of the setting.

Art therapy approaches naturally stimulate a child's exteroceptors, which is why they are usually effective. Intentionally applied, sensory stimulation can be achieved through looking at toy figurines, cuddling a teddy bear, crawling into a cubby house, hiding underneath a blanket, sniffing out a favorite essential oil, crunching a biscuit, tasting a drink—anything that is helping a child come to their senses. It is important to take enough time to allow the child to orient with the eyes, ears, nose, and through touch, at times even through taste, understanding that while they may still feel afraid, in this very moment, though, they are safe.

You shift the focus away from the internal sense of gut-wrenching fear toward the external reality of here-and-now. If a child gets activated while working with the clay, it is important to listen to their statements. Some children can only tolerate ten minutes at the Clay Field, and then they need something else to downregulate, which they do through activities. Reading a story can help to calm down. Playing Lego can offer a welcome focus away from anything emotional, and instead they can experience safe social contact. This is not avoidant behavior, but rather nervous system regulation. It can empower children significantly and reduce their sense of being overwhelmed by uncontrollable forces within their body.

Safe Place

Children who are capable to create figurative representations benefit from creating a safe place from collage materials. If possible, I offer them clay as a base material to shape the place on a paper picnic plate, and they can then add wool, feathers, sticks, leaves, sand, paint, glitter, whatever their place needs. Since many cannot think of a safe place that they know, the need for it can be projected onto a toy animal of their choice, for which they build a shelter. The session may continue to discuss all the animal's needs, likes and dislikes, safety concerns, talents, instincts, and food and sleep requirements.

When this exercise is done in groups, the various animals can talk to each other, sing together, and acknowledge and share with each other their safe environment. This has been helpful when working with children in refugee camps and after natural disasters, where it was important to remember a sense of safety.

After the 2011 earthquake in Christchurch, New Zealand, schoolchildren who had lost their homes built entire towns from collage material by connecting their safe places.[12] These were children who knew what safety felt like, however—they had experienced a single-event trauma but were not suffering from complex developmental trauma, which is far more difficult to treat.

FIGURE 7.2. A safe place for a swan mother and cygnets. The cave has been lined with wool, and beans have been supplied for food.

Warm Water

Warm water is a magical sensory remedy. It can be deeply soothing. It needs to be warm because children who are frozen in fear are literally feeling bone-chilling cold. They just float their hands in a bowl with warm water, or the therapist runs warm water with the sponge over their hands, or the child holds the sponge and begins to apply rhythmic pressure to the sponge like a heartbeat, or they run the water over their hands themselves with the sponge. It is important to observe what the child's hands feel comfortable with and to give lots of time to allow the sensory response to gradually emerge, like a shy animal. If pushed, such children may simply retreat again into contraction and immobility. What is important is to gently support any rhythmic movement of the hands, or the body beginning to rock or sway. Natural soothing movement patterns will emerge without prompting, given time.

The image (fig. 7.3) clearly shows the rigid tension in the seven-year-old girl's hands. It was at her request that the therapist "nurtured" her hands with a continuous flow of warm water, which can remind the nervous system how to be in flow again.

The sponge encourages a natural squeezing motion. We saw in Joel's example (see "From Red to Green in Forty Minutes" in chapter 6) how the rhythmic pressure and release of the sponge brought him back from the brink. The basis for this intervention is that all life is movement. Every cell in our body rhythmically contracts and expands. Like a jellyfish, we pulse our way through life. It is not important, certainly at this stage, to investigate what happened, but rather to bring a client back to life's rhythm.

At this fragile stage, the clay can be too resistant, and the sponge is better suited to respond to the initially often tiny pulsing movement patterns that emerge. Sometimes when I watch such terrified clients, I think of them giving CPR to a little bird as they rhythmically squeeze the sponge. However, as the accompanying therapist, if you are patient, little miracles can happen.

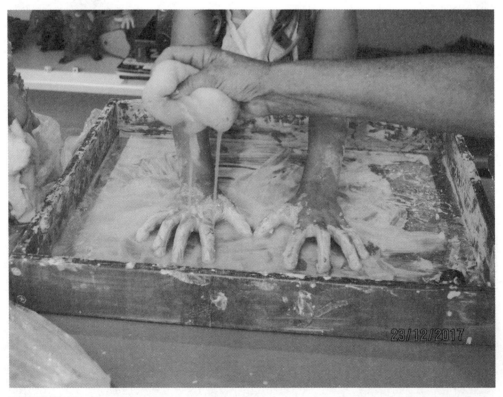

FIGURE 7.3. The therapist pours warm water with a sponge over the rigid, frozen hands of a seven-year-old girl.

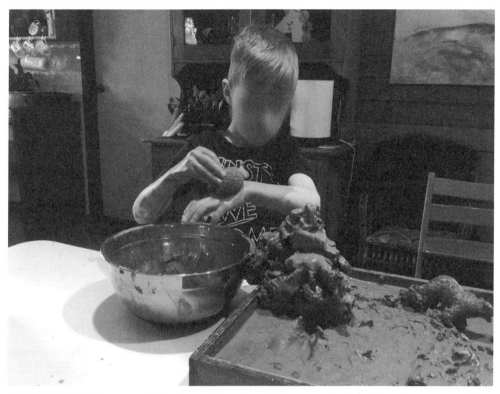

FIGURE 7.4. This five-year-old boy is soothing himself by caressing his skin with a sponge. His left hand is visibly relaxed.

Encasing the Hands or the Feet

If the hands are too sensitive or easily triggered, the child can place their feet into the field, and the therapist will either make "boots" from clay for them (fig. 7.6), or, as in fig. 7.5, the child can cream their legs with liquid clay. The contact of the feet in the clay is grounding, and the creaming is nurturing.

If the child can tolerate it, the therapist can pack both hands into clay to hold them in a safe place and to provide an assuring, comforting hug without inter-personal skin contact. Packing the hands firmly into lots of clay, the arms resting on "clay cushions," can provide a much needed hold. The therapist speaks and moves slow during the process of encasing the hands and gives lots of time. If it feels good, applying rhythmic pressure on top of the mound can stimulate memories of a pulsing womb. There is never skin-on-skin contact, but the weight of the clay and the applied pressure hold the child safely. Some children's nervous systems almost crash into letting go of tension to such an extent that they may want to put their head onto the field and temporarily go to sleep. It is good to give

FIGURES 7.5–6. Placing the feet into the Clay Field and creaming the skin with liquid clay can be grounding and nurturing.

lots of time to feel the hold and calm down. Children who existentially need such a safe hold do not get bored and can stay in their clay mound for an entire session. They will emerge when they are ready. A most positive sign is when their forearms begin to push sideways in order to create space. Such a movement opens up the ribcage and the chest, so they can discover "There is a place for me in this world." In the process, the braced upper arms, which were clamped to the chest for safety, become mobile, and "the armpits begin to breathe," which is one of Deuser's humorous observations.

Billy is seven years old, a boy in his twenty-eighth foster care placement, when he begins a once-a-week series of Clay Field sessions with a psychologist. He comes from a violent home. He is the youngest of four, his siblings are significantly older than him, and all his family members have drug and alcohol issues and are prone to violence. Billy's developmental age is about two years old. His first session reveals that he has no capacity to build anything with the clay. All he can do is grab it and add water, creating a bog, which he pushes around with delight, very keen to have it all (fig. 7.7). He has no concept of how to use the toy animals or how to role-play with them. Occasionally he uses them as tools to stab the clay, or he tries to dig with them.

In the second session he begins to create a pile of clay, then hits it hard with his fists, then pauses visibly, and collapses on top of it. Next, he uses the empty water bowl to cover the pile he hit before, and leaning on it, he covers it with his body, trying with all his might to protect the pile of clay he has hit (fig. 7.8).

FIGURE 7.7. First session. Initially six-year-old Billy could only create an unstructured bog. He had no idea how to build something with the clay.

FIGURE 7.8. Second session. After he has hit the clay hard with his fists, he protects it with the overturned water bowl and then with his body.

The therapist's response is to offer packing his hands into the clay (fig. 7.9). Being held in this safe way made this hyperactive traumatized boy slowly tilt over. The therapist provided the paper towel roll to rest his head on. He wiggles a couple

of times—and goes to sleep. He rests his head for ten minutes in this posture, his hands firmly held in the clay hug (fig. 7.10). His whole nervous system can finally calm down and settle. He claims these Clay Field sessions are the "best ever" and he cannot wait to return.

FIGURE 7.9. The therapist can pack the client's hands into the clay in order to provide a hold.

FIGURE 7.10. As a result of being firmly held, he almost goes to sleep. He rests his head for over ten minutes and only emerges when the therapist tells him it is time to finish the session.

From then on, he is much calmer in the sessions. He still asks a number of times to have his hands packed in but never again goes to sleep. Instead, he chats with the therapist and gives instructions on how and where he wants the clay packed around his hands. Next, he becomes intensely focused on learning how to build things with the clay. He begins with simple landscaping, including the toy animals, creating a mountain and a lake. His main focus, however, is to be able to build a house. He wants instructions on how to build a wall and a roof. In the seventh session, for the first time, he creates an age-specific landscape using fine motor skills, building a shelter for the polar bear and a lake for the seal (fig. 7.11). He is proud beyond words.

During this time, his attention span at school improves noticeably. He gets into fewer fights. His social, behavioral, and learning skills all change for the better. His foster parents report that his dissociative episodes, "where he just stares at one spot in the distance and cracks his knuckles like a tick," have almost disappeared.

In seven sessions, Billy has developmentally grown from a two-year-old to the seven-year-old boy he really is.

FIGURE 7.11. In his seventh session, he is capable of applying fine motor skills. He can concentrate and spends the whole session on creating an age-appropriate shelter for the polar bear and a lake for the seal. He puts both the bear and the seal into the house and closes the door. After twenty-eight foster care placements, he has finally found a home.

Trauma-Informed Interventions to Strengthen the Motor Division

One of the most important trauma-informed interventions for clients in shutdown is movement. How can they come back to life? Dissociative freeze states are characterized by immobility. Porges's red traffic light is characterized by "I can't," and often this manifests as: I can't move; I can't breathe; I can't hold myself up; I can't hear; I can't do this. It is rarely the case that the whole individual cannot move; rather, certain parts are dissociated, such as that the child will only work with one hand in the Clay Field, and the other arm hangs down at the side as if dead.

Rothschild[13] and Levine both state that we dissociate the most stressful elements of an event but "survive" with the rest of ourselves. Levine's SIBAM model describes how a complete experience consists of five core elements:

1. **S**ensation marks the felt sense, including the internal sense and the body's response.

2. **I**mage includes all five senses: sound, taste, sight, smell, and touch.

3. **B**ehavior is the only one observable from the outside.

4. **A**ffect is the emotion we felt at the time of an incident.

5. **M**eaning refers to understanding what happened.

A complete experience could look like the following: We feel good in our body, because we are holding a loved one's hand and feel the sunshine on our skin (sensation), we take in many sensory cues such as hearing the ocean and seeing the beach; yes, we are walking hand in hand (behavior), my heart sings with happiness (affect), and it is the best way to spend a Sunday afternoon with my family (meaning).

During a traumatic event, the most disturbing parts will be dissociated, and only fragments of the experience can be remembered. Many children, for example, exhibit repetitive play (behavior) but do not display any emotion (dissociated affect) or appear to remember anything at all (image).[14]

During a panic attack, sensation and affect are remembered, but all the other elements are dissociated, which makes it so hard to know what triggers the panic attack in the first place, because all the child experiences are disturbing physiological reactions and resulting fear without any known context.

Rothschild writes: "Once the missing elements can be identified, they can be carefully assisted back into the consciousness when the client is ready."[15] However,

with children this does not work as easily, because many events happened to them before they had language and the ability to critically observe the actions of adults. Their nervous system may never have learned to be organized in the first place.

Many children react with constriction, freeze, or immobility in their body. They repeatedly complain about tummy aches, headaches, or asthma. They develop digestive problems and bed-wetting. They display postural problems such as raised shoulders or being hunched over. They have trouble coordinating their hands and feet. Emotionally, they feel shame and guilt, or just do not seem to enjoy anything. Their behavior is avoidant, such as not wanting to go to certain places, or they display repetitive play. They may become clingy and regress to younger behaviors.

Movement

I live on several hundred acres. Sometimes the easiest way to get going again is to go for a walk. Van der Kolk developed a modified trauma-informed version of yoga. Tai chi, qigong, and martials arts have a profound therapeutic effect. In my twenties I spent years and years practicing aikido, which in some ways was the most effective therapy at the time. This says a lot, considering I was studying Gestalt therapy, Jungian therapy, and various arts and body therapies during those years. Young children respond to rhythmic clapping, jumping, and hopping, preferably in combination with songs or rhymed verses.

After establishing safety, we can look for age-specific movement patterns. Peter Levine and Maggie Kline developed a whole range of trauma-informed body-based songs and plays accompanied by movement.[16] Children enact stories about animals in the wild that are being hunted by predators, and they animate the running toward safety with their legs:

Have you ever had to run fast and escape?

Can you feel your LEGS, their STRENGTH and their SHAPE?

You have a body that is healthy and strong.

You can jump high and you can jump long.

Feel the POWER of your arms, they swing as they run

Feel the BEAT of your HEART and the WARMTH of the sun.

Feel the BREEZE on your face; does it tickle your hair?

Feel your HANDS and KNEES as you fly through the air.

Now you have come to a SAFE hiding place

Take a DEEP BREATH because you won the race!

How does it feel in your TUMMY and CHEST

Now that you have found a safe place to rest?[17]

These songs are designed to enact the fight-flight response, which, based on Levine's research, are able to complete incomplete action cycles that were interrupted due to traumatic overwhelm. Levine studied animals in the wild and observed that they go into metabolic shutdown when their autonomic nervous system deems that neither fight nor flight are an option. Many predators lose interest when they encounter the playing-dead freeze response in their prey, or, if the hunted animal now gets killed, being dissociated makes it a lot less painful because its spirit has taken flight and left the body. Our autonomic nervous system does exactly the same. In addition, though, Levine observed that once the predator is gone, and the animal realizes it is safe and has survived, it begins to shake. Levine filmed the animals shaking and looked at the footage in slow motion, realizing that each of these animals completed the incomplete fight-or-flight response they could not do at the time because they had dissociated and collapsed.

His research has become a core piece of trauma-informed practice. The brain stem, which is purely body-based, needs body-based trauma responses for us to complete what we wanted to do before we froze in shock and terror.

There are many options for such an embodied approach; here are just a couple of examples from my Somatic Experiencing training:

- Children in a day care center in a poor and troubled neighborhood benefited from being rocked in a sheet held by two caregivers, one at each end, swinging the child in rhythmic repetition like in a hammock, while one caregiver made eye contact with the child, saying: "You are special." For hours afterward, these children's behavior was more downregulated and less disruptive.[18]

- After the 2004 tsunami in Aceh, Indonesia, therapists worked with children who had lost their parents, often their entire village, by enacting with them through song, movement, and imaginative play the flight response. After rhythmic high excitement simulating the flight response with a ball being "chased" by all the children, they began to wave a large hot-air balloon parachute sail, mimicking the huge wave that came. Rather than being overwhelmed by the wave, fifty children now made the wave as an active

response. At the highest point, they all slipped underneath the parachute sail, singing: "I am safe; I am safe." Having an active response allowed them to end the trauma and to come to an embodied realization that they had all survived, and all were alive and safe now. None of the children who participated in the program later developed PTSD. They certainly had a terrible experience, but they were no longer stuck and frozen in it, and could move on.[19]

- An art therapist in Israel put a video together to teach the kindergarten and primary school children an active response to the constant sirens and rocket fire from Gaza going off nearby, which kept the children in a constant state of high alert and anxiety. The song has a catchy tune and is enacted by the children with movement patterns. Initially the song focuses on the fear felt in the body. The children then enact an active fight-flight response to avoid freezing in overwhelm, until they all find safety and can discharge the inner tension through shaking. The positive effect on the children is palpable, and many have integrated the song into their recess play routines. All the children interviewed report that they now feel better because they know what to do when the sirens go off. The video is available on YouTube as the "Code Red Song":[20]

> Color Red, Color Red
> Hurry, Hurry, Hurry
> To a safe area
> Hurry, Hurry
> Cause now it's a bit dangerous
> My heart is beating
> Boom, boom, boom, boom, boom,
> My body is shaking
> Doom, doom, doom, doom, doom
> But I am overcoming
> Cause I am a little different
> Falling down—Boom
> We may now stand up
> Our body we
> Shake, shake, shake, shake, shake
> Our legs we
> Loosen, loosen, loosen, loosen, loosen
> Breathe in deep

Breathe out far
We can laugh
It's all gone
and I feel good it's over
Yes!

After these examples, let's return to the Clay Field. How can the therapist encourage and support movement for children in shutdown who are terrified, given that the child feels sufficiently safe?

Pressure

When children in shutdown touch the Clay Field, they tend to avoid coming in contact with the material. Their hands bridge the field such that the forearms rest on the hard edge of the box, the fingertips touch the clay, but the base of the hand and the middle of the hand do not connect. Because they are so compliant, they might even become quite busy in the field, but without ever feeling what they are doing. All are empty action cycles, just like they are "going through the motions" in their life. These children may benefit from resting their forearms on the field. Not doing anything, except applying downward pressure, they fully lean onto their forearms until they become aware of a physiological sense of support. This field, this ground, is supportive; it is reliable; it can hold me. This simple exercise can make a difference in a child's perception of life and relationships; the option of support becomes a felt reality.

This nine-year-old girl (fig. 7.12) had been sexually abused. She enters the field by drilling with her index fingers into the clay multiple times, eventually covering the entire field, claiming her hands were octopuses. In the ensuing session, she radically and decisively deals with what happened to her in a number of active responses. However, she needed these steps to come in contact with her body, to feel herself to be sufficiently empowered to act.

Other children need pressure to come into being. I have discussed this before: pressure through making footprints in the clay, making handprints, walking on the elbows, leaning on their forearms in the clay, swaying

FIGURE 7.12. Through rhythmic applied pressure a child can come into being. Similar to taking tentative steps into the world, each step resonates reaffirmingly in the body through the counterpressure.

from left to right to test whether the field is really supportive. Here it is important to emphasize voluntary control of the striated muscles to move clients into the yellow traffic light zone of "I can."

Pressure projected into the field creates reciprocal pressure in the body. In order to apply pressure, a child has to align the skeletal build, ligaments, and muscles to have an effect. The pressure they apply resonates in their body as strength. Some children will exert sustained pressure until their face turns beet red from the effort; they are that strong. They need verbal feedback from the therapist that brims with admiration and praise.

FIGURE 7.13. This eight-year-old boy pushes with all his might. The therapist has to firmly hold the box. Standing up to the counterpressure will resonate as life-affirming through his entire body.

FIGURE 7.14. Here it is downward pressure. Again, the child's whole body is involved. He was diagnosed with ADHD, and these simple pressure exercises reduced his outbursts significantly.

Working with pressure is especially important for children with a diagnosis of ADHD. Even though they are acting out, they do so because they are immensely frustrated. They cannot have a desired constructive effect on the clay or in life. They often suffer from poor posture and disorganized coordination of their physiological self. If you recall the brain-hand connection, many cannot read or write, not because they are stupid but because their brain hemispheres are in chaos due to the ongoing chaos they live in. These children at the Clay Field cannot landscape the field. They cannot build anything, even though all their peers can.

Teaching these children through simple exercises involving pressure, initially with footprints, then with drilling into the clay, pushing it away and pulling it toward their body, tunneling into it, all while the therapist praises how strong they are, how great their accomplishment is, allows them to learn organizing their body into having an effect on their world. The seven-year-old boy in fig. 7.15 was not interested at this stage in building anything; all his effort was about organizing his body into having an effect. During his intense lifting and smashing and lifting and smashing cycles, he could hit the clay and discharge pent-up frustration due to whatever trauma he had experienced, thus completing the inhibited fight impulse. After this session, his lengthy fits of uncontrollable rage entirely stopped. His parents were almost in disbelief.

FIGURE 7.15. This seven-year-old boy, diagnosed with ADHD, was absorbed in putting all the clay into one lump, then lifting it up, smashing it down, lifting it all up again, and smashing it all down again. In the process he learned to organize his body, feel his strength, and move out of helplessness.

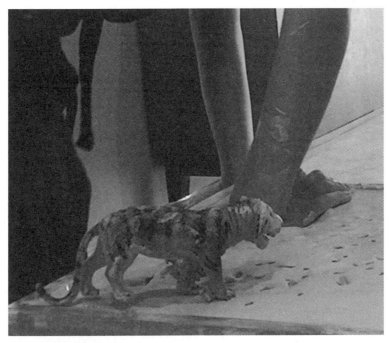

FIGURE 7.16. This ten-year-old boy applies all his strength to making an impression. It is visible how he needs to align his wrists, elbows, shoulders, spine, and hips down into his legs to succeed in becoming as strong as the tiger he chose as a totem.

With the pressure exercise, it is possible that anger and even rage is discharged as individuals come out of shutdown, especially when intense emotions drove them out of their body in the first place.

The seven-year-old boy in fig. 7.17, who is now in foster care, suffered horrendous neglect and was never supported. Here his forearms can rest on the ground surrounded by wet, smooth, sloshy clay. As he leans with his weight into the field and into this sensory bog, the embodied experience of being held on solid ground surrounded by nurturing skin contact allows his entire body to relax. He can begin to arrive within himself. The same is the case for the teenage girl in fig. 7.18, who also grew up in foster care. For her it was finding support and a resting space within the chaos she had experienced.

At a later stage, children might be inclined to rewrite the narrative of what happened through enacting stories in the Clay Field. As an initial intervention, though, all that is important is getting the exteroceptors back online and retrieving the voluntary control over the muscles through rhythmic repetition, if need be, of really simple motor impulses. This way children can come back into being and reconnect with life.

FIGURE 7.17. Leaning on his forearms, this severely traumatized seven-year-old boy deeply settles his nervous system, feeling supported throughout his body.

FIGURE 7.18. This teenage girl rests her forearms on the field. The support she receives from the ground she leans on resonates in her entire body.

8

Sequential Development

"Therapy seeks to change the brain. Any effort to change the brain or systems in the brain must provide experiences that can create patterned, repetitive activation in the neural systems that mediate the function/dysfunction that is the target of therapy."[1] Perry is adamant that there is no use addressing children's higher brain functions when the brain stem is disorganized. Therapies need to target the developmental age when the disruption of their development occurred. And just like children repeat action patterns over and over again, until they have integrated them, so will they need to repeat certain action patterns in the therapeutic setting. We can and need to exercise the brain like a muscle.

Most of us think of memory in relation to names, faces, or phone numbers, but it is much more than that. It is a basic property of biological systems. Memory is the capacity to carry forward in time some element of an experience. Even muscles have memory, as you can see by the changes in them that result from exercise. Most importantly, however, memory is what the brain does, how it composes us and allows our past to help determine our future.[2]

Child psychiatrist Bruce Perry continues:

Our brain filters out the ordinary and expected, which is utterly necessary to allow us to function. When you drive, for example, you rely automatically on your previous experiences with cars and roads; if you had to focus on every aspect of what your senses are taking in, you'd be overwhelmed and would probably crash. As you learn anything, in fact, your brain is constantly checking current experience against stored templates—essentially memory—of previous similar situations and sensations, asking "Is this new?" and "Is this something I need to attend to?"[3]

According to Perry, neural systems have evolved to be especially sensitive to novelty, since new experiences usually signal either danger or opportunity. This is the state of children arriving for a session at the Clay Field. The relational experience on offer in a box filled with clay holds both options: that of a threat and that of an opportunity.

We have all seen the images of a fetus in the womb sucking its thumb. We know the grip of an infant around the finger of a caregiver, the challenge a toddler faces to hold a spoon and guide it to the mouth. We have praised a preschooler for the achievement of the first pencil grip and shared the triumph when a child learns to button up a shirt and tie shoelaces. From there, steps are taken to increasing haptic skill levels, such as drawing, writing, playing an instrument, building a Lego spaceship, and onward into specialized training to become a professional mechanic, pianist, chef, surgeon, or something else.

We have learned about the intricate connection between the hands and the neocortex. Whatever learning steps the hands take will awaken, stimulate, and develop particular areas in the brain. Playing stimulates important learning steps for children. Putting building blocks together in sequence teaches their brain to put words together in sequence. If the hands lack certain age-specific movements and skills, the brain will too. Neurologist Frank Wilson investigates the hands-brain-language connection in his book *The Hand:* "The attainment of early language milestones in the child always takes place in company with the attainment of very specific motor milestones."[4]

Jean Ayres's life's work on sensory integration has informed thousands of occupational therapists about the building blocks characterizing a child's development:

> Sensory integrative functions develop in a natural order, and every child follows the same basic sequence. Some children develop faster and some more slowly. But all travel pretty much the same path. Children who deviate a great deal from the normal sequence of sensory integrative development are apt to have trouble later on with other aspects of life.[5]

From birth onward, the development of sight and sound teaches children the perception of things and events farther away, while touch and taste are proximal senses, and smell communicates both. Without these five senses it is hard to orient in the external world. Jean Piaget has demonstrated, in a number of simple exercises, how children's perception of objects changes as they grow up.[6] A four-year-old will simply assume that the therapist sees exactly the same as they do, and will have no concept of a different perspective. More or less the first ten years of life are dedicated to honing the ability to orient in space and assess the size and placement of objects.

The same applies to the sensory and motor skills of a child. If you give a bird that has fallen out of its nest to a two-year-old, the likelihood that the bird will survive the toddler's love is quite slim. The hands of the toddler can hold the little bird, but because they love it so much, they may not necessarily be able to assess how much pressure they are applying in the process. At age four the child will have gained sufficient control over their sensory and motor impulses and be able to gently enclose the bird in their hands.

Ayres speaks about developmental building blocks describing play activities as "putting functions together to form more organized functions."[7] Children integrate such sequences through repetition. While the development of motor functions is easily observable, for children moving from crawling into uprightness to being able to walk, for example, it is harder to see that the senses also develop in sequences of building blocks. I will therefore mention, throughout the following chapters on haptic development, how the sense of balance develops as children grow up. The relationship of the body to the gravitational field, called proprioception, is one of the first senses babies have to integrate as they emerge from the weightless fluidity of the womb. We have all seen newborns struggling to lift their heads. While lifting the head is a motor impulse, to do so requires a proprioceptive sense of orientation, such as where up and down are located; without this internal sense of proprioception, we are unable to move.

Bruce Perry's Neurosequential Model of Therapeutics explores how the brain organizes itself during a child's development from the bottom up, from the least complex area of the brain stem to the most complex cortical areas, starting with the sensorimotor base as the foundation for all further development. If the sensorimotor base is compromised due to trauma and neglect, all higher brain functions will be unstable, affecting behavioral and learning capacity. All-important brain functions develop in the first four years of life. Complex trauma, in particular neglect and abuse, have devastating consequences for the development of a child.[8] In his research, each brain area has its own timetable for development. "Microneurodevelopmental processes such as synaptogenesis will be most active in different brain areas at different times, and thereby more sensitive to organizing or disruptive experiences during these times."[9] Hopefully one day there will be a research project gathering the evidence on how Work at the Clay Field is capable of restoring synaptic connections that were missed due to adverse developmental influences.

The Neurosequential Model of Therapeutics is a bottom-up approach. Developmentally we progress from the implicit memory systems, starting with the brain stem to the midbrain to the limbic system, to eventually surface into the explicit cortex.

The autonomic nervous system and the survival responses are online first. Lloyd states that the tactile system in a newborn is primed for survival, with all receptors alert to danger. The initial sensory function is defensive, to protect the baby from harm. "With nurture, love, and care, the system shifts from this defensive functioning to a discriminatory functioning."[11] This shift "allows the developing child to stay tuned to the moment and experience and explore rather than being preoccupied with protection and safety."[12] Dyadic attachment supports the healthy integration of the sensory and motor memory systems until the explicit, cognitive memory can come online.

> The brain develops in a sequential and hierarchical fashion, organizing itself from the least complex (brain stem) to the most complex (limbic, cortical areas). These different areas develop, organize, and become fully functional at different times during childhood. At birth, for example, the brain stem areas responsible for regulating cardiovascular and respiratory function must be intact for the infant to survive, and any malfunction is immediately observable. In contrast, the cortical areas responsible for abstract cognition have years before they will be "needed" or fully functional.[13]

Perry emphasizes that memory, neural tissue, and development are *use-dependent;* they need patterned, repetitive activity to change. Systems in the brain that get repeatedly activated will change, while those systems that do not get stimulated will not change. "It seems like a simple concept, but it has enormous and wide-ranging implications."[14]

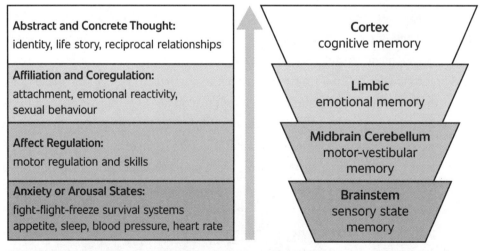

FIGURE 8.1. The Neurosequential Model of Therapeutics, building from the bottom up.[10]

Every time someone sits down in front of a Clay Field, similar sequential steps are necessary, such as sensory contact with the clay first to make sure it is safe, followed by organized motor impulses, before a child can shape anything meaningful with the material. Every session is equally a bottom-up approach, where we engage the brain stem and the midbrain first, and build the limbic relationship with the therapist and the field before we can create symbolic landscapes and scenarios, which in turn allow us to reflect on their meaning. I will next introduce the Expressive Therapies Continuum, an art therapy framework that can be loosely associated with the Neurosequential Model of Therapeutics.

9

Expressive Therapies Continuum and the Clay Field

The Expressive Therapies Continuum (ETC) developed by Vija Lusebrink is a brain-based art therapy model that adapts well to the complex needs of traumatized clients. Lusebrink and Kagin were pioneers in their field, already investigating the connection between human neurobiology and art-making activities in the 1970s.[1] The ETC integrates psychosocial behavior, psychology, information processing, executive functioning, and sensorimotor development into a contemporary art therapy framework for clinical and educational settings. The ETC levels can be loosely associated with Perry's Neurosequential Development model as a developmental bottom-up approach. They are designed to apply a nonverbal, art-based language able to engage and stimulate different parts of the brain.

Their terminology for brain-based activities:

- sensory: for the brain stem
- kinesthetic: for the midbrain, the cerebellum
- perceptual: affective for the limbic system
- cognitive: symbolic for the neo cortex

Within this framework, they have developed an abundant list of inspiring expressive art therapy exercises designed to stimulate different parts of the brain. This becomes

particularly useful when working in clinical settings where clients need specific stimuli to address certain impairments.

A sensory experience is wet clay creamed onto the skin, which can be nurturing and mirror attachment styles. The kinesthetic part of the cerebellum is stimulated through rhythmic repetition patterns such as drumming onto the clay, punching and lifting it, and piling patties on top of patties only to knock them over again. The *kinesthetic experience* includes proprioception and the vestibular sense of balance, and how children can or cannot organize the motor impulses in their body in order to make an impact.

Affect is stimulated in art therapy, for instance, through exercises with the vivid colors of finger paints; rhythmic drawing to music also brings emotions to life. The haptic connection with the clay makes it a profoundly relational medium: the clay is able to trigger strong emotions from both the brain stem region and the limbic system. Attraction or disgust, fear, and implicit trauma responses such as rage are survival responses, whereas drilling curiously with one finger into the clay, tunneling through the whole mass with the entire arm, and grabbing handfuls of clay with greed and a deep desire to have lots are action patterns filled with affect. Affect as it develops between four and six years of age manifests at the Clay Field as an emerging awareness of what I cannot have, cannot be, cannot do. It is this affect that drives sessions forward as children are searching for a more fulfilling way of being. I have discussed this impulse in chapter 3, on dual polarity.

While body mapping and drawing landscapes will hone *perceptual* skills in art therapy, at the Clay Field children now begin to landscape the field into increasingly meaningful environments. Initially this is a simple high and low that gradually turns into a mountain and a lake until it becomes populated with toy animals crossing over into symbolic play and more cognitive engagement.

Role-playing as a way of *symbolically understanding* the world emerges reliably from around age six onward. Primary school children are still dependent on their caregivers and cannot be critical of them. Rather, they use magical thinking to process traumatic events, very much like living in a Grimm's fairy tale.

Cognitive integration happens for children through acknowledging what they have achieved, such as taking pride in having built a "really, really high mountain"; such an enterprise being witnessed by an accompanier enhances self-esteem and is empowering. Based on the explicit acknowledgment, the experience can be embodied *and* remembered.

A Clay Field session always moves from the bottom up. Being able to connect with the clay, balancing uprightness, and aligning the muscles, ligaments, and the skeletal build on the kinesthetic-sensory level is necessary. Without this base, all creations will lack vitality, and children need to compensate such deficiencies with imagination.

Table 9.1. Expressive Therapies Continuum and the Clay Field as a bottom-up approach.

Cognitive–Symbolic Level

- Acknowledging personal achievements and tracking their fulfilling felt sense in the body. Linking the language of implicit memory to conscious autobiographical events.
- Understanding the haptic expression of the hands, what they have shaped, how they have moved, and their intended direction as a review of the session (teens and adults).
- Able to give meaning to created objects, landscapes, and the associated felt sense.
- Roleplay. Figurative representations. Updating old belief systems.

Perceptual–Affective Level

- Directing motor impulses with intent; applying motor impulses to orient and to affect change. Ability of adults to internally orient at the field with closed eyes—knowing where I am. Ability of children to age-appropriately landscape the field and orient in it.
- Touch provokes and evokes emotions.
- Felt Sense of encoded emotions (teens and adults).
- Able to experience affect in relation to the clay.
- Express affect through shape and movement.

Kinesthetic–Sensory Level

- Expression of motor impulses according to sensed physiological urges, impulses, and desires.
- Curiosity (urge to touch) and fear (withdrawal from touch) as natural impulses to connect.
- Sensing resonance in the body, which will lead to movements executed as motor impulses.
- Ability to organize the muscles, ligaments, and skeletal build to be able to move the clay (depth sensibility). Ability to organize uprightness and proprioception in relation to the field (balance). Ability to connect with the material and to have it (skin sense).
- Compromised feedback loop between motor impulses and sensory perception as a trauma indicator.

Putting the different frameworks I have discussed in this chapter into a chart relating to Clay Field Therapy (table 9.2), we can see how it applies to the Expressive Therapies Continuum, to the developmental stages of a child, the different brains regions, Perry's three R's, Levine's memory systems, and how it is a bottom-up approach. The second part of this book explains these developmental steps in detail.

This chart just serves as an overview in the context of the developmental stages and how they manifest in Work at the Clay Field. I encourage taking note of how many developmental, implicit steps it takes until imagery and figurative representations emerge along with conscious meaning making. If you recall the iceberg, most of our neurodevelopmental development is implicit and hidden from view.

Of course, these developmental stages are interrelated. Some of the core proprioceptive developmental milestones happen for babies in the first year of life: lifting their head, rolling over, and crawling, but in the context of this work, we are looking at the organization of the body once a toddler can stand upright and begins to walk. A two-year-old has strong emotions during a temper tantrum, but only from age four onward is able to be aware of these emotions. The same is the case when a toddler names objects, exercising a cognitive function, attaching a sound to a thing, but this is not yet an objective thought process.

When a child comes into the session with a conscious plan announcing, "Today I want to build a castle," they will need to engage with the clay first just by taking it, which triggers the question, Is the clay available for me? Can I have it? Children with attachment trauma, for example, will not necessarily trust that they can just grab the material, but rather experience the clay—just like their caregivers—as unavailable, hard, unyielding, and icy cold, and they will pick around on its surface with their fingertips. Next the child will need to organize proprioception and the body's combined and organized strength in order to lift and move the material.

Children are not able to build and create anything in the Clay Field unless they have regulated and integrated their sensorimotor base in a reliable way. The castle will have to remain an imagined castle, or one that is just scratched as an image into the surface of the field, without its empowering, three-dimensional, vital manifestation. However, this is the reality of the majority of children I see in sessions. Due to developmental trauma, they do not trust an other-than-me, and they are not able to organize their body in a reliable way because they are partially collapsed or too braced in order to effectively project their physicality into the clay, dealing with its weight and resistance. The Clay Field is more than any other art therapy medium I know of suited to address and re-pair such frustrating deficits, which makes children despair and act out, until they appear "on the spectrum." Once this sensorimotor base has been consolidated, usually through repeated action patterns over several sessions, children will grow up to their biological age in a couple of sessions and learn to read and write within one term, even though it was not possible for them to take in anything in the previous four years of school.

Table 9.2. Developmental stages in the Clay Field, the ETC, and Perry's neurosequential processing.

EXPRESSIVE THERAPIES CONTINUUM	CLAY FIELD THERAPY	APPROXIMATE DEVELOP- MENTAL AGE	BRAIN
Cognitive Level ⇨	**centering** positioning in the world mandalas or erect centers positioning the emerging self	16–18 years 13–16 years 11–13 years	neocortex left brain hemisphere reason
	questions concerning: identity, sexuality, ethics, individuality, peer pressure protecting the emerging self		
Symbolic-Cognitive Level	**identity** me and the world oppositional empowerment	9–11 years	neocortex reason
Symbolic Level	**symbolic storytelling and imagery** toy animals as symbolic parents symbolic landscapes, home environments, role-play adventures and disasters	6–9 years	neocortex right brain reason

(continued)

EXPRESSIVE THERAPIES CONTINUUM	CLAY FIELD THERAPY	APPROXIMATE DEVELOP- MENTAL AGE	BRAIN
EXPLICIT ⇑	**Conscious**		
IMPLICIT ⇩	**Unconscious: Body-Based**		
Affective Level ⇦	**haptic emotions:** triggered by the relationship with the clay: joy and pride, caring and nurturing, playing with water greed as emotional hunger: wanting and having the clay investigative curiosity: drilling into the clay resistance as opposition trauma-related shame, fear, and worry: frozen movements	4–6 years	limbic system relate
Perceptual Level	**landscaping** of the Clay Field into: high-low, left-right, front-back connecting "there-and-there" places with tracks, channels, and roads animating movement	4–6 years	limbic system relate

EXPRESSIVE THERAPIES CONTINUUM	CLAY FIELD THERAPY	APPROXIMATE DEVELOP- MENTAL AGE	BRAIN
Kinesthetic Level ⇦	**sensorimotor development:** depth sensibility: organizing the physiological build to be able to make an impact balance: organizing the body in space, proprioception	2–4 years 1-2 years	midbrain cerebellum regulate
Sensory Level	**skin sense:** contact with the clay, being able to have it, to connect with it, mirroring attachment styles	0–1 year	brain stem regulate

In the previous chapters we have mainly looked at the brain stem and how it requires a trauma-informed approach to regulate anxiety and arousal states. The next part of the book discusses the developmental stages of children in the context of their haptic development and how it manifests at the Clay Field.

Clay Field therapists observe the hands of clients and their age-appropriate capacity to handle the world. The diagnostic assessment of children is not based on a psychological narrative but on their haptic abilities. How can children organize their hands and their bodies to make an impact in the field and build what they want to create with the clay? If these sensorimotor action cycles are age-specific, they will be deeply satisfying for them. They will confirm their identity and build their self-esteem. Such action patterns will also help regulate their nervous system because whenever we can find an active response to something that happened, the active response neurologically completes the stressful event:[2]

> Somatic Experiencing is not primarily about "unlearning" conditioned responses to trauma by rehashing them, but about creating novel experiences that contradict overwhelming feelings of helplessness and replacing them with a sense of owner-ship of physical reactions and sensations.[3]

In his groundbreaking research, Levine has proved that the story is not essential in order to heal trauma. This becomes particularly relevant when we work with children who have experienced ongoing adverse events from an early age onward. They often have no story to tell because they had no cognitive capacity in utero and as infants to put into words what happened to their bodies. Yet these implicit, formative experiences shaped their identity profoundly. These are the children who turn up for Clay Field Therapy sessions, and they benefit the most from them because in this setting they can postnurture the missing building blocks they could not develop during their traumatic upbringing.

Deuser created the term *postnurturing* because children do not just regress; they will actively seek to fulfill their developmental needs once they feel safe in the setting. I have witnessed children and adults of all ages engage in seemingly simple acts at the Clay Field, such as caressing the clay, creaming their hands and arms and faces with liquid slosh, squirting handfuls of material through their fingers, delighting in having "lots." If this need for skin contact, for example, is something that has been lacking during their first year of life, they will find deep satisfaction in exploring these possibilities, and only once they have satiated this developmental need will they explore more grown-up action cycles in the field. Ayres is another expert who is vocal that all

later academic achievements, such as reading, writing, and behavior and emotional growth, rest on this early sensorimotor foundation.[4]

The core sensorimotor discoveries of children during their first four years become the vital basis for the rest of our life. With this *haptic toolbox* in place, we learn to trust our spontaneous, vital impulses to act in the world—and in the Clay Field. These actions are preverbal, nonsymbolic, and impulsive. They reflect how we "handle" the world and how we store this implicit information in our procedural memory in the brain stem.

The three core elements of this vital sensorimotor base are:

- skin sense

- balance

- depth sensibility

Developmental deficits in any of these three areas will have lifelong implications; all higher building blocks will be compromised if the sensorimotor base is not available, regulated, and synchronized.[5]

In the following chapters, I will discuss these building blocks, how they appear as developing haptic milestones in Clay Field Therapy sessions, and how they can provide diagnostic insights for the therapist.

PART 2

Haptic Developmental Building Blocks

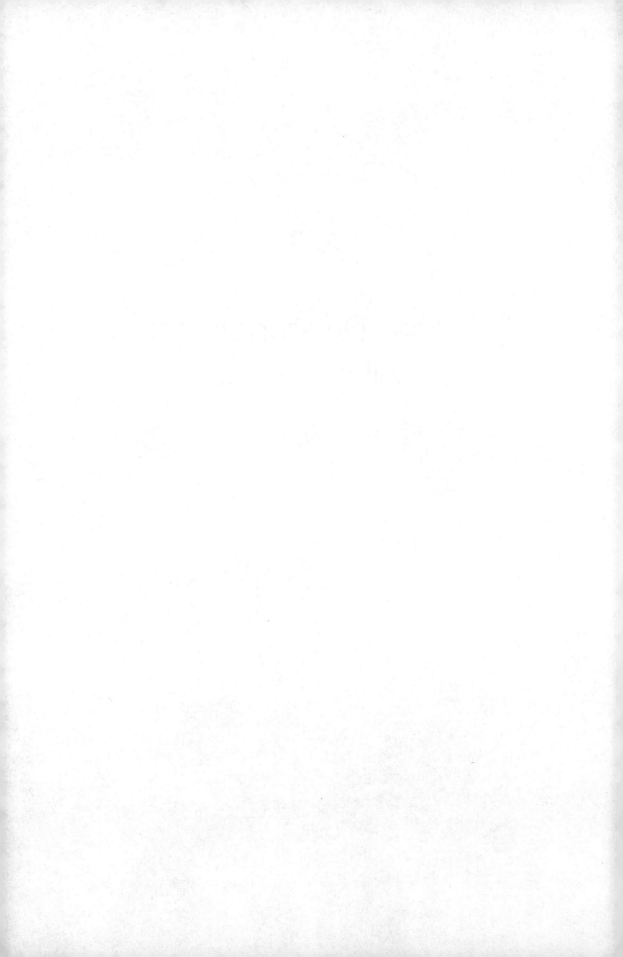

10

Developmental Building Block 1: Skin Sense

Age: 0–12 Months

Children at this age do not work at the Clay Field; however, developmentally, the learned skin contact experience in infancy will become the organizational framework for the relational capacity of a child, and this is reflected in how a child touches the clay and connects with it. Skin contact is the primary mode of communication for infants. They learn safety, love, and emotional regulation through how they are being caressed, held, rocked, bathed, creamed, dressed, and fed by their caregivers. Skin sense shapes the attachment style of an individual.

In the Womb

The experience of skin sense begins in utero. In the womb, the fetus is surrounded by water. Bruce Perry describes pregnancy from the perspective of the child as a world of rhythmic, somatosensory, fluid oneness, where the baby floats in perfectly maintained temperature, constant food supply, and rhythmic pulsing. It is a vibratory, auditory, and tactile environment in which infants' brains learn the patterned regulating of their nervous system.[1] The developing brain will integrate the rhythmic patterning of the mother's body as its autonomic nervous system baseline. This baseline will remain the perceived implicit "normal" for the rest of an individual's life. If

the mother predominantly relaxed during the pregnancy, the infant will be born with a relaxed baseline. If the mother is stressed, drug-addicted, or tried unsuccessfully to abort the pregnancy, babies are born with a high activation level as their normal. This stress level can reach similar cortisol levels to that of soldiers after years in open combat. These infants have feared for their lives, and their nervous systems experienced the pregnancy as an inescapable threat.[2]

Children with perinatal needs enjoy playing with their hands in warm water. The temperature of the water is really important here. Refills from a thermos might be necessary to keep the water soothingly warm. A three-year-old will splash and play with the water. Here, however, we are dealing with perinatal trauma, which has a very different haptic pattern. When healing of events that occurred during the pregnancy is necessary, the hands will float. They are dreamy and slow-moving, just like the hands of the boy in fig. 10.1. This is a very quiet, nonverbal state in which tiny rhythmic movements of contraction and expansion can act as a pulsing lifeline to restore the rhythm of life. Rhythmic squeezing of a sponge may provide a hold, a connection with life. The rhythm can be minimal, like a heartbeat, so the hands, and with them the child, can gradually relax and emerge out of metabolic shutdown.

Offering a sound experience such as the heartbeat with a shamanic drum may add to ways of calling such children back. If there is a real need to restore trust in this primal water world, children may need several water sessions before they have gained sufficient resources to be ready to be "born" into gravity. For others the state of being

FIGURE 10.1. A four-year-old boy on the autism spectrum delights in having his hands in the water. You can observe that his hands have little tonus. They just want to be in the water and not do anything.

before their birth was the last time they implicitly remember being safe, held, and contained. Whatever followed from then onward in their life was hurtful, chaotic, or abusive. In such cases, trust needs to be built toward this transition, which can manifest for some as bridges being built from the water bowl into the Clay Field, or water being transferred from the bowl into the field. The therapist can gently squeeze a sponge filled with warm water and make it flow over the child's hands to introduce a sense of being nurtured and cared for.

Carol is five years old and has been diagnosed with severe autism. Her mother experienced an undiagnosed medical condition that left her infant malnourished during the last two months of the pregnancy, which could have been a contributing factor. Carol refuses to be touched or touch things; she is erratic and erupts easily in huge fits of anger, and her attention span is minute. Every time she sees the Clay Field setting, she makes attempts to climb into the water container. Eventually we get her a flexible laundry tub, fill it with warm water and a big blanket, and let her climb in (fig. 10.2). Next, Carol wants to eat. Lots to eat. She has food floating in the water, which she picks out and puts in her mouth; she drinks juice; she drinks the bath water. She smiles and stays in her "womb" for fifty minutes, and even then she does not want to get out. The tub bath became a nightly ritual with her mother, which allowed her to settle much better overnight. While it was not a cure, being contained in the warm water helped her to downregulate, at least for a few hours afterward.

FIGURE 10.2. After several attempts to climb into the water bowl, we gave Carol a laundry tub filled with warm water. Finally she could settle.

Somatic Experiencing considers autism as perinatal trauma, preventing the nervous system from developing the necessary synaptic connections due to experienced stress. Children diagnosed with autism tend not to like touching clay; many are hypersensitive to touch and sound. They did suffer trauma during a time when their key life-affirming information was relayed through touch; accordingly, touching the material triggers their stress symptoms.[3]

Many autistic children struggle with relationships; they tend to live in a stereotypical, repetitive, autosensory world. Their traumatic perinatal injuries occurred very

early in their development and are occasionally severe. Their trauma impacts their ability to relate. This impacts the child's sense of touch, as developed in skin sense. One hypothesis is that children with autism have a compromised mirror neuron system.[4] They have trouble understanding the thoughts, feelings, and intentions of others, which in turn causes social-skill deficits. If the mirror neuron system is not functioning in autism the way it does for neurotypical individuals, it makes sense that both children and adults with autism struggle to predict, understand, or imitate the actions of others. This would make social interactions confusing and unpredictable, which is reported by many children, teens, and adults on the spectrum.[5] However, occasionally the Clay Field is just the medium to meet the needs of an autistic client.

I worked with Brenda as a client for four years. Brenda is sixteen at this stage. Before this session, a family upheaval resulted in her internally shutting down more than usual. Her cocktail of drugs was changed again, and what little speech she used almost disappeared. It was at this point that I introduced the Clay Field again. Previously she had appeared uninterested, poking the clay once or twice and pushing it away or getting up from the table to resume her ritual behaviors.

Brenda is mainly nonverbal with a lot of echolalia. If she has any internal pain, it is always accompanied by much rocking, rolling, and screaming. However, she can also scream just because she knows others find her screaming distressing, and she will scream when she feels excluded. Because Brenda is unable to communicate verbally, I would have to intuit her gestures and ask questions in a different way, such as: Are you feeling stuck today? Frustrated? Angry? If I was wrong, she would either look me in the eye with a wry smile and laugh at my ignorance, or she would repeat the word as an affirmation.

How I regulate is vitally important to how the session will unfold. Children with a disability need to be held by the therapist, who needs to become their ego and their auxiliary cortex. If they can trust that the therapist can provide an energetic safety net, they will relax into that hold.

On this occasion we drank a hot chocolate together. I placed the Clay Field on the table with a bowl of water on top. I offered to wash her hands. She put her hands into mine within the bowl and we played for about ten minutes, sometimes moving, sometimes still. Eventually I took my hands from the bowl, and Brenda followed by putting her hands on the clay. Before I could do or say anything, she had poured all the water into the field, creating a mud bath. Initially her actions were frenzied, but within ten minutes a great calm descended. Her

hands disconnected with the clay and hovered over the field. The few words she had were freed, and whatever had been weighing her down lifted. She smiled beautifully and breathed evenly. Returning to her father that night, Brenda was calm and engaged with him in her normal manner.

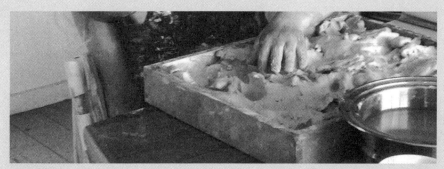

FIGURE 10.3. Sixteen-year-old Brenda at the Clay Field. Notice how soft and round her baby hands are.

Brenda relies on felt-sensing the people she is with. If they are open, she knows immediately whether she is accepted or not. It is no surprise that most of her time at the Clay Field involves pouring water into the clay and mashing it between her fingers like a small child does with food. The squelching and grabbing bring her joy, always resulting in slowing down her breathing, a marked downturn of her otherwise typical heightened arousal.

Brenda was aware that she could self-regulate in the Clay Field. She would let me know if she needed it or not. It became part of the way we could communicate with each other. After this session she began to ask regularly for "clay, clay" like a mantra for relief. Only once did she refuse the water, working the clay as if it were the enemy for a short time. At one stage, she piled all the clay high within the field before putting it all into another bowl and then pushing the field away from her. "Clay finished" she said. It had done its job. It was clear it was no longer needed. Whether it will be required again in the future, she will let me know.

Contributed by Lyn Duffton

In this context it is important to differentiate between an underdeveloped rather than a broken foundation system. Autism is a physiological injury that affects the organization of the brain stem rather than a psychological one. All the other case examples

I am discussing in this book concern physically healthy children who have missed out on particular developmental patterns due to adverse events in their lives, rather than suffering from a medical condition like Brenda, who lived in a loving supportive home. Brenda's needs were special and are not part of my expertise. However, I know a number of therapists who have successfully accompanied children and teens with disabilities and have been able to significantly further their haptic development through postnurturing and rebuilding bodily and emotional layers that were asynchronized.[6]

The First Months

Skin contains and surrounds the entire human body. It divides our inside from the outside; it is a boundary membrane. As there is only a rudimentary sense of self in the first few months after birth, the skin needs stimulation from something coming from the outside.[7] Liquid clay can be creamed onto the hands, arms, and face. The clay then embeds and surrounds the skin and warms and caresses it like a mother's touch. Such active self-fulfillment can be deeply reassuring. If the clay begins to dry, then this dry clay on the skin will enhance the awareness of the skin boundary. For some the perception of a felt skin boundary can now emerge as a layer of contact between the self and the other. Some children may cream not only their hands and arms, but also their legs, face, and hair.

Individuals who need to repair and nurture this stage, due to insecure attachment, for example, or due to the need to reconnect with a comforting maternal presence, experience the clay purely as contact, as something that is available, smooth, supportive, and soft. The clay is perceived as "there, somehow." It has a being-quality as the hands search for contact, for a tangible supportive base on which they can rest. The hands and also the arms, elbows, and even the head may want to rest on the clay or cuddle into it. Water is used with abundance. Figs. 7.17 and 7.18 in chapter 7 are good examples for finding fulfillment in finding a nurturing support.

It is clearly visible when the clay is not available for a child's hands, when they cannot connect with the field. The hands scratch the surface without getting anything. They seem to ask: Is it safe to touch this? To support contact with the clay, a sponge can be used to add water. Water supports connection and softens the material when it is experienced as unavailable, cold, or ungiving, which usually relates to the fact that these children experienced their primary caregivers as unavailable, cold, or ungiving. Many, however, need several sessions before they can gain sufficient trust to go any farther than rolling tiny balls between the fingertips or drawing faint marks with one finger.

FIGURE 10.4. There is a delightful sense of self-discovery in the way this four-year-old girl explores her skin boundary.

FIGURE 10.5. This shy six-year-old girl delights in creaming her entire arm with water and soft clay. It was a nurturing experience for her. In addition, the applied pressure helped her coming into being.

I can think of thousands of situations in the past few years where I have observed infants or toddlers trying to engage with their parent who is absorbed in checking their phone. These toddlers do not comprehend the work pressures of their caregivers, but they learn that they are not important in comparison, and that contact is unavailable for them.

If you compare the six-year-old (fig. 10.5) and the eight-year-old (figs. 10.6 and 10.7), it becomes painfully obvious how little a child dares to take when they lacked support in their early development and the clay, just like the world, is not available for them. They may compensate with imagination for their lack of connection, but their embodied self-realization will be compromised.

Children with attachment needs, who lack experiences of being held and supported, will greatly benefit from having their hands packed into clay; it is akin to and often experienced as being held in a warm safe embrace. A colleague of mine who works in a women's shelter found that once children have experienced this holding space, which is the equivalent of a hug, they want this space created for them first thing in every session. It becomes the basis for all further explorations at the field.

In this case, the therapist firmly piles clay around the child's hands; warm water can be poured into the cavity to create a "womb." It can be quite surprising to find otherwise restless, unfocused children settle in this holding space, to witness how they calm down and surrender to the fulfillment of their need to be nurtured and held.

FIGURE 10.6. This eight-year-old girl is an example of insecure attachment. After much hesitation, she made one mark in the field, only to retreat with her hands, closing them off from contact as if curling up in defense.

FIGURE 10.7. In the following session, she left tiny faint lines, drawn with one finger, which she wiped on the sponge after every time she touched the clay. Trying to be as invisible as possible, she has no trust that this world on offer is safe and available for her. It took her thirty minutes to draw a few lines.

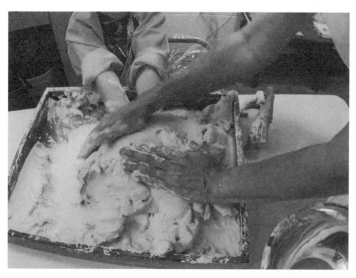

FIGURE 10.8. Packing in of the hands. This eight-year-old boy has grown up in foster care. Here his hands are firmly packed in, and the therapist applies rhythmic pressure on top. This is a firm hold. Many restless children with sensory integration needs enjoy firm pressure to really be held.

There is also a difference if the hands are packed in together, as in fig. 10.8, or if they are parallel on the table, as in fig. 10.9. Both hands together in one mound represent the "womb" version, where unity and oneness are confirmed. The parallel arms reflect the need to align the parental archetypes, which means these children are "born." This is likely an unusual concept to contemplate, but try to picture a toddler learning to walk. They use their arms to balance their uprightness. We can picture a hologram of their father and mother on either side holding their hands. These are the archetypal parents we all need in the triad of father, mother, and child. While it is not possible to undo a child's experience of insufficient parenting, the implicit archetype can be restored through a felt sense experience of safety and being held on both sides, a parent

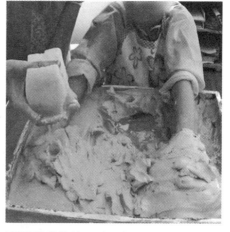

FIGURE 10.9. Here the therapist has packed the boy's hands separately into clay. Notice the supportive clay cushions underneath his wrists and forearms, providing tangible support. Each hold has a hole on top through which the therapist pours warm water from the sponge into his encasement. This is profoundly nurturing.

on either side. In this case, each hand gets its own encasement (fig. 10.9). At times, a child will create such an encasement with one hand for the other on their own, when only one "parent" needs strengthening or repair. At times I view such encasements like a plaster cast, where a broken limb needs to rest and heal. You may recall Jason, discussed in chapter 3, who encased his left arm for most of the session (figs. 3.9 and 3.10). Children will intuitively make the right choice for what they need; this does not have to be directed by the therapist.

If children have more prenatal needs, or want nurturing, they will enjoy the addition of water. If they want to be firmly held to feel safe, just clay and rhythmic pressure on the top of the clay can provide a safe hug. It might again be important to remember that everything that happens to the hands reverberates through the entire body.

The arms are outstretched when children are exploring unmet needs during this developmental window of the first year of life. This can be observed in most of the pictured case histories. The outstretched arms into the field signal "help me," which is developmentally appropriate for young children requiring the support of their caregivers. Accordingly, the positioning of the arms can become an important diagnostic tool.

The parallel arms can be developmentally observed between six months and four years of age (fig. 10.10). Balance is organized through parallel outstretched arms. Children at that age need the assistance of their caregivers. They reach out to them, asking for help, and they project this same need into the Clay Field. At that age, they have little core strength, and their gravitational security is still tentative.[8]

The parallel arms represent the alignment of the parents in a child's life. Here the Clay Field is perceived as supportive. Hands and arms move forward and backward, up and down, and experiment with alternating movements and pressure. Fear at home manifests as tension in the shoulders and neck. Maltreated children at this age have no choices; they cannot run away. They are not even critical of their parents. They accept them unconditionally. However, if they fear their caregivers, they will simultaneously reach out for support and try to withdraw from it, which results in pulled up shoulders and blocked necks. This is an important haptic diagnostic indicator to observe for the therapist and easily identifiable when a child is looking for support at the Clay Field with outstretched arms. Speech problems at that age result from turtle-style necks

FIGURE 10.10. Parallel arms.

that are pulled in, often to hide in fear. While developmentally the outstretched arms belong to the window between six months and four years of age, they can be observed even in adults if they have been injured at a young age and they need postnurturing and repair.

When older children and adults connect with attachment needs of this developmental age, their hands will appear soft and round, with little tonus. Either they will sweep in a dreamy, unfocused way with the flat hand, or they will grip the clay with the fingers close together without the use of the thumb. The grip will look for a hold simply because it is there, similar to how an infant will grasp the dangling earrings of a caregiver just because they are there. The infant might even pull the earring without any sense of the pain caused by such an act.

In all cases it is of utmost importance to be aware that deep sensory integration takes place that is primarily nonverbal. Children will be disturbed in their explorations through cognitive questioning. They need the full presence of the therapist, and to be given lots of time. This infant stage is still timeless and without spatial orientation. Action patterns are not intentional. The hands have little tonus and no focus. Such sessions can feel very quiet, almost meditative, while the nervous system of the child settles, sometimes for the first time. All that needs to be developmentally acquired at this stage is that the Clay Field is *there* for the child and available in order to nurture unfulfilled attachment needs.

In those cases, where the infant's needs have remained unmet over a lifetime, the forearms appear puffy, blocked at the wrists, as if all that longing to reach out has been held back and cannot flow into the hands and into contact. In severe cases, several breaks can be observed in the hand-body-brain connection. The wrists are angled in a way that blocks flow coming through, and the inner hand arches away from contact with the clay. In hyperaroused children, the fingers are tense and rigid, with white knuckles showing the effort to brace away from contact, whereas in hypoaroused clients, such as in fig. 10.11, the hands have little tonus. Such inner tension can be observed most clearly at the beginning of a session.

Some children who have lived with sensory dissociation due to attachment trauma all their lives can mask their touch aversion with deceptive business. They may be able to do lots in the field, but none of it arrives in their inner hands. Traumatized children's nervous systems are often set to chronic high activation levels, and they have been "out of their mind" for most of their lives; they have been acting out due to their inability to receive sensory feedback when they communicate. Such clients work very hard at the Clay Field but leave the session empty-handed. The flow of the dual polarity between motor impulses projected into the field and the sensory

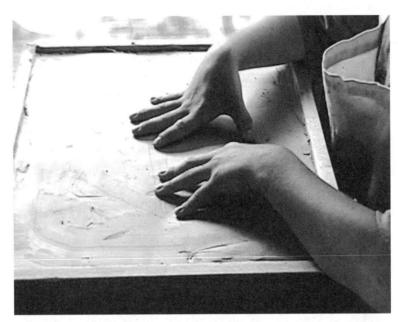

FIGURE 10.11. We can view several layers of blocking the sensory connection with the clay. The hands are arching away from connecting the inner hand. The wrists of this ten-year-old girl act like brakes, and so do her forearms, which press down on the edge of the field to block both her motor impulse to engage with the clay and the potential sensory feedback resulting from such contact. Her hands have little tonus.

feedback received from this encounter has been dissociated. Clients act, but they can't feel. It is important that the therapist is not being deceived by their dissociated productivity, but rather perceives the underlying trauma and addresses it.

Cody is seven years old. He is the youngest of six boys. His father has been in and out of jail. He attends a school in a "problem" area, where he has been singled out by his teacher for Clay Field sessions due to his behavioral and learning difficulties. At the Clay Field, even though he is very interested in the sessions and attends them willingly, he is only capable of picking two small pieces of clay out of the box. He then swirls his hands around in the air, animating the clay blobs with noisy, aggressive fights. It takes many sessions until he begins to actually touch the field. Most times the therapist has to model simple action cycles for him to believe they are safe. Once safety has been established, Cody plays with water and soft clay, very messily at times, but he enjoys creaming his arms and his face. He loves to have his hands buried in the clay by the therapist as his nervous system visibly drops from hyperactive aggression to almost sleepy states.

In a household full of boys, Cody grew up in an environment where strength, power, and fighting were rewarded, and feelings made you weak and vulnerable. His overwhelmed nervous system had dissociated the sensory feedback loop in order to survive. However, without the ability to receive sensory feedback, he could not relate to others; he could not connect with himself and come into being. He remained ungrounded and deprived of realizing himself, except acting out his inner tension in violent imaginative play.

When such attachment trauma can be resolved and a safe, nurturing connection with the clay can be established, deep relaxation happens for children. As sensory, calming, nurturing holding informs their implicit being, two physiological responses are quite common: the child will either fall asleep with their head resting in the Clay Field, or they will announce the need to go to the toilet for a big poop. After high sympathetic arousal states, the parasympathetic settling can be so strong that reparative sleep for about ten minutes becomes an overwhelming need. Children should be allowed such a sleep to integrate the unfamiliar level of safety; many are deeply exhausted from ongoing high arousal states. The eight-year-old boy, pictured in fig. 10.8, in his twenty-eighth foster care placement, did exactly that when his hands were packed in and firmly held. Bowel movements often occur when the autonomic nervous system comes out of shutdown and fear-based holding patterns. The entire digestive tract can relax; we can hear gurgling sounds, which can culminate in a releasing trip to the toilet.

Age: 6–12 Months

Developmentally older infants, who have gained a sense of trust, will now play with the clay similar to a six-month-old left alone with a bowl of mashed potatoes. They will pat and smear, squish, squirt, and relish how the clay can ooze through the fingers. In this context, the fingers become unstuck from each other; they spread out and gain space in between one other. They appear larger, but the thumb is still not included in the grip.[9]

All is sensual delight. The hands want to grab the clay full of vital desire. They do not want an object, they just want to have it; they want to explore how much they can have of it. Clients who have never, or not sufficiently, experienced this live with an almost existential hunger. They enviously view others as always getting more while never getting enough themselves.

Usually lots of water is added to the clay. It is important to allow full satiation if this is a developmental need. Such sessions can be messy as a child deeply and

FIGURE 10.12. This six-year-old girl loved the
squelching of it all through her fingers.

unquestioned explores that "all this is for me," all of it is available. It is important to
patiently and quietly give time to integrate a profound need that had not been met
when the child was an infant to satiate this vital hunger.

The fulfillment of these vital actions resonates in the entire body and awakens
tonus and awareness. If a piece of clay is lifted out and shown to the therapist: "Look!
I've got something," it is in the context of skin sense, purely about desire, not about
creating an object. All these actions have no permanence. The two middle fingers
may draw lines or drill into the clay, but such furrows and indentations are filled in
the next moment. Similarly, piles are stacked up and then patted down. The hunger to
have is vitally necessary for inner stability. Object constancy here is acquired through
building up and tearing down, digging out and filling in as a lustful acquisition, sim-
ilar to how a seven-month-old will grab a toy, put it into her mouth, then throw it
away, only to want it back, to do it again.[10]

Rhythmic repetition, through tapping with fingertips, banging with the fists,
caressing with the open hand, or poking with the index finger, are implicit, somato-
sensory achievements. The hands can be full of vitality and be inconsiderate. The
purpose of explorations is not to build something, but to experience sensory contact

with oneself. The hands, as they grab and squish and squeeze, chew the clay like teeth. They have it and claim it as "mine" in a process of vital embodiment. There is sensory delight. There is ravenous wanting as an acquisition of the embodied self in a world that is fully available for one's needs.

It may take a number of sessions to complete developmental cycles that were not fulfilled as infants. It is important not to push for meaning, rather to allow children to satiate their need for safe attachment, and that they can have it all. Children with attachment deficits like it when the therapist holds the sides of the box. It can give them a tangible sense of someone being really interested in what they are doing and creating; they are worthy of such attention.

Completing this developmental stage provides the lifelong vital base that the world is available and accessible for an individual. If this core trust is lacking, all further relationships with projects and people will lack vitality and grounding. Children can compensate with fantasy and imagination, and later on with cognitive achievements, if they are fortunate enough to grow up in structured households; however, the vital base of embodiment will be compromised. This ravenous having, and the attachment needs to connect with the world at hand, have to be satiated and embodied.

When children come from homes where they have never experienced structure, their messiness is different. They can create chaos in the therapist's room, and their need is the opposite to the previous case: they need to experience something tangible and solid because mess is all they know. In such cases, either a crystal or a glass marble, something that cannot dissolve, can be introduced into the bog. This way the hands can become familiar with the haptic sense of something structured.

Jasmin was eleven years old when she was picked up on the streets, where she had survived in a gang for several months. Her father was a drug dealer, her mother an addict, and her stepfather in jail. Her development had arrested at this infant stage. She could make a bog, but she had no further ability to create anything in the Clay Field. Her hands did not know how to shape something. All she knew was pouring water into the field until the clay became soft and squishy. Then she would wallow in it, lean on her forearms, forcefully pushing with them against the boundary of the box, and in the process the clay landed on the table, the floor, and the walls. This instantly stopped when I dropped two glass marbles into the bog. They gave Jasmin a hold, one in each hand, something to connect to that did not dissolve. In the following session I packed her hands into a solid clay hold, as described above. She asked again for the marbles and held them inside

the cavity. When I applied rhythmic pressure on top, she responded by pushing against my hands from the inside, asking me if I could "feel the baby moving." She experienced the solid marbles and a firm hold as a pregnancy, which might have been the last time she knew she had been held safely. In the following session, she re-created the cavity herself and moved in with her marbles. She had found a home and a place for herself, all prompted by the haptic sensation of two solid marbles.

In her famous essay "The Making of Mess in Art Therapy," Frances O'Brien states:

The evidence appears to suggest that there might be connections between early brain damage through neglect and abuse, and the symptom of excessive mess made by children who have been abused. It would seem that the mess itself fulfills an important role in enabling emotional knowledge to be observed. The very messy products of abused children might come about because they are tapping directly into an underdeveloped neurological structure where connections were not made. That emotion has not been regulated by the face-to-face interaction so essential in the earliest years of life would seem to have serious consequences.[11]

11

Developmental Building Block 2: Balance

Age: 1–2 Years

Over the next few months, toddlers will begin to walk. Standing upright separates them from the ground. This means the arms and hands are no longer engaged in loco-motion, as when an infant is crawling. The moment toddlers shift from crawling to walking, the arms and hands take on a new role; they become a double organ, with two parts, left and right, which requires structural organization through a third, the spine, to stay in balance, similar to a seesaw.[1] This duality of the hands requires inte-gration. Children begin to observe their hands as mobile organs; they can cooperate or disconnect from each other; they can perform different tasks.

The healthy and securely attached two-year-old boy in fig. 11.1 experiments with taking clay from the field with the intention of placing it into the container. We can see his hands performing two different tasks. His right hand grabs the clay, and the thumb is now actively involved in the grip, while his left hand balances him to make sure he does not tip over. The left hand is just as involved in his explorations as his right. They work together, each with a specific purpose, helping him to keep his balance.

FIGURE 11.1. Balance between both hands. The left hand of this two-year-old boy is necessary to stabilize the spine, while the right hand grabs the clay.

We have all seen toddlers when they take their first steps, how they sway with their arms stretched out to both sides in order to keep their balance. It takes almost another year until their core has gained sufficient stability and they no longer need to employ their arms for balance. Jean Ayres describes standing up as the magnificent achievement of integrating gravity, movement, and muscle and joint sensations as the end product of all the efforts of the months before.[2] Uprightness is the most significant developmental achievement at this stage; it is the implicit sensation of identity, of being a separate individual. The child leaves the symbiotic oneness with the mother and discovers her own stand. What emerges is an embodied sense of self, a growing awareness of who I am. Many children discover now that they have a name attached to them, not yet as I-ness, but they perceive themselves as a separate object. They will not yet say "I want," but rather, for instance, "Peter wants."

FIGURE 11.2. The fencing position.

The fencing position occurs developmentally between eighteen months and four years of age (fig. 11.2). Children still do not have sufficient stability in their upright axis; their weak inner core and wobbly gravitational security receive natural compensation through the positioning of their arms to make sure they do not fall over into the field and get lost. The challenge here is how they can engage in a haptic relationship with the Clay Field world

without being overwhelmed by the experience. Often uncoordinated, one hand is in "heaven," the other on earth.

Balance is achieved by holding one arm up or sideways while the other is engaged in the field (fig. 11.1). The arms regularly swap over. Older children hold on to the boundary of the box with one hand and work with the other in the field, then swap over. To put both hands into the field would present a threat, as young children don't have sufficient hold within their inner vertical axis to find reliable stability. The movement initially is similar to holding a mother's hand while exploring something new. Later, the boundary of the box becomes this hold.

Children's vestibular sense and proprioceptive functioning develop from the top down. We all know that one of the first achievements of babies is to hold their head. Next, the arms gain in strength, allowing the infant to roll over and push the upper body off the ground. Once the spine has been sufficiently exercised with commando-style crawling, the hips begin to be engaged until children can crawl on all fours. It takes many more months of practice until they can begin to stand up. At this age, between one and two years of age, the arms are still necessary to maintain balance to ensure children do not fall over because their lower limbs are still relatively weak.

In life and at the Clay Field, children are now exercising their inner vertical core, which involves the head, neck, shoulder girdle, and trunk. When walking, the arms align with the legs, practicing a diagonal rotation around the spine in order to balance. Children explore very similar movements at the Clay Field, such as asynchronous back-and-forth patterns or diagonal strokes. Seesawing movements cause delight, such as weighing bits of clay in each hand, or "walking" across the field while holding balls of clay or square-shaped stamps to claim the space. These balanced action patterns are all part of this body-based seesawing discovery of the self. The Clay Field in this context takes on the role of the stabilizing third that gives the moving hands and the moving body a reliable hold.[3]

In the process, the hands gain confidence and tonus. The soft, sweeping movements we observed during the first year of life now gain direction. The thumb becomes included in grabbing handfuls of clay. At this stage, children often hold tools in a fisted grip like a dagger. The index finger can point at objects with curiosity, often with a sound attached to it: "da" and "da," there and there. The fingers gain independent movement and differentiation, which can be encouraged through songs and finger games such as "Itsy Bitsy Spider." Clapping with both hands while singing, for example, is a favorite of this age group. Such alternating, synchronized, rhythmic movements stimulate a rotation around the spinal axis and provoke physical self-awareness. Drumming a beat into the clay resonates in the

entire body and stimulates the awareness that the body has two sides and a center, the left and the right and the central axis of the spine, another reminder that identity here is physiological.

The diagonal movement patterns encourage rotation around the spine, which strengthens the foundation system of *gravitational security,* and along with it an embodied sense of self. I will describe the progression of age-appropriate development of the vestibular sense at the Clay Field in each of the following chapters. Older children and adults inevitably resort to these movement patterns at the Clay Field, whenever they have lost their balance due to adverse events. How they then seek to regain their balance can be an indication of what age the trauma occurred at. The infant's outstretched arms signaling "help me," described in "The First Months" in chapter 10, would developmentally be earlier, for instance, and there are more grown-up versions to follow in the subsequent chapters.

The psychological theme of this age group is object constancy. Children are now mobile and, of course, they are curious; they begin to explore things and events away from the safety of their caregivers. On one hand they are driven by a powerful urge to discover, while on the other they are confronted with the terrifying expanse of an unknown world. The discovery of this new duality is charged with emotional ambivalence. In addition, the child's caregivers may now go back to work or be absent for certain amounts of time, which asks the child to manage the separation until the parent returns. Winnicott describes how children charge certain transitional objects with an "internal version of the mother, which remains alive for a certain length of time."[4] By holding an often smelly and well-loved object, the child can soothe their anxiety until the mother's return.

Separation anxiety provoked by this encounter between the self and the "world" is acted out in the Clay Field by touching and letting go, connecting and disconnecting of the hands, picking bits out of the field, and putting them back in. A handful of clay becomes separated from the whole and then is reunited with it. A handful of clay is placed on top of the sponge, then hidden underneath the upturned water bowl, then retrieved and reunited with the clay in the field. The hands can cause imbalance and then repair it. Separation and contact have now been transferred onto a thing, an object. Many repetitions may be necessary to integrate such discoveries. This developmental stage is about object perception. Children are not yet ready for object creation. They are dealing with understanding the concept of: There is me, and there is an other-than-me.[5] They discover that they have a separate identity. They begin to differentiate between self-perception and object perception.

FIGURES 11.3–5. A two-year-old boy experiments with his age-appropriate separation anxiety by placing small bits of clay on top of the two sponges. They have been separated from the whole. He then hides the sponges and the bits of clay underneath the empty water container, checking several times whether the sponges are still there.

A game toddler's love worldwide in this context is gone-there or peekaboo. Something disappears and returns; mother leaves and comes back. A marble can be hidden in the clay and found again. Trust is gained through distancing and connecting. Object constancy is acquired through the caregiver disappearing and the belief that she will return.

This is how children explore object constancy. It is "gone" when they cannot see it, and it miraculously returns when it reappears. Being in charge of such gone-there experiments allows children to build trust in relationships. His mother might disappear, but through his actions, he consolidates the belief that she will return. While this is age-appropriate play for a toddler, it may become part of the therapy for older children who did not experience secure attachment when they were young and are still vitally dependent on their caregivers.

Jason is six years of age when he commences his Clay Field sessions, organized by the school he attends. He can make sounds, but he has no language. No one understands what he is saying. He is hyperaroused most of the time while feeling helpless. He acts out with abrupt mood swings such as temper tantrums and crying; he is easily and frequently stressed out. He has high anxiety around going to school and will do much to avoid attending. Jason's parents are both busy professionals, and he has been cared for at a childcare center full-time since he was three months old.

Jason has his hands in the clay up to his elbows while the clay is still covered with a sheet of plastic and the therapist fetches the water for him. Next he works the clay with great intensity: he piles it all up, pours all the water on top, takes it all out of the field, brings it all back in, tips it all into a bucket on the floor, all the while making sounds. The therapist tries to put his actions into language with a running commentary to encourage his cognitive understanding and to connect it to his actions. Jason shows no intention of landscaping or engaging with the toy animals offered, which would be age-appropriate. Developmentally he is clearly much younger. He washes and mops the empty field, places a small plastic container into it, and squeezes water into it with the sponge. Next, Jason drops the sponge into the container and then covers it all with the large water bowl. Spontaneously he places the duck on top of it (fig. 11.6). In this moment, all his frantic action cycles crash to a halt. Jason cannot look at the duck. He looks down or sideways but avoids facing it. He becomes very, very quiet, almost reflective, as if his entire being is trying to process something. Tentatively his hands move around the entire outer edge of the field, as if trying to secure the space. With

his head bent down he points at the duck and says in clear words: "Duck stays forever." In a following protective move, Jason places the duck inside a small container filled with water and covers it again with the water bowl (fig. 11.7).

FIGURE 11.6. The duck sits on top of the water bowl while Jason slowly secures the four edge of the field.

FIGURE 11.7. The duck is hidden underneath the bowl.

It is deeply moving to observe this boy, who suffers from troubling attachment trauma issues, as he tries to grasp the concept of trust and object constancy. It takes several sessions, over the duration of a term at school, in which he experiments with versions of peekaboo. Over time these strengthen his language skills and significantly settle his anxiety.

The duck, or any other toy animal with a female connotation, is offered in sessions with primary school children to represent the mother archetype. This is discussed in more detail in the following chapters. It is astounding how Jason's attachment trauma comes to the foreground the moment a relatable figure appears in his arousal-driven action patterns, and how this duck allows him to rewrite the narrative of his needs for close and safe contact.

Balance as a spatial order manifests at this age as small and big, high and low, empty and full. These are not yet meaningful landscapes. For example, lumps of clay piled on top of each other only to be pushed down again, and then piled up again, become experimentations with high and low. Water poured into a container or into a created pool is dabbed dry with a sponge only to be filled again, to experiment with empty and full, or inside and outside. In this way, children learn self-regulation and containment, such as what fits into what and the orientation between up and down.

The lack of opposite pairs may be an indicator for traumatic overwhelm, as it points toward a lack of perspective and orientation. In the case of Jason, for example, he would move all the clay in and out of the field, but each time in the process he was taking on way too much, matching his sense of internal overwhelm. It was overwhelming even to watch. As a three-month-old infant in a childcare center, he would have had no reliable focal point. Even a basic ability to orient never developed sufficiently. Only once the duck appeared did his action move into perspective, and with it his attachment trauma. On this basis, he could act upon it and begin to be empowered by his narrative rather than just acting out blindly.

It is important to give older children that have missed out on this crucial building block sufficient time for their explorations. Once this building block is integrated and the developmental need satiated, they will quickly lose interest and move on. Pushing for meaning will put such children in the same dilemma they suffer at school, where cognitive processing is required, while they are still grappling with their non-verbal, somatosensory identity.

12

Developmental Building Block 3: Depth Sensibility

Age: 2–4 Years

While children come into sensory being with skin sense and discover their implicit identity in balance, they begin to organize the structural build of their body in order to *do* things in depth sensibility. The clay now takes on an able quality; it becomes manageable, graspable, pliable, and moveable. Children's hands dig, push, pull, squeeze, excavate, lift, pound, hit, turn, and manipulate the clay in a multitude of different ways. The core achievements of depth sensibility are pressure, pushing, pulling, drilling, and tunneling, culminating in impressions and imprints. All these are intentional gestures that are directed toward an object, and the effect the hands have becomes instantly visible in the clay.

Initially the execution of intentional motor impulses is acquired through applying simple downward pressure (fig. 12.1). This develops into pushing the significant weight of the clay away or pulling it toward oneself, which cannot be done without engaging the entire body. Such movements require tonus and coordination of the muscles, the ligaments, and the skeletal build. In the dual polarity setting at the Clay Field, children learn during this process to apply their physical strength, how they can align their hands, wrists, elbows, arms, and shoulders, then down the spine, the hips, and the knees until they can plant their feet firmly onto the ground to apply maximum pressure onto the clay. To be able to effect this much makes children feel strong; they gain competence,

and with such competence comes self-esteem. A child can proudly announce: "Look how strong I am!" The clay in this context still has no particular symbolic meaning. It is simply a mass that is there, and it provokes handling. Children learn to deal with tension and charge directed toward an opposite. Their hands are now firm and filled with tonus; they radiate enthusiasm, anticipation, and tension.

While psychologically skin sense represents the mother archetype and balance the child archetype, depth sensibility now requires the activation of the father archetype for healthy development. In psychoanalytical family therapy, the process is called triangulation.[1] Mahler defined triangulation as the process of separation that occurs when a third person is introduced into a dyadic relationship; such separation is necessary to balance either excessive intimacy, too much conflict, or disproportionate distance, and provide stability in the system. On this basis, individuation can occur. In the traditional context, this setting is described as the mother-child dyad, representing the symbiotic relationship, into which the father as the third party needs to intrude in order to liberate the child from overprotection. This intrusion is necessary for the child to gain new mental and physical abilities. This process already started

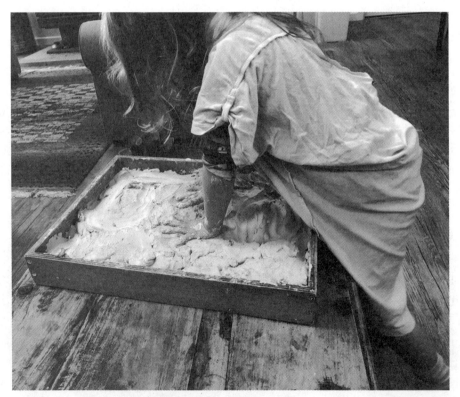

FIGURE 12.1. A three-year-old girl applying downward pressure, which engages and organizes her entire body to have an effect.

between the ages of one and two with the curious explorations of the world, which, as described in chapter 11, causes separation anxiety. Swiss psychiatrist Ernest Abelin defines *early triangulation,* occurring at around the age of 18 months, as transitions in psychoanalytic object relations theory and parent-child relationship.[2]

Family systems have changed quite significantly since the 1960s when this theory was formulated, but a child certainly benefits from being able to access two caregivers. Having an alternative parent gives the child significant freedom rather than the total dependency on one adult. Hölz-Lindau describes this structural triad as an important prerequisite to learn closeness and distance.[3] If children have trouble with one parent, they can access the other for safety and an alternative response. Temper tantrums and an intensely declared "no" belong to this process of separation and becoming an individual in their own right. With only one primary caregiver, such separation becomes stressful, because children at that age are still fully dependent on the love of their caregivers, while if there are two, they can experience themselves safely distanced from one, while being with the other, allowing time and space to discover their own identity.

It is this pushing-off impulse that is reflected in the encounter at the Clay Field. By applying simple downward pressure onto the field, for instance, children become intensely aware of their embodied self. Initially children really like to hold this pressure until they are red in the face and out of breath, but what they gain is the felt sense experience of their skeletal build, their muscles and ligaments all working together to make an impact. Through pushing off, they find themselves.

Physiologically I like to picture this developmental stage as the play fights kids love to have with their dads. These wrestling games on the floor are rough, loud, and involve the honing of physical strength. Children learn in the process to have an opposite partner, rather than being contained and nurtured in a maternal field. They gain embodied self-esteem through such encounters; their competence, courage, and empowerment become liberated.

As mentioned in the previous chapter, physiological development for children is top-down, from holding the head first, down to the shoulder girdle, to the trunk, and lastly to the feet. When children have felt unsafe as babies, they tend to get up earlier, because sitting up and walking feels safer than being on the floor, but that does not give their upper body sufficient time to develop. Lloyd describes one of the physiological indicators of developmental trauma as lack of coordination between arms and legs; the fluidity of movement between upper and lower body is asynchronous.[4] These children tend to have an underdeveloped upper body with weak muscle tone, and they can seem quite floppy and either tire very easily or never seem to tire.[5] Such core imbalance

becomes a real problem once children start school. They perceive themselves as different from peers and have to work hard to find a way to compensate for their areas of underdevelopment. A "child who feels insecure in their movements may do things very quickly—speed can make up for a huge lack of control—and it is only when we slow them down that we can see whether doing things quickly is a choice of necessity."[6]

In my experience this lack of core stability and movement coordination is one of the observable indicators for an ADHD diagnosis. While there are multiple schools and discussions around ADHD at present, Somatic Experiencing associates the majority of children with this diagnosis as having experienced trauma that occurred during the developmental window between the ages of one and four.[7] While the nervous system of these children is often chronically hyperaroused, their internal physiology is collapsed or braced. They feel helpless and cannot sufficiently coordinate their body to do what they want to effect. The distressing energy pent up inside is expressed through emotional outbursts that can be prolonged. Much of these outbursts is sheer frustration due to the unrealized desire to do things and being unable to execute tasks. Often these children don't even remember their outbursts in the aftermath, and it is not helpful when they are punished for them, with school detention and other measures that tend to intensify their isolation, frustration, and hyperarousal.[8]

Different from the child with an autism diagnosis, the ADHD child has developed a core sense of self and remains reachable through human contact.[9] The trauma occurred slightly later in life and may involve any of the sensorimotor stages that have been discussed so far. Clay Field Therapy is one of the most successful approaches I know for ADHD children. Deuser, just like Levine, is adamant that it is not the exposure to the narrative of the trauma story that heals, but the rebuilding of the underdeveloped or collapsed action patterns in the sensorimotor cortex. When we deal with developmental trauma, aspects of these building blocks have never been acquired in the first place due to the adverse circumstances in which the child grew up, and they are mostly nonverbal and implicit anyhow; they do not have a narrative.[10]

The Clay Field offers such children a relational object where they can complete the arrested action patterns and integrate missing developmental stages. Depth sensibility as pressure, in the context of dual polarity, provokes the internal organization of the body. Through applying pressure, children become aware of their physical presence. Standing up and projecting maximum downward pressure into the field strengthens particularly the upper body, and from there organizes the muscles, ligaments, and skeletal build top-down all the way into their feet. In the process it strengthens exactly those systems that tend to be underdeveloped in children suffering from developmental trauma. If these children did not commando-crawl enough as babies because they stood up too early and their legs developed but with their upper body being weak or

collapsed, they lack balance. Others who were older when they got hurt brace against contact and withdraw, which is also negotiated in the upper body.

It is interesting that children, who need to strengthen their proprioceptive system, their core stability and gravitational security, do not tire in experimenting with such pressure exercises, frequently for several sessions, until their upper body and legs are working together, their movements have become smooth and coordinated, and they have bilateral integration of both hands. They will test their endurance at times— "Look how long I can push down!"—and thus experience their impressive power and simultaneous grounding in their body.

In the brain it is the cerebellum that monitors and regulates motor behavior and movement patterns, particularly those implicit ones discussed in this chapter.[11] Lloyd differentiates between *innate movement patterns* and things we need to practice to get good at them.[12] Ayres calls it *central programming,* in that we do not have to teach a child to crawl.[13] However, children do need to practice their crawling in order to integrate it as a skill. Deuser's term for this phenomenon is *movement fantasies,* an inner knowing or urge on how the hands want to progress at the Clay Field.[14] If the therapist can read these movement fantasies, children can be supported in the most effective way.

The other advantage of pressure exercises at the Clay Field is that they allow the child to uncouple the trauma from their physiology. While we hold traumatic memories in our muscles and connective tissue, these implicit systems are not identical with the trauma. Pressure allows children to feel themselves without the burden of what has happened to them. Pressure creates a new, empowered felt sense, from which the child can build self-esteem and competence. Such pressure exercises usually include standing up to move all the clay, to push and pull it, to lift it up, to divide it, to tunnel through it, and to make imprints. It is important that the therapist confirms and acknowledges such self-discoveries.

Shevaughn, a six-year-old girl with gross and fine motor skill deficits and a speech impairment, has been recommended to work at the Clay Field by her teachers. She is academically behind her classmates and quite clumsy. Shevaughn lives with her grandparents and has never met her birth mother. Shevaughn receives ten therapy sessions. She is happy at the Clay Field and loves the specialness of working one-on-one. She often creates cooking scenarios, feeding the people she knows, taking clay out of the field to create her pizzas and pies and nests for animals.

Toward the end of Shevaughn's sessions, she tends to remove all of the clay from the field and clean the field before putting some of the clay back into it. During one of these final sessions, she creates a large round shape with all the

available clay on the table and picks it up. Next, she runs around the room, a large and mostly empty room, holding the entire contents of the field, squealing and laughing with delight. Shevaughn is so engrossed in her activity of running with the clay that she seems unable to pay attention to my voice as I speak to her in short clear sentences asking her to take care and to return to the table. Shevaughn does eventually return to the table, drops the clay there, and says in a clear and purposeful voice, "I am strong." I agree with her. After this session Shevaughn shows more awareness of herself in her environment.

Contributed by Erasmia Vaux

Tim is eight and has an ADHD diagnosis. His outbursts are unmanageable, according to his parents, but they do not want him to be medicated. After a couple of initial trust-building sessions, he discovers that he can gather all the clay in one large lump, lift it up above his head, and then fire it into the empty field with maximum effort, only to gather it all again, lift it up, and smash it onto the table, over and over. During six consecutive weekly sessions, Tim's competence level increases, while his emotional outbursts decrease noticeably. He does not tire of this action cycle. He is not interested in any age-appropriate symbolic play; his entire focus is on his strength and competence, until, in his ninth session, it is all over, and he begins to landscape the field and add meaning to his creations, just like a healthy eight-year-old would. Tim never relapsed into his former outbursts; there was no longer any need for them, because he had been able to integrate a missing building block.

FIGURE 12.2. Pulling the material with tonus; applying counterpressure.

FIGURE 12.3. Pushing, also applying counterpressure.

The clay needs to be solid for such explorations. Here children no longer need the boggy liquid clay that was essential to explore skin sense. Depth sensibility requires the material to be firm and resistant.

Pushing and pulling are far more dynamic than simple downward pressure. Now, children are dealing with mass and resistance in a linear, intentional movement away from or toward the body. The hands cause distance; they cause the creation of new space; they cause separation. If they want to have a close encounter with an opposite, they can bring in the material, retrieve it, and pull it close to the body. Once push and pull have become integrated patterns, the entire mass of clay becomes available. The material can be moved to the sides, and it can be rolled, turned over, divided, and put together.

This six-year-old boy (fig. 12.4) in a psychiatric hospital was diagnosed with selective mutism. He had not spoken for the past three years. After he had divided the pile of clay into two with a cutting movement in his second session, he began to make sounds. Over time he was able to regain his speech.

Drilling into the clay allows the investigation of the inner substance of the material: its texture, reliability, and resistance. During these explorations, touching the ground with one finger becomes an incentive to fully uncover it, to reveal it, and to turn it into a reliable base. The bottom of the field becomes tangible as a space. Pushing the material away, for instance, creates an interspace between the child and the clay; pulling it toward the body reduces this interspace. The perception of foreground and

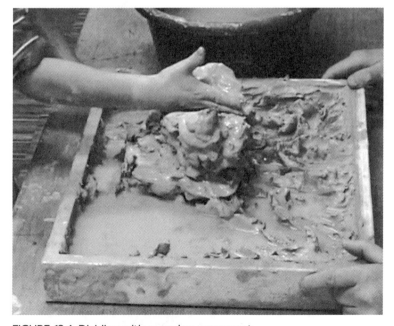

FIGURE 12.4. Dividing with a sawing movement.

background gradually turns into orientation and spatial awareness. Large formations gain shape, such as high and low, a tower and a lake filled with water.

In the process, the hands become amazingly potent; they can move it all, handle it all, own it all, or discard it all. They will squash down piles and vehemently flatten mountains, exploring their relentless potency. Experiments with differentiation involve small and large amounts of clay that are bulldozed out, shoveled out, cut out, raked out, or drilled out. However, something that has been separated from the whole is now no longer returned to the whole as in balance, but it demands handling. Such bits survive as something special and are deposited outside of the box or collected in the hands. Piles are placed along the boundary, often as patterns or emphasizing the corners. Eventually, the hands pick up the pieces, gather them in a ball, and place the ball into a central space in the field. Such an object becomes enduring and lasting. Children often want to take such a ball home.[15] They have come in touch with their conscious identity.

It takes the separation of the hands from all this action, however, to perceive consciously that they have made a mark: "I was there—now I am gone—but the mark is still there." This is the beginning of object creation. It is similar to the handprints in prehistoric caves, where the intention was then, as it is now, to leave a mark. Imprints expand the haptic gesture into visible, traceable marks. Identity now expands into the becoming of a conscious creator. Furrows, dents, ruts, and grooves in the Clay Field

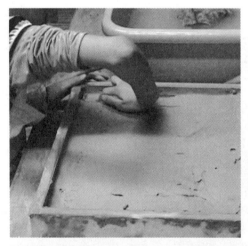 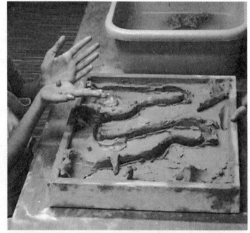

FIGURES 12.5–6. This eleven-year-old girl is hospitalized for anorexia. The angle of her shoulder, her elbow, and her wrist are awkwardly organized. She withdraws from touching the clay, and simultaneously she is under enormous inner pressure, longing for expression. Her fingers are rigid and her knuckles white from the tension. At the end of the session, she has been able to project her inner pressure into the field, creating a deep channel filled with water. Her body is more organized, and she has found a precious pearl: her self.

will no longer be wiped away, and such marks demand a story. From this point onward, children know two core life lessons: the knowledge that they can create, and that their creation has lasting stability. They have gained sufficient physical stability within to be able to effect this. They can create, have direction, and have a place in space.

Pressure can help to bring traumatized children back into their bodies. We discussed previously how making footprints with a toy animal, drilling the elbows into the clay, and making imprints with the hands are able to bring them out of dissociation without engaging in the story of what happened.

> From age three onward, Sam was sexually abused by his stepfather. At the age of nine, when he commences his Clay Field sessions, he has been diagnosed with ADHD. He cannot write or read, and his attention span lasts about two minutes. He is disruptive in the classroom and constantly gets into fights with his peers. At the Clay Field his wrists and hands are collapsed; they have no tonus. He has no ability to actually build anything. During the crucial age between two and four, when the neural window was ready to develop depth sensibility, the structural organization of his body, this boy collapsed into overwhelm and helplessness due to the sexual abuse. In the following term, Sam has ten sessions, one per week, at school. During his therapy, the abuse is never mentioned, but he focuses intensely on using the weight and resistance of the material to gain coordination, structure, and tonus in his body and over time the necessary skill sets to build landscapes, tunnels, mountains, and rivers. Sam comes to the point where he can come into a session with a plan, knows what he wants to make, and can realize it. He has finally acquired the ability to create a world according to his imagination. Parallel to these achievements, Sam's behavioral and learning difficulties improved significantly. He is no longer frustrated and disempowered due to his lack of depth sensibility. For the following school year, he has ten more sessions on a monthly basis. By the end of that year, Sam can read and write, his motor skills are age-appropriately developed, and he has friends.

If such older children feel safe in the environment of their Clay Field sessions and have gained sufficient trust in their therapist, they will inevitably regress to the earlier building blocks. While they repair their compromised sensorimotor foundation, it is important that the therapist does not push for meaning by encouraging the making of things or landscaping the field but rather supports the child's spontaneous, nonfigurative discoveries.

The felt-sense identity of these early preverbal years remains mostly unquestioned for the rest of our lives. We just assume that this is how it feels to be me. This implies that children who grow up in secure and supportive homes feel secure and worthy as individuals, while those who come from dysfunctional households feel bad because their environment makes them feel bad, and therefore they identify with being bad.[16] No child at this age questions his parents' behavior or their stressors and moods. Whatever is learned as an ongoing pattern of behavior feels normal and shapes the child's implicit identity.[17]

The benefits of Clay Field Therapy become apparent when, with sufficient trust, past events, charged with fear and conflict, can become uncoupled from the developmental needs they compromised. What happened cannot be undone, but the sequential structure in sensorimotor development can be repaired.[18] The therapy doesn't need to investigate "what happened," nor does it need to deal with the attached emotions, all of which is often impossible for children to express anyway. Instead, such children need time and patience, sometimes many sessions of doing the same thing over and over again, until the developmentally necessary sensorimotor pathways have been integrated. These movement memories stored in the midbrain will not be forgotten. Similar to riding a bike or learning to swim, they become integral learned action patterns. Such embodiment communicates solid positioning within the physical self, and as a consequence it is empowering and gives confidence.

Primary and Secondary Sensorimotor Base

This sensorimotor base ought to be complete by the age of four. Deuser refers to these acquisitions as a sensorimotor toolbox every four-year-old should developmentally own, even though occasionally one needs to make some belated orders. From then on, these qualities become an integrated part of our implicit competence and a way of handling the world around us.

Deuser distinguishes between the primary and secondary sensorimotor base.[19] The primary base is achieved during the age-specific window of neural development in the brain stem and the midbrain. The secondary sensorimotor base is implicit integrated action and perceptual patterns: sensory perception, vestibular sense, proprioception, and learned motor actions.

Secondary skin sense becomes our sensory awareness. Through mostly sensing with the flat hand, we can distinguish physical qualities in the clay such as soft or hard and dry or soggy, as well as the emotions projected into the material, such as loving or disgusting, broken or fertile, reliable and safe. If clients experience the clay

as overwhelmingly resistant, impenetrable, icy cold, or terrifying to touch, it will mirror avoidant or ambivalent attachment styles, and the therapeutic focus needs to be on creating sufficient safety to be in contact with the material. All of the primary skin sense explorations may become necessary to repair such insufficient attachment. This could also be explored as leaning on the field with the forearms to feel supported, through creaming the hands and arms with wet clay for self-nurturing, or the therapist packing the client's hands into clay in order to evoke a sensation of being safely held.

Secondary sense of balance manifests as having found age-specific bilateral coordination, gravitational core stability, and flexibility to be able to orient in the world. Through observing the positioning of the arms, and clients' posture at the Clay Field, we can observe their developmental age, especially when it differs from their chronological age. We commonly refer to "losing balance" when something upsetting happens. When we sense this inner vertical, we feel strong yet light and present. When we lose balance, we brace in different parts of our body; we hold tight to hold ourselves together. Worse is when we "lose it" and we collapse. These are physiological events, and we can observe them in the posture of our clients. Age-specific healthy organization of inner balance provides a reliable inner hold for any individual.

Secondary depth sensibility describes the world of motor impulses. Individuals become able to create intentionally with the clay, which depends fully on their ability to coordinate muscles, ligaments, and their skeletal build in order to move the material. Being able to do things generates self-esteem and confidence in individuals. Accordingly, low self-esteem and disempowerment is inevitably noticeable as weak tonus in the hands, collapsed joints, and the inability to apply core stability as pressure and intentional action patterns. Such clients benefit from encouragement to test their strength; they need praise when they are able to push and pull and move the clay in whichever way they want to. Sometimes this may require modeling, just like a dad would show his child how to build a cubby house.

Only when this sensorimotor base has been integrated as learned action patterns in the brain stem and the midbrain does the process begin for intentional creations, the building of objects, the meaning making, and the narrative of the higher brain functions. The vast majority of children who come into therapy have deficits in this area due to adverse life experiences, including birth trauma, surgeries, neglect, and abuse. These complex trauma issues are implicit. They have no narrative of what happened, but these children lack basic action patterns based on trust, balance, and being able to organize their body in an effective way. The majority of those who act out and are diagnosed with being "on the spectrum" have deficits in their sensorimotor base.

Innumerable children live frustrating lives due to their compromised, disorganized, or asynchronous sensorimotor base. The Clay Field offers a unique opportunity to repair such action patterns. Astoundingly, most children who lack focus in almost all other areas of their lives become engaged in these sessions, as if their entire being knew that here is an opportunity to relearn those missed action patterns. In this case, children do not regress, as it is often viewed by clinicians, but rather they postnurture those neural windows into being.

Virtually all children who come into therapy are older than four years of age, which means that in almost all case examples we discuss the secondary sensorimotor base and how missing aspects can be reclaimed and integrated in the therapeutic process.

13

Developmental Building Block 4: Vital Relationship and Perception

Age: 4–6 Years

At around the age of four children begin to enter a relationship with the clay, rather than just moving it around. This correlates with their increasing social needs at this age. Children have by now consolidated their sensorimotor base and have claimed ownership of the clay. They have the material, they want it and own it, and they now receive an emotional response from this connection. Affect is a response to something or someone. Sensorimotor haptic organization in the brain stem shifts up into the limbic system. It is not that children do not experience emotions before this time, but they will not be aware of their own emotion as a relational experience.

In the context of the developmental needs at this age, Deuser uses the term *haptic aggression* as a necessary developmental milestone. "Our vital relational haptic sense lives by aggression and destruction. It is not peaceful; it is about piercing, drilling, taking, grabbing, penetrating, dividing—and in all this, it is about us and the natural urge of life's unfolding."[1] Haptic aggression has nothing to do with anger as an emotion, but we need to be able to destroy in order to create. When the hands are caressing the flat surface of the clay, this only takes us to a certain point, and then

FIGURE 13.1. The Clay Field becomes a relational and emotional experience.

the hands want to appropriate the clay, which means they will have to destroy the smooth surface in order to take the material. Whatever is no longer satisfying will need to be destroyed and be created anew.

Sabina Spielrein speaks of "destruction as a cause of coming into being"[2] as a necessity for any creative process. The whiteness of a sheet of paper is destroyed the moment we write on it. The existing shape of the clay is destroyed the moment we begin to apply pressure onto it with our hands. Creative destruction is an existential part of the process. Am I allowed to do this? Almost every child now experiences a challenge toward empowerment. There is vital curiosity and excitement to explore the opportunity on offer at the Clay Field—and the reluctance, even fear, to claim such power. The hindrance of this impulse is embedded in the child's history. Will I get punished for getting dirty? Will I get hurt when I touch this? Will I be shamed for revealing how strong I am? Spielrein describes this as the dilemma of renewal, which can only happen if the old dies: "I find that a feeling of anxiety is normal and moves to the forefront of repressed feeling when the possibility of fulfillment of the wish first appears."[3] Deuser sees the emergence of affect at this age in exactly this context.[4] We now have sufficient self-awareness to notice our inner yearning for fulfillment, and we also have sufficient self-awareness to notice our inner hindrance. These are

vital impulses of curiosity and frustration, which are not conscious in children, certainly not at this age; even most adults are not aware of these urges. The exception is a felt sense or behavioral patterns of wanting and hindrance: the hands reach out into the field and withdraw. Virtually every client does this as a first impulse when sitting down in front of the Clay Field. It is this tension between the promise of fulfillment and reluctance to claim it that from now on drives sessions forward in a vital, dynamic tension that affects all children and adults alike from this point.

The most detrimental emotion is fear, and at this age children become conscious of their fear rather than just suffering it as a physiological phenomenon. Children who have been overwhelmed by destruction in their history have often lost their belief in creative repair. The dual polarity between reaching out through a motor impulse and then receiving sensory feedback from this act is frequently disturbed. They either fear to feel themselves in contact with the clay because their feelings have been hurt too often, or they need to stay invisible because they fear any attention given to them will harm them. What both groups share is noticeable fear of coming into contact with the Clay Field. Such children will either be locked in repeated action cycles, engaging in hyperactive motor impulses without any sensory fulfillment, or they will be so overwhelmed by their fear-driven sensory interoceptors that they have lost all trust into an active reaching-out into the world. The first group of children will destroy but not come into sensory being in the process because they shy away from feeling themselves. The second group will fear the consequences of their destruction and hold back on acting at all. However, underneath the frustration is also a hidden longing, which is what keeps children and adults engaged in their search for fulfillment.

I have discussed the plight of these traumatized children in previous chapters. Experimentations with pressure and counterpressure can be really helpful here. Taking note that "nothing" happens might be of utter importance when the expectation is that all hell will break lose. Cause and effect, motor impulse and sensory resonance, can be investigated in this way.

Those in sensory overload and suffering from inhibited motor impulses may benefit from active support from the therapist and the assurance that making a mess will not have detrimental consequences. The therapist may hold the box as symbolic support to emphasize that they are not alone but are held in their endeavors. Symmetries and repeated patterns can also be stabilizing, such as creating rows of small balls all around the boundary; these create order. Guardian toy animals in the four corners of the field may act as protectors.

Those with "senseless" motor impulses may need the assurance that sensory experiences can be safe. As mentioned before, some may benefit from having their

hands packed in, once they can tolerate this as a safe holding space. Others will enjoy simple play with water and very soft clay, integrating attachment needs through their skin sense, once they trust that they will not be ridiculed or attacked if they let down their defenses.

Destruction is necessary at the Clay Field. Without breaking the smooth surface of the field, nothing can be created. But creative change is only possible when sensory perception and motor impulses are both online and emotionally tolerable. What is being gained is haptic vitality as a creative force. We can look at this vital issue in a psychological way: as human beings, we fear nothing more than the withdrawal of love. Hence we suppress nonconformist impulses to adapt to the essential relationships in our lives. However, every time we hide such a vital impulse, we lose a part of our life force. It might take a lifetime to reclaim our congruent self-realization. This is happening here. The emotion children experience at this stage is related to the lack they come into contact with when confronted with the possibilities in the Clay Field. This is rarely conscious, but an embodied knowing that demands resolution. It is this emotional response that drives the process forward, an intangible longing and knowing for fulfillment.

Affect in Relation to the Clay Field

As children's hands discover a relationship with the clay world, they experience this relationship with surprise, love, grief, lust, greed, joy, disgust, shame, and fear. Levine calls these primary emotions "mammalian universal."[5] We share the evolution of our limbic system with the animal kingdom. They are "innate felt sense emotions"[6] that provide crucial social and survival responses much faster than we could react mentally. Such emotional memories are experienced in the body as physical sensations. Through facial and postural muscles, along with feedback from the autonomic nervous system, we signal to others what we feel and need. We also signal to ourselves what we are feeling and needing. This second loop especially becomes an essential connection to our inner knowing, to our inner voice and intuition; it shapes who we really are.[7] At the Clay Field this feedback loop is acted out through the hands, which are perceived in the clay world as the other-than-me. Through the movements of the hands in the clay, through the effect these touch experiences evoke, children take another step toward discovering their identity.

When, for example, Kamal slides a hand deeply underneath the clay, his upper hand is being touched. This comes as a surprise. It is foreign. He knows the connection with the inner hand, but not the sensation of contact on the upper side. The hand is pulled out. There is hesitation, and then the hand is put back in. Kamal announces: "There's gold in there!" For the first time he has become *aware* of being touched. The

material has *responded*. A self-generated relationship with an other-than-me has happened, and it has caused self-perception. Kamal has quite literally come to his senses. This is a significant shift. Children's focus changes from simply executing action patterns toward an emerging self-awareness of what they are doing.

Children discover these implicit felt-sense emotions in a number of developmental steps, which again are acquired for life. Deuser's use of Freud's terminology in the haptic context does not relate to Freud's age-specific developmental stages, but rather to haptic achievements in the hands' learning. Deuser adds the *reality principle of haptics* to Freud's concept of the *pleasure principle*.[8] The purpose is the concrete acquisition and integration of sensory and vital possibilities. What drives this process is the pleasure we experience when movement become fulfilled, when our vital sensory needs find satiation. Such sensorimotor satiation and fulfillment are a tangible, real state in which the entire body-mind experiences a sense of arrival, an embodied homecoming, even if we have no created images or words for what exactly happened.

Children experience this process in simpler terms. Clay Field Therapy is fun. They enjoy coming to the sessions, where they can search for and find their true identity through touch and movement. And in the process, they build resilience and competence and get to know the deep satisfaction of what it means to be uniquely them.

Haptic aggression as acquisition of the material involves:

- taking and getting the material (haptic oral actions)

- owning the material (haptic anal actions)

- penetrating through the material (haptic phallic actions)

- penetrating into the material (haptic oedipal actions)

Such haptic acquisition involves rudimentary emotional states of excitement such as vital desire, pride, having a superpower, and even greed, but due to their biographical conditions, lack, insecurities, hinderances, and frustration, children also experience becoming aware of fear and shame. Such emotional and embodied blockages now become an intense incentive to act. Haptic acquisition involves the perception of the material as something that is available to satiate one's own vital needs.

Hungry Acquisition

Hungry acquisition, or as Deuser puts it, oral acquisition, happens as lustful states of excitement. The hands and fingers act like teeth fully grasping as much as they can get. The clay is "chewed" and processed in order to assimilate it. The mass of the material arrives in the inner hand and creates a sense of satisfying satiation. This

represents the vital application of skin sense as an older child or adult, now with emotions attached to the contact.[9] The theme here is taking and having. Given that children feel safe in the setting, they can dare to grab as much as they need to have. They can satiate their emotional hunger, their attachment trauma, or whatever other biographical conflict is the source for feeling that "others always get more." Emotions arise around the theme of having, having enough, or experiencing the lack of not having. Such experience of lack has no biographical narrative for a child at this age, but they will experience emotions around having, having lots, feeling really full, or not getting enough.

Shy children, intimidated by the filled field, which they would need to destroy in order to work with the clay and who spend their sessions scratching barely visible marks into the surface, benefit from arriving at an empty field and a bucket filled with the clay next to it. The therapist apparently "forgot" to fill the field for them. Hence, they have to take clay from the bucket and fill the field with lots—as much as they need. This can be a joint action, where the therapist models how to take and have while both fill the field together. In this way, children can learn that it is possible to take what they want.

The creaming of the hands in this context has the purpose of self-nurturing. Liquid clay is smeared onto the hands and forearms. I like the image that each pore

FIGURE 13.2. Hungry hands enjoy chewing the clay and having lots.

is a little mouth being fed with love and care. This is particularly necessary if early skin sense needs were not satiated in the maternal dyad. Such existential lack never goes away. Nothing external and no individual can satiate this hunger until we learn to take what we need ourselves and experience that it is possible to receive. Haptic oral action patterns connect skin sense and the sensory base to the mammalian, relational limbic system.

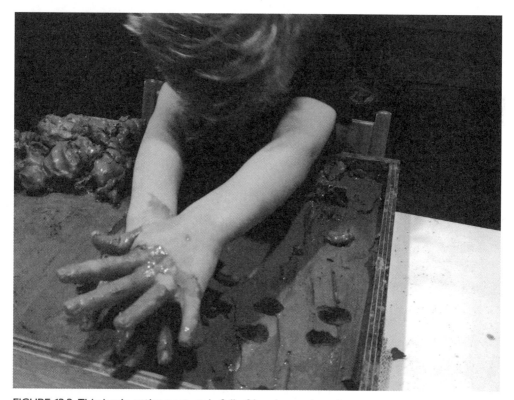

FIGURE 13.3. This boy's entire posture is full of longing and want.

Possessive Acquisition

Possessive acquisition, in Deuser's language anal acquisition, describes *owning* the clay, and taking *possession* of it. Having here is expanded into *owning.* This is similar to a dog marking its territory. Deuser likens graffiti and the need to leave marks all over a city to a frustrated anal haptic sense. Owning the clay is an extension of skin sense into the limbic system, where it now becomes a relationship with the material. At the Clay Field, such owning is performed with lustful empowerment. Clay is smeared around the field, onto the table, and onto the sides of the box, or it is collected by

grabbing handfuls of it. Frequently children pile all the clay into the water bowl as a gesture to fully own it.[10]

> Tim, a five-year-old boy, moves the available clay into the water bowl, then turns it upside down. Next, he climbs on top of the table to be able to lean with his entire body onto the bowl, really making sure he can have it all.

Others enjoy "cleaning" the table around the field with a lump of clay, in the process leaving their mark (fig. 13.4). Many such sessions end with the desire to make handprints in the field, on the table, on paper—or on the therapist's apron. Owning here takes on the theme of expansion and appropriation of the space.

> Malik, an eight-year-old boy with complex developmental needs, washes his hands at the end of the session and then turns around and wipes them on the therapist's apron, leaving clay marks all down her front. It had been a good session, and the therapist was initially put off until she realized that this was his way of telling her how much he accepted and appreciated her.

> Samir, a five-year-old boy who suffers from crippling shyness, spends an entire session covering every inch of the table with a layer of clay. Samir works quietly and with great intensity, like he's performing a sacred act. He moves around the table several times to make sure he has taken possession of the whole setting. He leaves a different child.

Other children delight in making "rude" noises with the material while they squish it and push it around in the field, delighting when water squirts out of unexpected places or makes squelching sounds. Here, their hands own the material with vital delight. Creating openings in the field and then filling them with water is another way of appropriating the space. Being able to make the water flow from here to there in a channel makes children aware of being able to have an effect. "I am, because I can cause this" is empowering.

The emotion in the stage of anal haptic aggression is around the vital sense of owning and the ability to take up space. Again, there is no conscious biographical story, but children who have been denied such possessive acquisition will have

emotional reactions such as greed or shame when they connect with others. The biographical experience of lack of owning will drive the vital emotional need to fulfill it in the clay.

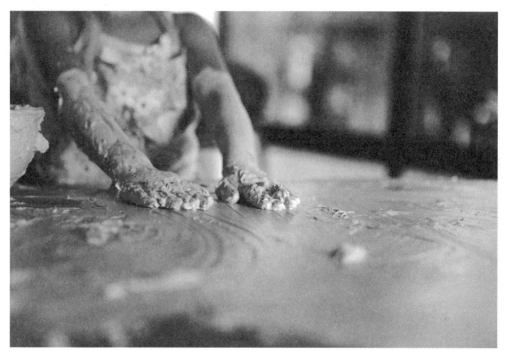

FIGURE 13.4. A four-year-old girl takes possession of the table by coating it with watery clay.

Oppositional Acquisition

Oppositional acquisition, or in Deuser's language phallic acquisition, is about tunneling through large amounts of clay or building it up into impressive erect structures. Often the entire arm is pushing into all the available material, and experimentations happen with being able to pull in and out of it. Alternatively, all the material is invested in a lighthouse or a tower. Such achievements want to be acknowledged and praised. The interaction here is informed by the resistance and weight of the material. Especially when children are dealing with the urge to oppose authority figures, in particular their parents, they relish dealing with the resistance of the clay. The haptic aggression here is driven by the need to have an opposite and about tackling an opponent—in this case the clay—to gain a vital, embodied sense of self and identity. This has nothing to do with aggression or being critical of the parents, but is similar to the pressure exercises, such as making imprints into the clay. The weight and resistance

of the clay enables children to position themselves in their body and in space; they can claim their *vital autonomy.* The motor impulses of Depth Sensibility gain the emotional dimension of pride and competence.[11]

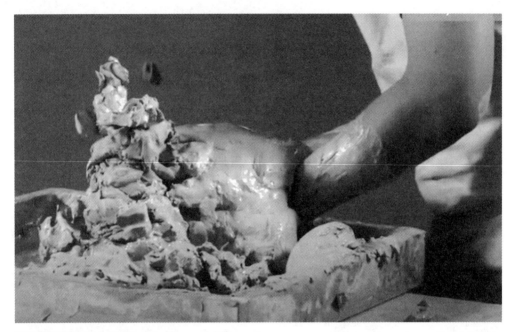

FIGURE 13.5. Tunneling as phallic acquisition.

Children have now entered a felt sense relationship with the material. Not only do they know that they can do things with the clay, but they can also receive vital emotional feedback from these actions. Such feedback, though, is not always pleasurable. Clients can withdraw quite abruptly from connecting with the clay, especially with the flat hand, when unpleasant memories suddenly surface. This usually happens very fast, in a practiced way, to avoid pain and abuse; it happens before the client consciously notices why they disengaged from contact. If the therapist does not pick up and address such a rupture, the client will leave feeling empty and dissociated; they have usually responded to many similar life situations in this way before.

Jai is in third grade. He is nine years old and displays angry outbursts at home that cause major disruptions to family life. Jai is the second child of five boys. When frustrated at home, he is unable to self-regulate his emotions, with poor recovery. According to Jai, all his family members annoy him, especially

his mom. His father recently returned to full-time work, and his mother is the main caregiver.

In his first session, Jai picks at the clay, not liking to touch it. As an alternative he adds water with the sponge, creating a "pond," all while barely touching the clay. He places the duck into the pond. Next, he creates, without much detail, a crocodile, a snake, plus rocks for its home. While filling holes with water, he says "This is a flood!" He tips the remaining water from the bowl onto the Clay Field, stating, "Pond for duck, pond for croc, and pond for snake. Done."

In the following session Jai builds a tower, only to squash it down. Next, he shapes several clay balls and throws them at the structure. In the end, he squashes everything flat. No water was used.

In the third session, he declares he wants to make a lake, and it is the Melbourne Cricket Ground. He floods the field with water. He states that a big crocodile lives underneath. He shapes a person to be eaten, which turns into a snake. This snake is placed nearby in another shallow lake with a bridge over the top. The connecting wall is removed, merging both lakes. The crocodile eats the snake, and then the crocodile falls apart.

FIGURE 13.6. The crocodile in the lake.

This case history reveals the powerlessness of a boy who could not develop his competence and exercise the oppositional haptic aggression described above during the window of time when a child develops his vitality in a relationship through resistance to further embody his identity. Here, the flooding of the field has no purpose, nor has the building and smashing down of the structure. It does not lead to any creations, no pride or satisfaction, just the frustrated fantasy of aggression in the form of the crocodile, which does not gain anything from its cannibalistic urges but falls apart—just like Jay, who does not arrive in the field, cannot take from it, cannot act in it, and cannot relate to it. Such desperation requires a strong intervention. One way of provoking Jay could be to firmly hold the Clay Field upright and ask him to run with his fists into the solid clay like a bull into a red flag. The therapist needs to give strong resistance, to guarantee that he really feels the opposing force of the encounter. He needs strong opposition to come into being.

Applying downward pressure, as discussed in chapter 12, on depth sensibility, could be useful. Boxing lessons might also do the trick. If this oppositional source of vitality is not acquired and integrated, it will become an increasingly frustrating source of powerlessness that, overcompensated with grandiosity (flooding the Melbourne Cricket Ground, the largest and most famous sports stadium in Australia), becomes more concerning the older these boys get.

Investigating Acquisition

Investigating acquisition—oedipal aggression, in Deuser's language—happens through drilling with one finger into the clay or tunneling underneath it with the flat hand. The inside of whatever is there is being explored with a sense of adventure and anticipation. Like a cave explorer, something is being investigated that takes courage and curiosity. This is an intentional piercing or poking. It is important not to associate the material as being penetrated in a sexualized way, but that the emphasis is on the intentional movement children make and the relational experience they have in the process. There is always something intimate and "secret" about this acquisition. Children may ask to turn the camera off, or will stand in front of it so no one can see what they are doing. Such taking possession of the clay has a sensual quality of lust, but it may also provoke shame and taboos. Am I allowed to do this? Am I allowed to touch and experience such excitement and pleasure?

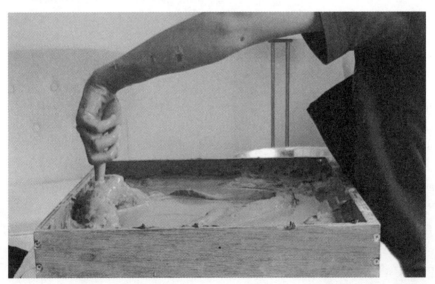

FIGURE 13.7. Drilling into the clay and inspecting what is inside it as oedipal acquisition.

According to Deuser, children begin to define their gender identity in the process.[12] This is not yet a sexual identity, but a becoming aware of one's identity in the context of the opposite gender. A boy seeks validation from his mother and the girl from her father. Children may claim to find an imaginary treasure inside, mostly gold for boys, or crystals as preferred by girls, which can be related to the discovery of the child's self-worth. Being precious on the inside is an important discovery, which prompts two responses: the need to be valued by the therapist, and the need to safeguard this discovery by hiding it because it is still too intimate and fragile.

Jarrah is six years old. He is in kinship care after having had a very troubled and chaotic upbringing. To begin with, he shapes a rudimentary landscape until he is prompted to drill with one finger into a mountain (fig. 13.7). He hesitates, and then Jarrah squeezes water with the sponge to flow through the hole. Next, he stands up and positions himself right in front of the camera. The camera can no longer "see" what he is doing. He rips out all the clay, bit by bit, and smashes it into a bucket on the floor while yelling and shaking. He yells the names of people and places and how he hates all the people.

When the field is empty, Jarrah settles, gently wiping the box with the sponge and paper towels, almost caressing the field. Whatever he encountered inside the mountain was explosive, and with an active response to it, he could resolve whatever had happened to him and restore his self-worth through cleaning the box, which survived it all intact—and so had he.

In such a case, where the boy clearly encountered a traumatic event, if questioned, he would likely not have a conclusive narrative. But he felt sufficiently safe in the session setting to actively respond to what had happened to him, which in the context of trauma therapy is all that is needed to end the trauma and settle his nervous system for good.[13] Responding to what he found inside the clay empowered him significantly. He made sure at the end of the session that he could come back for more. His caregiver reported that he was far more regulated after this session, with noticeably fewer emotional outbursts.

When children experience sexual abuse, especially if it is committed by a caregiver, their natural curiosity and search for gender identity becomes compromised in the most terrible way. Girls want to marry their dad at that age, and boys long to conquer their mom through becoming formidable heroes. This has nothing to do with sexuality, but all with gender identity.

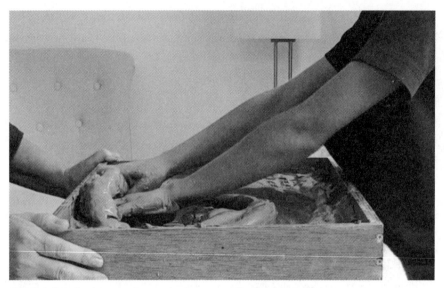

FIGURE 13.8. Pushing underneath the material with the flat hand.

Fig. 13.8 depicts the same boy as fig. 13.7, moments before pushing his hand underneath the small clay mountain. It is the same investigative movement, now also touching his upper hand, prompting a new level of self-awareness.

All children need to integrate oral, anal, phallic, and oedipal haptic aggression to develop their vital individual and relational potential. If not, they will go through life empty-handed and as poor and frustrated as Jai. We may develop some of these stages earlier and other aspects later, but in order to fully come into being, we need to be able to take what we need (oral), own and have it (anal), relate with strength and confidence (phallic) to the world around us, and explore it with curiosity in the knowledge of our self-worth (oedipal).

Balance

Observations of thousands of Clay Field sessions revealed that children navigate their vestibular sense from this point until approximately the age of nine through their elbows. It is as if they are holding an invisible balancing beam through which they negotiate their equilibrium in the force field between their parents. They are no

FIGURE 13.9. Balancing through the elbows.

longer reaching out with their parallel arms, nor are they holding an invisible hand in the fencing position. Both hands have become available, and balance is now managed through the elbows (fig. 13.9).

Children can now sit upright with ease. Their gravitational core has gained in strength, and along with it, children's sense of identity has begun to emerge. Children are still fully dependent on their caregivers. but they are also by now in the process of carving out an emerging social self, their own identity in the middle. The parental poles at the peaks of the elbows can be understood as an archetypal necessity, constituting an internal polarity. A child needs this polarity, whether a parent is absent, insufficient, or otherwise. The elbows act like a balancing pole in this relational field between the parents, where the child has to keep the equilibrium similar to a tightrope artist, constantly negotiating the inner vertical axis.

Fearful, unsupported children at this age quite literally "hold themselves together" by squeezing the arms tightly to the chest. They are braced like being strapped into an invisible straitjacket, and accordingly their chests are tightly held and their breath shallow. In their experience, there is no one out there holding them. It is a delight to observe, once they have gained trust and core stability in their sessions, when their upper arms become mobile, like a bird unfolding its wings. Along with this unfolding, they can breathe more deeply, and their life force can return. Those who have given up have no tonus in their upper body. They are floppy and "hang" in the chair. And children who existentially miss one parent may not use one side of their body at all. One arm, for instance, is collapsed, and they sit on one hand and only work with the other. I will focus on how to work with such imbalances in more detail in the following chapter.

Preschool: Orientation in Space Through Perception

As children discover affect, they will also need a system to deal with these emotions. This is when the need for perception and orientation emerges. Perception at the Clay Field manifests as structural elements. During this age-specific window, children will map out environments in a symmetrical order, such as rows of balls, lines along the boundary, or figures positioned in the four corners of the field. These give security through supporting inner balance, providing structure, and visualizing a mental ordering system. Lusebrink links both the affective and perceptual component in the Expressive Therapies Continuum to the limbic system.[14]

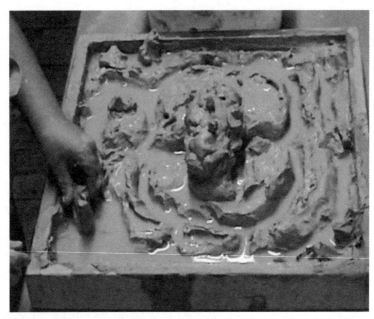

FIGURE 13.10. A five-year-old boy has created a world of channels, bridged in the center. Boats are parked in various places. Here he moves one boat along in a channel filled with water.

This developmental stage is characterized by a rudimentary landscaping of the Clay Field. Orders are being discovered. Objects are sorted into rows or piles or placed into particular locations; connections between objects are created. Random bits "there" and "there" are being connected with furrows or tracks.

These movements in the field now receive symbolic significance; they turn into roads or rivers. It is important, however, to note that at this stage these images are still movement based. Because the child can make the water flow in a track, it becomes a river. Because the child can push a marble along a trail, often animated by the sounds "br-r-rm, br-r-rm," it becomes a road. A "quack-quack" sounding frog hops into a pond and makes a splash. What children at this age are interested in is the cause and effect of their action patterns, and in this context, the animation of a movement. Symbolic meaning is discovered through sensorimotor experimentations. This is different from creating imagery, which is later on, at school age.

Children may experiment with high and low, piling clay up and pushing it down, drilling into it, making a hole, filling it with water. All these action cycles are about having an effect on the material, and as a consequence they experience their own potency. At this still primarily sensorimotor stage, when a child makes a "pizza," for example, the imaginary play is about flattening the clay on the table with the fists and the flat hand. Once it is flat enough, it is usually rolled up into a ball, and then

flattened again. It is about the ability to make a pizza, not about the image of a pizza and the associated role-playing, such as sharing food.

Goals are set and possibilities are tested as to what works and what does not. It is important to have safety in these actions, to be able to relate to them, to show them to the therapist, and to experience the pleasure and pride to have created them. Experimentations with water can become insights into what can contain how much. When does the water run over the edge of the field or a container? Is it important for a child to experience boundaries, or is it necessary that they are allowed to make a mess?

Through all these experimentations with cause and effect, children gain orientation in the field—and thus in the world. They become capable of landscaping the Clay Field into a space that has high and low, far and close, boundaries, and "good" and "bad" places. They can move in this space from here to there with confidence, and they can experiment with their individual control over such movements. Once children can orient in this manner, they have reached school age.

Mountain and lake, tower and swimming pool represent classical opposites that give orientation; one is high, the other is low; one is compact, the other is empty and can be filled with water.

One indicator of traumatic overwhelm is the creation of landscapes that have no orientation points. There is no high and low, or big and small, or close by and far away. When all the clay is piled up into one huge mountain, for example, and the child struggles to lift it all at one time, it is overwhelming. There is no perspective, no

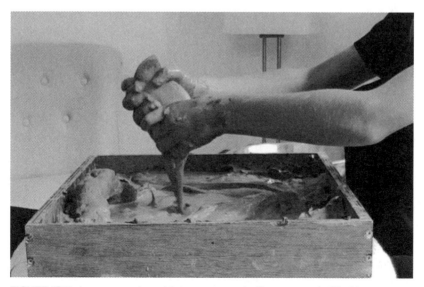

FIGURE 13.11. As an experiment into cause and effect, water is filled into an opening.

taking it down in smaller portions, or taking steps. The same could apply when the Clay Field is being filled with water without any concern for the boundaries of the box, flooding everything in its vicinity; or when children create an expansive mess.

> A six-year-old Syrian boy, Samir, has lived in various refugee camps for almost two years. As it happens, when he tries to take some of the clay, the whole slab begins to lift in the box. This should not happen, but occasionally it does, when the bottom of the box was wet when the field was filled. Unquestioningly Samir takes this on, applying huge effort by rolling the entire undivided mass of clay into a huge fat "dragon." The dragon hangs over the edge of the field on both sides, and he tries with all his might to lift it and shift it into various positions to make it fit. The dragon weighs several pounds, and Samir is visibly straining to deal with it.

In such a case, the therapist needs to intervene. Sometimes it can help to suggest or introduce something small, such as a little toy animal, to quite literally put the overwhelm into perspective. Samir had learned that it was expected of him to deal with whatever came his way, dragons and all. There had been no acknowledgment of how overwhelming his experiences had been. He had no idea himself; overwhelm was his normal. Small things not only would give him orientation, but also could teach him that things can get done in steps.

> Waru, a six-year-old boy, in his first term at school, is overwhelmed at having to leave his mother. He is unable to settle in the classroom, cannot complete tasks alone, has frequent emotional outbursts, and is, according to his teachers, difficult. Waru has nine sessions at the Clay Field. Initially he uses a lot of water and finds the wet and sticky clay overwhelming. The introduction of marbles and three small toy bears helps Waru to prompt age-specific landscaping in the Clay Field. Waru requires encouragement and suggestions to access the full potential of the clay. After three sessions, Waru begins to manipulate the clay, pushing and pulling it, making tunnels and mountains, islands and caves for the three bears. Over the course of the sessions, Waru's parents report improvement at school, certificates of achievement are being awarded, and an overall happier boy emerges, who can walk through the school gate alone. Waru makes himself a necklace with a photograph of his mother on it. He wears the necklace to school, solving his dilemma of separation versus autonomy.
>
> *Contributed by Erasmia Vaux*

Developmentally Waru should have been ready at age six to separate from his mother. However, his action patterns at the Clay Field reveal that he could not orient, and his depth sensibility was underdeveloped. The maternal, wet, and boggy clay no longer serves him to orient in a much bigger world. A world without orientation is a very scary and overwhelming place. Once he has learned to manipulate the firm clay, rather than just pouring water into it, and to landscape the field, he begins to distinguish between high and low, mountain and cave, foreground and background, inside and outside. In the end, it just takes the symbolic necklace to assure his autonomy.

Children who can't orient will suffer from chaotic, confusing, and overwhelming sensory overload once they commence school. They understandably react with fear and frustration. They lack structure to make "sense" of the world around them, and lack the competence to adequately respond to the challenges that face them. Such children may not have been able to develop reliable skin sense and balance. Their bodies may not be sufficiently coordinated, or their hands have no effect. Worst of all, it may leave their identity too feeble to have the courage to acquire new skills and to relate to others in a fulfilling way. A diagnosis of behavioral and learning disorders becomes prevalent for children whose history holds abuse and trauma. At the Clay Field, they do have the opportunity to repair the developmental stages that could not be acquired in a sufficient way.

This stage completes the implicit foundation. If you recall the iceberg, now is the time healthy children will emerge above the surface into the world of symbolic play. Their sensorimotor base is consolidated, and they are able to experience themselves as competent and vitally empowered. Their physiological sense of identity now demands to expand into their psychological sense of self.

14

Developmental Building Block 5: Balance in the Relational Field of the Parents

Age: 6–9 Years

With the completion of the fourth building block, the sensorimotor foundation has been consolidated and shifts to higher brain functions. Children have now reached school age and are beginning to show signs of using logical thinking similar to adults. However, their logical thinking is limited to reasoning about real-life situations only. Piaget considers milestones to be children's ability to recognize that their thoughts and perceptions might be different from others around them.[1] Their cognitive learning involves increased classification skills; they are able to identify objects by number, mass, and weight. They learn now to read and write and to think logically about certain objects and events.

Children are also far more aware of their identity. Developmental markers are their social and behavioral skills, such as a child's ability to form friendships and find a place in the peer group. Children begin to develop relationships away from home. They learn to accept social rules and social hierarchies, and they experiment with antisocial impulses to test those rules. They also develop periods of intense and absorbing interests, be this basic science, sports, the arts, or reading, and they will pursue these interests with vigor.

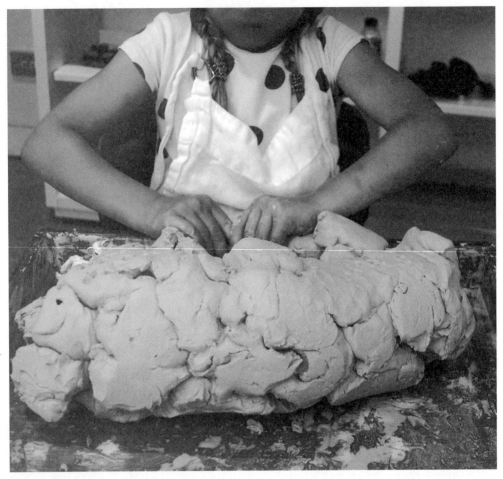

FIGURE 14.1. Sophie, a seven-year-old girl building a unicorn house.

At this stage, the Clay Field gains meaning as a qualitative-emotional field of action; it becomes a space for one's own creations. These are figurative creations of events that have a story, even if some children will not verbalize these. The urge to do things becomes stronger, and mostly these action scenarios demand discussion and reflection. Impulses, affect, and solutions are viewed in the context of their social implications and significance. The field becomes a universal space in which created beings have meaningful encounters. Landscapes have stories; they offer an environment for role-playing to happen. Environments that represent the organization of life, such as sports fields, homes, shops, restaurants, fairgrounds, and workplaces, are being formed. Such environments have rules, social hierarchies, and possible and impossible relationships; they represent a social order.

In contrast, in the previous developmental stage the creation of pizzas, for instance, was primarily about the vital impulse of flattening the clay and then rolling

it up again. Such pizzas are now cut into slices and shared with the therapist, favorite toppings are being discussed, and in the process, children learn that they have something to give.

Identity is being explored in role-playing scenarios in the landscaped Clay Field. The child becomes an adventurer, a hero, a space explorer, a restaurateur, a shop-keeper, the captain of a ship, a knight, or a zookeeper. Adventures are enacted, including disaster scenarios that require dangerous rescue missions. An icefield will need an icebreaker to get through if the parental relationship has been icy. The bad ones are being killed, occasionally with the support of the therapist, in order to share the responsibility, such as the boy who asked the therapist to shape the cannon balls, which he then fired into the dungeon where the bad knights were being held captive, his father among them. At times, boundaries are pushed or violated; such antisocial impulses test out a child's identity and the therapist's authenticity.

In this context, the therapist must be aware of exaggerations, the denial of loss and guilt, negative fantasies, and sudden outbursts of affect. Artificial activities, fake maturity, paralyzing shame, domineering behavior, and excessive shyness are indicators of the child feeling overwhelmed and not coping. If attachment as skin sense, identity through balance, and competence through depth sensibility have not been reliably acquired in the previous years, these developmental deficits will now demand completion before a child can move on to more age-specific behaviors.

Dan Siegel's concept of the upstairs and downstairs brain describes the behavioral challenges for caregivers of that age group. The downstairs brain encompasses the brain stem and limbic system, which regulate emotions, in particular fear and anger. The upstairs brain describes the neocortex, which has now come online, albeit predominantly in the form of symbolic thinking and problem-solving, which is age-specific for young primary school children. Downstairs emotions require increasing self-management by a child through the upstairs function to modify behaviors. Being able to control emotions and the body is a conscious achievement at that age. This is, however, not easy, especially for traumatized children. Siegel distinguishes between *upstairs tantrums,*[2] where a child essentially decides to throw a fit like a little terrorist in order to blackmail a parent into fulfilling a certain desire, and much different *downstairs tantrums,*[3] where children are activated with a trauma response and their neocortex has been highjacked by their survival instinct. For the latter group, no reasoning or punishment will downregulate their behavior; they are not aware of what they are doing. Instead, they need safety, pendulation in the form of distraction of their attention toward a less activating external source, and containment through regulated and calming adult interventions.

A colleague of mine would, for example, tell children who tested her boundaries with making a big mess with the clay that they could do so, but it would shorten their session, because she would need extra time to clean up. This is a strategy for upstairs tantrums. It does not, however, apply to panicked children, who are blindly acting out in fear. The latter group needs safety, a calming adult, and a trusted environment.

Balance in the Relational Field of the Parents

Embodied balance, as mentioned in chapter 13 for the age group of four to six, is also specific for six- to nine-year-old children. It is characterized by their elbows jutting out and becoming a balancing beam, similar to that of a tightrope artist. The image of the seven-year-old girl at the beginning of this chapter (fig. 14.1) illustrates the posture beautifully. Different than at four years of age, however, children are now more aware of this equilibrium because it affects their psychological identity. Their growing sense of self is powerfully influenced through the modeling of the parents. Children are still dependent on their caregivers; they do not yet stand on their own feet but negotiate their embodied self through adjusting to those in charge of their existence—mother on one side, father on the other.

FIGURE 14.2. Balance through the elbows.

If the parents' relationship is imbalanced through marital difficulties, absence, death, or divorce, this imbalance has to be reset on an internal archetypal level. Children who are able to repair their insufficient parent in this way become more resilient.

When the upper arms are clamped to the sides of the chest, it is usually a sign of fear and lack of support. Children need to hold themselves together and cannot reach out. They are braced because they do not have sufficient inner hold. It is an observable diagnostic indicator when the upper arms and elbows become mobile and the child can literally open up.

Balance is now no longer just a physiological achievement; it also becomes a psychological one. Children attain this through active, haptic story-telling and role-playing. Their sensorimotor base is mostly consolidated. They have learned to handle the clay with vitality and orient in the field through basic orders such as landscapes. From now on, they add psychological meaning through symbolic play to explore emotional and relational qualities.

In this context they will begin to project their felt sense into the Clay Field as a symbolic landscape. Up to now, the Clay Field was either just there to develop the sensorimotor base, or perceived as "stuff to do things with," whereas with school age it takes on the quality of landscapes as emotional body maps. Not consciously or intentionally, the body's left side will emerge on the left, the right side on the right, the head in the top half of the field, and the pelvis and abdomen in the bottom part. Balance is created through high and low, mountain and lake, active and passive in complementary equilibrium. The classical archetypal landscape involves, for instance, a father-archetype mountain on one side and a mother-archetype lake on the other, and a place for the child in the middle. Such archetypes are not gender specific. The father or yang-archetype can just as effectively be represented by a female and the mother yin-archetype by a male caregiver. What is important is that children have access to the balanced polarities of two related caregivers. This is the force field in which children can find their own identity, touching on each parental archetype with the tips of their elbows in their posture.

In the Clay Field a lighthouse on one side as the archetypal erect yang structure, and a swimming pool as the concave, complementing yin equivalent on the other, constitutes the parental archetypes. The field becomes divided into two parts, and the therapist needs to pay particular attention to the road, river, or bridge connecting these or not, because these connecting features represent the child.

Such landscapes can reveal balanced scenarios, but also war zones between continents with fences, military fortresses, and walls separating two worlds that cannot relate to each other. Gorges and trenches separate divorcing parents. Picket fences with toothpicks map out the battlefield. One side is heavily populated while the other is bare and virtually untouched, illustrating power imbalances. Most children create bridges that connect the opposing parties. If the bridge is placed as in fig. 14.3, it points forward and is easier to deal with, as its trajectory will move the child forward. Most times the divide is vertical and the bridge horizontal, which blocks the child's progress. The dominant feature is the divorcing vertical, and the child's energy is consumed by holding the two sides together rather than moving forward with a focus on her own issues.

In fig. 14.3, the eight-year-old girl's parents have separated, and both have repartnered. The many conflicts in both families find their illustration in creating two continents divided by an "ocean." She then builds a bridge, which represents herself. She animates the connecting water that flows underneath the bridge. The water connects the two continents energetically, which requires less effort than holding the bridge, or her psychological self. Such a landscape is a symbolic solution to a problem, representative of the difficult emotional environment she lives in. It will not

resolve her parent's issues, but it will make her more resilient, knowing that she can deal with it.

This six-year-old girl with acrimoniously divorced parents creates a lake on her left and another lake with a bridge on the right. The bridge and her body's direction point away from the left. She has chosen an alliance with her mother against her father as the safer option at present (fig. 14.4).

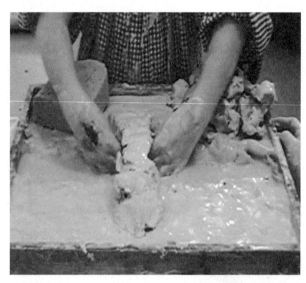

FIGURE 14.3. A vertical bridge separating the two worlds of her parents helps her to move forward.

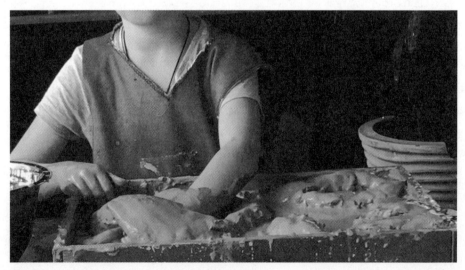

FIGURE 14.4. Also in life, this girl avoided her father and identified with her mother, in the process even moving her chair away from half of the field.

For this eight-year-old boy, it was important to enact his stressful home environment (fig. 14.5). He brought the figurines himself to the session in his schoolbag and was utterly dedicated in landscaping the severity of the war that was going on, of course without mentioning his parents. There is a clear power imbalance in the landscape, one side having a fort, lots more space, and many more men than the other, and there is no connection between the landmasses.

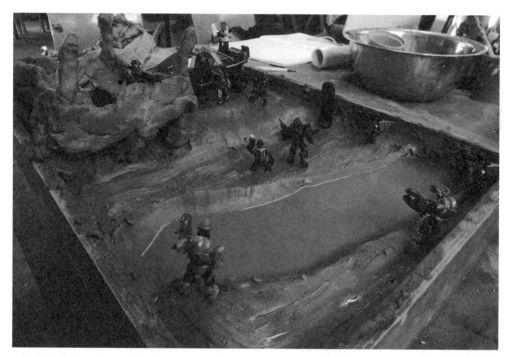

FIGURE 14.5. A stressful home environment as a war zone depicting a clear power imbalance.

Dealing with Developmental Trauma

Any Clay Field therapist working with children will confirm that six- to nine-year-olds are their main client group. It is the age when complex trauma issues remain no longer hidden or can be dismissed, and they present with behavioral and learning difficulties at school. Many of this group have so-called downstairs brain difficulties. Their sensorimotor base is compromised, they cannot landscape, and they have poor control of their affect. When presented with symbolic toy animals, for example, they use them as tools to dig, if at all. They have no concept of role-playing, even though they are eight years old. And this, of course, reflects their lack of social skills, leading

to the behavioral difficulties they suffer from. Such developmental deficiencies can also be observed as unexpected disconnections, distortions, constructs, and sudden secrets that cause disasters. In this context, affect is either inadequate or disproportionate to an event.

Troubled children at this age often escape into pure fantasy worlds, especially if the sensorimotor base is disorganized. They are up in the air and need patient support to restore the missing building blocks until they can engage in real events and reliable relationships. To repair such a lack of safety and containment, sessions with these children need to focus on their developmental needs and engage with activities discussed in the previous chapters, until they have consolidated their sensorimotor base. Once children can trust the therapist, they will usually engage with their developmental needs with enthusiasm and gain deep satisfaction from their explorations, without any concern that this is not age-appropriate behavior. They are finally getting the opportunity to heal and postnurture their deficits.

Once these are integrated—and this process can take many sessions—they will emerge, often as if overnight, and all their age-appropriate skills will suddenly be online. This can be done on average in about ten therapy sessions, with infrequent follow-up sessions to consolidate the embodied repatterning of the brain stem and limbic system. Children with disabilities usually take longer, but the same repairing of developmental needs applies. I will not rediscuss these earlier developmental needs, as this subject was covered in the previous chapters.

Dealing with Hyperactivation and Hypoactivation

Hyperactivation and hypoactivation are most likely trauma-driven dysregulated states of the autonomic nervous system. They are involuntary responses; we could call them a child's version of PTSD. The child's nervous system is either stuck "on" or "off." They either experience high sympathetic arousal states that are easily triggered, or they are in dorsal vagal shutdown due to high levels of shame and overwhelm. These states are *downstairs emotions,* and only time and trust will be able to reset the survival system in the brain stem to less alarming states of being.

- "On" is characterized by hyperactivity, rage, hypervigilance, hypersensitivity, panic, elation, and mania.

- "Off" presents as crippling shame, depression, deadness, disconnection, and exhaustion. Hypoactivation is the far more serious trauma response. It always

masks unmanageable high activation levels under the veil of dissociation. Once a child feels sufficiently safe, the underlying rage that the child has dissociated will erupt. You may recall Joel's session, described in "From Red to Green in Forty Minutes" on page 97 in chapter 6, which illustrated this.

Boys with high activation levels especially use the field as a space for movement while also testing the boundaries of the setting. For some, their antisocial behavior has become their identity. Age-specific solutions and interventions are best embedded in games. The therapist needs to meet the child without judgment in his world, because being told what to do never works.

Manuel is seven years old. He discovers a small box in the therapy room and instantly declares it to be a racing car. The Clay Field is his racing track, and he a famed Formula One driver. He noisily enacts the sounds while he races around the track, crashing into the sides of the box, all of it at high speed. Round and round and round at dizzying speed. He postulates the dangers in half-mumbled and yelled sentences and announces his fabled courage. Suddenly the therapist shouts, "Pit stop!" and his car instantly comes to a halt. From now on he races, races, and races, and then makes a pit stop. He establishes a break—and accepts in that instance a relationship with the therapist. In the following sessions, this discovery is expanded into tire changes and other necessary pit-stop interventions.

In the fourth session, something new happens. He pushes the car into the clay, then he piles clay on top of it and hits the mound with his fist. Then he digs out the car, inspects it, and buries it again. This time the mountain is much higher. He repeats this pattern a number of times, becoming increasingly quiet, no longer frantically talking and moving. In the following session he builds a high mountain with a large cave in which he places his beloved car. He now handles the car with calm care. The cave is "warm and comfy." He has arrived at an inner home.[4]

While Manuel did not know how to stop, his car did. Imbedded in the game, the therapist's intervention worked. Such brain stem–based action patterns require many repetitions, until they are reliably integrated. Manuel found his own solutions once he felt understood and accepted by the therapist. Burying the car in the clay can be viewed as embodiment, a quite literal incarnation process. From Latin, it translates

as "going into the flesh": *in-carne-ire.* His dissociated psychological, or as I like to call it, *spirit self,* was able to reconnect with his physical self.

Hypoaroused children scratch with their fingertips on the surface of the field, and they require a different form of patience until they have gained sufficient trust to explore more vital action patterns. The therapist can support any movement involving pressure. A faint mark, repeated, will slowly turn into a channel into which some water can be dribbled, and then a bit more, until a hole is tentatively poked and filled with water. And then, suddenly, all the water is poured in, everything is flooded, a volcano erupts from underneath, and finally the material becomes available. However, this might take several sessions, until this is a safe option.

Dealing with Parental Conflict

A dominant client group is one with children whose parents have marital problems or are going through divorce, or where the child's development is being affected due to an absent, ill, or disabled parent, including other current problematic issues that have not necessarily impacted on their earlier developmental stages.

At this age, children's lives are still dependent on their caregivers, but they now begin to perceive their parents' behaviors rather than just accepting them unconditionally. In order to stay safe, however, critical thinking and problem-solving have to be deferred onto a symbolic level. Magical thinking dominates their questions about the key people in their lives.

I like to think of this phase as the fairy-tale age. If you read Grimm's fairy tales, they are populated with abusive, uncaring parents, evil stepmothers, man-eating father-giants, and devouring witches. Good parents die, and others abandon their children, attempt to kill them, or lock them in cages and towers; they are unjust and selfish and treat their child as an annoying commodity. The child has to find a way to deal with the impossible, the uncontrollable, the evil. And yet, all the protagonists in these tales get through it. They survive their ordeals and victoriously come out on top. The injustice becomes righted, the bad ones get killed, and everybody lives happily ever after. These tales would not have survived for centuries if they were not instruction manuals for dealing with trauma.

Many scenarios in the Clay Field find similar symbolic solutions for seemingly unmanageable, overwhelming problems. Children emerge from such sessions more resilient and empowered, even though they will not be able to change their parent's incompetent or abusive behavioral patterns or reverse the fateful events that altered the course of life for a whole family or community.

Children love their parents despite the harm they may inflict on those in their care. Four-year-old children reach out with their outstretched arms for help, and if they are being abused, simultaneously pull back in fear, which results in tense shoulders and speech impairments, as discussed in the previous chapter. Now this conflict has to be resolved on a symbolic level through role-playing. Emotional strength allows children to deal with ambivalence, and solutions are found on the basis of such ambivalence.

> A seven-year-old boy in a women's shelter creates a crocodile that is so danger-ous that it needs to be locked up in a shoebox outside the Clay Field. He uses copious amounts of sticky tape to seal the box shut but then creates a window through which he can feed the crocodile. In this way he negotiates his fear of his father and his love for him.

In the following case history, there seems to be no place for the child at all. The paren-tal dynamics take up all the oxygen.

> Henry, an eight-year-old boy, has ten sessions in the Clay Field. Henry comes recommended by his teachers because he is not able to organize himself or his belongings in the classroom, and he can't start or complete tasks without assis-tance. Henry comes to the Clay Field a nervous and talkative boy. Over most of the ten sessions Henry builds the same two large and menacing figures that fight in the field for supremacy. There are times when the figures are destroyed or that one figure has engulfed the other, and then Henry can rest his hands in the field and say that he feels peaceful.
>
> In one later session, Henry creates a different figure, part human, part android. He asks me to keep this figure for him. It is possible that this figure is a precious part of himself, risen from the chaos. He has retrieved a lasting and enduring aspect of his identity. Henry went on to be a more organized student who initi-ated tasks in the classroom.
>
> *Contributed by Erasmia Vaux*

Toy animals support acting out conflicting emotions about the caregivers. After observing children over many years, we have begun introducing a small yellow bath-tub duck and a bear figurine—or other small toy animals that suitably represent the mother and father archetype—to support the expression of conflicts or hidden desires

about one or both parents. The duck usually represents the mother archetype and the bear the father, but children who have a choice may pick other animals. Such figures may have to endure lustful aggression, even murderous impulses, or they are cared for with gifts, food, and shelter. A small toy animal may also take on the function of a transitional object that assists a child in dealing with fears.

> Jeremy is eight years old. His parents are separated. He lives with his mother and sister. Access weekends where he stays with his father are a source of quarrel and conflict between his parents. His father often forgets to take him back home in time, which inevitably leads to blaming shouting matches between his dad and mom. His sister now refuses to see his father, but Jeremy still wants these visits, though he is in conflict because of his mother's response to him (she would prefer him not to have these access weekends) and his dad.
>
> At the Clay Field, Jeremy creates a little lake and puts the duck into it to swim around. Then he takes a large amount of clay and piles it into the lake until the duck is fully buried underneath it. He leans on this mountain and reacts with great delight when he hears the toy duck quack underneath all the clay. He presses down several times, hears the squeak, and laughs out loud. He then takes the bear, whom he walks across the entire field, while Jeremy sings and whistles, enacting the pure pleasure of freedom with his body. He then builds a cave for the bear in the top-left corner and puts him in there. Next, he digs out the duck and lets her swim again in a restored lake. He repeats these events for two sessions, basically reenacting his life with his mother and the access weekends with his dad.
>
> In the third session, Jeremy again covers the duck with ample clay, but now lays down the bear on top of her burial mound, and then buries the bear as well. He places a marble on top of this double grave. He is very content with this effort. Occasionally he checks in on both of them by poking a finger into their mound, but for the majority of the session, both duck and bear remain buried. Toward the end of the session, he digs both of them out. The duck gets her lake and the bear a hill with a cave next to it. He enacts mutual visits, where the bear has a swim and the duck climbs the mountain. The marble rolls across the entire created landscape and can be "everywhere." He leaves the session almost skipping.

We know such death and revival stories from myths and fairy tales. The insufficient parent has to die and be transformed, just like the witch has to be killed in "Hansel and Gretel" and be resurrected as abundant wealth, or many evil stepmothers must die in such tales in order to establish change. For the therapist it is important to apply no

morals here, but to fully accept the symbolic transformative character of such actions. For Jeremy, eventually both parents had to "die" and be resurrected as the parents he needed—a mother and father who could peacefully coexist in his inner landscape. It is actually interesting that he created a vertical burial mound, his parents on top of each other and himself as a marble at the peak. This is like the anticipation of a virtual vertical, his inner axis, which will eventually allow him to stand up for himself. He needs to liberate his inner father-bear as his own dormant male identity. The bear represents Jeremy's psychological self, being modeled by a symbolic father figure, to compensate for the deficiencies of his real-life father. For Jeremy it is of vital importance to bury the mother-duck, being able to end her control over his life and find an emotional, unhampered alliance with his father. This is necessary to liberate his emerging manhood.

According to Freud, this is the oedipal phase, and children are involved in finding their identity through symbolic encounters with the opposite gender. Such conquests may involve boys capturing a ship, or a fort that contains a treasure, or girls building a house for dad, with furniture in it and a telephone, so he can be called, if need be. Others may create care images with beautiful gardens, beds with blankets, or gifts for a missing, sick, or absent parent. Deuser describes the process as a liberation of emotionality and another step toward gender identity.[5]

Carla is six years old. She builds a special island for a bear (fig. 14.6). A boat delivers bowls filled with small clay balls, which are food. Along the boundary of the field, she has created rows of such bowls. Her supply is abundant to provide boatloads of

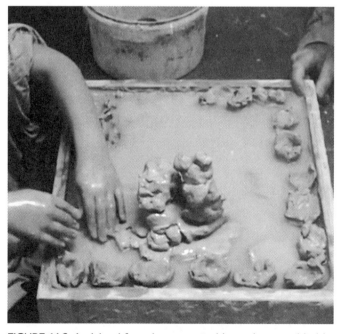

FIGURE 14.6. An island for a bear, created by a six-year-old girl.

food for the bear. Carla's father has been absent in her life for many years. Here she nurtures her inner father archetype to gain strength and presence in her life.

The appearance of the snowman in this scenario is both as a symbolic father figure and a role model for Carla's emerging psychological self. Such erect figures are put together by three balls of clay, hence the snowman association, but it could just as easily appear as a bear figurine, or a figure called captain, lifeguard, policeman, zookeeper, or something similar. These figures model being in charge of worldly environments. If they are amiss as a paternal role model, like in Carla's life, they have to be nurtured into existence. They are essential in the acquisition of gender identity. The father in a girl's life has a different function than for a boy. Carla creates an island, where she alone has access and she facilitates this nurturing relationship with the bear, which in return defines her self-value as special and unique.

Dealing with Trauma

When children experience traumatic events, they rarely want to speak about what happened, especially if the trauma involves loved ones, as it puts them into an unbearable loyalty conflict and the fear of losing the love they depend on with their lives. Yet they need to resolve such a conflict. I have experienced hundreds of times that as long as children feel safe and trust the therapeutic setting, and they may take time to do so, they will find the most surprising solutions through predominantly nonverbal role-playing. They rewrite the narrative of what happened and find an active response to settle their nervous system, and in the process liberate their vitality and identity.

Lisa is six. When she was four, she was asked to watch her two-year-old brother while her mother attended to an errand. Her brother tore away from her hand to run across the street, where he was fatally hit by a car. Lisa is shy and hardly present. When by accident a piece of clay slips from her hand and drops onto the floor, she freezes in shock and looks at the therapist in terror. With some encouragement she is able to pick up the piece of clay from the floor. She places it back into the field and shapes it into a fish. Next, she creates from clay a bed for the "fish," a blanket, food, and presents. She leaves the session with her symbolic brother (which is never worded as such) being surrounded with gifts and the love and care she feels for him. The emotional repair settles much of her guilt and completes what she could not do at the time. Her soul now knows how much she loved her brother.

The therapeutic focus is never on "What happened?" Rather, the concern is how life movement was arrested in the event due to overwhelming fear, which triggers an autonomic nervous system response in the brain stem that is beyond our control. These scared-stiff dissociative patterns can only be undone by completing what one wanted to do at the time but could not due to fear and overwhelm. This is where Clay Field Therapy and Somatic Experiencing agree and complement each other. What is important is to create sufficient safety to allow the liberation of the blocked life movement, to complete the story with the intent of a resolved outcome, similar to what happens in fairy tales. Children will naturally aim to rewrite the narrative, so they can move forward rather than being exposed to the trauma story, which they want to leave behind.

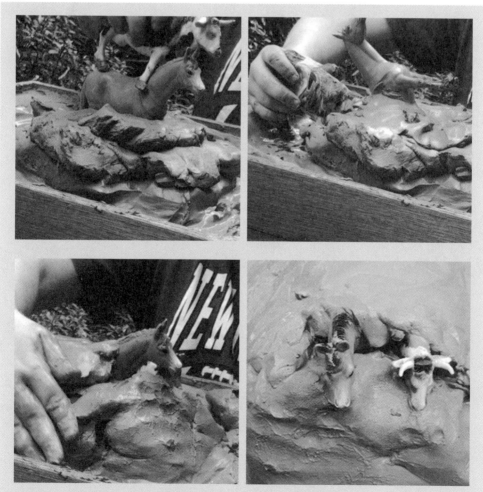

FIGURES 14.7–10. Over two sessions, this eight-year-old boy, diagnosed with oppositional defiant disorder (ODD), tells his story.

Ray is refusing to attend school, which is the reason for his sessions. He has been diagnosed with ODD. His choice of animals is a cow and a horse. Ray commences the first session by making a racetrack into which he sprinkles some water. Next, he brings in the cow and the horse, which are his choice of the two "allowed" animals. They are "having a fight," then they "hug," then the cow sits on top of the horse, and he pushes it onto the horse with pressure. Both are having more push-pull mud fights, until he decisively pushes both animals into the center next to each other. With great satisfaction he packs them into lots of clay until only their heads stick out. Ray declares them to be "pregnant."

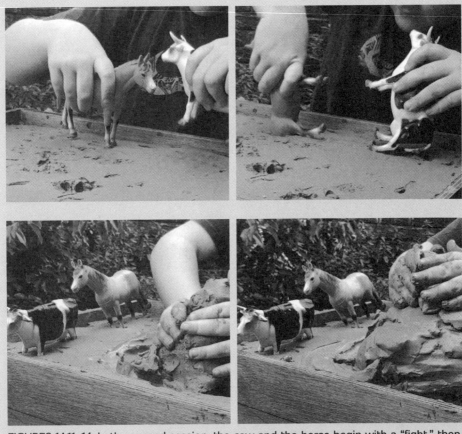

FIGURES 14.11–14. In the second session, the cow and the horse begin with a "fight," then "kiss," and next Ray pushes them decisively into the ground to make them "sit down." For the rest of the session they are firmly pressed into the clay on the right side, while he builds a "huge mountain."

Of course, a child his age will not talk about his parents, but when there is conflict, as it seems in his case, it will take center stage. What I am trying to demonstrate is that it only took Ray one session to express his concern, and then resolve the problem by burying both and aligning his parents in this way. In the second session his parent's conflict is sorted out within a couple of minutes, and from now on he can dedicate all his attention to himself and his age-appropriate needs. The mountain he builds is his own representation of his unique identity, different from his parents, and not filled with their issues as in the session before and likely in his life. This is symbolic conflict resolution, enough, for example, to empower Ray to go back to school.

Katie is nine-years old. Social services have picked her up for her highly sexualized behavior, performing oral sex with a bread roll, trying to tongue-kiss adults, and exposing herself. She is seeing a pediatrician for a soiling condition and a rash that forms around her crotch and genitals. Katie's parents are divorced and both have repartnered. Katie and her older brother have been exposed for years to domestic violence, drugs, and alcohol abuse. Two previous therapists have been "fired" by the father when Katie's behavior was addressed. The father accuses the stepfather of abusing her; the stepfather accuses her older brother, and the brother blames the father. Katie is not disclosing who is harming her. It is in this unresolved situation that Katie comes for several Clay Field sessions. They last thirty minutes each.

In her first session, after some initial hesitation, Katie rips out big chunks of clay, almost as if tipping the content of the field into a vertical position. She piles the chunks up at the top boundary of the field. Her hands do not process the clay, but all the available material is arranged into forming a huge wall, which she pats flat at the top. Such unprocessed chunks represent issues in her life that she cannot deal with. A bear, duck, and monkey figurine are placed on top. After a while she pulls the entire wall toward herself to the bottom boundary in one piece. The therapist praises her effort enthusiastically. The wall is huge and right in front of her body, reaching almost up to her shoulders. She has to stand up and lean over it in order to continue. However, she suddenly kicks the three animals off the top of the wall and brings in a rather large shark figurine. This

particular toy shark squeaks when compressed. The shark begins to vigorously attack the wall from the ground right in the middle, basically thrusting himself into her lower abdomen. It is violent, and the shark makes loud squealing noises each time it hits the wall, until it has pushed through. It is horrific to witness. Eventually, the bear begins to attack the shark, stomping on it, which makes the shark stop, and she pulls the shark out, and instead Katie puts her hand through the opening from her side. She spends the following few minutes closing up any gap in her wall and creates a channel at the top of her wall, which she fills with water. Time is spent with concerns that all the water is contained, and nothing can leak through any openings into her wall. Monkey, duck, and bear are placed back on the top. Shark is discarded. She pushes her entire wall, filled precariously at the top with a water channel, back to the far end of the field, very proud that she is that strong and can move it all.

In the second session, she seems to arrive with a plan. Very decisively she builds two large mountains, one on the left and one on the right, again using all the available clay. Next, she lifts the left mountain out in just a couple of moves and chucks it into a bucket. She shifts the mountain from the right side into the center of the field, and then meticulously cleans the ground with a sponge.

Katie commences her third session with hesitation, poking patterns, row after row of holes, into the entire field. Then she divides the field into a top and bottom land mass separated by an ocean, which she bridges. Her father had invited her and her brother for an overseas holiday, but her mother did not allow it due to the looming unresolved abuse situation. She is very angry about this missed holiday and time with her dad. For a while she plays in the water, sliding each hand in turn underneath the bridge. In a surge of emotion, she picks up both land masses and throws them onto the floor in big splashes, yelling "no, no, no" as she does this. She cleans the now empty field with dedication, asking twice for clean water, using the sponge and paper towels. She brings in the shark, a tiger, the duck, the bear, and a zebra. The tiger figurine is significantly larger than the others and is placed in the center of the field. The other four go one into each corner. She reverently sprinkles the tiger with water. She tests the sounds each animal can make as they encounter the tiger in the center. The bear stomps, the duck quacks, the shark can squeal, the zebra gallops. All animals are placed in the water bowl, and another cleaning round begins, until she picks up the now very clean and lovingly dried tiger and

places it on its own in the field. Each of the other animals, one by one, enter the field, and each one gets dominated in different ways by the tiger stomping, roaring, and punishing each animal before it is kicked out again. The therapist encourages the tiger to make a noise. Katie begins with a timid little roar, which increases to a really loud one, while the tiger prowls the boundary of the field, behaving very impressively in the defense of her boundary. The tiger is definitely a girl; Katie refers to it as "she." With the space secured, she builds a small clay house in the top-left corner and places the zebra into it. The zebra has food in there and a bed to sleep.

As awful and concerning as Katie's situation is, her therapy sessions enable her to rewrite the narrative and empower herself. She certainly does not want to verbally discuss the abuse, and she probably could not do so, even if she wanted to. However, in the first session, she clearly tells her story. Her need is to defend herself with the huge wall that consumes her entire being, and still it does not protect her from the shark attacks, which are directed to her genital area as she stands and animates the shark. The bear intervenes, kicks and beats the shark, and evicts the shark from the field. This allows her to repair her wall and push it back to the top of the boundary, which gives her access to the field as her space.

In the second session, she claims that space, almost as if evicting her insufficient parents in the form of the two mountains, and instead she places herself in the center. This is empowering, and she works with intention and pride for the whole time. I have described the phallic acquisition of such towers in chapter 13. The vital impulse here is oppositional, to stand up for herself.

In the third session, she seems to evict her family dynamics in a rage by discarding the divided landscape. Trying to bridge the ocean just seems not sufficient for what is needed. Next, she brings in all her family members as animals, and maybe the empowerment she experienced in the previous session brings on the tiger as a new player. She refers to the tiger as "she," and it is clearly an aspect of her. The tiger is able to express her rage with every one of the animals and restore her full vitality in the roar, protecting her boundary. At the end of her third session, she can finally relax and have a safe, small life as the zebra in the house she built for it. For the first time, she is safe enough to create something proportionate in size, something that is not overwhelming.

In the process Katie learns to defend herself, speak up, punish the various perpetrators—those who abuse her, but also those who do not defend and protect her. The sessions are primarily nonverbal. She speaks through her actions. The therapist supports her emotionally, cheers her on where appropriate, and verbally describes her actions in order to encourage cognition and bring conscious processing into her play. Such verbal accompanying is not interpretative, but descriptive, such as: "Oh, wow, you are building a really big wall." "The tiger is so strong, she can defend the whole place." Such comments have a visibly encouraging effect on Katie.

In the context of applied trauma therapy, she completes in every session something she could not do before, or others did not do on her behalf. Punishing the perpetrator for the penetration of her "wall," repairing her wall, and claiming her space in session 1. Empowering herself in session 2 and establishing justice and her vital response to each family member. Each session moves her further out of overwhelm and helplessness.

Katie's situation is very distressing, and several health and mental health professionals are involved in supporting her and her family. What has happened to her cannot be undone, but she has empowered herself in the safety of the setting and with the support of her therapist to come out of shutdown and dissociation into an active response. It clearly enabled her to settle her nervous system to the extent that she could move as a symbolic zebra into a safe space to eat and sleep, rather than being in walled-off shutdown or in tigerlike high sympathetic activation.

The Unicorn Queen

Sophie is a seven-year-old girl, the oldest of two children; her younger brother is four. Sophie attends eight Clay Field sessions. Her parents report that they have difficulty with bedtime. She does not want to go to bed, is restless, and "can't switch off." She holds her emotions in her "tummy" and complains of nausea. Sophie is described as extremely sensitive. She can be avoidant in social situations, appearing "shy." She has difficulty taking criticism, insisting that she is right, and when she is not right, appears "crushed." In physical activities, Sophie is said to lack ease of movement and doesn't appear to trust her body. Sophie has avoidant behavior around going to the toilet and has suffered from urinary tract infections. Sophie has been diagnosed with voiding dysfunction by a psychiatrist. There are a number of clear indicators that something is deeply troubling her. Erasmia Vaux contributed this case history.

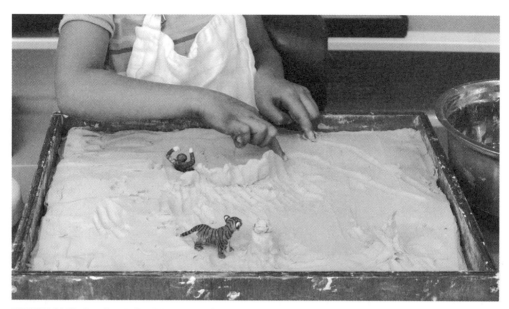

FIGURE 14.15. Session 1. Sophie arrives for her first session at the Clay Field compliant and well mannered. She chooses two animals: a baby tiger and a monkey. She does not know what she wants to make. She uses her fingertips to draw on the surface of the Clay Field and to make trees and bridges and homes for the animals.

FIGURE 14.16. Sophie uses the water and creates a river around the four boundaries of the field. There is a small bridge from the left side of the field joining it to the box. In the bottom-left corner is a road, and later a nest is being added to the corner. Lastly, using her middle fingers, she digs a tunnel under the road. With the fingers of her left hand, she smooths the road. Sophie speaks very quietly during the session.

If you watch Sophie's hands closely in her first contact with the clay, you may perceive the white knuckles, and tension in her hands. Yes, her two index fingers reach out and poke the clay, but her entire body pulls away from the field. Something powerful is holding her back. Accordingly, Sophie only works with her fingertips. While she is able to landscape the field with a lot of details and is able to integrate the toy animals, her explorations lack vitality and joy. The various places are connected with roads, bridges, and a small tunnel, which points toward a network of connections within her family. As it turns out, it is not her parents and the family dynamics that are troubling her.

The drilling movement is very similar to the first contact she made with the field in the previous session, only now her body follows rather than holding her back. Such drilling with one finger is haptic aggression and what Deuser calls oedipal acquisition. We discussed this in chapter 13, on affect and perception. For whatever reason, Sophie has missed out on integrating this essential developmental building block. With unerring knowing, she now explores what she could not at the time, obviously feeling safe to do so. The purpose of drilling is investigating acquisition, which is necessary to become aware of gender identity and finding self-worth. It is exactly this aspect of vital identity that is missing, and she has gained sufficient trust to claim it.

FIGURE 14.17. Session 2. Sophie chooses two foxes: a male and a female. She begins by drawing lines and poking her index finger into the field.

FIGURE 14.18. Sophie then pulls the top-right corner of the clay forward, creating a roll, and continues to poke deep holes into the clay with her index fingers.

FIGURE 14.19. In the middle foreground of the field, Sophie digs out a home for the mother fox and then a second hole in the bottom-left corner for the male fox. She adds water and digs a narrow trench along the front of the field. More water is added to the top-right corner, and Sophie bathes the mother fox there. Round balls are shaped and placed in the center. Sophie then rolls the entire back section of the field toward her and holds onto it with both hands. A "snowman" figure is shaped with the three balls in the center of the field placed on top of each other.

Sophie does not talk much. In among her playful endeavors, however, she discovers something of utmost importance. It is visible how tentative she is to start with. Initially all her contact with the field is with her fingertips only, and much of her body is braced, holding back. However, once she dares to drill into the fat clay roll, she quite literally assures herself that engaging with this world in the field is safe. To consolidate her explorations, she places the two toy animals, which symbolically represent her parents, into holes, into a much deeper layer of the field than in the first session, where everything happened at the surface. Once this polarity is constituted, she is able to place herself in the center. The shape of the so-called snowman appears frequently at this age and represents the emerging ego. It is as if she has retrieved her identity from deep inside. This now becomes the theme of the following sessions. Drilling in has quite literally provoked her self coming out.

It is evident that Sophie has been processing the previous session and for the first time arrives with a plan. She creates the same shape, but now she moves in as a "unicorn queen." The symbolic snowman has gained color and identity, just like Sophie; she discovers she is magical and powerful. She is also fertile with the potency of eggs.

FIGURE 14.20. Session 3. When Sophie is asked whether she knows what she wants to do today, she says "yes." The increase in confidence is evident just in this yes statement. She digs the clay out from all sides of the field and folds the layers toward the center. With this shape in the middle ground, she introduces the unicorn (whom she names "the queen"). Inside the shape she creates shelves and shelters, doors, windows, and ramps for the unicorn. She makes many eggs for the unicorn, which are "baby unicorns." She pours water into the middle of the shape and adds some more details in the surroundings. Sophie is clearly more talkative today.

FIGURE 14.21. Session 4. By again rolling the clay from the sides toward the center, she creates a cave-like shape with all the available material. Sophie shapes a small seat and places it on top of the mound. Animals are introduced, and water. She makes nests and places eggs in the nests. The whole structure eventually turns into a tunnel, which Sophie explores by putting her hand through. At the end Sophie helps to pack up the clay. This turns out to be a dynamic time as she thumps and squeezes large lumps of clay with abandon.

In addition to more validation of her female, fertile-creative queen identity, Sophie now focuses on oppositional haptic aggression. Through tunneling she gains a vital, embodied sense of self and identity. As mentioned before, this has nothing to do with anger or being critical of the parents, but similar to the pressure exercises, such as making imprints into the clay. The driving of her hand deep into the clay mountain, feeling the weight and resistance of the clay, enables Sophie to position herself in her body and in space; she can claim her vital autonomy. She confirms and consolidates this desire for embodiment by helping with the packing up, where she can relish in the thumping and squeezing, really owning the material. What Sophie lacked was embodiment. During the developmental window between ages four and six, she had somehow missed out on some of these aspects of vital haptic aggression, which consolidate inner grounding and stability. Her shyness, lack of trusting her body, and inability to settle at night all point toward this lack of gravitational security

when she started the sessions. Different from the affect-driven relational quality that characterizes the explorations between ages four and six, however, she now adds story and meaning. She integrates her vital embodiment into a symbolic narrative, which confirms her psychological identity.

Sophie speaks freely about what is happening in the field in both sessions. Her mother reports that there is less resistance about using the toilet, and overall Sophie is happier.

Toward the end of the session, Sophie's right arm fully tunnels underneath the clay from the front to the back of the Clay Field, followed by her left arm. These are thrilling moments for Sophie. She is very keen to show her mother what she has achieved.

In the follow-up, Sophie's mother reports that Sophie woke up to go to the toilet during the night, and on the following day she spent a long and happy day with a new friend. The increase in vitality and dynamic engagement with the Clay Field is very obvious, if we compare this photograph of her seventh session (fig. 14.24) with the beginning of Sophie's therapy, where she remained timidly at the surface and only worked with her fingertips. All the held-back libido before she started these Clay Field sessions becomes available for Sophie, and she can express it with increasing confidence.

FIGURE 14.22. Session 5. Sophie squeezes and grabs this unprocessed ball of clay, creating rooms, bridges, slides, and tunnels. Animals and marbles are put into the rooms, and water is added. The unicorn is again the main character. It is important to notice that she now digs with her fists and a firm grip. Her hands radiate competence. It is hard to believe only four sessions have passed.

FIGURE 14.23. Session 6. This session involves a detailed story about the unicorn queen, her eggs, the threat of theft of these, and how she deals with this, trapping the thief. Three animals—the duck, the dog, and the unicorn—again constitute the symbolic mother-father-child scenario, in which Sophie, as the unicorn, is again the central character, with a home in the center foreground of the field.

FIGURE 14.24. Session 7. Sophie announces on arrival that she wants to build a tower. She chooses three bears and a duck. The bears are mother, father, and a baby bear. The bears are each given a pool and tunnels to travel between them. Without going into the details of her story, the symbolism represents her family issues, likely involving her baby brother. She processes the narrative, and she finds insights and solutions.

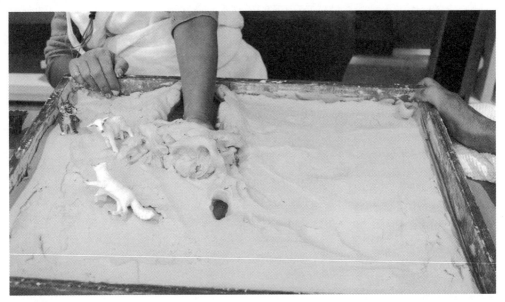

FIGURE 14.25. Session 8. This is Sophie's last session. She introduces three animals. Using her right hand and then her left, she applies her fist in a corkscrew motion to make a round hole. She drills in even farther and then pushes into the hole to enlarge it. She builds a trap for the "naughty goat" on the left side of the field and a "bog" in the left front. Water is added and the bog becomes the focus. "Next time I'm going to make the whole field a bog. Oh, there is no next time." I suggest that she can make it now, and she replies, "Yes." She makes the bog bigger and squeezes it with both hands. After about twenty minutes the whole field is turned into the bog, and all the clay has been squeezed. The animals are removed, and Sophie digs her hands under the clay, fully immersing herself. Sophie talks throughout the session.

In this last session she drills confidently into the material, claiming it with her fist. As mentioned before, this is the movement of oedipal acquisition, which Deuser associates with discovering sensuality and vitality, not as projection into the material but in response to her own actions.[6] Such determined pressure resonates in the entire body. It is a relational experience. While this is a developmental deficit in Sophie's case, she integrates her discovery into the age-appropriate context of building her identity.

These underground caves are usually filled with treasures. Sophie traps a "naughty goat" in there. She is dealing with a taboo, her sensual pleasure, which she might want to hide. This is not sexuality, but a felt sense, sensual discovery of her gender identity. She is, after all, in all these discoveries a "unicorn queen"; she is mysterious and royal. The role-playing with the toy figurines provides the narrative but is not central in her process. Different from several other sessions I have discussed in this chapter, her area of conflict is not her parents, but she needs to claim her vital, sensual, embodied identity. For some children this becomes a liberation from conventional norms. Throughout Sophie's process her family is represented by bears or foxes, while she

defines herself as distinctly different, as a unicorn queen. In this role she is mysterious and potent, and she is creative, generating plenty of eggs. She is special in her sensuality and her self-worth. Sophie confirms this in her final exploration in the field by creating, with significant dedication, the big bog, and fully immersing herself in it. Some children might go as far as completely covering themselves with wet, liquid clay, calling themselves a "mud witch" or for boys a "mud monster." The "naughty goat" has come out in the open. It needs to be naughty because it does not conform. She dares to be herself, different, sensual, and bursting with vitality.

Sophie's parents report after the eight Clay Field sessions that Sophie has made improvements in most areas. Sophie has made moderate to good improvement in going to bed and settling. She has made some improvement with "tummy" sensitivity. She is less avoidant around going to the toilet, better at taking criticism, and more resilient. She is more active physically and socially. She has been choreographing a dance to perform at a school assembly. She is no longer seen as "extremely sensitive."[7] Active involvement provides the best opportunity for changes in the brain that lead to growth, learning, and better organization of behavior. Active involvement depends on the child initiating, planning, executing, or dynamically responding to an activity.[8]

Sophie needed to claim unintegrated aspects of the previous developmental building block to consolidate her psychological identity, embody it, and ground herself in it. It is clearly visible how much vitality and confidence Sophie has gained. We will never know what made Sophie so fearful, and it is not important. She has found a way to access her embodied vitality and self-worth. Claiming one's psychological identity in the relational field of the parents is the theme of the fifth building block. Sophie's parents were encouraging and supportive; it was Sophie who had to step up and claim her essence.

Developmental Building Block 6: Departure from the Relational Field of the Parents

Age: 9–11 Years

I remember age nine and ten as a time of an almost seismic shift in my perception of the world. I remember clearly realizing that not all parents were alike, that different households valued sometimes very different paradigms. Up to then I had unquestioningly assumed that my parents' world was *the* world. I began to build my own world, much in opposition to the authority figures in my life. I began to stand up to my parents and was surprised that I could have an effect. I feared the repercussions, but inside me a core had begun to stir, a still confused but firm knowing of what I wanted that had not been there before.

From around the ages of nine to eleven, children gain a much firmer sense of embodied identity. They no longer need to balance between the parents to find a hold because they are less dependent on them. They detect an emerging core strength of their own. Not only at the Clay Field, they are looking for resistance to lean into or push off. The field becomes an opposite in which they can experience their individual strength.

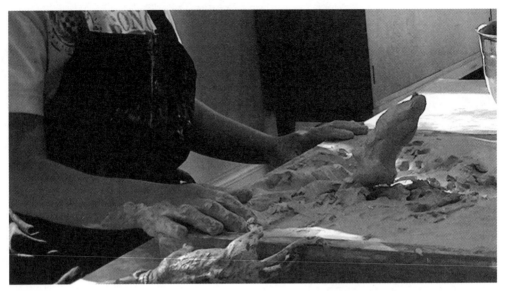

FIGURE 15.1. It is obvious how much of an inner core this ten-year-old boy has. He no longer needs the field for support; he no longer needs his elbows to adjust to either side. He sits upright with ease. He calls the "snowman" version he has created "a statue of myself as the best player in the world," mirroring his identity in the field.

Physiologically they no longer negotiate balance through their elbows as a left-right adjustment to the force field between the parents, but they now seek the confrontation with an opposite. Children at this age, for example, tend to align with one parent, while the other parent temporarily moves to the background. It is no longer mom and dad they seek, but mom or dad.[1] They collide with or confront one parent and seek to have the other as an ally. With less dependence on the parents, children can afford to become critical of them, which serves to strengthen their sense of identity, their likes and dislikes, what they consider fair or unfair, and where they want to rebel. The Clay Field as a world in front of them is confronting them. Inner stability is confirmed through the wrists and hands: they can push off or push down, the body leaning backward or forward or to the left or right with outstretched arms. Deuser calls the triangle of the outstretched arms the "integrated parents," and they test and affirm the child's inner positioning in the body.[2]

FIGURE 15.2. Balance as triangulation.

Balance as triangulation gives children a much firmer sense of embodied identity. The triangle's sides symbolically represent the integrated father and mother archetype, and the self is experienced as an inner vertical (fig. 15.2). This developmental stage goes along with a sense of liberation. The search for balance is now an internal one that will be projected into the Clay Field.

This stage represents the discovery of possibilities, and with that also comes the challenge to fulfill them. A child will now look for certainty through questioning the parental authority figures. In this context, experimentations at the Clay Field with pressure become again important, now with the focus of positioning oneself in it. Pushing gives instant feedback to the body. The resistance of the material resonates in the child as a confirmation of embodied physiological order and psychological identity.

The Clay Field becomes a space for one's own creations. It becomes a space that children can fully own and position themselves in. They may even vehemently take possession of the field, of all the material. All of the clay gets gathered and is being intensely tested to own it, to have it, to be able to destroy it, to move it all, to lift it all, to feel its weight and fullness as an opposite the child can be in charge of.

We have witnessed the developmental progression of balance at every stage and how children negotiate their embodied sense of self through the positioning of their hands and arms and torso. We have also learned how depth sensibility progresses, how three-year-old children learn to organize their body in order to be able to move

FIGURE 15.3. Applying downward pressure with both hands now becomes embodied identity and a way of taking possession.

FIGURE 15.4. Hitting the field with fists as a joyful testing of strength for this ten-year-old boy.

the material, how preschoolers are exploring their strength and later their emotional, vital relationship with the clay. Now this testing of strength becomes aligned with an embodied psychological sense of identity, a felt sense of "This is me." At times this can be witnessed, as when a child of this age and older has made a handprint in the field; next she will lift her hands, put them together, and look at them. The externalized pressure of making the print resonates internally after she has let go and becomes a felt sense of connection with the self. Many children will look at their hands in that moment, as if discovering them.[3]

This powerful sense of competence can be offset by taboos, denial, and shame, where the hands withdraw or engage in creating feeble, fragile constructs that have no vitality. Children make "art" that can be incredibly tiring to witness because of the lack of vitality and the mental control that goes on, manifesting as fiddly fingertip constructs. Sometimes authoritarian belief systems get in the way, or certain paradigms discourage the vital expression of individual power. Having to be "good," not getting "dirty," being "such a sensitive child" can become an obstacle course. Instead of creative *constructions* we get planned *constructs* that lack vitality and engagement. Sometimes it is a history of abuse that contaminates the vital engagement with the clay.

However, therapy is not the place to point out to a client that a tree is top-heavy, with the big branches likely to collapse, and that it will require a stronger trunk. Children are not attending the session to learn how to make the perfect tree but to learn about stabilizing their identity, their creative potency, and their place in the world. Failures, frustrations, collapses, and resurrections have to be suffered in the process.

FIGURE 15.5. Connecting the hands, often with pressure, after having made handprints. In this way the projection into the field is taken back, and the gesture becomes a reassurance of one's identity.

FIGURE 15.6. Next the hands are looked at. This is the equivalent of a conscious recognition: "I did this. This is me." This eleven-year-old girl smiled in wonder, gently moving her hands as if acknowledging their presence, and with this her presence.

Centered landscapes begin to take shape; a swimming pool, a tower, or a mountain are positioned in the middle of the field. Such landscapes want to be acknowledged. The child wants to be valued and seen as the creator, or both hands roll a small ball and place it in the center; such a ball is "precious." It represents a sense of self that has been attained.

In this quest for identity, an intriguing figure might emerge that has the function to model the ego. The most common is the "snowman," created from three balls placed on top of each other. This now becomes a trickster figure; it represents the ego, which of course is never quite reliable and solid. In figures 15.1 and 15.7, Toby builds this "statue of myself as the best player in the world" but then proceeds to attack this figure with a tiger, smashing it into the ground, only to rebuild the statue again and to destroy it with the tiger for another couple of rounds. The ego is grandiose and then collapses; it boasts and struts, only then to curl up, mortified, when we fall apart. Psychologically the ego is modeled on the father figure.[4] Because authority is being questioned at this stage, consciously or not, such figures now appear as notoriously pompous and unreliable. The primary school child, for example, will admire or fear the father figure in their life: six-year-old Carla nurtured her snowman-bear into existence (fig. 14.6), and Sophie prided herself on being a unicorn queen (fig. 14.20), whereas now such an authority is being questioned.

FIGURE 15.7. Ten-year-old Toby is dealing with a trickster figure. His "snowman" is "a statue of myself as the best player in the world." Next, a tiger attacks the statue and knocks it over. He enacts several heroic battle rounds with the tiger. In the end he writes "ME, ME, ME" over the entire field.

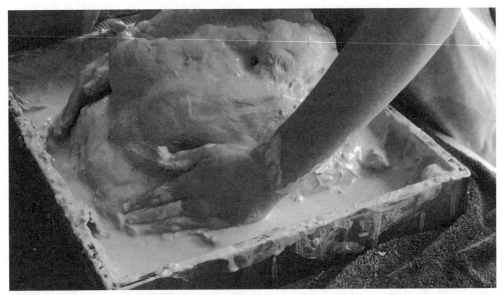

FIGURES 15.8–10. At the beginning of the session, this ten-year-old boy creates an arch bridging a path, which is still reminiscent of the previous stage of balancing and connecting his parents, also visible in the angled elbows. However, this soon disappears and makes way for his own world in the form of a "huge" mountain, which is then filled with water, made even larger and declared to be a "volcano." For the boy, this was an image of formidable strength and him being in charge of it.

A good trickster example is Captain Hook. Although he is powerful, he is quite damaged, and has only one eye and one hand. In the Clay Field, similarly damaged figures appear, a rabbit with only one ear, or plenty of water is poured over the snowman until he "melts." Such a trickster figure will be destroyed once its purpose to guard the conquest of vital identity—a treasure, which is what all aspiring pirates are looking for—has been served. Another version of such a trickster figure is the wolf in "Little Red Riding Hood," who pretends to be her grandmother after he has

devoured her. He is reclining in the grandmother's bed, deceiving the girl with his pretend authority, until she becomes aware of what is going on, and Red Riding Hood can claim her emerging vitality and identity. This is when the wolf dies, and when Toby can write proudly into the field: "ME, ME, ME."

Children are also confronted with life situations that cannot be changed; they have to adjust to these, question such existing worlds, and in the process learn how things work. The field is being squared and divided into sections of significance, or being centered.

This might lead to concrete depictions of games and rules that display a world order or the creation of stories that interpret "my world." "Evil" figures may need to be dealt with.

The creation of meaningful scenes, landscapes, and stories has the purpose of telling of the development of the self, coming to terms with fateful events, and creating renewal. In the process, opposites have to be tested, vital needs defended, and lost aspects of the soul retrieved. The therapist has the function of assisting with the reflection of events and significant fantasies and being a compassionate witness.

Harriet is nine years old. She has been sexually abused by the mother's new partner. When her older brother told the mother what was going on, the mother actually punished the brother. The brother eventually told a teacher at school, and child protection intervened. The mother and her partner, a registered pedophile, as it turned out, are now in jail. Both children live these days with their biological father.

In the first session Harriet barely dares to touch the clay. She then goes through a wiping and cleaning phase, cleaning the clay with a sponge and paper towels. The cleaning rituals oscillate with hard-to-witness "feeding" games, where she force-feeds a frog, stuffing clay into its mouth. Once she discovers pushing is safe, with the support of the therapist sitting next to her, she finds the courage to move all the clay. Harriet pushes some of it out of the field onto the table and smashes other parts onto the floor. With this vitality-charged act, which is an active trauma response, she can claim the field as her own. This is when Harriet begins to deal with what has happened, never verbally but symbolically. In the context of her narrative, the snowman is the perpetrator, the mother the duck, the father the bear, and Harriet the crystal.

In the Clay Field, Harriet creates a snowman in the center and slowly builds a wall around him. She rolls lots of little balls then squashes them flat to make

bricks for the wall. She puts the duck inside the enclosure, looking at the snowman, and then places the bear behind the snowman, saying it was "to protect the snowman from being dangerous." Harriet pushes a gemstone inside the wall. As she squeezes increasing amounts of water with a sponge into the enclosure, it becomes a "lake." The bear on the outside also gets a wash, which leads to water seeping into the area outside the wall, until Harriet decides to make a new pond for the duck. As she shifts more than half of the clay, it becomes a new wall enclosing a space in the bottom-right corner filled with water. In the process she destroys the snowman. In the new pond the duck can swim, while Harriet hides the gemstone in the enclosing wall with the bear placed on top. However, the duck breaks out and steals the gemstone. But the bear retrieves it, and Harriet takes great care to stomp the gemstone back into the clay, and then places the bear on top of it by pushing him halfway into the clay with great force.

This is how children tell their story without compromising their loyalty to either parent and without getting retraumatized. She certainly was lucky that she had a brother who acted on her behalf. What distinguishes this session from the earlier developmental stage is that she takes charge of the entire space in the field. She places the figures; she moves them. They are players in her world. In the process, she retrieves the gemstone from the dangers of being abused by the snowman and the duck and affirms that the bear can be trusted to keep her safe.

A rebellious child may need to be given a choice: does he really want to attend the session? It might be important to remind him that he does not have to come. A ten-year-old girl spends four sessions sitting in front of the Clay Field knitting. Each time she vigorously sweeps the duck off the table at the start and then knits. Gradually she begins to talk. She is an only child in a single-parent family. She knows that engaging in the field would compromise the relationship with her mother to an unmanageable extent. After the fourth session, the mother breaks off the therapy, stating she wants a treatment option they can both attend together!

It is hard for children to push off and rebel against parents who are too close, dysfunctional, in need themselves, or unavailable. In each case the therapist will have to listen carefully to the individual solutions the child explores and support them. Knitting in front of the Clay Field can have a purpose. Asking to fold origami cranes can be a way of downregulating and shifting the focus away from something unbearable. Most importantly, children need to feel sufficiently secure to be able to integrate incomplete developmental milestones. Most need to do this; otherwise they would

not be in therapy. In some cases, this can manifest as a curious mix of age-specific centering and positioning, and within this setting, earlier developmental needs are being addressed and nurtured. I have also observed that children from chaotic and abusive homes often have to grow up really fast; they have to stand on their own feet way too early while they suffer from painful developmental deficits.

Most concerns will emerge from incomplete developmental stages that belong to a younger age. Often such deficiencies simply need to be unconditionally supported until the existential need has been fulfilled—or as much as is possible under the circumstances. Children who deal with a specific traumatic incident may need assistance to find sufficient resources to first strengthen their "healing vortex," to gain an embodied sense of safety, before they can begin to process traumatic events.

16

Developmental Building Block 7: Centering as Discovery of the Inner World

Age: 11–13 Years

Early adolescence is a time of huge change, of "emotional intensity, social engagement, and creativity."[1] The brain begins to change, the body begins to change, hormones begin to surge. Girls are usually earlier affected by these physical changes, and boys can lag up to two years behind in their physiological development. At eleven and thirteen, these changes are not necessarily pronounced, but they are sensed by the young person as an inner shift, which can be the cause for tremendous curiosity and anxiety. They experience excitement and confusion. Adolescents now begin to push away from the parents and seek to meet their attachment needs with friends and peers. Such friendships can be a source of strength, but equally a minefield of loyalty and betrayal, if not abuse. The relationship with the parents changes from dependence to one of interdependence. They still need the support of their caregivers but will also deal increasingly with issues they feel unable to discuss with them.

During this stage, children often start to grow more quickly. They begin to notice their bodies changing, including hair growth under the arms and near the genitals, breast development in females, and enlargement of the testicles in males. Girls may start their period at around this age.

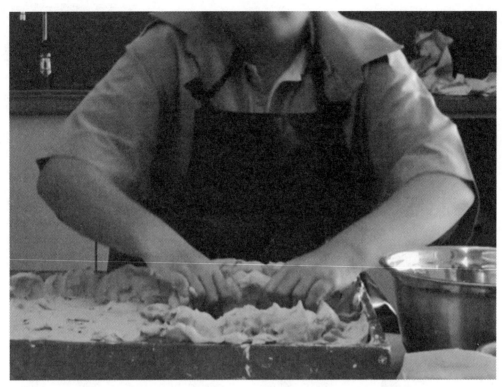

FIGURE 16.1. Centering in the Clay Field as a source of inner search for identity.

The heightened emotionality of early adolescents can manifest as black-and-white thinking, where things are either right or wrong, great or terrible, without much room in between. In this context, preteens will push boundaries and may react strongly to parents or other authority figures if limits are being reinforced. It is normal at this stage for young people to center their thinking on themselves. As part of this self-focus, preteens and early teens are often self-conscious about their appearance and feel as though they are always being judged by their peers, or at home. These inward changes, and the fragile emerging identity, are likely to be the cause for preteens' increased need for privacy. All of this can be observed at the Clay Field. I will share a number of case histories that reflect this need.

According to Piaget, this is the commencement of the formal-operational stage, which continues into adulthood. From now on, children show signs of using real as well as abstract situations as a form of thought, including advanced reasoning in science and mathematics. They also now develop the ability to think hypothetically about situations that have no real-life implications to them. In the Expressive Therapies Continuum, the cognitive level becomes pronounced.

From this point on, inner balance is organized as *centering,* according to Deuser.[2] Centering happens developmentally from the onset of puberty. It is the projection

of triangulation, attained in the previous stage, into the Clay Field. The hands meet and find a central core in the field. The quest, which will continue into adulthood and beyond, is for a reliable place in the world for the individual to be. The mass of the material is experienced as available to realize the self. Such positioning goes along with aiming to liberate oneself from the parental authority figures and the systemic entanglements of the family of origin.

In the Clay Field, a number of themes emerge during early adolescence. Much of the focus now shifts inward. It is no longer interesting to create external worlds in the field, such as house plans, landscapes, football fields, and pizza bakeries. The symbolic representation of a narrative with the toy animals also stops. Instead, the internal search for identity manifests in the Clay Field as a search for a central positioning: my place in the world.

FIGURE 16.2. Centering.

Initially this central place is fragile, just like adolescents feel fragile about what is happening inside their bodies. These enormous physiological transformations profoundly impact their body image and self-esteem. I remember myself at that age and how I was so occupied with what was happening inside me that I was convinced everybody else could also see into me, as if I was transparent to public view. I have witnessed a number of adolescents who mark their central place in the field by digging into the clay, but then try a number of ways of covering it up. Every mark gets wiped away with the sponge, or lids are created to cover up the opening in the clay. The inner world is still too vulnerable to be exposed. If the therapist understands this urge and supports it, safety and relief ensue.

Twelve-year-old Mel has been suspended from school. She is rebellious at home, stays locked in her room, and is highly aggressive when someone does not "keep out." At the Clay Field she sits helpless, not touching it, not knowing "how to cover it." The bare field is like her soul laid bare. The therapist brings in another bag of clay and begins to shape patties, which she then hands to Mel. Mel places the patties onto the field. Mel begins to shape patties as well. They spend the full session making patties and covering the untouched field with twenty pounds of patties. In the process, Mel's breath regulates, and her posture relaxes. The heavier the field gets, the lighter she feels. She is safe and protected from view. When she skips out of the session, her mother thinks a miracle has happened.

> Saskia is also twelve. She creates a central "fireplace" in the field but then gets very concerned that it could rain and the fire might get extinguished. With the help of sticks and some fabric, she creates a tepee, covering the entire field. Only she can reach into the tepee to check whether the fire is still going. Saskia asks the therapist to keep the field untouched until the following session.

Saskia not only deals with the need for protection, but in addition touches on the second key theme at that age: permanence. Along with such usually centered positioning comes the question of permanence. What will last? What can survive the endless succession of change? Crystals are popular as treasures that can be buried and found. Harriet used her gemstone in this context. A tree is declared to have "been there for hundreds of years," and a pyramid or temple is described as "very old." Dinosaur footprints have been made millions of years ago. Especially if the ego feels weak and confronted with overwhelming change, which is looming due to the onset of puberty, imagery of objects of permanence that can survive it all becomes very attractive.

> Zac is twelve years old. Several mental health professionals are involved in managing the chaotic and abusive family situation. The parents have had an acrimonious divorce and have both repartnered. Zac's childhood has been dominated by domestic violence as well as drug and alcohol abuse. Among all this, Zac is found at school with an open tablet loaded with pornography and gambling apps. Child protection gets called in. This is how he ends up at the Clay Field.
>
> In both sessions Zac instantly creates a central cavity. The clay he retrieves out of this hole is turned into a small ball. He fills the hole with water and places the ball inside. He briefly explores the movements of the ball but is more interested in dissolving the ball until it becomes a smooth bog. He spends repeated rounds squeezing water with the sponge into this central space, dabbing it dry, squeezing more water into it, and trying to fit both hands into the center, creaming them with wet clay. This alternates with putting the sponge, soaked with water, into the center, and then covering the opening, including the sponge, with clay.
>
> Toward the end of the second session, after an unsuccessful attempt to cover up the hole, Zac takes a lump of clay, shapes it again into a ball, and wraps it

into several layers of tissues. It is a "mummy." He places the mummy into the central circular space into the water and then covers the entire center with clay. He declares he is finished.

Zac maintains the age-appropriate center throughout both sessions. It is important that the therapist does not name this center as a "lake"; it is not a lake, but an internal, nameless place of great importance. However, it was at times heartbreaking to watch how this twelve-year-old yearned for early infant attachment, playing with water and mud in the center, creaming his hands. His hands looked round and soft. He was postnurturing his inner infant while also negotiating his adolescent identity. At the end of the second session, when he places the mummy into the center, he has created an image of permanence; the core of his identity has endured and carries the promise that it also will be able do so in the future.

I even took his sessions to supervision to make sure I had not overlooked anything. However, there was nothing sexualized in his play. If anything, his huge emotional need for secure attachment and the questionable male modeling in his family might have driven him to inappropriate behavior. What he craved, however, was close contact, not sex.

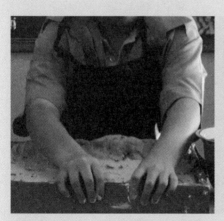

FIGURES 16.3–4. Jade is almost twelve years old. This is her second Clay Field session. To begin with, she creates a boundary all around the field. She is clearly marking the field as her world. Next, she shapes a central place, which she opens all the way to the ground. This could be viewed as synonymous with the opening up of her inner world. Jade connects with the ground. The hand can be seen not pushing down but pushing into the layer underneath, an impulse she completes further on.

FIGURES 16.5–6. With the water, Jade brings life and vitality into her inner world. She places the duck into the pond, but almost immediately commences in shaping the ball, which can be seen as her identity. The duck gets evicted very quickly.

FIGURE 16.7. Instead, Jade now places the ball into the center, then slips her own hand into the pond and begins tunneling underneath, all the while hiding the ball inside the tunnel.

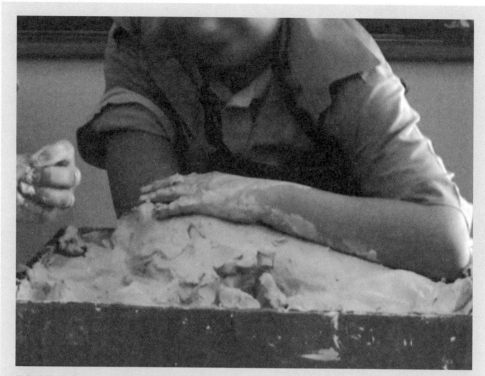

FIGURE 16.8. Jade packs her entire hand into all the available clay. This is not the equivalent of the self-nurture we could observe in skin sense. Here it is a becoming aware of her inside and a strengthening and protecting of this sense of self.

Jade's case history beautifully illustrates the need to go inward at this age and how fragile this discovery of this soul space is as an internal landscape. It still needs to be protected from view until it has gained sufficient strength.

17

Developmental Building Block 8: Centering as Search for Identity

Age: 13–16 Years

When I first began working with teenagers, I thought they were all dissociated. Many were just drawing with one finger or the fingertips, scratching images into the surface of the field while they talked. There was none of the vital engagement with the material I was used to from working with younger children, who tend to be up to their elbows in the clay. Only gradually it sunk in that they needed, more than anything else, exactly this: to talk. Among all the developmental turmoil, this is a cognitive developmental stage. The neocortex now wants to clarify issues around identity, sexuality, authenticity, future career, and relationships. Many teenagers do not want to discuss these issues with anyone at home, and also not in their peer group, because it would make them too vulnerable. They can be very alone, and the option of therapy is often an opportunity to process burning questions. At the same time, they tend to feel uncomfortable talking to a therapist. The Clay Field or other art therapy activities can become a welcome distraction, where they can focus on doing something while discussing certain issues without having to make eye contact. In a way they are talking to themselves.

Given that adolescents have an intact sensorimotor base and the previous developmental stages are more or less integrated, they are now predominantly interested in running a flow of questions and self-answers past the therapist. Deuser describes the therapist's role at this developmental stage as similar to that of an ancient Greek choir, to confirm emotionally whatever is said. The adolescent produces the drama center stage, and then the choir simply confirms with a musical wave of: "Oh, oh, oh, how terrible." Or: "Oh, oh, oh, how glorious." Teenagers believe they always know better than the adult, but they do need the sounding board.

The haptic sense in the fingers is closely connected to the neocortex and cognitive processing. The fingers experience a developmental leap during adolescence. They gain tonus and spread out. When they grab, they really take up space now. It is as if the space in-between each finger becomes conscious. Also, the fingers begin to speak as they point and explain and explore in the field.

As the Clay Field of a sixteen-year-old illustrates, the focus is now firmly on the self (fig. 17.1). This is an egocentric time, where the adolescent is the center of the world. Geoff marked his center in the field, and bit by bit built it up during the session. The surrounding clay was not landscaped and did not hold his interest. It was just there to supply the material for his central creation, which appeared like a bird's nest, put together by fragile bits and pieces, to gradually form a relatable and visible gestalt. The ego is fragile at this age. Geoff mostly worked with his fingertips; his full

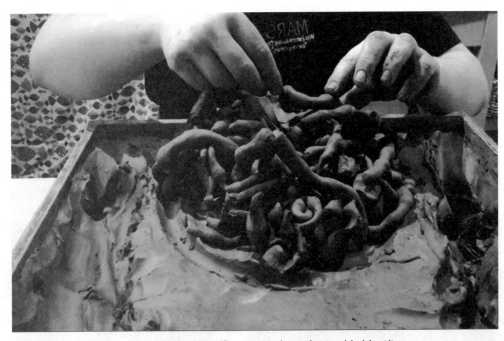

FIGURE 17.1. A sixteen-year-old who identifies as gay investigates his identity.

hand only engaged for rolling or flattening small bits of clay into shape. His hands never rested flat on the field's surface, for example.

We can understand his creation and mapping of the field in the context of most teenagers, who still live at home but no longer *feel* at home in their parents' house. They are pushing off the parental base, but most are still too young to have a base of their own, just like Geoff here. He builds his own place by taking material from the field, which we could view as being charged with his family's identity, and he transforms these bits in careful, tentative steps before he adds them to his island, a space he marked in his first movement as separate from the surrounding field.

Physiological changes from puberty continue during middle adolescence. By now, most males will have started their growth spurt. Their voice lowers. Some develop acne. Physical changes may be nearly complete for females, and most girls now have regular periods. At this age, many teens become interested in romantic and sexual relationships. They may question and explore their sexual identity, which can be stressful if they do not have sufficient support from peers or their family.

Sexual identity can in fact become a huge focal point and potential source of crisis. The physiological changes can inspire curiosity and anxiety in some—especially if they do not know what to expect or what is normal. Some adolescents may also question their gender identity, and this age can be a most challenging time for transgender or gender-fluid children, who despise the changes that are happening in their body because they cannot identify with them or because they do not fit the norm.

Middle adolescents tend to have arguments with their parents as they struggle for interdependence. They may spend less time with family and more time with friends. They are often very concerned about their appearance, and peer pressure may peak at this age.

The brain continues to change and mature in this stage, but there are still many differences in how a normal middle adolescent thinks compared to an adult. Much of this is because the neocortex is the last area of the brain to mature; development it is not complete until individuals are well into their twenties.[1] The neocortex plays a major role in coordinating complex decision-making, impulse control, and being able to consider multiple options and consequences. Middle adolescents may be more able to think abstractly and consider the big picture, but they still may lack the ability to apply their knowledge in the moment. They know that smoking cigarettes is unhealthy, but they still light one if they consider it cool at a gathering. They know they are not yet allowed to drink alcohol, but I've never seen a Western teenage party where everyone is sober. While adolescents may be able to walk through the logic of avoiding risks outside these situations, strong emotions and peer pressure often continue to drive their decisions when impulses come into play.

Being part of a group of friends is of vital importance at this age. These peers are there to give care and support while parents "don't get it." Boys feel less vulnerable if they have friends to back them up and if they can escape with them into, say, sporting or gaming activities, where their emotional turmoil is more directed. Romantic and sexual relationships become a complicated emotional hothouse where falling in love and losing oneself competes with self-preservation and the protection of one's dignity and pride.

The tentative negotiations of sexual interests feel much safer if girlfriends are available to look out for each other, discuss strategies, give advice, and dream of possibilities. Girls who do not fit in, usually due to unresolved developmental trauma, become painfully and dangerously vulnerable at this age. They are easy prey for sexual predators and are frequently taken advantage of.[2] They get raped, gang raped while drunk, groomed online, and mercilessly bullied. They have no friends to counsel them and no adults they can trust; they rarely go to the police, and if they do, almost never get the support they need there either. Consequently, they disappear in a quagmire of shame and low self-esteem, often for years, if not decades.

Peer pressure, however, can just as well be the source of extraordinary failures regarding risk assessment. Adolescence and young adulthood are a most dangerous time, especially for males, and many do not survive their "crazy" adventures involving cars, fights, drugs, and other tests of their strength and daring.

Injuries through violence or senseless risk-taking are one side of the dangers of adolescence. The other is self-harm and suicide, where the inner pressure, despair, and pain are turned against the self. The cause is likely to be what I discussed in a couple of previous instances: that trauma disrupts the dual polarity of sensory perception and motor impulses. Without being able to feel and perceive what they are doing, adolescents are now *senselessly* acting out in risk-taking behavior. Being "cool" can also be viewed as being dissociated from sensory perception, being without the warmth of feeling. Others, on the opposite side of the spectrum, are frozen in shame and fear, unable to move and act; they suffer from such overwhelming sensory overload that they retreat into shutdown and numbness. Self-harming is often an attempt to feel anything or to release the emotional pain that cannot be expressed in a physiological way. The cause, in both cases, is developmental trauma, which at this point gets harder and harder to address.

Fifteen-year-old Mike towers over his therapist. He is tall and strong, but not in a toned, confident, athletic way. He arrives with a security guard who attends the session to keep the therapist safe. Mike has a history of violent outbursts.

At the Clay Field he adds increasing amounts of water until the clay is turned into a liquid bog. He leans into the field onto his forearms and pushes to the sides until he is stopped by the boundary of the box. He pushes hard against the boundary, over and over and over again, while the watery clay spills and splashes over the edge, onto the table and the floor, which he hardly notices. It is not his intention to make a mess; what he craves is the resistance of the box to give him a hold.

The neglect, insecure attachment, and lack of boundaries that likely characterized Mike's early childhood make him a dangerously dysregulated, needy, and frustrated young man. The boggy clay appeals to his skin sense and need for safe contact; leaning into the field with the forearms occurs when clients are looking for support, and through the resistance of the box's boundary, Mike is looking for a hold. Apparently, none of these implicit developmental building blocks were satiated in the first four years of his upbringing, because otherwise his sensorimotor base would be more reliable.

Mike's case also illustrates the difficulty of providing adequate therapy for such individuals. Which government is prepared to pay for a therapist and a security guard for months if not years of therapy to heal this extent of developmental trauma?

Kevin attends a high school for gifted children. He is fourteen years old and spends most of his day on his computer, playing games, with his bedroom door firmly shut. The therapist has the radio playing pop music in the background in order to "relax" the awkwardness of the session.

Kevin sits down at the Clay Field and only works with his right hand. The left arm rests next to the field and is completely inactive for over twenty minutes. This is imbalance, and if we regard this from the neurological perspective, his right brain as the emotional brain is not connected to his actions. Kevin talks a lot about holidays, racing cars—he is building a racetrack in the clay—and his future plans for college. Eventually he begins tentatively to engage his left hand. The racetrack deepens. He is enthralled like a little boy.

In his second session, again the left hand remains motionless, but now for a shorter time. He carves out a large central area and builds up the walls of the "castle." Then the question arises: what would happen if he poured water into this central basin? Will it flood everything? For the rest of the session Kevin carefully pours water into the middle and then blocks the leaks to the outside with clay and a sponge. He gets increasingly invested, pouring more and more water

and managing the leaks. The therapist also pays full attention to observe the leaks—and provides increasing amounts of water. In the end the "castle" is filled up to the rim with water, and Kevin is deeply satisfied.

Experimenting with water, landscaping, and affect regulation in this manner is developmentally acquired at a much earlier age, between ages four and six, where affect and orientation are the core themes. Whatever caused Kevin's deficit at the time is not important. However, the developmental void now becomes an obstacle, as he has not learned to trust his emotions. Water can represent the fluidity of emotions and the flow of libido, both of which are heightened at this age. The relaxed and nonjudgmental setting allows Kevin to quietly integrate a missing developmental building block and learn how to manage and contain his emotions rather than just dissociating them.

Vertical structures often appear in adolescents' Clay Field work, in particular trees, pyramids, lighthouses, and water towers. Water as symbolic libido flows from the tower down, is dabbed up with the sponge, only to flow down again. Such images mirror the body and within it the circulation of libido, emotions, and possibly for women, as menstruation cycles.

Adolescence is a time of extremes. On one hand these teens will talk and only scratch around on the surface of the field, while others will postnurture developmental needs from earlier stages. They can "play" at the field as engrossed as preschoolers in their healing repair. They want to be seen and perceived in their growing identity, while they also feel self-conscious and awkward about it. Such inner tension reminds me of a fourteen-year-old girl whose body language was one of practiced invisibility. Her voice was barely a whisper, her shoulders were pulled up to her ears, she virtually tiptoed, but her hair was dyed a fluorescent green. She yearned to be seen, even though she did not yet know how to embody this urge.

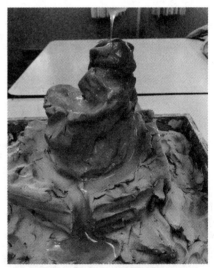

FIGURE 17.2. A fourteen-year-old boy has built a vertical "water tower." He delights in letting water flow from above through specially designed canals and channels. He is in full charge of the flow.

Siegel writes: "Adolescence is not a period of being 'crazy' or 'immature.' It is an essential time of emotional intensity, social engagement, and creativity. This is the essence of how we 'ought' to be, of what we are capable of, and what we need as individuals and as a human family."[3] As therapists it is our job to help these young individuals to become capable of what they are capable of being.

Developmental Building Block 9: Centering as Search for One's Own Base

Age: 16–18 Years

Adolescents are now significantly less dependent on their caregivers, which allows them to address conflicts at home more proactively. At the same time, they are searching for their own base by making career choices, moving out of the parental home, and setting up their own. Should they stay at home, they strive to reestablish a more mature relationship with their parents, considering them increasingly as equals from whom to ask advice and discuss topics with, rather than as authority figures. Increased social and behavioral skills become important to form friendships and find a place in the peer group. Friendships and romantic relationships become more stable, while adolescents become emotionally and physically separated from their families.

Adolescents begin to stand on their own feet and become increasingly responsible for their actions, including in legal terms. Social relationships away from home involve the acceptance of social rules, social hierarchies, and experimentation with antisocial impulses. Teens entering early adulthood have a strong sense of their own individuality, and they can identify their own values. They may become more focused on the future and base decisions on their hopes and ideals. Such hopes and ideals

often involve intense social engagement, dreaming of ways to build a better world, novelty seeking, and creative explorations of topics in their field of interest. It can be an exciting time of high energy, deep passion, and groundbreaking ideas that can set the theme for a lifetime to come.[1]

The experience of an inner world often collides with the outside world, and questions about authenticity of self and others arise. The quest to experience oneself as purposeful and with a goal includes questions about education and the future. But along with these dreams comes the confrontation with limitations due to socioeconomic conditions, lack of opportunities, and overwhelming inner and outer obstacles that hamper progress. Unresolved developmental trauma may lead to drug and alcohol abuse as an attempt at affect regulation. Others struggle with hopelessness and lack of spiritual and ethical resources, which can end in suicidal ideation and depression. Or there is the rage and risk-taking of those with chronically high activation levels due to the traumatic setting in which they grew up. While some have now consolidated, at least to an extent, sexual partnerships, for others they remain a source of conflict, humiliation, violence, and betrayal of trust. While it is a time of great change and transformation, I must say that I have never met any adult who wanted to be seventeen again. It is not an easy time to become yourself by any means.

Nurturing the Developing Identity and Healing Old Wounds

Julie Wilson, a psychologist colleague of mine, works mostly with young women with diagnosed eating disorders. These teenagers often have systemic family histories of abuse. She claims that many of her clients would not have lasted the ten or more therapy sessions without the Clay Field. It must be said that Julie took all of them through a number of art therapy exercises to build resources before they got to sit in front of the Clay Field. Especially for eating disorder clients, the physicality of the clay would have been way too provoking without sufficient preparation. At the Clay Field these young women could act out stressful emotions. All of them worked on earlier developmental needs, often with rage, evicting the clay from the field, cleaning the box in order to make it less contaminated with abuse, providing self-nurturing to themselves through playing with water, or creaming the arms and hands.

In chapter 12 I mentioned the eleven-year-old girl hospitalized with anorexia (figs. 12.5 and 12.6). She could not critically look at her family of origin, especially since

her caregivers were put in charge of her home-based therapy, such as supervising her daily food intake. The Clay Field sessions of young girls are usually characterized by tiny fingertip marks. However, at seventeen and eighteen, these young women can distance themselves from their family of origin. It can be astounding to witness how underneath the restrained surface of utmost control lurks raging anger, which can now be released in the clay, once these clients are safe enough to come out of metabolic shutdown. At an earlier age, while still living at home and quite interdependent, such big emotions would not have been safe. Now, even though the majority still live at home, they can muster sufficient emotional distance to be able to focus on what they feel and experience, and they are up to their elbows in the clay, thumping and strangling it, washing and purging it, until their own world and identity can emerge. At the core is the question of self-realization and authenticity: pushing away from the parents and the dependence on them, distancing from the family of origin and other social structures that no longer fit. It is a struggle to find their own existential and social base.

Young people dealing with drug addiction, especially, will need to reexperience early bonding and safe attachment, being held and having safe boundaries. This client group usually has complex developmental deficits. Frequently they are dual-diagnosis clients, suffering from mental illness and addiction. Similar to eating disorder clients, these are mostly silent sessions. This is a client group that needs lots of time to address the underlying trauma issues. Many are still doing drugs while they are in therapy, which means there can be enormous variations in what state the individual arrives for the session, whether they arrive at all, or are in a drugged haze. And then there are other sessions, where deep, life-changing shifts become possible. Most of them are dealing with early developmental attachment needs, which manifest at the Clay Field as all the sensorimotor haptic needs we discussed in skin sense and depth sensibility. During their adolescence, long-term therapies are often necessary to postnurture these preverbal developmental stages. Occasionally sessions can have an almost shamanic ritualistic aspect, to call back the spirit, which has been dissociated in the process of too much trauma and too many drugs.

The Homeland

If the vertical axis of empowerment has been achieved in the previous stage, the focus is now directed toward the ground of the field, the space it offers as "my world," my homeland, my place to be. This of course correlates with the search for a place in the world, which these adolescents dream of, but at the Clay Field this

place takes on a spiritual or mystical internal connotation. A seventeen-year-old mentions how much he longs for his grandfather's farm and how happy he was there as a child. When I suggest he could fly there for a visit, I instantly notice that he withdraws, realizing that he was not speaking about the physical farm, but an inner homeland, which reminded this young man of a particular feeling and way to be.

Resolution emerges as a resolved "I," which at this age manifests not so much as transpersonal oneness but as a concrete opposite the adolescent can relate to emotionally, socially, physically, and spiritually. Adolescents create soul-landscapes that represent "my world," "my life." A homeland will emerge that counteracts the sense of abandonment that they experience when leaving old securities behind. This inner home represents spirituality and permanence versus impermanence. Many times, mandala structures emerge, or significant figures are placed in the four corners of the field. These sessions are ruled by their own timing and by inner centering: not by objects, but by an inner order.

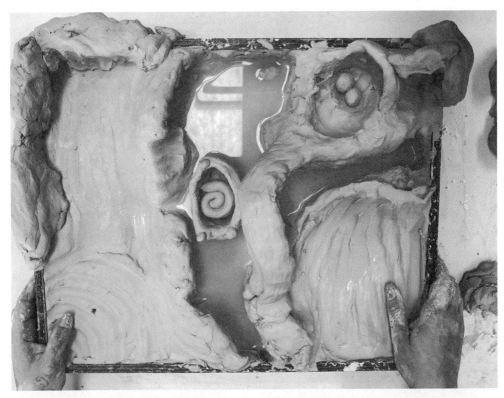

FIGURE 18.1. Ritual mandala that held deep meaning for the young woman who created it. It was a soul landscape where she journeyed toward renewal and spiritual growth.

An eighteen-year-old transgender man processes the many facets of his identity crisis at the Clay Field in mandala structures as he transitions from his female body into becoming a man. He attends his sessions in an open psychiatric facility for a period of two years. He is sixteen when he starts, having been diagnosed with dissociative identity disorder (DID) and hospitalized for some time. Much of his therapy is dedicated to discussing his physiological changes, the hormone medication he is taking, and his chaotic, unsupportive family situation. What becomes a constant is that in each session he creates a mandala. He draws channels while he speaks. He never builds these mandalas up. The ordering force of the mandalas helps him to focus and order his life. The voices he hears become less intrusive, and he feels calmer. These mandala rituals are a lifeline for him and represent an inner healing place where he is whole and complete.

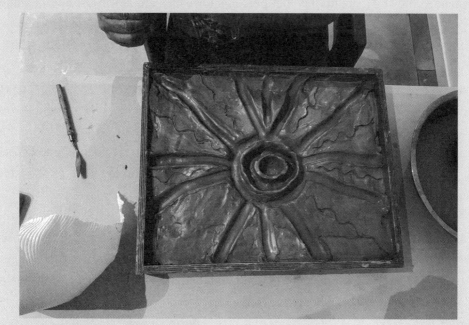

FIGURE 18.2. Mandala as a ritual space.

Entities

A spiritual and ethical source can become a challenging obstacle for some clients. The core or central figure can take on the opposite qualities of empowerment and instead become an "entity," an authority figure of Old Testament proportions. Something

vertical is erect in the center of the field, such as a tower, church, general, priest, queen, or similar. This vertical center will project a code of honor or a value system that has to be obeyed. This ruling entity is usually in conflict with the individual needs of the client. This is, for example, the distress of many victims of sexual abuse by priests. There is not just the abuse in question, but on top of it the entire church hierarchy and the associated religious beliefs that are forbidden to be challenged because they claim divine authority.

I have worked with many clients, particularly Asian and Middle Eastern young women, where a young female taking even small liberties is in breach of the code of honor of the family. Many of these young women, for example, have a Western education and related values, but their families are traditional, expecting them to enter an arranged marriage, not to have a boyfriend, live at home until they marry, and dress in a certain way, along with many more issues arising in specific cultural environments. The key issue here is that personal decisions are never just an individual responsibility but affect the entire clan. If these young women do not conform, they shame and compromise the honor and social standing of their entire family. This is very different from the individualistic focus of Western paradigms.

In such cases, the entire Clay Field may become charged with "the family" in an outspoken or implicit way. The family can be experienced as supportive and loving and will find its place in the field, but there can also be tremendous conflict with one or more family members—and they cannot be evicted, which is the preferred Western solution. Accordingly, hostile family members are sectioned off into allocated "pens," aspects of the field that are virtually dissociated within the layout.

Such entities have to be dealt with in a culturally sensitive way and yet include the individual needs of the adolescent. This involves becoming conscious of the consequences of one's own actions and those of others. There might be related fears, anger, and guilt. When issues seem overwhelming, intangible, or very frightening, it can be helpful to remember that all heroes get assistance if they ask! The ego faces the hero quest, the dragon fight. What it gains in return is permanency.

When we look at hero myths in this context, not all of them are Herculean musclemen wrestling beast after beast into submission. When we face an entity, a confrontational stance will likely destroy the individual. In such cases "little heroes" can be role models. The Brave Little Tailor and Tom Thumb in the Grimm's fairy tales are both small, powerless individuals, but they are nonetheless brave and smart in their dealings with a bone-crushing giant, murderers, and thieves.[2] They face imminent death on several occasions. They hide, they are tricksters, and they trust in somehow

being protected. This is how David faces Goliath. In some tales, animals come to the rescue of the protagonists, as in *The Wonderful Adventures of Nils.*[3] In the process, these heroes learn integrity, self-preservation, when to hide and when to be visible, and most of all, to trust their intuition.

The following case history illustrates such a worst-case scenario, when the center of the field is occupied by a large mountainous figure that does not represent individual empowerment but an unnamed authority. Pushing off the field, evicting parts that have been outgrown, moving out, and rebellion and anger cannot be expressed, even when the entire being of the client screams in distress.

Keith experienced systemic sexual and physical abuse over most of his formative years. His violent father ran a pedophile ring. The Clay Field is charged with overwhelming evil, which renders him powerless (fig. 18.3). He fears repercussions of biblical proportions should he dare to rebel or defend himself, which would have been his reality as a boy. He is clinically depressed, suicidal, and has a history of addiction.

FIGURE 18.3. The all-powerful evil.

In the following session, Keith tentatively pokes and prods this entity that is not him, that he cannot own and cannot handle, and yet it rules his life. The poking here serves as a test. His shame and fear, a looming court case, and the involved mental health system merge into an overwhelming entity that is threatening his life, externally as public humiliation (being interrogated about "it") and internally as unbearable shame. He would rather die than face such exposure of his soul.

Keith has transferred his distrust of all authority figures onto the psychiatrists treating him, which complicates his mental health situation because he avoids seeing specialists for appointments. After some discussion and prompting, he continues his session by taking the entity apart, to make the issue more manageable (fig. 18.4). Each clay item is a person, including his family members and mental health and legal professionals. Disassembling the overwhelming lump into smaller portions even enabled him to give himself "permission" that some of

the clay could be evicted; he could state he did not need to deal with "that" right now. He himself is placed on the overturned box "to get an overview" and some distance. It is this new position that allowed him to tackle the huge issues he was facing, step by step, one at a time.

FIGURE 18.4. Small steps.

For some adolescents, this phase can be dominated by morbid fantasies: the obsession with death, dying, and negative transcendence, such as the Goth culture, which I view as simultaneously being rebellion and spiritual search. There might be suicidal ideation and self-harming. In all cases it is usually necessary to retrieve lost and dissociated aspects of oneself, to "re-member" them in order to heal childhood trauma. As in all of these cases, this involves the need to postnurture earlier developmental stages and to find active responses to what happened. I also recall a number of clients at that age, however, who could only walk away from the abuse they had experienced. They did not yet have the resources to deal with the overwhelming pain and humiliation they had to endure during their formative years. In such cases, self-designed rituals can become useful to contain the overpowering evil until the individual has become stronger.

Centered vertical structures are age-appropriate in late adolescence. In the context top and bottom, cognition and vitality are being connected and aligned as lighthouse or mountain. Such often impressive figures represent a solid positioning of the individual in the world.

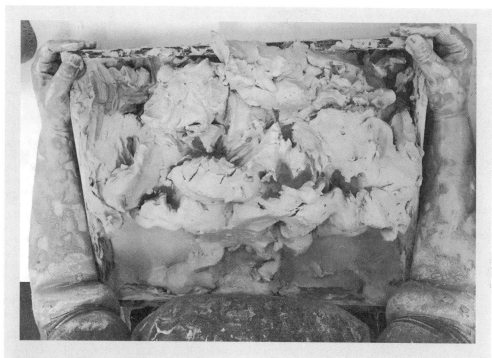

FIGURES 18.5–6. A young woman is confronted with the lack of structure and the mess in her life due to neglect and abuse, which at this stage is still too overwhelming for her to resolve. She throws all the clay onto the floor, cleans the box meticulously, and turns the field upside down. She literally can only walk away from "it" all. She then creates a pure mandala shape on top of the upturned field, which for her is her spiritual core that has survived everything unharmed and represents her essential wholeness and beauty. She has found and established a new order. On this field she can lean with her forearms, receiving the support she has always wanted.

FIGURE 18.7. This seventeen-year-old girl has had a troubled upbringing. Here she has taken all the clay out of the field, liberating herself from her family. In this case the box represents the family home that she can now leave behind. She has taken herself out of an environment that did not nurture her and no longer fits. Instead she establishes herself on the table in a visibly empowering way. Her movements make sure to connect with the ground. She presses the base of her hands and forearms into the "tower" to integrate it implicitly. A new life can begin.

Soul Retrieval

There is one distinct version of homecoming that I have rarely witnessed with any other age group. It is a transpersonal sweeping movement with the flat hand almost not touching the field, sometimes for several sessions. Some of my clients called it giving Reiki to the Clay Field; some told me exactly where the good and the bad places in the field were located, but without touching the clay; others saw colors rising from the field like auric energy. The lack of orientation manifests as sweeping or wandering on top of the field. There is no form, no symmetry, no gestalt. It is as if the individual's spirit is hovering above the field waiting for the right moment of entry. For the therapist it is important not to encourage motor impulses such as downward pressure, but to witness these transpersonal, sweeping movements like a meditation. Interventions such as "How about taking more material" will cause the spirit to take flight again. Supporting intuition to follow the hands, such as asking "I wonder where you are?" will encourage orientation and invite focus onto the "earth" of the field.

Such sessions are a spiritual search for an inner home, a place in the world where the spirit can "land." These transpersonal movements always culminate in marking with a tiny bit of clay a pearl-like central place. A connection with the physical and the spiritual has been established; something invisible has manifested in the physical realm, and a place for soul-permanence has been found. I do not believe that the purpose of these sessions is the integration of dissociated aspects, but rather the incarnation of another layer of the adolescent's spirit self. It is the homecoming of a transpersonal state of being that can now become connected and embodied.

Deuser calls these meditative, quiet sessions the search for *space-related identity*.[4] They are characterized by caressing the flat field with the flat hand with circular movements. There is no pressure involved and hardly any marking of the clay. Such hovering of the spirit can last for four or five sessions until this tiny center emerges, driven by a need to find inner unity, an inner self that represents a spiritual and ethical source.

Many of the sessions with this adolescent client group touch on working with adults. Witnessing their sessions, I have seen the need for empowerment by building large vertical structures, the fulfillment of infant developmental needs by creaming the hands and arms with liquid clay, and the spiritual search for permanence and a meaningful life purpose. Only at the age of eighteen, even up to twenty-four, according to Siegel,[5] will individuals have gained a sense of inner balance and develop an implicit vertical they can rely on, similar to what we colloquially refer to as an inner backbone. The shared theme is finding the true self, consolidating the psychological identity, and finding a reliable position in the world. From here on the world of adults begins, which is the focus of my first book, so I will not discuss their process here.

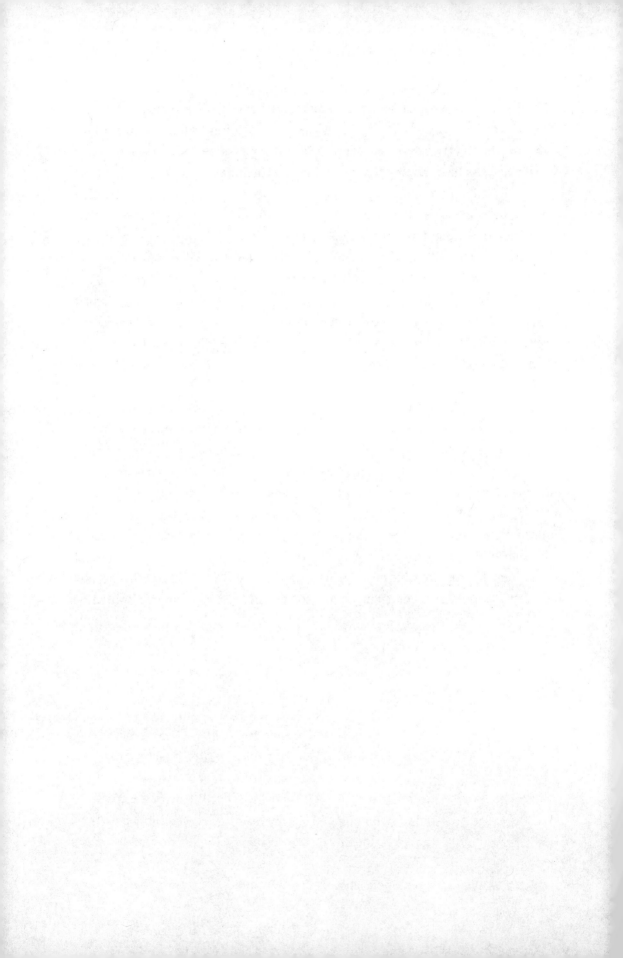

19

The Five Situations
for Children

The five situations describe the necessary steps all clients have to take to orient in the therapeutic environment and to fulfill their individual possibilities in a session. In my first book on working at the Clay Field with adults, I discussed nine situations; for children there are only five. Deuser compared these situations to railway stations. We don't need to travel the full length of the rail line every time we board for a session; we will only go as far as is required to reach our destination. Such a destination is not necessarily a planned, directed outcome but depends primarily on the present life movement needing to find a response.[1]

While adults work generally with their eyes closed and have the option for all nine situations, children work with their eyes open and do not go any further than situation 4, unless they are teenagers and young adults, which might take them to situation 5. All further situations rarely occur before middle age. I will reiterate the five situations here with an emphasis on children.

Some children traverse the earlier building blocks at the Clay Field with ease and move quickly on to that level where their learning needs to take place. A boy, for example, who never learned to swim needs time to trust the water, and needs to be supported so he can safely make his first moves. Another boy of the same age who has already learned to swim might now only be interested in learning to jump from a springboard. Jean Ayres, the founder of sensory integration therapies, emphasizes that children are designed to enjoy activities that challenge them while they like to experience new sensations and develop new motor functions: "We can adapt

to a situation only if our brain knows what the situation is." Only then will a "well-organized adaptive response leave the brain in a more organized state."[2]

At the Clay Field, children and adults alike will quickly go to whichever situation is necessary for their individual development. If we liken walking into the pool area with the first situation, checking out the water with the second, jumping in with the third, swimming with the fourth, it might become clear that the first boy will require plenty of time to integrate the first and second situation. He will need time to orient in the pool area, be introduced to the temperature and depth of the water, and be given sufficient support to feel safe. The other boy will traverse these stages within seconds. This second boy will jump into the water with confidence and then look for a new challenge.

Situation 1: Finding a Safe Base

Arriving in a new space, children have to orient physically, emotionally, and socially. They need to feel safe and have to find their place in this environment in order to be able to settle internally. Children will arrive with expressed or secret fears and expectations, and they need to build trust in their relationship with the therapist. Children are not in charge of their lives. Who has decided they need a session? Are they attending voluntarily or not? Who brings them to the session? And how supportive or disruptive is the caregiver involved?

These are the core challenges surrounding the first situation. Even when we have been to the clinic before and know the setting and the therapist, each session is a new experience where we need to settle into the present moment. Young children will perceive the art room, the therapist, and the Clay Field as one undifferentiated experience. This can be overwhelming, and it is necessary to make the child feel secure.

Adults may have greeting rituals that help bridge settling in, whereas children might need a less formal approach. Children who have not experienced that relationships can be trusted or are reliable, especially, will need time to orient and time to connect to the therapist through games, play, and occasionally jointly developed rituals.

While some children will traverse this first situation within seconds, others will need a number of sessions until they have gained sufficient trust in the setting, the space, and the therapist.

We need to feel safe before we can progress. We need to be able to orient in the room; children may require a "tour" and being shown the options that are available. It might be really important to know where the toilet is located, or the sink. The moment we face the therapist, our mirror neurons may fire entire cascades of information: "she looks scary" or "friendly"—perceptions that may have little to do

with the therapist herself. Most trauma is interpersonal. If clients have experienced boundary violations in previous relationships, they will at best oscillate between fear and hope as they encounter their therapist.

The therapist needs to anticipate such fears and deal with them primarily in a nonverbal way. Children especially may require spontaneous, at times unconventional, responses in order to settle their anxiety. A transitional object such as a teddy bear can be offered to hold or to vicariously bed it in a safe place. Little ones love peekaboo games. They may hide the moment they enter the therapy room, yet they want to be found; they want to be seen, but also find it unbearable.

> A four-year-old girl dives straight underneath the table where the Clay Field is placed. The therapist covers the table with a cloth and turns it into a cubby house. She then calls out for the girl, calling her name: "I wonder where Janet is?" After a while, the girl responds; after another while, the therapist is invited to sit with her underneath the table, and they both read a picture book. A relationship has been established.[3]

I rarely offer Clay Field sessions to a new client; most likely we engage in more traditional art therapy approaches first, such as drawing, collage, or sculpting a "safe place" as a resource. Sand Tray therapy compliments Clay Field sessions well; it is a more conscious, symbolic approach. The figurines invite play and communication, and a child is more visibly in charge. In addition, the Sand Tray introduces the concept of the "field" as a container in which events can take place. Children may eye the Clay Field during these sessions, and they can be quite decisive when they are ready to explore it.

In this first situation, attachment styles surface. Are children secure, avoidant, insecure-ambivalent, or disorganized in their relationship patterns? Preschool children may be scared to be left alone with a stranger and need their caregiver to be present for a number of sessions to be able to transition. Some parents are too keen to attend and observe; others are too keen to leave as soon as possible to have time for themselves.

> A five-year-old boy falls asleep during the car journey to the session. His mother is irritated when she arrives. Should she wake him up? The therapist suggests she stays with him in the car while he sleeps. For the next session the mother brings a blanket. Her son sleeps. She realizes that she never has time to simply and securely *be* with him. For the third session the boy arrives awake.[4] He needed his mother's assurance.

A four-year-old girl sits on her mother's lap at the Clay Field, which gives the girl safety, but then the mother begins to put her hands into the field and takes over the girl's session.

The first situation is also about getting "ready," putting on protective clothing, tying up the hair, rolling up sleeves, adjusting the chair to the right height. However, foremost is the establishment of a relationship with the therapist so that children can trust, and they feel safe in this encounter.

Situation 2: Facing the Clay Field

The focus now turns to the Clay Field as a haptic object that invites actions and a relationship. The environment of the therapy space and the therapist retreat into the background, and the Clay Field is perceived as a dual polarity: something is over there, and I am here. The Clay Field is not yet touched; rather, the potential of this relationship is being assessed.

The question arises: how safe is this? When I look at something, I can remain distant to the object, but the Clay Field invites me to touch it, which is an entirely different experience. Touch is a proximal sense. As I touch the clay, I am touched by it. As I reach out into it, I will be affected by it. It is not simply that I am here and the Clay Field is over there; that would be a visual experience. Here, dual polarity describes the haptic knowledge that as soon as I touch this other-than-me, it will have an impact upon me; it will impact how I feel. Deuser calls this the *reality principle of haptics.*[5] Tactile contact will trigger a pleasurable or frightening experience; I cannot distance myself and stay neutral or "objective." This relational experience describes the greatest potential and the greatest threat this work may pose.

As I assess the clay, it may look smooth and soft, or cold and resistant, or even disgusting and dirty. Touch memories go back to earliest sensory experiences, such as being soothed and settled as infants, hugged and held by parents, and as connecting with friends. Yet, also virtually all traumatic experiences involve touch: physical and sexual abuse as well as accidents and surgeries are all boundary violations that touch our skin in an unwanted, hurtful way. Many children will unconsciously remember such violations the moment they face the relationship with the Clay Field. It can be of utter importance not to rush clients into making contact or to override their fear. I have listened to many women who had been sexually abused as children telling me how their own feelings were overridden by the perpetrator, making them "like" the abuse. Therapists who promote the Clay Field as "fun" can disturbingly retraumatize

such clients through repeating the abuse by making them touch something they do not want to touch. Sessions where clients are able to state they do not want to come into contact with this haptic object on offer can be life-changing. Rather than complying, such clients experience empowerment and that they are able to say "No!" If need be, several sessions will be spent practicing this right to have a choice. The field can be covered with a big lid that reads "No!" Others find it deeply satisfying to evict the entire box—as the symbolic perpetrator—from the therapy room. If they are old enough to do so, they may literally kick out the "disgusting" field until it is gone and they can close the door for good, leaving the abuse behind. Young children will likely be hyperaware of the field in the room and choose not to touch it, but rather opt for other activities, until one day they state that they feel ready now.

Most times children negotiate their first contact by touching the surface of the clay, or the side of the box, or the water with one finger, and then they withdraw. They will repeat this touch-and-go until they have gained some certainty into the relationship with the field. We can compare this to a handshake. In that fingertip we may assess whether we can withdraw, if need be, or not get lost in this world on offer, or if it is safe. Many hold their breath at this point, waiting for something to happen, and have to process it when *nothing* happens. They may have learned in unsafe relationships that things happen when they make contact.

This touch-and-go could be repeated a couple of times, until there is a pause and the hands rest for a moment in the lap, on the field, or on the table. Only now the process of establishing a relationship with the field is complete.

FIGURE 19.1. A seven-year-old girl makes her first contact with the box while she asked the therapist many questions about what other children were doing here. The therapist diverted her concerns to lead her to her own experience. The girl had learned to negotiate safety through being very aware of what others were doing.

It must be understood that what I describe here can be traversed within seconds, or take up several sessions. In most cases, situation 1 and situation 2 do not take more than a couple of minutes. In others it might take much time to build the trust that the child will not be harmed if she touches the clay and enters a relationship with it.

Young children will sit down in front of the Clay Field wherever the chair is positioned; if this is at an awkward angle, they will twist to accommodate that unless the therapist moves their chair or the field for them. They are used to accepting the world as it is presented to them; they are not in charge of it. Adults, for example, will move the field into position and then position themselves in front of it. Teenagers may do the same, but not younger children.

Many children like to be asked at this stage, if they already know, what they would like to make today. Safe children will know, whereas the unsafe child might ask: "What do you want me to make?" This is an indicator that more support is needed to make the relationship safe enough.

In such cases, helper figures can be employed: a toy animal to watch over the field, or a crystal with "magic powers" placed nearby. Children need to have at least one focal point away from the Clay Field that makes them feel safe. To be resourced is the basis for all trauma exploration. It allows *pendulation* to a counter or healing vortex when things in the field get too intense.[6] It is always stabilizing when the therapist holds the field in place with both hands, which contains the relational experience and assures a child to be worthy of undivided attention. Abused children know the terrible loneliness when no one is there to protect them. The therapist's positioning—opposite the field, at the side of it, or even next to the child—may empower the child through an instant felt sense.

Situation 3: Haptic Questions

In the third situation, children will orient in the space in front of them with repetitive spontaneous impulses that usually have no conscious resonance. Depending on their constitution they will approach this environment with one of the following impulses, which we have gotten to know as the building blocks of the sensorimotor base:

- Skin sense asks: How does that feel? The flat hands are used for *sensing* the quality of the clay. They sweep in often circular motions determining whether the clay is smooth, hard, warm, cold, friendly, or harsh. This is rarely an objective perception but will reflect how the client feels.

- Balance as our proprioceptive sense asks: Where am I? The hands will orient in the space, touching the boundaries, the top and bottom part, and the sides.

The field is perceived as a space. Spaces can instantly take on a good or bad connotation, or just be there.

- Depth sense asks: What can I do here? The hands begin by testing the material: patting it, applying pressure, or drilling into it with one finger. These are usually simple rhythmic gestures that have no purpose yet.

In all three approaches, the need is to find a hold in the Clay Field, something that will constitute a basic trust in the relationship on offer, something that will give the child's hands orientation and something to hold on to. Only then the child can begin to actually enter this relationship.

The therapist can support this crucial initial phase through suggesting pendulation toward safety, if children perceive the field as activating and are anxious. The bowl filled with warm water can offer nurturing relaxation and meet early infant deficits if skin sense is compromised. Holding on to the sides of the box can give structure and a sense of being in charge of the field. Tools and marbles can have the same purpose. A toy figurine may have more courage than the child to make contact, or a doll can be asked for suggestions.

Children may use water to enhance their skin sense exploration. They might use alternating hand movements, such as diagonal strokes across the field or drumming with their hands on it, in order to gain a sense of balance through rotating motions, which will activate their inner axis. They may also use props to assist them to orient in the field, such as employing small toy animals as an extension of their hands in order to make footprints on the surface. These animals have no symbolic meaning in this context, but only assist in orienting in the space.

In order to actually enter the field with their hands, children need to negotiate a new level of dual polarity. They need both to have sufficient inner stability in order not to get lost in the experience, and to have sufficient flexibility to explore their curiosity. They need a basic sense of:

- gravitational security, a reliable hold within their body, so they do not fall over or off the chair

- core stability, which enables flexibility and inner balance, so they can reach out and explore something new

- trust in the haptic relationship on offer, so they do not get overwhelmed by fear

If you recall the example of the boy and the swimming pool, this stage might make more sense. A safe and internally well-organized child will now jump into the pool, just like a child will wiggle a little on the chair, and then begin to explore the Clay

Field. However, many of our clients are those who do not know how to swim, are afraid of the water, and experience this field placed in front of them as a destabilizing threat because they learned attachment and intimate relationships as unkind, overwhelming, or even harming them. They may brace, collapse, or divert attention, and yet they do want this relationship because to relate is a human need. In this case they need specific therapeutic interventions and resources to allow the repair of their asynchronous sensorimotor base, all of which has been discussed in detail.

If children are safe enough, they will now state their intention. This could be compared to adults stating the theme they want to discuss in this session, but children do this through haptic actions. They do, however, want these haptic questions answered. In order to understand a child's haptic question, the therapist needs to observe carefully:

- how the child's hands come into touch with the clay, how they connect with it, and how they avoid it

- how the child's body is organized in the tension between anticipation and fear

Haptic diagnosis reveals much about a child's needs at this stage. What can they do, and what do they long for? When I teach haptic diagnosis to my students, many are still getting ready for the session at this stage, while their client has already stated the most important question. This haptic statement of intention happens within the first couple of minutes, if not within the first seconds in the session, and it is important for the therapist to "hear" and perceive this question to understand the nonverbal intention of the child. This haptic intention will inform all further therapeutic interventions in the session.

Does someone use primarily the fingertips or the base of the hand, or can the full flat hand come in contact? If handfuls of material are taken, does the clay actually "arrive" in the inner hand? Only then will the child have a sense of fulfillment and competence. All children negotiate this stage with a mixture of impulse and resistance. Both can be observed in the hands, arms, and posture.

It is natural to enter any new situation with a particular mixture of anticipation and inhibition. Here, the hands reach out because they want something, yearn to connect with something, which, though undefined, manifests as an urge. But then there is the fear to connect, the holding back because of potential repercussions experienced in the past. The impulse to reach out is usually age-specific, a natural curiosity flowing from our libido. However, fears around safety or internalized, learned action patterns inhibit this impulse. This is similar to the toddler who is curious about something and runs toward it, but then realizes that the mother is no longer there, and suddenly the world is overwhelmingly large. Hence, the toddler begins to run back to mom, but

then again toward the point of interest, and in this way negotiates her ambivalent need for safety and her curiosity. Every time the hands reach into the Clay Field at the beginning of a session, exactly this conflict manifests. There is the curiosity to explore the symbolic world at hand, and the fear to get lost in it, or punished, or shamed. It is the therapist's role to facilitate age-appropriate support and encouragement, but beyond that, children have to discover their answers for themselves.

Let's look at a couple of children and how they commenced their session. We will revisit the same children in the following chapter to look at how they answered the question their hands projected into the field.

Each of these children orients at the field in a different way. The first child perceives the Clay Field as a space with the implicit question of: Where am I, and how can I have access to this world? For the second child, the field is a place for action. He orients with a motor impulse: What can I do here? The third child approaches it from a sensory perspective: How does this feel? The fourth child also asks a sensory question: Does this relationship nurture and support me?

FIGURE 19.2. Case 1: This six-year-old boy has been diagnosed with ADHD/ADD. He has trouble coping to live in a blended family of seven adults. In his left hand he holds an elephant, tentatively pressing it into the field. There is not a lot of tonus in his arms and hands. He is also positioning himself in a corner of the field. His question seems to be, how much space can he dare to claim for his world?

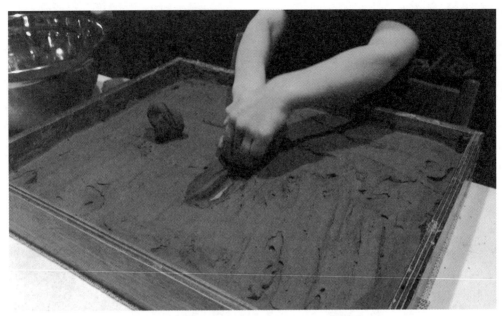

FIGURE 19.3. Case 2: This seven-year-old boy uses a lot of pressure, placing his hands right into the center and digging all the way down to the bottom of the box in one move. This is a statement about competency, but also like someone who feels the need to shout in order to be heard. His body radiates tension. Such an intense motor impulse lacks sensory resonance within him. He is someone not used to getting answers and overcompensates with acting out to get attention.

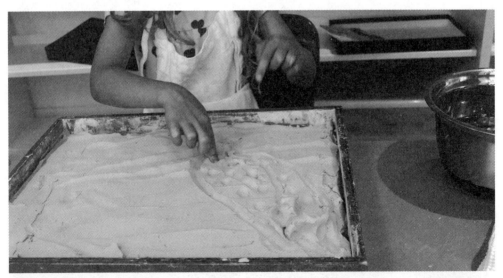

FIGURE 19.4. Case 3: We have met Sophie already ("The Unicorn Queen" on page 224 in chapter 14). She is seven years old. She touches the field with expectant yet hesitant curiosity. Only the index fingers are involved. Hers is a more sensory approach, assessing what is there, and if it is there for her to have. Her index fingers are full of anticipation while the others are lifting off the field and bent away from contact. Her knuckles are white with tension, and her elbows pull backward, away from the field.

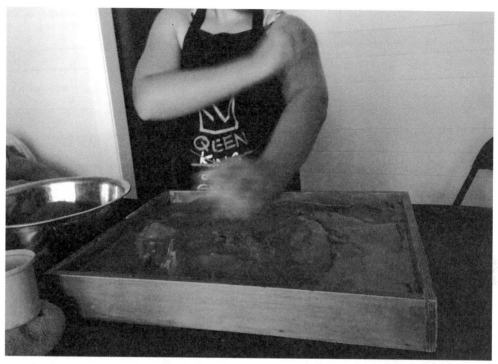

FIGURE 19.5. Case 4: As a first move, this eleven-year-old girl poured water into the field and then began to coat both her arms with slushy clay. She grew up in foster care. Her early childhood was chaotic and violent. She instantly rushes to get something while it is on offer, as if it could disappear at any moment. And whatever nurturing she can get she will have to provide herself. Hers is a question about being held. Can this or any relationship offer her a reliable hold?

The therapist can learn much about a child's constitution by observing these first movements of the hands, their tonus and way of connecting, and the body's posture in response to the action taken. Again, we have a dual polarity: the hands reach into the field, and the body needs to respond accordingly so the hands can make an impact. If the body lacks tonus for a child's age, it is utterly disempowering. If there is too much charge, sensory feedback will be compromised.

Situation 4: Finding Fulfillment—Haptic Answers

Children want to create, and they want to find themselves in these creations, which happens in situation 4. While children enter their question in situation 3, here they want to find the answer. The hands now need to acquire safety and trust on several levels:

- in one's own body as their internal, implicit world, which children organize as inner balance in an age-specific way

- in the Clay Field as a symbolic external world, in which they need to orient

- in the relational experience between the field and the self, facilitated by the therapist

- in the trust that the field will provide a hold that can support them when they project motor impulses into the field

- in the belief that the field will respond to them through sensory feedback

- in the mental assurance that they will be able to understand themselves better through this response

The hands need to find a hold. They need to find what Winnicott calls object constancy.[7] Object constancy is about trusting an other-than-me, finding safe love. For children who have experienced caretaker trauma, it is important that they repair the inner archetypal parents at this stage in order to find a safe way of loving. Trust is achieved through loss and retrieval, the experience that I can destroy and create; in fact, I can only create if I have the courage to destroy. Ultimately, we enter this process in the hope that unsafe experiences, insufficient parental care, and developmental setbacks can be repaired. The objective is to make the other-than-me relationship in the Clay Field a safe and nurturing one.

Let's revisit the four children in the context of the questions they projected into the field in situation 3 and how they answered them in situation 4.

Case 1: Now the boy has taken possession of the entire field. His left hand reaches exactly into the opposite corner from where he started. He has created a cave, which allows his hands to find a home. Of course, he would not have been able to verbalize his need in any conscious way. He would not even have had a plan of what he wanted to do. However, his initial contact tells that he is not confident to simply walk into

FIGURES 19.6–7. Case 1: The six-year-old boy diagnosed with ADHD/ADD whose hands asked about how much space he could take.

this world. He hides in a corner, making himself small. After thirty minutes, he looks capable and confident in the space he has taken up. There is a world that has received him and given him space to create, to leave his mark, to landscape, and to tell a story.

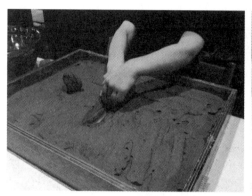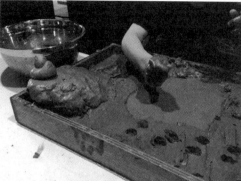

FIGURES 19.8–9. Case 2: This seven-year-old boy applies a lot of pressure scooping out a channel in the center, right down to the bottom of the box. His sensory response is filling the cavity with water, creating a deeply satisfying "lake of chocolate milk."

Case 2: This boy would have felt under a lot of pressure, which would have been his plight, his undefined "question." Once he has dug out the center, he takes great pleasure in filling the entire cavity with water. He squeezes it in with a sponge. His hands delight in the soothing, fluid, sensory experience this water world has given him in response. According to his mother, he suffers from anxiety and wets his bed at night. Here he takes charge of the water. But more so, the water is the element that responds to his need to be heard, to fill him with sensory nourishing delight.

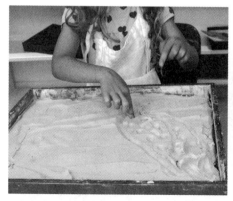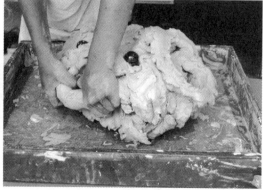

FIGURES 19.10–11. Case 3: Sophie is seven years old. In her first session, she visibly holds lots of tension in her body and only dares to connect with her fingertips. She experiences sensory overload and lacks motor impulses. During the session she becomes fully capable of handling all the material.

Case 3: This is Sophie's fifth session. She has learned it is safe to destroy. Here she relishes the possibility of squeezing and grabbing the clay, making tunnels with her fists, pushing marbles into it, and adding water. She is standing up to be able to exercise more power. Her hands are firm in her grip. This is no longer the "hypersensitive" awkward girl who does not know how to move. Here she acquires confidence in her motor impulses and competence in her actions.

While the boy in the previous case history could apply strong motor impulses but lacked sensory feedback to feel himself, Sophie lacked coordination in her body to be able to apply herself. For Sophie, her process of creative destruction led to a significant reduction of her anxiety. She became noticeably more confident at school. It is visible in the grip she has on the material.

In Case 4, the developmental need is for safety, for loving contact through the skin like a baby. She needed to be held by someone rather than nurture and hold herself, and when the therapist offered to pack in her hands, she remained in this cocoon for over ten minutes, feeling "blissed out."

I believe it is obvious that none of these four children would have been able to verbalize their need to anyone. They would not have known, even if they had tried. Yet their hands could clearly communicate their state of being in the world and what they needed to be more complete and more confident, to be able to come into being.

Deuser refers to the question that the hands ask in situation 3 and the answer the child gets in either situation 4 or situation 5 as an "echo."[8] The efferent motor impulse from the beginning of a session has to find an afferent sensory response. When such a response arrives in the central nervous system, we feel fulfilled and whole.

The theme of situation 4 is safe love; it has to be established before anyone can move on, whatever the age. Here we learn object constancy as the ability to trust an other-than-me. We repair relational trauma and relearn to trust.

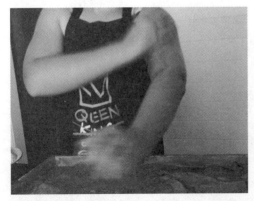 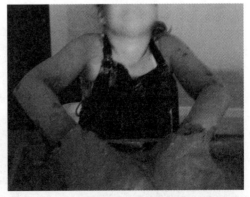

FIGURES 19.12–13. Case 4: This eleven-year-old girl grew up in foster care and instantly covered her arms with liquid clay.

Situation 5: Building My Own Base in the World

In situation 5, the meaning of the Clay Field shifts from an external "world" and a relationship with another to becoming an inner space and a relationship with oneself. Along with this theme of finding subject constancy, tentative questions arise about trusting the self rather than others. Situation 5 may arise on the brink of adolescence, when teenagers leave home and have to find their sense of self and place in the world.

Situation 5 occurs earliest from age eleven, when this challenge may constitute for the first time. It gains increasing momentum as teenagers grow into young adults. The theme is to understand the self and to position the self in the world. Adolescents are now coming into their own. They are no longer as dependent on their caregivers, and the world opens up in front of them, full of possibilities but also full of questions, dangers, and fears. How can individuals find their sexual, ethical, and moral identity? How can they find self-esteem and empowerment, especially at a time when their physical, emotional, and social identity undergoes rapid and dramatic changes?

Independence requires being able to trust the self. In situation 5, this process is dominated by gradual liberation from dependencies. Authority figures may get evicted from the field, onto the table or into a bucket. The clay gets sorted into me and not-me. Clay that feels disgusting or foreign or not-me will be taken out of the field. This gains particular meaning and intensity when clients have suffered physical or sexual abuse in the past. Abuse often prompts cleaning rituals. The box emerges as the only solid base that has survived it all and now needs purging before anything new can be built inside it. The empty box may be turned upside down to "start a new life," or the clay "moves out from home" onto the table.

Designs are dominated by centered configurations that illustrate the client's place in the world. These can be mountains or lakes or mandalas representing a homeland for the young person to arrive. All these are positionings of the self in the world, and in the process, adolescents become more self-reliable and begin to stand on their own feet.

Self-Perception as Intentionally Feeling

A last step here is what in adult sessions would be called *cognitive integration*. It is important for children to *perceive* what they have gained, to make the achievement conscious. In the bottom-up approach, this happens explicitly at the end of a session, when there is a new, quite often unfamiliar "weird" felt sense. This new implicit identity needs to be appreciated. This is the new you, the authentic you, that needs validation through the therapist. Children need to be encouraged to feel in their body

who they are, what they have gained, when they have fulfilled the need their hands asked for at the beginning of the session.

If we do not become aware of what we have accomplished, the Clay Field experience becomes equivalent to a dream we did not write down when we woke up. Or it's like when we eat a lot but then do not become aware how satisfied we feel, which is different from just being full. Feeling "full" needs the additional step to become a new cognitive paradigm of identity, such as: "I am able to have that much. I can do this." Pat Ogden calls the process "updating your belief systems." Children's belief systems are less fixed than those of adults, but they are belief systems all the same; otherwise children would not be as afraid or disruptive as they present in social settings.

This can be as simple as saying to the boy in case 1: "Look at how much space you can have." "What is it like to have this much space?" The boy in case 2 really wants to be seen and heard. Saying "Look how big a lake you have created. I think *you are in charge* of all that water" can address his bed-wetting without mentioning the issue. The seven-year-old girl in case 3 might like to hear: "Did you know you could be this strong?" "Amazing." And the eleven-year-old in case 4 stated herself that being held like this was pure "bliss." She might be ready to hear that, even though she did not have this as a baby, it is possible to have relationships where she can be nurtured and held. Such statements work best if the therapist picks up sentences the child has spoken, repeats them, and maybe reframes them as full sentences.

We saw in situation 3 how children have no words to explain their needs and fears. Most likely they have always felt like this, and they do not question their implicit identity. As human beings, however, we are "driven for meaning."[9] Through naming what has happened, by encouraging children to *intentionally feel* what has been achieved,[10] we support them to take back their projections into the field, and we enable them to integrate the insights as their own sense of self. Such awareness can significantly shorten the length of the therapy because the change has been internalized and owned. The importance of this point is not to be underestimated; it is a beginner's mistake I observe in many of my students. Because haptic achievements have been made, they are not necessarily conscious.

We can compare this tremendous developmental achievement to running along the beach and then turning around and witnessing that you have made those footprints. The prints are there, and you are here. No animal does that. Self-awareness is a unique human ability. Only in this case this is not only a visual but also a haptic experience. All children need to turn around at the end of a session, look at the field, and state in their own words: "I have made this." The step of taking a photograph of the completed field can be part of this confirmation.

PART 3

Case Examples

20

Working in Different Settings

In the following chapters, several art therapists who are friends and respected colleagues of mine have contributed their lens of insight. They are sharing various case histories that are designed to highlight different art therapy settings, such as in private practice, as designated social service providers, in schools, as mobile art therapists, and lastly in a psychiatric hospital.

Many art therapists know of the plight of working in unsupported environments. A colleague offered Clay Field sessions mostly for Indigenous children at a primary school in a troubled neighborhood. All the school would provide was the windowless storage space where the janitors kept their cleaning products. In addition, the door had to be kept open for security reasons, which meant hordes of children walked past the room at regular intervals. Another had been given a corner in the teacher's staff room right in front of the toilets. Others have to organize all their clay, clay fields, water bowls, and props on trolleys to move around to different locations every day. The fortunate ones have designated art spaces with many different workstations for clay, drawing, playing, Sand Tray, cubby houses, and cushions—a dream setting for the many underprivileged children these therapists see.

In Indonesia I worked sitting on the floor at the feet of a huge statue of Buddha with at least twenty villagers and a translator present. Therapists in Indigenous communities find that all involved are more settled if they can sit on the ground, preferably outside.

Indigenous boys from the camps surrounding Alice Springs will not come on their own. They do not trust adults. Many live in groups of underage children keeping each other safe during the night when the adults at home are drunk and violent. The

trauma-informed school they attend provides food, a place to sleep, and clothing, if need be. They will come to Clay Field sessions in groups of four, which gives them a sense of safety. And the doors of the therapy room have to be open to allow them all to bolt in case something triggers them.

At a school for children with behavioral and learning disabilities, the Clay Field sessions proved to be so effective that all sessions were conducted in pairs of two. Two children from the same class would arrive, each would receive a Clay Field, and each got their own water bowl and sponge. Even though they were sitting close together, these children generally became so involved in their own process that they hardly took any notice of what the child next to them created.

At another school, also for children with learning and behavioral issues, the sessions were conducted in a classroom setting with up to ten children present. Many of these children were normally extremely dysregulated and disruptive, yet present and attentive during their Clay Field sessions. Most had significant developmental needs, lacking basic sensorimotor skills, which was likely the cause of their frustrated acting out. Our observation, however, was also that they had different developmental abilities. One could tunnel, for example, and one by one every child would observe the one tunneling and then try it out themselves. These children started to teach each other the developmental building blocks, something they desperately wanted to learn. It was inspirational to watch. The teacher was there to witness and support, but mostly these children needed a safe, nonjudgmental space where they could explore what they needed in their own time and in their own way. Lyn Duffton, who facilitated these classes, states: "Something I learned from this group of special needs students is how important it is for them to take ownership of the session. Once this happens, they work with more freedom, a greater trust in the material, and the ability to let go within the field."

Another art therapist taught Clay Field at a secondary school for severely disabled children. All these teenagers were in wheelchairs; many were restrained due to regular epileptic fits or self-harming behaviors. Still, each child was given a Clay Field, including the teacher-therapist. Due to their disabilities, the teenagers could hardly move, except to pick up tiny bits of clay from the field, but the teacher worked her Clay Field in front of them, slightly dramatizing her movements, while making eye contact with the group. I actually cannot say for certain what happened in these sessions, but the school enthusiastically supported them because all the teenagers, who normally had up to four epileptic fits per hour, stayed fully present and incident-free during the Clay Field classes, and in the filmed recordings, they are all smiling. I have had similar experiences with amputees, where these clients had a fulfilling felt sense

experience through their mirror neurons when I worked in the field on their behalf, based on their instructions and intuited needs.

Lyn Duffton writes:

> For many individuals with special needs, there is an acute sense of failure. This sense of failure is further exacerbated during therapy sessions when there has not been sufficient time taken to create a social relationship. To some, this time-taking might seem a superfluous requirement; indeed, many therapists may feel it crosses professional boundaries. However, if you want the session to have depth and meaning, there must be an authentic relationship between the client as the inquirer and you as the companion. The therapist accompanies students on their voyage of self-discovery, and those with intellectual challenges have just as great an interest in self-development as anyone else; in fact, maybe even greater interest because they know they are marginalized and they also know it's because of who they are.

> With the positive movement toward greater social inclusion within the community and the emphasis on notifying and educating students on what they need and should expect from their caregivers have come other challenges. We now expect more input from students with additional social and intellectual needs, but they do not necessarily understand these expectations. When clients are referred because of behavioral issues, which is often the case, we need to unpack what has been happening to understand whether the issues are a direct result of their diagnoses or from not being able to meet the expectations placed on them, and which are therefore distressing the clients. In the latter case, we can help students to communicate their needs more clearly.[1]

Some teachers working with small groups have to make sure certain rules are in place. One rule is that each child is given a bucket to discard clay or to fire clay cannonballs into it to discharge aggression, but there is no throwing of the clay; there is no interference with another child's field; there is no commenting on another's creations. Over time we have found it helpful to create colorful cardboard lids for the Clay Field to make sure children do not start before everyone has settled. Then, all at once, they can all lift their lid and begin.

Most Clay Field sessions, though, happen as one-on-one sessions, and most likely have their deepest effect in this individual relational field between therapist and child.

In schools the teachers recommend Clay Field Therapy sessions with the permission of the parents. In private practice it is usually the caregiver who contacts the therapist, or social services might organize the sessions and then ask the child's caregivers to bring the child.

Different settings have different requirements about record-keeping and how the therapist receives the necessary information about the child's problems. There are issues around how this can be conveyed in a respectful manner while the child is present or not.

We have begun worldwide to apply the Art Therapy Star (fig. 20.1) as an assessment tool because it is not language dependent. It can be filled in jointly by the child and the teacher or caregiver, and children can monitor their progress as their star grows. Faculty member Chris Storm developed the model, and it has been successfully adapted to fit the international requirements for Clay Field Therapy.

The ten boxes around the star can be filled with areas of concern and the child's accomplishments. Both then rate each star spike from 0 = low to 10 = high and connect the dots. This exercise can be repeated on a monthly or three-month basis in order to discuss progress and remaining areas of concern. Many children express pride in witnessing their star grow.

We are currently working on an international quantitative research study that includes the star because this model has the advantage that the assessment has a visual component and is not solely language-based. Let's now begin with the journeys of some children in various settings.

Art Therapy Star

Name: _____ Date: _____

FIGURE 20.1. Art therapy assessment star.

21

"I Love the Clay and the Clay Loves Me!"

PHILIPPA ROSE

Sammy is having his second turn at the Clay Field. It has been five months since the first session. The program was interrupted not long after it began due to external events, but now I am back at the preschool, and nearly four-year-old Sammy has come to his session with great enthusiasm. In the first session he made it quite clear that he wanted "another and another and another turn," and he hasn't forgotten that enjoyable experience.

The clay is still in blocks in the box waiting to be spread, and Sammy comes straight in, sits down, and grabs handfuls from the nearest block, saying, "Hands are chomping the cheese. Chomp, chomp!" Not long after this, as he explores the clay, finds finger holes, then takes more handfuls from the wet slippery blocks, working them from hand to hand, Sammy joyfully announces, "I love the clay, and the clay loves me!"

After a pause, he adds, "because the clay is real." Then, thoughtfully, he starts to list other things that are real: "The school is real; we're real ... everyone's real." I wholeheartedly agree!

In a discussion with the preschool teachers a few weeks later, they say that the sessions have been very helpful for Sammy. He has experienced some difficult family conflict and the separation of his parents earlier in the year, and the teachers observe that he can be "a little bit lost" when he arrives at preschool, coming from Dad's on some days and Mom's on others. Compared to other children, Sammy often seems floaty or

dreamy and can be "moody, or just not easy to read." Perhaps with the dislocation he has experienced in his family life, Sammy is less connected to where he is in present time and space than others. The spontaneous joy with which Sammy proclaims that "The clay loves me" just as much as he loves it is a delightful affirmation and echo of what Deuser means when he says, "In Work at the Clay Field, we touch something, and are ourselves touched…. We experience ourselves by the other, and the other only by ourselves."[1] Elbrecht puts it this way: "Through grasping the clay, I grasp myself. The material reflects. It gives feedback about every impulse of contact."[2]

The fact that Sammy expresses his feeling of love for the clay, and simultaneously receives as feedback a sense of being loved by it as he feels it between his hands, brings him immediately to the profound realization that this is *real*. He is here, now, alive and present in his own body, and he is touching and being touched by real clay. He is at the real preschool, with me, another real person beside him. Best of all, he is so happy to find himself here.

After several more sessions, the teachers confirm that Sammy does indeed seem to be more confident, grounded, and at ease as a result of the clay work. They note

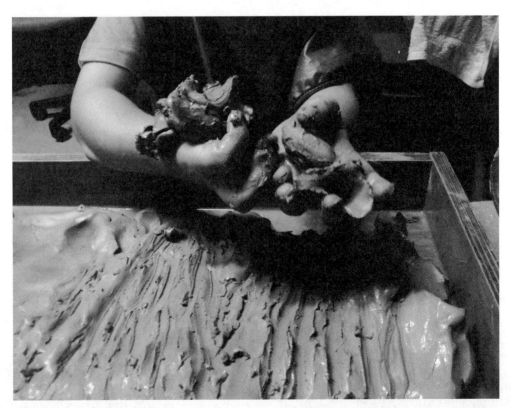

FIGURE 21.1. "I can take all this."

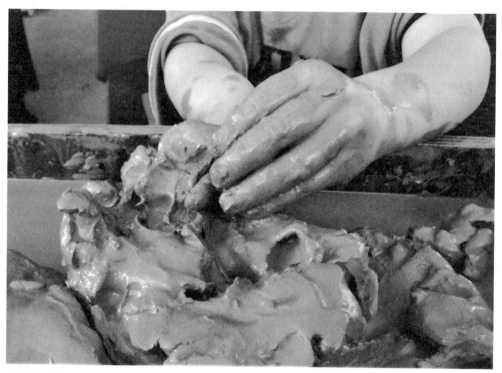

FIGURE 21.2. "I love the clay, and the clay loves me."

how valuable it has been for him to have the one-on-one time, which allowed him to "slow down, and go at his own pace, with no expectations." His mom, who came to watch us begin one of the later sessions, and who at the end of the year (with Sammy's permission) viewed my video clips and photos of the whole sequence of sessions, is amazed at the accuracy with which some of the family dynamics have been unconsciously revealed and then dealt with in the clay sessions, and delighted at the sense of achievement and confidence, alongside the joy, that Sammy has clearly derived from his clay play. She leaves our final meeting to go straight to the local pottery supplier, in order to get a block of clay as a Christmas present for Sammy so she can provide him with similar sensory experiences at home.

The Monster

The effect of the clay work has been no less helpful for "Damien," another preschooler with a very different personality. This little boy has an overabundance of energy. He is overflowing with ideas and plans, imaginative games, and constant chatter as he works at the clay.

In his first session, Damien loses no time in using up all the clay to construct a monster. He tells me all about it as he works: "He has a curly tail, and he squeezes up water, and he has a waggy tail, and he has scary eyes and a scary mouth, and a scary, scary nose, and he is ... a yucky and gooey slug monster." After all this effort, Damien rests, momentarily silenced.

In the second session, he asks for my help to make a dinosaur. He spends a long time lovingly shaping the smooth body with his hands and carefully forming the face with his fingertips, after which he holds up his cupped hands and says proudly, "You know what? I made that big tummy with my hands." He indicates the curved shape of his hands, and how that is echoed by the dinosaur's bulging tummy.

This is a great example of depth sensibility. Damien's imaginative and constructive actions in the clay have undoubtedly given him a sense of competence and power as he took full control of all the material, shaping it into upright sculptures. The teachers remark that for Damien, who has so much dynamic creativity they find it hard to keep up with him, the clay has been an ideal way for him to channel and focus his energy.

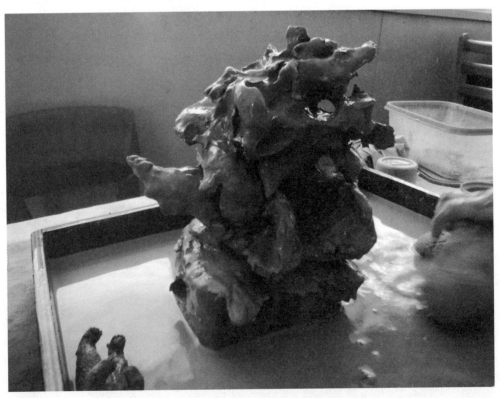

FIGURE 21.3. The yucky, gooey slug monster.

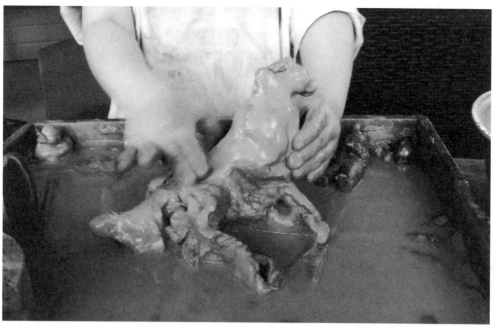

FIGURE 21.4. Smoothing the dinosaur.

Separate Homes for Duck and Bear

Another child at the preschool—let's call him Christopher—is a cheerful, easygoing boy who has had to deal with a lot of distress over the year.

In session 1, before he is really able to connect his hands with the clay, Christopher takes the bear and stamps its footprints all over the surface, then pushes the bear into the clay up to its hips. He pours water around it, then all over the clay. Once the clay is wet, his hands connect. Soon he decides to create a pool, center front, in which the bear can lie down. I show him how to do the walls, and he takes over. Gradually the walls of the pool are made thicker and stronger, and Christopher takes more and more control of where the water should go, using the sponge and cups. After a while, the pool is big and strong and very full, while the surrounding area—the rest of the box—is almost dry. He finds this very satisfying. Christopher has learned he can push and pull the clay the way he wants it.

As with Sammy, for session 2, five months have passed since the first session. At this time the teachers share with me that Christopher is experiencing a lot of "family trouble"—the parents are going through a very unhappy and argumentative time.

Christopher has an incredibly energetic session, burying and digging up duck and bear, over and over again, and in the process "chewing" through all the clay. He shows total and full engagement with strong busy hands, breathing heavily as he works his way through all the material in the box. It seems as though he really is processing the inner turmoil he must be experiencing. At the same time, the repeated experience of "gone, there" with the toy animals is reaffirming his sense of trust, as the figures disappear but then are found again. Eventually he remembers the big strong pool he made the last time, and replicates that.

By the time Christopher comes for session 3, I am told by the teachers that there is still major family conflict, but his parents have now separated and live in different places. Christopher has shared this with his teacher, who reassures him that although things will be different, it doesn't mean his parents love him any less. At no point does he mention it to me.

He has another energetic clay session. This one focuses for a long time on making a pool, with lots of water in and water out again. He loves the way he can use the sponge to control this. Then, quite suddenly, he has created separate caves for duck and bear. He even finds a third "baby cave" behind the duck's cave and creates a clay baby to go in that one. Duck and bear are put in their caves lying down to sleep,

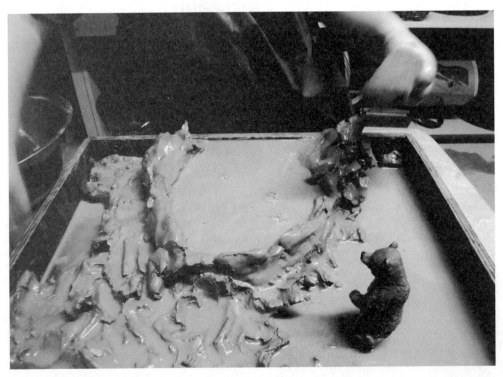

FIGURE 21.5. A big pool for bear.

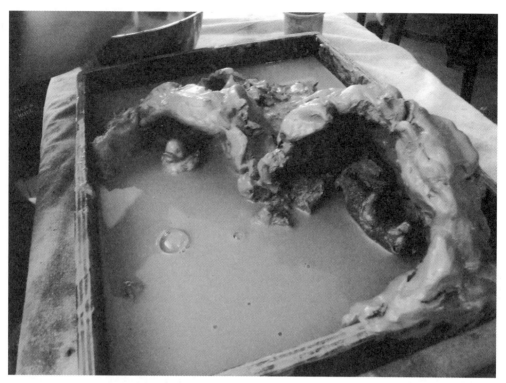

FIGURE 21.6. Separate pools for duck and bear.

and Christopher repeats several times, "Make sure you don't break this. I mean it; don't even break it." In this way, it seems to me, Christopher is finding some sort of resolution: a nonverbal, felt sense of coming to terms with the new, different family circumstances. However, he will still need time to integrate this. After a short time, he destroys the caves himself, and then exclaims, "Oh, no! Let's build it again." We start to, but this action quickly changes into duck and bear being buried under all the clay, before they are retrieved, and at the very end of the session, they are actually reunited in a pool.

Perhaps, with this final action, Christopher is maintaining an inner archetypal space where both "parents," duck and bear, after being destroyed and then resurrected, are able to be together.

Work at the Clay Field with Older Children

I am always intrigued by the way children of different ages interact with the Clay Field setting. In my experience, preschoolers of ages three, four, or five will accept exactly what is on the table in front of them—the clay, the water, cups, the sponge, the duck and the bear—as "This is what I get to play with here today." The nine- to

twelve-year-olds I've worked with, however, do not necessarily accept those limitations. "Haven't you got any tools I can carve this with?" I hear. "I need a knife or a digger." If there is only a duck and a bear, they will ask, "Aren't there any more animals?"

It is very important to note, as a rule, that it is not advisable to combine Clay Field and symbol work, or to offer more things to play with, as this can allow children who may already be dissociated due to trauma to avoid touching the clay. It is the full hand contact with the clay that we want to encourage. Rather, I suggest we make the needed figures out of firm clay. However, the following case of Elizabeth is an exception. This child, with her high level of energy and strong will, whose hands had already been busy sculpting and creating forms in the clay, was clearly going to do everything with great speed and intensity, so I followed her lead and offered more animals.

The Safe Zoo

Elizabeth was nine when we started, ten and a half before we finished. I saw her weekly during school terms for almost a whole year. The referral from her school said: "cumulative behavior issues, angry outbursts, lack of confidence, oppositional behavior, disorganized, extreme moods, taking others' belongings." We covered a whole range of emotional resilience strategies and art therapy approaches in our time together, but the two Clay Field sessions she completed during the first month were, I believe, highly significant, especially in light of her family history:

Elizabeth and her older brother were brought up by their mom, Leah. When she was just three months old, Elizabeth's parents separated; the father left the mother, but also kidnapped the baby. With her own parents and police assistance, Leah tracked them down, and after three or four days of separation, managed to get Elizabeth back. In her own words, it has been an "ongoing battle" ever since.

Following family court orders issued when Elizabeth was three, she has spent every second weekend plus half of each school holiday with her father, his partner, and her children. Although she looks forward to seeing her dad, the dynamics in his home have been continually challenging to Elizabeth's sense of safety. Leah notes that it always takes several days for her to settle back into home routines after each visit, and she feels that this recurring disruption is what prevents her daughter from being able to express or regulate how she is feeling. While Leah's goals include helping Elizabeth deal with her anger appropriately, we acknowledge the challenge involved, given that she has no power to change or control the events in the other household, or the unpredictability of the fortnightly visits.

My first introductory chat with Elizabeth reveals a vast knowledge of, and a deep love for, all animals. I hear in great detail about all the animals and pets in her life at both houses. At our second meeting, we go straight to the Clay Field.

ELIZABETH: SESSION 1

Elizabeth creates a pool in the middle for the duck; this gets modified for the bear, and they occupy it separately, never together. She asks if there are more animals to make a zoo. We find some in the cupboard. She chooses a crab, a dolphin, a lion with a cage, and later a big dog to be the patrol as well as two smaller dolphins.

From there, it's fast and furious work for the rest of the hour, creating pens, fences, and pools for each creature. The original pool needs to be stretched and expanded for the big dolphin. Once the enclosures are done, the lion is craned in, in his cage, and carefully released. The bear comes in, encased in two plastic cups. A pool for fish is added to his area.

Everything is very secure, separated, and safe, and to make sure, the big boxer patrol dog is given a platform at center front, above the dolphin pool, where he can survey everything by rotating his head, plus three small clay human figures are formed and placed on the ground outside the cages to keep the animals in and people out. Elizabeth asks if it can be left up to keep going next time; it can't, so we take photos in order to reconstruct it.

ELIZABETH: SESSION 2

Again, Elizabeth works with astounding energy and speed, keeping up a running commentary all the way. Another great story unfolds, with the many animals being assigned to their enclosures, and baby animals in with their mothers.

However, despite all the effort put into keeping everyone safe, a fire-breathing dragon, lurking beneath the unicorn's watchtower, comes out and challenges the unicorn for leadership. It takes control, and during the night, when all are asleep, the dragon removes the small animals from their mothers and hides them outside the box.

On waking, the mother lion and dog are furious. They break down the walls of the lion's cage and fight off the bears, who are trying to stop them, and successfully retrieve their babies. Dragon is defeated and sent back to his cave. Unicorn is reinstated as the true and just ruler of the zoo. The walls are restored, and the rescued babies are taken directly home with their mothers, or kept safe with unicorn.

Elizabeth has possibly heard the story of what happened to her as a baby many times, but she certainly didn't come into the session with a conscious intention to act out a version of it with symbols in the clay. It was not something she was talking

or thinking about, as her hands worked and the narrative unfolded. My feeling is that it arose from her very deep and felt sense of the need for all babies to stay close to the protection of their mothers, and that there can be forces that will try to come between them. This sense was finely sharpened on account of that early traumatic experience, and it resides deep within her preverbal memory, her body memory.

FIGURES 21.7–8. Enclosures for mothers and babies in Elizabeth's session 1.

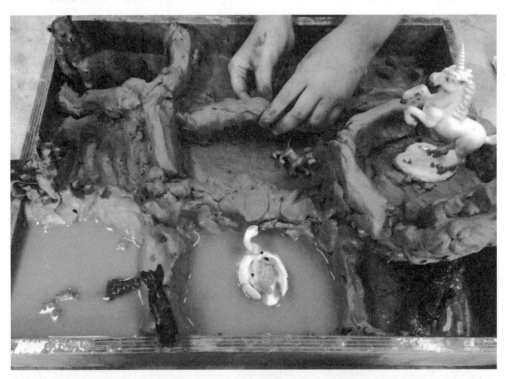

FIGURE 21.9. The following week, Elizabeth is very keen to keep going with her clay work and continue the zoo story. She is delighted to see a greater array of animal symbols and chooses many, giving them all a bath in the bowl before commencing the work. She then re-creates the zoo with lots of compartments, but this time starts with a great watchtower for the unicorn to stand on and keep guard.

The reconnection to self through implicit memory that contact with the clay can provide is, I believe, what allowed Elizabeth to access this biographical material and bring it to the surface for conscious expression, completion, and, in this case, a happy confirmation that separated mothers and babies will be reunited. It allowed this to happen in a playful, gently restorative, and extremely satisfying way.

Toward the end of the year, after Elizabeth and I have worked together using various therapeutic techniques, which helped address some of the trauma she has experienced on the visits with her father and stepfamily, she announces on arrival one afternoon, "I think I'm finished." Then she adds, "I don't want to stop coming, but I haven't been angry or in trouble or had a meltdown for ages." Her teacher tells me on the phone that she has been much more regulated and settled: "Overall there has been a massive decrease in the intensity and frequency of flare-ups from Elizabeth at school." Her mother is surprised and delighted when she not only participates in the class concert but takes a primary role, and comes home the same week with awards for responsibility and leadership.

Self-Nurture

Hilary is an eleven-year-old girl in her final year at primary school. At my first meeting with her mother, "Hannah," I learn that Hannah's own childhood was very traumatic: she shared with me that she was "born a junkie baby," grew up in foster care, and survived several sexual assaults as a small girl. Hannah has had ongoing health challenges as an adult. After she became a young mom with Hilary, Hannah found herself once again in a situation of family violence. It got to the point where she voluntarily put Hilary into care for a couple of years, around the ages of three to five, as she felt this was the only option for keeping her daughter safe. Hannah was eventually able to end the destructive relationship she was in, and Hilary was restored to her, but she acknowledges a lack of attachment and bonding between them. She comes across as a conscientious parent, willing to do her best. She specifically requests that Hilary gets some help managing her angry outbursts.

Hilary goes to a psychiatrist regularly, as well as various other medical appointments. She has been diagnosed with chronic radical attachment disorder, ADHD, depression, and anxiety. Hannah says she struggles with schoolwork and can be a "very pushy and needy kid." When I meet Hilary, she seems a bright, cheerful, engaging child, certainly very used to adult attention, seeing therapists and specialists. I soon learn that she indeed tries to assert control in any situation and deliberately does "provocative" things to see how far she can go with me, how much she can "get away with."

After a first get-to-know-you session, where Hilary did some drawing and clay modeling as we talked, she spent the next three sessions at the Clay Field. The following commentary is taken directly from my case notes.

HILARY: SESSION 1

Hilary starts off keen to explore the clay with her hands, adds water, brings in a bear and a duck, then buries the bear in mud "to get his anger out." Within minutes, she is suddenly coating both her arms in smooth creamy clay, right up to her shoulders. She leaves it on for rest of the session.

Soon after, her right hand begins packing her left hand in the clay and smooth-coating the arm, again right up and into the armpit. The right hand continues to work, digging, bringing water in with cup, while the left hand rests in the cave, eventually coming out, then going in and out a few times. Next it is the right hand's turn, in the same spot. The left hand buries the right hand and smooths clay around the wrist. When done, both hands work together for a while on an enclosure: a "warrior fence." Toward the end of the session, I offer to pack in both her hands, and she spends the last five or ten minutes relaxing blissfully, with clay-coated arms, eyes closed, smiling.

HILARY: SESSION 2

While talking of the sadness around her biological dad and his dismissive treatment of her, Hilary creates a small snowman, "Olaf," in clay, then brings Bear in to act out a little dialogue: the snowman is sad because he has no friends; Bear befriends him. He is kind and reassuring. Putting the two friends to the side, she then digs out a square pool, fills it up with water, destroys it, and asks if she can put her feet in the clay.

I prepare the floor with tarps and towels and Hilary sits in the chair. She rinses her feet in the bucket of warm water, then steps them eagerly into the clay, moving them back and forth to create foot pools. We add more warm water; she bends down and, using both hands, proceeds to coat each leg in smooth creamy clay, all over, front and back, and right up to her shorts. She then sits there happily for several minutes before equally attentively cleaning it off again, one leg, then the other.

HILARY: SESSION 3

Hilary carves out a diamond shape with a plastic card, and digs it out into a pile, which becomes a long thick lump in her hands. She wants to rub it on her face, and does so, using the clay as a crayon and dipping it in water, starting with her forehead. She talks all the while about her upcoming baptism (this was Mom's promise to Great-Grandma before she died). The clay lump is then formed into a small tower with a thick base, a ball is carefully attached to the top, and a thin rolled strip is attached over that; she names it "Angel." I ask Hilary if she wants to say anything to

the angel—straightaway she answers "Bless me." That done, she continues to "color in" her face with her fingers, until it feels complete. I take a photo to show her. Only her eyes and mouth are left uncovered. We go to the bathroom so she can see herself in the mirror. She washes the clay from her face very carefully and thoroughly, announces she's finished, and asks if she can draw now. While drawing, I ask her if she has a feeling that her great-grandmother is watching over her. She does. We keep the angel.

Here we have a child, Hilary, born to a mother who herself had no positive experience of early attachment or bonding. We also know for certain that as a young infant, this girl experienced a degree of trauma, and then a complete disruption of the bond with her mother during her early childhood.

Now, in three consecutive sessions, Hilary has spontaneously and completely covered her arms, which included tending gently to each hand in turn, then her legs, then her face, with soft creamy clay. Without discussion or any suggestion from me, these actions of Hilary's occurred spontaneously, in response to her felt need, through a purely natural urge or instinct. In a restrictive setting such as a classroom, a child acting this way—for example, painting her face during an art lesson—could indeed easily be labeled as someone deliberately trying to be "naughty" to make a mess. In this therapeutic context, however, Hilary's actions can clearly be seen as an expression of that unerring drive children have to complete their unmet sensory needs when the opportunity is presented to them. Certainly, this was done by Hilary with an adventurous, life-affirming, try-anything-to-see-how-it-feels spirit. And she does have a cheeky sense of mischief about her, but it was this urge to fully experience everything on offer, combined with her reliable sensory impulse, that allowed Hilary to just go for it. The impulse, and permission to follow it in the Clay Field, is what allowed her to "feel herself," covering herself in clay, exploring and defining her skin boundaries in a way that clearly gave her a sense of, "This is who I am. This is me! I am alive, and I'm here in my body." It was delightful to observe.

After these sessions, Hannah confirms that not only has Hilary loved coming to them, she has also been a lot happier at school and is having fewer angry outbursts at home.

Clay Field Therapy in the School and Preschool Setting

I work in the community sector at two local community preschools, and I am also part of a program delivering early intervention mental health support for children and families, both with a significant proportion of Aboriginal and Torres Strait Islander families in their enrolment.

As in most therapeutic settings, my role as a facilitator is to stay present and aligned with the child throughout their session. This means engaging in their imaginative play, encouraging them through conversation, and guiding or else narrating their actions, if that feels more appropriate. Most importantly, I am paying attention, observing the hands, and making suggestions accordingly, offering to help build structures, dig out material, or bury their hands—basically allowing and supporting them to follow through whatever impulse is presenting. Often there is a story, a narrative being created, and then I will participate in furthering that—for example, by digging dams or building mountains—howsoever the child requests. As with adults, I encourage rhythmic movements, exploration, and complete hand contact with the clay.

I keep a record of the process by taking photos and mini videos regularly throughout the session, and go through these soon afterward, following up with written notes to describe the main themes of the session, including anything of significance the child has said.

Like all counselors, therapists, and teachers, I am bound as a mandatory reporter to notify appropriate people if I witness direct disclosures of abuse or risk of harm. Outside of this requirement, and as long as it is not breaking the child's confidence, the notes and photos I take can be important feedback for parents and teachers. Here, however, I will just make general observations; I am always very careful about jumping to conclusions, extremely cautious around making any diagnosis or analysis of the child on the basis of a clay session, for obvious reasons.

First, I am not clinically qualified to do so—this is sensory play, not psychiatry! Most importantly, though, it is because with all expressive therapies, and especially with Clay Field Therapy, it is the work itself, the tactile engagement and following through of the sensory motor impulse, that allows for the healing of underlying trauma and restoration of unmet needs. As Elbrecht and Antcliff conclude:

> The body remembers. It remembers its injuries and traumas, but it also remembers its needs, its instinct to survive and to heal.... The hands are representatives of the body in the symbolic world of the Clay Field. They are capable of finding solutions by connecting with the most ancient parts of the brain in an often astounding and creative way.[3]

My colleagues in both social work with children and families as well as in education who have observed children having Clay Field sessions with me are continually amazed at how this work will "hold" a child when nothing else will keep their attention; some who are known to "stick at nothing for more than five minutes" will happily spend forty-five minutes or more at the Clay Field. People are always impressed by how focused, and often calm, children become when they sit down at

the clay: how their breathing changes, and how seriously some of them take it, as if it is indeed their "work."

There is great interest and increasing demand for more knowledge about the method, its development and theoretical background, plus the tools and equipment needed for Clay Field sessions. One of the preschools I work in immediately ordered two boxes to be made—not so they could try to replicate Clay Field Therapy, which requires a trained therapist, but so they could offer children who might need soothing or settling simple sensory play with clay and water in a contained space.

It is my intention and hope that the contribution offered in this chapter will add to a wider understanding of how this incredibly simple but extraordinarily effective form of sensorimotor art therapy allows children to fulfill their developmental needs; how Clay Field Therapy allows people to work through challenging issues or events in their lives, to safely integrate and help heal traumatic body memories without necessarily needing to revisit or talk about them; and how it can assist people of all ages to arrive at a recognition of their own resilience, a clearer sense of their own worth, and a stronger, embodied sense of self.

Mobile Clay Field Therapy: Setting Up a Session

Equipment list: to be mobile, you need a strong trolley stacked with the following:

- clay: smooth, nongritty terra-cotta or white clay, packed in large plastic lunchbox-style tubs with lids that seal firmly. I take one tub for each child I am going to see. Ten or twelve pounds of clay formed into blocks will just pack into a three-quart tub. I find this is enough for three- to five-year-olds, who almost always use lots of water. Older children can have fifteen to twenty pounds of clay (fits into a five-quart tub). Often I have the child help me spread the clay blocks out across the clean box.

- clay field boxes: marine ply, made to specifications, and coated with multiple layers of floor varnish. These need sanding back and recoating every couple of years. One box is enough if you can allow time to take out the wet clay and clean and dry the box between sessions. If timing and timetabling demands back-to-back sessions in rapid sequence, I take a few boxes.[4]

- tarps: house-painters canvas drop sheets to protect floors and tables if working indoors.

- towels and T-shirts or art smocks: I take my own and bring them home to wash.

- buckets: two sturdy three-gallon buckets.

- hot and cold water within easy access; a thermos if access to hot water is difficult.

- bowl: stainless steel or plastic.

- sponge and cups to easily bring water in and out.

- duck and bear small toys: useful as mother and father archetypes. Children will use them if they need to.

- I also keep on hand, but don't necessarily offer, sticks, clay carving tools, marbles, and crystals.

- plastic cards, such as expired credit cards: invaluable for scraping wet clay back into the tubs.

- camera: I currently use a small waterproof camera to take photos and mini videos (up to sixty seconds) during sessions. It is always set on silent mode so as not to interrupt conversation or concentration. Smartphones are useful too, but you risk getting them muddy.

Processing wet clay for reuse: To return a tub full of wet sloppy clay to blocks of just the right consistency, the secret is to spread it out on a plaster of paris slab, or "bat"—simple to make with about six pounds of plaster and a mold; instructions are easy to find online. After a couple of hours or overnight on the bat, depending on the wetness, the spread clay will be firm enough to pick up, flip over, and work back into blocks. Store these in cleaned airtight tubs, ready to use again.

For hygiene and health safety in the post–COVID-19 environment, I keep separate sets of clay and sponges for each child or client, storing it in tubs labeled with their names to ensure that no one else touches it. We use paper towels rather than cloth and thoroughly clean the toys and tools between uses. When all their sessions are over, the child will get to keep their clay.

A Case Study in Developmental Trauma

CHRIS STORM

Developmental trauma has been defined as multiple or chronic exposure to one or more forms of developmentally adverse interpersonal traumatic events, such as abandonment, betrayal, physical assaults, sexual assaults, threats to bodily integrity, coercive practices, emotional abuse, and witnessing violence and death.[1] Research has also shown that adverse childhood experiences are not only extremely common, they also have a profound impact on many different areas of functioning.[2]

This case study focuses on Jack, a seven-year-old boy with a history of threats to bodily integrity, emotional abuse, witnessing violence, and experiencing neglect. He had been taken into full-time kinship care with his aunt and uncle following the discovery of this neglect and family violence that alerted authorities and the subsequent intervention by child protection services.

Overview

Jack's caregiver aunt contacted me explaining that Jack had experienced a troubled upbringing and that they, Aunt and Uncle, were now full-time caregivers for Jack. Aunt was concerned that Jack needed to have access to therapeutic support to assist him, as it was her belief that this grief arose following the intervention that resulted in him living permanently with them.

Jack was the youngest of four siblings, with two deceased brothers and a sister. The middle brother died at six months of age from sudden infant death syndrome, and his eldest brother died at age twenty-three. Jack's story begins with the purpose of his conception, which was to provide umbilical cord blood support for his eldest brother, following the brother's diagnosis of leukemia when he was thirteen years old.

As time progressed, more information was revealed about his situation, including that Jack had experienced severe neglect resulting in a statutory intervention. One example of this was at just over two years old. Jack was found wandering the streets at night searching in rubbish for food.

His aunt and uncle were experienced foster caregivers and had fostered many children over the years, some of whom still were considered members of their extended "family." The uncle's family is quite fragmented, with a long history of conflict and tension, and only some family members remain in contact, resulting in them not being aware of Jack until the statutory intervention occurred and they were contacted as a potential placement for the boy.

Jack—Lives with Paternal Uncle, Aunt, and their child.
Family contact occurs only with those outlined in black.

FIGURE 22.1. Genogram.

After an initial assessment and intake session, where various modalities were discussed with Jack's aunt, it was decided to proceed with Clay Field Therapy as a strategy to support Jack's nervous system and assist with processing of the known adverse experiences from childhood.

FIGURE 22.2. Meeting the field for the first time.

Session 1: Finding Safety in His World

Jack entered the therapeutic space as a very quiet and timid boy. Time was spent gently showing him the field, finding a T-shirt smock to fit him, inviting him to assist in filling the water bowl, and checking in with his level of comfort and whether he would like his aunt to be in the session with him.

This gentle building of the therapeutic relationship was important, as Jack had the presentation of someone unsure of the world around him, and establishing safety became the priority in these initial stages. The Clay Field was then introduced to Jack with the explanation that he could do anything he would like to do, with the exception of throwing material around the room. Jack sat silently at first, making lots of eye contact with his aunt for reassurance, and appeared unsure of being able to exercise his own choices. He was initially quite tentative, only lightly touching the surface of the material and seeking out the water to rest and clean himself after each interaction with the clay. Eventually, with encouragement, he progressed to interacting more with the material and the warm water. He appeared to settle into the activity using

the water until he announced that he needed some more water to work with. Jack used his T-shirt smock to wipe his hands throughout the session, every time he considered them to be dirty. He continued to do this until he found a level of trust with the field that allowed him to venture further.

As the session progressed, he became more engaged with the material and started to experiment with various ways he could shape and move the material around. Jack spent some time shaping "Toothless," a dinosaur, from the material, adding more and more water. When he announced that he was done, he was asked to tell the story of Toothless the dinosaur. When asked if Toothless had any friends, Jack then decided to make a water snail friend, Angus, and he then engaged Toothless and Angus in a game of "water tiggy" together.

As he relayed his story, Jack said that the water snail was always angry, but not with Toothless, and then placed them in their own parts of the field. The session ended with Jack creaming the clay up his arms to make some "gloves" for himself, an activity that brought some satisfaction. Jack left the session more relaxed and asked to return again.

It is important for a child who has a traumatic history to experience emotional and physical reliability and safety in a fundamental way, especially through the core senses through skin sense, depth sensibility, and balance. In his process, Jack was

FIGURE 22.3. Self-care and nurturing.

engaging in lots of activity with water. As Jack had experienced a lack of natal and postnatal physical needs being met, it is through touch that he begins to find a way to engage in processes to satisfy this need for nurturing self-care experiences.

Session 2: Finding Meaning

In his second session, Jack was much more confident in how he approached the field and the material. He had given some thought between sessions to what story he would like to develop, and in doing so eventually processed the material both inside and outside the box. His final symbol came after he was given a fifteen-minute warning of the finishing time, and he created a Christmas tree with an angel on top. This upright symbol is indicative of Jack being able to build himself up in the field and in the process becoming visible and being witnessed and accepted unconditionally. He built something that was supported by his commentary, and he was delighted in producing something he described as "so wonderful."

Again, Jack was involved in a lot of skin sense work—a phase that is aligned with a need for nurturing and one that is indicative of early disruptions to the attachment processes.

FIGURE 22.4. Creating his Christmas tree and finding comfort in interacting with the material.

Session 3: Building Confidence

Moving into his third session, Jack began experimenting with various impulses and following his desires. By this session, he was confident in requesting support for various aspects of his creative work and asked for clay to be put around his arm to make a "crocodile cave." Still working at creating opportunities for natal and postnatal needs to be addressed, Jack was intuitively creating metaphors and responding to his impulses. The construction of a cave for the hands or arms to be contained is the Clay Field equivalent of a hug—and it is well recognized that being lovingly contained and nurtured is a core need of all humans. Having his arm packed in had an immediate calming effect on Jack, as he clearly resonated with the safety and connection that this provided him.

Once Jack completed this, there was laughter and giggles as he experimented with various noises involved in slurping and sloshing around inside the cave and proclaimed that the experience was "magnificent." He made some dinosaur eggs to be stored in the cave, and at the completion asked that the field be kept for his next session. This work held great importance for Jack, and the symbolism of the dinosaur can be representative of something very old and an expression of lasting quality for a child. It was notable that as he continued on his therapeutic journey, requesting that

FIGURE 22.5. Developing his safety.

his field be preserved between sessions was something that Jack began to do with regularity. It appeared that having reliability of "being there" for him was becoming an important aspect for Jack.

Session 5: A Symbolic Birthing

Jack had once again requested that his previous field be preserved and was pleased to see how the material had coped between visits. After examining that his field had been preserved as best as possible, Jack announced that he needed to rebuild it once more, and commenced the destruction of his previous symbol. As he rebuilt it into a new symbolic representation, the story became alive with a tale of a lazy king and difficult sons, journeys of danger and adventure, and an eventual shift in the king to being a good king because one son had made it possible—an interesting metaphor for Jack's own life and the circumstance and purpose of his conception.

He spoke about a strong feeling he had to put his head in the material, which was encouraged. Jack then proceeded to create a symbol that closely resembled the shape of a pelvis. While at no time did I comment on the similarity, there was lots of support

FIGURE 22.6. Following an impulse to put his head into the field.

for him in his creative movements. Once he had shaped it to his satisfaction, he then stretched it open and placed his head in. There was a bit of a wriggle around, and he emerged from his field with his eyes shining and a broad smile on his face, seeking immediate engagement and connection—not unlike a birthing experience.

There has been evidence from various areas of neuroscience around the importance of engagement and connection as a fundamental building block of early attachment. Dan Siegel, Allan Schore, Stephen Porges, and John Bowlby are just some of the names that come to mind in exploring the fundamentals of human attachment and its impact on the body and the brain.[3] This experience has provided Jack with a positive "rebirthing" of sorts—and something, I suspect, that may have been lacking in his own developmental processes.

At the completion of his joyful experience, Jack then focused on destroying his creation and began building another cave for his arm. This time the left arm was immersed in the cave, and a warm slurry of clay provided a playground for his hands to explore and engage in self-nurturing once more.

The core senses of skin sense, depth sensibility, and balance, through boundaries and through contact with another person, provide opportunity for repair to the previously ruptured attachments. In order to awaken the skin as a sensory organ, something has to come to it from the outside. To be immersed in this way satiates the

FIGURE 22.7. An adventure in a cave and being held.

need to be held, to be safe, and to be able to be cared for. It is in the repetition of these creaming actions that opportunity for integration is developed, and the warm water contributes to the nurturing aspects of the work being undertaken. Using the slurry becomes an action that is both nurturing and self-fulfilling.[4]

Session 6: Fully Engaged with the Material

Session 6 found Jack excited to engage in the various aspects offered by the Clay Field. He became chattier with me, talking about his time at school, holidays with his aunt and uncle, various friends that he had made in his new school, and the family pet. After spending time initially making mountains and caves, Jack began creaming himself all over with the material. This was wonderful progress, as he was showing more and more signs of being able to nurture himself with all of the skin sense that a baby requires, something that he had not experienced himself as a baby. In addition, he was starting to create more solid symbols and landscapes that had a representative aspect of strengthening his identity, his ability to orient in the world, tell a story, and construct an environment according to his plans and ideas, all of which were empowering for him. Jack was growing up in the field!

FIGURE 22.8. Moving into healing and nurturing of the self.

Session 10: Working on His Supports

By session 10 Jack was presenting as happy and able to articulate his needs. He requested that the session start with a clean box in addition to the Clay Field preserved from the previous session. Once this request was met, he then commenced the session with a ritual cleansing of the empty field before progressing to the material in the second field sitting next to it. The Clay Field frequently represents the "family" or the "world." Building a "new family," leaving another one, and building in a field of his choice seemed significant for him now.

Jack was responding to the needs of his infant self, to be held and to be able to feel the solid ground beneath him. When the insufficient parent is unable to provide this bedrock for development, dysregulation of the nervous system can result, with the child being in a constant state of alert for danger. Being able to express his desires and being able to work to fulfill those desires are both important developmentally.

At the completion of this field, Jack had developed a restful place that appeared to be very supporting and relaxing for him to chat with me about his session. As the hands gain trust in the process, they settle down, and inner tensions settle. He engaged particularly well with me after this session and calmly spoke about how his new life with his Aunt was going, and all the things he was doing, including some of the school-based difficulties.

FIGURE 22.9. Exercising choice.

FIGURE 22.10. Finding a supportive place to rest.

Session 11: A Review of Jack's Situation

I utilize a star chart to track any shifts and changes in areas that have been identified as areas of concern. For Jack's situation, the relationship with his foster family, his school, his level of anxiety, his level of confidence, his contact with his birth mother, his ability to relax at home, his sleeping patterns, and his eating habits were all areas raised by his aunt as being of concern during the initial intake and assessment phase. The chart in fig. 22.11 shows how she viewed his involvement at regular intervals in each of the highlighted areas, giving a score of 0 (none) to 10 (optimum).

The inner dark gray line reflects when Jack commenced his therapeutic journey with the Clay Field. The expanding lines each represent a review every three months. The outer light-gray line marks the follow-up six months after completion of the sessions.

The aunt reported back to me that Jack has been displaying more settled behaviors in the area of eating, sleeping, anxiety, and confidence. His school was reporting back to the aunt that he was more confident (his reading advanced seven levels in twelve months), and he presented as less nervous in general. He was previously scared to interact with others at school, and this had improved greatly.

His aunt reported that Jack is more settled in the home environment, moving between spending quiet time in his room and spending time with the family. He had

FIGURE 22.11. Using a star framework to measure Jack's journey.

previously spent a lot of time in his room alone. She also felt he had started to contribute to keeping his space clean and reasonably tidy.

Jack was starting to make things at school for his aunt instead of for "mom." There had not been any real contact with his mother for eleven months, and eight months prior to this review. Mom had returned to live with his dad. He was still occasionally mentioning his time with mom and dad, with some of his narrative positive and some negative. Overall this aligns with what was known of his history with regard to the impact of both family violence and neglect.

His case was transferred from a rural children's services office to a closer regional office, enabling better contact for caregivers with these services. At the time of writing this case study, Jack had been with his caregivers for over twelve months.

This had not been without complications, as there was a recent drowning death of a young cousin, something that impacted the whole family. Jack's behaviors regressed at school and at home following this tragic event.

Interestingly, not long after this session, Jack informed me that there had been an incident at school where Jack went against the school "rules." He expressed an understanding of what he had done wrong and responded well to the subsequent consequence of a half-day suspension. He was also required to write a "sorry" letter, and when describing the incident in detail to the writer, demonstrated a healthy level of remorse and an understanding of the importance of "sorry."

His aunt believes that the Clay Field work has been instrumental in his progress and reported that she wanted to continue, and Jack was more than keen to keep up his involvement.

Session 13: Age-Appropriate Landscaping

The developmental phases of childhood can be reflected in the Clay Field.[5] Jack has been moving through the various developmental stages to the point where he is now almost congruent with his chronological age. He has commenced constructing walls and a roof for a small house with a moat surrounding the boundary. He has used far

FIGURE 22.12. Creating a meaningful landscape with intention and a story attached to it.

less water and has not flooded the field, as he had been done previously. His hands are purposeful in how he works with the clay, and he is able to engage well with the material. He has been creating landscapes with a story attached to them and a social order—he has been finding ways to deal with the challenges that this brings. At this point, feedback from his aunt indicates that despite several difficulties at school, he remains engaged and attending.

From Jack's first experience with the Clay Field to his most recent one, he has actively demonstrated both his developmental growth and the repair work undertaken. His original attachment needs, to be held and nurtured, were a driving force for him in the field. Initially this drive was focused on the creation of various instruments to satisfy those very early unmet needs of attachment, ambivalence, and neglect. Working gently and in an environment of safety within the therapeutic relationship has supported his progression, and he is now actively constructing landscapes and stories in a much more competent and connected manner.

Jack continued for several additional sessions, found his voice, and was able to ask for a variety of experiences and art therapy activities. He continues to be settled in his schooling and remains living happily with his aunt and uncle with no contact with his birth parents.

23

Combining Expressive Art Therapies and Clay Field to Support Children

ˋ MONICA FINCH

I work in the private sector in regional Victoria, Australia, as an art therapist. My clients are adults and children who come from a variety of backgrounds and with different reasons for seeking art therapy. There is a common theme among them of trauma and the experience of adversity in childhood. I would like to share this case because it demonstrates how the creative art therapies, sand play, symbols, and the Clay Field can be combined to support a child's healing process.

In this chapter you will see art therapy being used to support the development of a therapeutic relationship, build resources, and serve as a tool for integration. The work at the Clay Field enables this client to process her internal world, and the use of animal figurines becomes a narrative communication tool. The client's process reminds us that children are impacted by the essence of events, that they are tuned in and are aware of things on an implicit level.

Clay Field is an experiential process, but the mind likes to have cognitive understanding. Chasing this can remove us and the client from the actual process. Being in the therapist's seat does not mean I have that cognitive understanding or know what is going on for the client. Being attuned with them is what matters, as a client

will sense when you are not present and may feel unsafe and unsupported. In the case study section below, I recall some of my thoughts and ponderings in the hope of giving you a glimpse into the therapist's thinking. For clarity I have put these thoughts in parentheses to separate them from the client work.

My General Approach

I identify as being a person-centered therapist, responding to what I see in the client rather than being prescriptive. My practice room is in a cottage that I share with another counselor. It has a comfortable homey feel, and clients comment that it is very peaceful. My room is set up to accommodate different modalities and includes shelves of small symbols and figurines as well as a Sand Tray on a small table. There is a dollhouse and other toys used in therapeutic play, an art and craft area, and the Clay Field is in view on a side bench.

We never really know how many sessions we will have with a client as circumstances change or their capacity to engage is low. Some of my clients are funded for only four sessions, so I've fine-tuned how to provide safety and build a trusting relationship quickly. When working with children, I get the parent to help with this by prompting them on what to tell the child before coming to meet me. Depending on the child's age, it might be something like, "Things have been a bit hard at home or school lately, so I talked to Monica about it. I feel better, and I want you to see her too. You can make art there and talk to her about anything." This gives me an entry point with the child to acknowledge why they are here. I meet with the parent prior to working with the child to discuss the family and child's history and their reason for therapy.

In the first appointment I help the client orient themselves in the room. This sets up safety and helps the child relax and become curious. I show the child the different activities (sand play, art, games, Clay Field, and others) and give them an open invitation: "Is there something here that you'd like to do today?" I quietly observe how they approach the activity, how they handle the materials, their level of concentration, language level, eye contact, and so on. All this gives me clues on how to be with them and informs me of how safe they feel. Safety must be the priority when working from a trauma therapy framework.[1]

The parent may be in the room with their child, and when appropriate I ask them to leave for a few minutes so that I can see how the child copes without them and what their reconnection is like when they return.[2] This informs me about their attachment style and strategies and may be useful information about how to support them or for a referral into a parenting program. If separation causes the child

anguish, I invite the parent to stay and participate in some art therapy interventions to support the parent child relationship.[3]

If the child is ready to separate, we have some time together on their chosen activity, and I focus on getting to know them and then creating a thread to pick up in the next visit. This includes setting a place for them to leave the art with me and talking about how many sessions we might have together. I find that the quickest way to develop a bond with a child is simply to "be with them" and "delight in them." These small phrases come from the attachment base parenting program Circle of Security and are as relevant to therapists as they are to parents.[4]

I also see children in the school environment. I visit the school beforehand to establish a relationship, orient myself to the school, and locate a space that gives privacy and safety for the sessions. I take in my own portable art therapy kit, which includes art therapy, games, and the Clay Field. There are some challenges taking Clay Field into a school setting, but it is well worth the effort. For some children school is their safe place. These children are mostly referred by child protection and foster care services. I repeatedly see them benefiting more from the Clay Field than art making, as their internal disorganization can be processed easier in the Clay Field. Given the opportunity, they naturally pendulate between art making and Clay Field, perhaps to integrate their process. Over many sessions I see them in chaos: flooding with water, building walls, burying the duck and the bear. Over time this becomes organized and structured.

I worked on and off with a boy for three years. He was six at his first visit. He came to my rooms, and for every session for about nine months, he repeatedly played in the Sand Tray with the toy soldiers, then made small windmills as a gift for his mom and sister. He showed an intense dislike for even looking at the Clay Field, akin to other troubled or traumatized children.[5] As his attendance was sporadic, I decided to see him at school. He then used the Clay Field for about a year with the focus of burying and killing the bear (fig. 23.1) and then making caves and walls to keep it in. (His dad was in jail.) Between these sessions he liked decorating boxes and making windmills that he gifted to others. Then one day he emptied out the Clay Field, cleaned and filled it with warm water, and put in the bear and the duck (fig. 23.2). He gently moved his hands in the water, then put his lower arms in. He quietly watched the water move, then slumped forward and rested. He fell asleep with his head suspended over the water. Finally, he was able to rest. His teacher later told me that he said, "The clay helps my brain not hurt, and the water makes me breathe easy." Early on I had tried to use his windmills with him to engage his breathing, but it had been a struggle to do this. It took the Clay Field process to bring calm to his nervous system so that he could breathe in life and not be frozen by trauma.

FIGURES 23.1–2. A six-year-old boy: "The clay helps my brain not hurt and the water makes me breathe easy."

The Big Mountain
Brief History and Reason for Attending

Sally's parents have given written consent for me to share this case, and details have been changed to protect the family's identity, but the session content has only been altered for ease of reading.

Sally's parents brought her into art therapy because she is experiencing some difficulties at school. She is seven years old and in first grade in primary school. Her parents tell me that Sally is extremely popular among her school friends but unfortunately is also bullied by them. They think this is because her friends are possessive and jealous when she gives attention to others. An example is given of a friend who punches Sally to get her attention to play at school. Sally told me that "my friend spat on me and threw sand in my face," and "She says very mean things to me when I play with others or don't do what she wants." Sally reported that she cries at school because it makes her sad and scared, and that she feels better when she talks about it with her schoolteacher and parents.

During the intake appointment, Sally's mother gives me the following history: The pregnancy was a wonderful surprise, and she had a happy and healthy pregnancy. The couple planned for a natural home birth, but unfortunately complications during the birth resulted in being rushed to the hospital. Sally required a forceps delivery and wasn't breathing, so she was rushed to the neonatal intensive care unit, where her condition improved. Sally's parents believe that her birthing experience may have been traumatic for Sally and have used services such as craniosacral therapy and kinesiology to support her healing. There is growing evidence that supports their thoughts that birthing imprints are stored in our brain and body and can impact our lives.[6] Stanislav Grof wrote that perinatal phenomena occur in four distinct patterns that become highly individualized psychospiritual blueprints that guide our lives.[7]

The family is currently impacted by extra stress from a few different sources. Sally's dad disclosed that one of these is that he recently experienced a critical incident at work that he is lucky to have survived. They told me about the efforts they have taken to protect Sally from knowing about this to shield her from these stresses. They believe that Sally is unaware of their issues and is only experiencing difficulties from the bullying at school.

Sally's mother describes Sally as having a great imagination, an interest in nature, a love of being outdoors and creating things, drawing, playing with her pets, and listening to audiobooks. We planned to provide as many sessions as Sally needed. This became four sessions approximately one week apart. Sessions were an hour long.

Session 1: Art Therapy

On arrival, Sally told her mom that she was happy for her to sit in the waiting room. As Mom leaves, Sally looks around the room and chats about what she sees. My first focus is to get to know her and form a therapeutic bond and create safety. I give her an open invitation, saying, "Did you see anything here you'd like to do?" She tells me about how much she likes drawing with HB pencils and that she is good at it. I ask whether she likes other pencils too, and whether she likes color or white paper. (I find that children respond well when we are curious and show that we want to get to know them). Sally explains she has only drawn on white paper, that she likes trying new things, and asks to draw, saying "so I can try something new." The table is arranged so that I sit opposite my clients to assist our mirror neurons firing together to attune our gestures; movements help with our learning of new things.[8] Sally draws a garden scene using colored pencils on brown paper. I draw a small simple butterfly that connects with her image. (I do this to consciously show Sally that I am present.) Sally likes my drawing and suggests we swap paper so that I can draw a butterfly in her garden, and she can add a garden for my butterfly. (I note that Sally interacts and engages with eye contact, which informs me that she experiences "the other" as safe and as a resource, not a threat. I also observe her vocabulary and comprehension are well advanced for her age; it's as though I am speaking with a much older child.)

Sally tells me that she's good at using pencils to create different textures and offers to teach me. Sally gives me step-by-step instructions and encourages my attempts to copy her. She is very confident, and we talk about how the different textures look and feel to touch. As the conversation is flowing well, I ask, "Did you and Mom chat about why it might be good for you to come and see me?" Sally replies, "Mom said you help people feel better when things at school or home make you sad." I affirm this, and ask if she is OK coming here, and she says, "Yes, because I do get sad at school, and we can do art too."

I observed that Sally approaches activities with confidence even when trying something new. Her image reflects that she is well within Lowenfeld's Stages of Artistic Graphic Development at Stage 3, Schematic (seven to nine years). Her image is brightly colored and imaginative, and has a baseline and recognizable objects that are spatially related.[9]

At the end of the session I notice Sally looking at the Clay Field, so I ask if she'd like to use clay next time. I hear a loud reply: "Definitely! Yes, please." I give Sally some colored paper to take home to draw on. This is to support establishing our new connection. Sally asks to take her drawings home, and as there is no personal content or risk, I agree to this.

Note on client's art: The art made in sessions usually stays on file as part of the case notes, and it is a legal requirement they be kept until the child turns twenty-five. Children often want to take it home with them. If there is no psychological content that is exposing or creates vulnerability, then I photograph it for my files and agree for it to go home. Other times I tell the child that it will need to stay with me and allow them to make something else to take home. I also consider whether the art will be minimized or damaged. I discuss with the parents that the play and art-making from sessions hold special meaning to the child and may be very precious to them.

Session 2

On arrival, Sally smiles and announces, "I've been thinking about the clay all week." It is set up ready for her: warm water in a bowl with a sponge and a roll of paper towels. As Sally sits down, she puts her fingers in the water and says, "Ooh, I like the warm water. It's so nice and a surprise because I wasn't expecting that." She then puts both hands on the clay and repeatedly pokes holes into the clay with her index fingers. My only instructions are "You can do anything you like.... Hmm, I wonder what you can do here?" With a big grin, she replies, "I know exactly what," and proceeds to work in silence (fig. 23.3). The action of poking holes in the clay gives me an immediate sense that this session is about depth sensibility.

Sally then starts digging with her left hand while her right hand rests on the clay surface. She alternates her hands to remove the clay from the center left side and piles it on the corresponding right side. As she digs, Sally shares memories about playing in the mud at home and in school and using sticks to build things. She asks if I have sticks she can use. I want her to experience the haptic processing, and I encourage her to continue working with her hands in the clay first. As a way of companioning her, I say things like, "Wow, your hands are working hard," and "You're moving a lot of clay." In this way of companioning, it is good to describe what you see being done and use brief statements to affirm the process. Sally smiles and proudly says, "Yes, they are, because I'm strong."

Now working with her hands in unison, Sally digs and grabs handfuls of clay and puts them on the lone pile; it starts to form a large mountainous form. She lightly taps the clay in place with each new addition and talks about the base needing to be made bigger. Sally pauses and says, "It's getting really high up, so the base needs to be bigger" (fig. 23.4). I suggest she push the clay down as she places it to give it more strength. I only occasionally make suggestions to clients in this way, and in this incident, I could see that her mountain form was going to topple over. My sense is that she is looking for strength and stability, and I also want her to have a sense of victory

in this process. (I'm not sure if Sally has heard and is choosing to do her own thing or if she is absorbed in the process and didn't hear me as she continues to lightly tap it without changing.)

After a short while she asks me to help collect the clay that is on the far side of the tray and to put it on the mound. I only enter the field if a child invites me or asks for help. It's important to collaborate with the child and not take over their process, so I ask Sally questions such as, "Where can I take the clay from?" "Where can I put it?" "Is this enough?" As this process is about Sally's strength, it is important that she places the clay on the mound, so I ask, "How about I move this clay over here for you?" (near her) I make sure to take only small chunks of clay to mirror the sizes she had done herself.

Sally works in a quiet and focused manner for periods of time and occasionally stops to talk about her plans. Her movements are purposeful, and she is intent on using all the available clay. When all the clay is formed into the mountain, she looks up and declares in a very satisfied tone, "I've done such a good job at making it so big" (fig. 23.5). Through the rest of the session Sally repeatedly says, "I don't think anyone else could have made something as big as this before" (fig. 23.6). She repeatedly describes it as "huge" and "enormous" and likes my affirmative responses. On the outside it looks like Sally is using clay to create a mountain. (I surmise that this mountain represents something internal that is "huge" and has "enormous" ramifications. Is Sally dealing with something that feels internally big, possibly too big to handle on her own, or threatening or having a huge impact or meaning?)

As she has used all the clay to create a tall mountain, I'm concerned that she may become overwhelmed, so I ask if there is something small that belongs there. My intention here is to help her find balance or a small anchor point and reduce the overwhelming aspect of the bigness. Sally replies, "Yes, water," and promptly begins to squeeze water onto the mountain's peak with the sponge (fig. 23.7). (My own internal response to this is again worry, as the water isn't small nor containing; it is flooding. I remind myself to trust the Clay Field and know to follow her process.)

Sally watches the water fill up in the tray and laughs. "Look, the mountain is so much stronger than the water." As if on cue the mountain begins to tip over, falling away from her (fig. 23.8). She grabs it, saying, "Oh! I did need to push it down; can you help me do it?" (I realize that she had heard my suggestion earlier and chose to do it her way, and I'm reminded again to give her space to find her own ways and learnings.) We work together to straighten it, and Sally pushes it down with lots of pressure with both hands. (Perhaps what is too big and threatening for her to manage on her own can now be handled as it has been shared?)

When the mountain is stable, Sally chooses to cover it in many layers of paper towels, wetting each layer and smoothing it down (fig. 23.9). (I feel a sense of reverence as I witness this.) I notice Sally taking time to feel the surface of the wet paper towel; she is using skin sense processing. Throughout this session Sally had been breathing from the mouth, and now that she is breathing heavily through the nose, it sounds congested and strained. I'm not sure what the significance of this is, but it is very noticeable.) Sally completely covers the mound with about ten layers of paper towel, and she uses both hands to stroke and smooth the wet paper. Sally says she likes the texture and that it would be interesting to see the texture on the clay. As texture is a theme in her last appointment, I say, "I wonder what it looks and feels like?" Sally shrugs her shoulders saying, "It's finished. I don't need to look at it because I can imagine it." (I'm left wondering about the mountain and have many questions going through my head: What is so enormous, why the need to have it covered or hidden, and why can't it be touched? Is it covered because it is too yucky to be seen and touched? Has the covering, wetting, and smoothing made it more bearable for Sally? I know it's important not to jump to conclusions, but I'm left with an uneasy feeling.)

Sally calls her mom in to show her what she had done. "I made a mountain; it is so enormous." I see Mom smile; they look at each other and then at the mountain together as her mom says words of encouragement and affirms its large size. We leave the clay covered in wet paper towels, and Sally walks away from the session chatting with Mom.

FIGURE 23.3. "I know exactly what!"

FIGURE 23.4. "It's getting really high up."

FIGURE 23.5. "I've done such a good job at making it so big."

FIGURE 23.6. "I don't think anyone could have made something like this before."

FIGURE 23.7. "Look, the mountain is so much stronger than the water!"

FIGURE 23.8. "Oh! I need to push it down."

FIGURE 23.9. "I've made a mountain; it is so enormous."

Session 3

On arrival, Sally lets me know she wants to do clay again. Her dad has brought her, and her mum will be coming at the end of the session. Sally puts her hands in the clay before getting an apron or sitting down, and sounds excited as she states, "I'm going to do that big mountain again."

Sally works in a similar manner as the previous session, although this time she uses both hands to dig up clay from the center on the right side. She places the clay on the left (fig. 23.10). This is in the exact reverse orientation to the previous session. (I wonder about her using different brain hemispheres and orientation, as I've not seen this happen before.) Sally seldom speaks during the building stage and gives no eye contact; her focus is completely on the clay and building the mountain. I notice again that Sally breathes through her mouth, and nasal breathing is labored.

Sally pushes each handful of clay down as she progresses and continually checks its stability. She doesn't ask for help today, and when most of the clay is used to form the mountain, Sally squeezes water over it using the sponge. She then layers it with paper towels, pouring water on each layer, patting and smoothing the surface. This continues in a ritualistic manner, and she occasionally lifts a corner of the paper towel up and describes the textures on the clay or comments on how smooth she is making it. Sally stops when she has covered the mountain with about twenty layers of paper towel.

There is some clay remaining in the field and lots of creamy clay. Sally uses both hands to pick it up and squeeze it. Her hands are chewing small chunks of clay in the creamy water, softening it and then smoothing it onto the outside of the mountain. Smiling, Sally looks up and says, "it's like I'm covering it with cream." She lets me know that her hands are feeling for holes and using the soft clay to fill them.

Sally talks about the similarities and differences between this and what she did last time, and congratulates herself, and tells me she has done a "better job." Sally then declares, "I have another good idea. Look, Monica." I watch her pick up clay in both hands and firmly place this on the top and rub it around the top and upper shoulders of the mountain. I ask, "How's that?" and she replies "Good."

Sally then stops and repeatedly looks back and forth from the mountain top to the shelf of animal figurines and says, "I'm thinking if there is something I can do or add now." She moves a small piece of clay between her hands while thinking, and then says, "I don't know why, but for some reason my head is telling me there is something I could put in here." I guide her to use her hands, saying, "Perhaps your hands know what they want? If you keep moving them ..." Sally cuts me off, saying, "Yes, and see if the idea turns up." She puts the little piece on the mountain, strokes it for a moment, and says, "I could put an animal up here on the top." I respond, "Hmm, an animal?"

FIGURE 23.10. "I'm going to do that big mountain again."

FIGURE 23.11. "It looks this big, but feels like it's so much bigger,"

FIGURE 23.12. "But really, it's not as big as I thought it was."

FIGURE 23.13. "It's definitely not so big anymore."

Sally sits back and describes the mountain as being "really big" and gestures with her arms, saying, "It looks this big, but feels like it's so much bigger," and then "But really, it's not as big as I thought it was" (fig. 23.11). She then peels the paper towels off the mountain and says, "Wow, now I need to find just the right animal to be here."

She gets a baby crocodile from the shelf and places it into the water, looking toward the mountain. She then decides to make a small flat island for it to sit on and moves it to be beside the mountain. (I assume that this baby crocodile represents her, and she is viewing her psychological material, but I could be wrong.)

Sally talks about what she is doing. "So now I have a big mountain and a small island. I wonder what will go on the top here?" pointing to the summit. She chooses an adult grizzly bear that stands on its hind legs and places it on top of the mountain. It looks down at the crocodile. Sally stands back and laughs, so I say, "that makes you laugh, doesn't it?" Sally replies," Yes, because it looks like he is going to jump on something," then, "But the bear doesn't belong up here. It's too high." She removes the bear and lays it on the table.

She then places both hands on the mountain peak and pushes downward with force. Using her whole body to lean into the clay and keeping her feet firmly on the ground, she uses her entire strength and weight to push the mountain down flat (fig. 23.12). As she does this, I notice she holds her breath and keeps pushing and pushing and pushing. (This reminds me of bearing down and birthing and makes me wonder if this process might be her birthing experience. Has the mountain represented the pregnant belly, gently cared for, wrapped, and bathed? Has the effort of pushing been about her own birth?)

Sally suddenly takes in a deep gasping breath and exhales loudly as she releases her hold of the clay. She then giggles and laughs, saying, "It's definitely not so big anymore" (fig. 23.13). I mirror her giggles and say, "It certainly isn't, and did you hear how big that breath was?" She sits up tall in the chair, nodding and smiling. This is wonderful. There has been a psychological shift both internally and externally, which has given her a new perspective.[10] She is triumphant in conquering the mountain; what was "enormous" has been transformed. She places the standing bear on the squashed mountain and declares that she has made an island.

Sally then creates a collection of habitats for many animals in the clay and tells me stories about them and why they are on the island. As she creates the scene, she compliments herself, saying, "This is really good; I like that there." Sally then remodels the mountain a little and creates a place for the standing grizzly bear by the water's edge. As she places it there, and a fish in the water, she says, "It can catch fish."

Sally dips her hands in the creamy clay and becomes quiet as she creams her hands in a very gentle and slow manner. It is as though she is giving herself a hand massage. Sally then removes the fish from near the standing bear and makes a big ball of clay

for the bear to hold, saying, "If I get another bear and put it here [pointing to a place in the water], and this is a huge piece of meat, they might fight over it." Sally selects a brown bear standing on four legs, with its mouth open, and places it to face the grizzly bear (fig. 23.15). (I wonder about the bears. Are they representing her parents, or perhaps the bullies at school?)

Sally then adds more animals, and I try and limit her, but she ignores me and brings even more animals into the field. (I'm a little concerned they will become a distraction from the Clay Field process, but when she ignores me, I relinquish my desire to control this and trust her process.) From a sand play perspective, animals symbolize our instinctive and intuitive intelligence, not the intellect knowing.[11] There is order to the placement of all the animals, each one in its natural environment (fig. 23.14), and she is careful to make sure they are all safe and have what they need.

Sally then tells me a story. The summarized version: "All the animals are worried about the bears because they might fight over the meat. The crocodile will sit here on the island and can swim away or swim to them. The snake in the cave is watching and will hide. If they start to fight, the eagle will fly up high. On this side [the opposite side to the bear] of the mountain is a wolf. It will see the eagle and howl a warning to

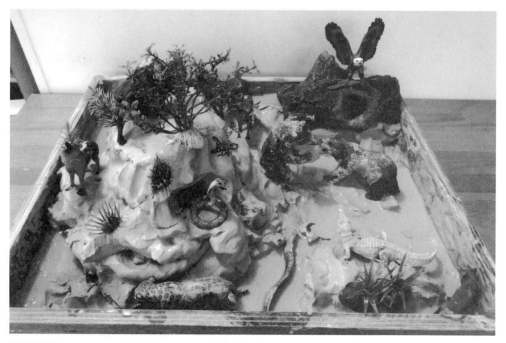

FIGURE 23.14. "All the animals are worried about the bears because they might fight over the meat. The crocodile will sit here on the island and can swim away or swim to them. The snake in the cave is watching and will hide. If they start to fight, the eagle will fly up high."

FIGURE 23.15. "The wolf will see the eagle and howl a warning to all the animals. The deer will then know to run away. But right now, no one knows whether they will fight for the meat or share it. Everyone is just watching and waiting. See, the deer are watching too; they are not moving, like they are frozen."

all the animals. The deer will then know to run away. But right now, no one knows whether they will fight for the meat or share it. Everyone is just watching and waiting. See, the deer are watching too; they are not moving, like they are frozen" (fig. 23.15).

Sally asks her parents to come in and see what she has made. They sit around the table together asking Sally sensitive and curious questions. I ask Sally if she would like to tell the story she had just told me. As Sally does this, Dad and Mom look gently at each other. Dad looks at Mom and says "Oh!" and Mom nods.

When the story is over, Mom helps Sally wash her hand. Dad takes the opportunity to quietly tell me, "We are the bears, and we are scaring her. I thought we protected her from our stress, but it looks like she knows. Should we tell her what has happened?" I arrange to talk with them over the next few days when Sally isn't present. When we speak, I'm informed that they did speak with Sally. They didn't tell her any details but affirmed that they have been distracted and worried about adult things and they were working it all out. Sally told them that she had noticed they weren't smiling as much, and Mom had been looking sad a lot. They told me that during this

conversation they all felt more emotionally connected to each other and that Sally is more relaxed and sleeping better.

Note on figurine use in clay: I've found that in my therapeutic space, it's not uncommon for children to be in the Clay Field and then collect the figurines to add to the clay scene, as Sally did. I don't invite or encourage it, but it's a by-product of having everything in one room.

If the child plays with the figurines on the surface of the Clay Field, it can be difficult to get them to move into the clay, and they will not access haptic perception. If this is a pattern with a child over a number of sessions, I remove the Clay Field and work on safety and relationship building via sand play, art making, or games.

I have noticed many children work silently in the Clay Field, then suddenly stop and move on to play with the figurines in the sand. I follow their lead and then ask them to tell me the story of the scene or the play. I am always surprised and amazed to witness through their story what just happened in the Clay Field.

Younger children, under age five, often use an animal or car or truck to make patterns on the clay surface before they will poke and touch it. This often leads to a game of hide-and-seek with marbles, where I bury a few just below the surface for them to dig out, and they reciprocate by digging and burying them from me.

Session 4: Art Therapy and Integration

Sally starts the session saying, "I've done such good things in the clay and told a great story, so today I want to do something different. Maybe I can build something to keep?"

Generally, I tend to be nondirective and encourage the client to move to what feels right for them. However, there are times when clients look for direction and need this support. In these times I look to their previous processes, their narratives, and themes for prompts. I also consider what has been missing in previous sessions and whether the client needs a structured intervention to support their organizational development. Hinz writes that a single creative activity may involve integration of developmental functioning.[12] I assess whether they have favored or avoided materials of similar properties. This is useful information, as it may show us where blocks and challenges lie, and help bring them online. I think Sally will benefit with movement to help find her internal rhythm and release of energy and have balsa wood, paint, and plasticine on hand.[13] (It's good having a plan but then to be able to be flexible and follow the client's lead.)

I remind Sally that she seemed to really enjoy using the animals last week and I ask if she'd like to make her own. Sally is animated and says, "It's a great idea! And I'll make people to look after them." She uses wooden doll clothes pegs, pipe cleaners,

soft air-drying clay, and permanent markers. (I am thrilled that she wants to make animal caretakers, and perceive these to represent resources. It indicates that she can connect helpers and supports.)

As we make art together, Sally begins talking about things that made her feel sad recently. She confides in me, saying, "Mom and Dad told me Dad got hurt at work. It was bad, but he's better now. They had to keep it a secret so I wouldn't be sad or worried." I asked her if she is worried now that she knows, and she replied, "No. We can help each other with things and make each other happy."

Conclusion

That was my final session with Sally, but the family has stayed in touch, and I occasionally receive brief updates. Her parents made the decision for Sally to change schools, where she adapted to the new environment with ease and quickly made new friends. A few months later Sally asked to come back to tell me about her new school. I noticed subtle changes in her; less tension in the body, her posture was a little more relaxed, she breathed with ease, and she seemed more light-hearted, joking and laughing more.

In this case study we see several narratives present: bullying at school, a difficult birthing experience, and unprecedented stress surrounding the family. The Clay Field processes could be perceived to be about processing any or all these situations, but it is more correct to say that they enabled an exploration of solutions and answers through the sensorimotor discoveries.

Through her exploration at the Clay Field, Sally was able to follow her own impulses into sensory experiences. She tested the clay's ability to stand up to the strength of the water and built up its resilience. Sally integrated left and right brain hemispheres, found balance in her skeletal system, relaxed her central nervous system, and was able to breathe with ease. Sally was able to access her own libido or vitality and connect emotionally with her parents.

24

From Phenomenological Observing to Accompanying

KATHARINA KRAMER AND INA SCHOTT

The complexity of what can be achieved within the simplicity of the setup never ceases to fascinate us. We are passionate about this therapeutic approach because of its limitless applications. Be it for individual support or for social development, clients are liberated from verbally dissecting their experiences. The haptic process instead offers them a path away from habitual behavior toward discovering alternatives and the option to apply those in daily life. As therapists we are seeking to understand the plurality of this process as is, while aiming to expand on it. As such, we are guided by the questions: How do I perceive the connection between *being* and *action* in the client? Our focus is not only on what clients *do*, but also on how they are present—or not—while they manipulate the clay.[1]

Through what prism can I perceive this? We like to call ourselves phenomenologists.[2] We observe haptic action patterns, which involve the whole body, and equally refer back to the client's emotional and psychological state of mind. In addition, we like to view such observations in the context of the client's social environment. The embodied presence of each client reveals simultaneously their emotional, psychological and social constitution. At all times, the Clay Field remains the point of reference; observing how a client moves becomes the most meaningful resource. The movement patterns of each client highlight the inherent relationship between these three aspects. Do we recognize coherence or disconnection? Are the movements

led by vitality and intention, or inhibited by fears? How does a client relate to the surroundings?

A key aspect in our practice is the work with children and adolescents ages two to eighteen. Some of the children are dealing with physical disabilities or psychological challenges; others are in crisis due to trauma or developmental delays. At all times, our focus is on creating an equilibrium between physical, emotional, and mental health. On this basis, we can build on stabilization and encourage further development. Those principles apply to all client groups. We refer to the three areas of self-development as embodied presence (vitality), the emotional world, and mental health, and we view all three in the context of clients' social environment. Our work with children and adolescents aims at strengthening their age-appropriate behavior and supporting their journeys toward individual fulfillment, vitality, self-efficacy, and self-reflection.

In the following, we will introduce several case studies. We wish to illustrate how interventions can enable clients to develop age-appropriate physical responses, how they can find fulfillment in their action patterns, and how the haptic process allows children to experientially redefine their own resources for emotional and mental well-being. With the support of the therapist, clients can come into balance, which as a consequence enables them to transfer the newly acquired experiences from the setting at the Clay Field into their own daily life. They have gained resources and new options to act, to feel, to think, and to relate to their environment.

Matthias

Matthias, age three years and seven months, attends Clay Field Therapy because his pronunciation and the pitch of his voice is compromised. He was born with a palatine cleft, which was closed surgically, but breastfeeding remained difficult. This early experience of being unable to take something from his mother and of not getting enough left a lasting imprint. It causes him emotional stress, which manifests in Matthias as being ambitious while feeling simultaneously inadequate. Already in the first Clay Field session—after hesitating only briefly—Matthias makes use of the whole field, builds sites, and uses water freely. In shared actions with the Clay Field therapist, it is apparent that he feels safe. He works the material with vigor: he piles pieces of clay on top of each other, digs furrows, and next squeezes and mushes it all together. Finally, he caresses the surfaces. As a significant step of progression, suddenly landscapes arise, which he shapes and names. He is physically engaged and works hard, but his rib cage is tense; it seems to be compressed, and his voice becomes squeaky when he talks, which he does enthusiastically. His whole condition

indicates physiological overload. His vitality appears to be less developed than his mental strength: he knows how to construct, but he is straining physically.

Addressing Matthias's sensorimotor development, the therapist emphasizes the sensuality and the tactility of the material as well as the possibility to take it into his possession: "It's a lot, and all of it is yours." On purpose, the therapist discourages his landscaping effort because Matthias's physiological condition prevents him from a vital and fulfilled acquisition of the clay. Instead, the therapist focuses on strengthening his physical and emotional access to the Clay Field, with the intention of reducing the mental overcompensation for his physiological weakness. In addition, she asks the parents not to inquire *what* Matthias has done and instead ask *how* he has experienced the session when they come to pick him up. Further, she recommends the whole process be accompanied with osteopathic treatment.

In the following weekly sessions, Matthias increasingly enjoys the sensory exploration of mixing the clay and water: he explores how to achieve the desired consistency. The amalgamation is in turn firm, smooth, or sludgy. He pulls the material bit by bit out of the Clay Field, collects the pieces in a bucket, adds water, and is fully engaged with all of it. He uses sponges with water and with clay. His pushing movements give him the experience of manageable pressure, and his rib cage relaxes progressively. As a result, his voice begins to sound freer and deeper, and his pronunciation becomes increasingly clear and understandable.

By the fifteenth session, Matthias empties the entire box, mixes the clay with water in a bucket, and very calmly spreads the smooth mixture over the entire tabletop, including the empty box (fig. 24.1). Matthias accesses the table from all sides and works with vitality and focus. He moves his body in a consistent and connected manner. Sometimes Matthias uses both arms and hands simultaneously in circling

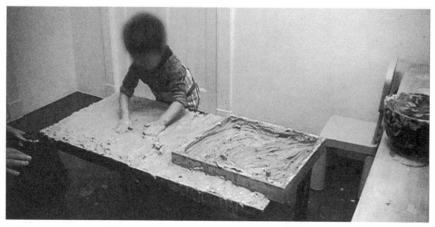

FIGURE 24.1. Matthias very calmly spreads liquid clay over the entire table top and the box.

motions on the table, and at others he alternates between his right and left arms. His movements are free and mobile. Matthias occasionally explains his actions. His breath flows evenly. The therapist addresses him only to ensure his physical awareness within the space and signals that his actions are appreciated.

Ever since Matthias's spreading of the clay, he displays referential awareness of the space surrounding him. He discovers new visual dimensions, which allow him to connect with the surrounding workspace. The room and everything in it appear different to him: he establishes a new relationship between his inner world and the external world; he builds connections, and he is able to participate both physically and mentally in equal measure. Deeply satisfied, he finally takes a look at his creation. With this session he achieved a real breakthrough: the tightness in his upper chest and around the vocal cords has disappeared, and he is able to pronounce the challenging sounds "s" and "sh" clearly. A medical examination confirms that Matthias does not require speech therapy. By this point, Matthias has completed four sessions of osteopathy. Matthias attends Clay Field sessions for another eighteen months. He continues to deepen his connection between vital intention, his felt sense, processing emotional and mental input, and last but not least, his relationship with his environment. Matthias attends preschool, and he is overjoyed at the prospect of starting school.

Elizabeth

Elizabeth, age five, attracts the attention of both her teachers and her parents by displaying irritatingly artificial behavior and becoming shy, even fearful, when faced with something new. She changes kindergartens in her final year before starting "big

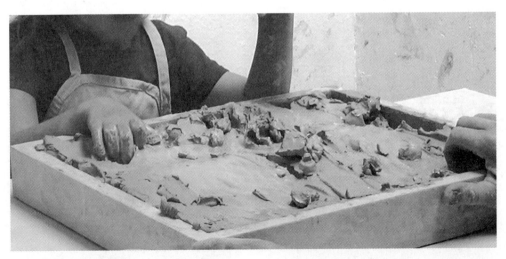

FIGURE 24.2. Elizabeth.

school" and struggles with the separation from her mother. The parents wish for their daughter to find more safety, vitality, curiosity, and confidence in the remaining year before the transition to school.

In the first session, Elizabeth shows a willingness to engage with the therapist and the setting, yet she depends on the presence of her mother: she wants her to stay. At the same time she makes strong eye contact with the therapist during the session. Her utterances are stilted; it is difficult to understand her; and she virtually contorts her body when speaking. She sits expectantly and very close at the Clay Field, but then delegates her movement impulse to the therapist, requesting: "You do it." Eventually, Elizabeth engages in joint action patterns, during which the therapist, while speaking slowly, comments on the mutual actions in short sentences. Through this process, Elizabeth gains confidence and a hold in the relational field. Her focus is not so much on the action patterns in the field, but on the fact that she can refer to the therapist as a social partner. It is this relationship that gives her the courage to explore.

Simultaneously, Elizabeth displays a strong desire when eyeing all the available items in the room, such as gemstones, animals, and marbles; they can be added to the Clay Field, which she promptly does. She extends her relational field into the space around her, and in the process manages the transition from the known to the unknown. The result in the Clay Field is "a mountain of treasures with a cave surrounded by a river." The mountain in the field reflects Elizabeth's developmental age, but these shaped forms are constructs—they do not result from a vital and connected engagement with the clay. Elizabeth is not yet able to embody her action patterns. As soon as she is challenged at the Clay Field, for instance, Elizabeth leans back in the chair and throws her head backward, or pulls her shoulders up and draws in her

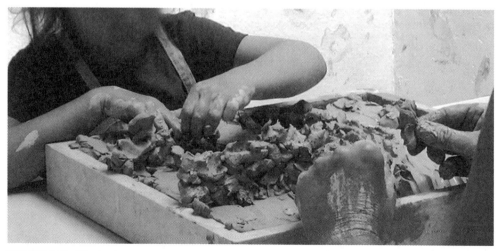

FIGURE 24.3. Elizabeth.

neck. She is not yet able to align her movements with her cognitive awareness. In the context of Clay Field Therapy, we understand this "throwing back" not as a psychological or emotional process but as a reaction to the preceding haptic stimuli, which Elizabeth cannot integrate vitally and emotionally. It might be significant that her mother mentions, when debriefing after the first session, that Elizabeth had a difficult birth involving a suction delivery.

The next few sessions are devoted to strengthening Elizabeth's sensorimotor base. Through explorations of skin sense, balance, and depth sensibility, she establishes the prerequisites for a successful, self-motivated development toward self-determined action. This gives Elizabeth the opportunity to catch up on early traumatic experiences. Because Elizabeth is likely to quickly become overstimulated in her self-awareness and physical tolerance, it is important to pay attention to this by letting the Clay Field sessions last only as long as she is able to process the haptic experiences.

Neela

Neela, age six, arrived in Germany from Syria with her parents and siblings in 2018. Now, in 2020, Neela is due to commence school but still speaks hardly any German. At the school entrance exam, doctors diagnose a developmental delay and consider the possibility of a learning disability. Several therapeutic attempts fail and are stopped early on because of a lack of connection between the parties. Finally, a doctor in the public health department recommends Clay Field Therapy. Neela arrives with her mother and an official interpreter. It turns out that Neela comprehends the German language quite well but does not yet respond in German. Almost immediately the connection between the therapist and Neela is good, and it becomes unnecessary for the mother and interpreter to stay. They withdraw and take their seats in the waiting room.

After initially hesitating for a moment, Neela heads toward the table with the Clay Field, climbs the stool, views the field, and then proceeds to pile up pieces of clay directly in front of her with shovel-like hands. She takes the material, adds water, and adds a toy crocodile, a turtle, and a duck; she does everything with blatant desire and indulgence, while her arm motions increasingly shoot out. She whoops effervescently and squeaks loudly with joy. In her overwhelming excitement, her movements break out sporadically and lack orientation. The real reference is challenging for her, and she is not yet able to respond. Nevertheless, she feels that fulfillment awaits her at the Clay Field. Neela's connection with the therapist deepens throughout the whole session. She makes recurring eye contact and engages in some "conversation" between Neela's hands and the therapist's hands, including onomatopoetic utterances associated with

action patterns in the field. A connection develops, and Neela is able to establish the first signals of dual polarity, which provide orientation and a hold for her.

At the end of the first session, she doesn't want to part with the Clay Field at all. Subsequently, she starts running along the corridors and hides in unlocked rooms. As a result of the dialogue with the therapist and the haptic challenge of the session, the surrounding space becomes an expanded point of reference to experience herself in. As a parting gift, Neela is given a small stone talisman and the verbal assurance that her Clay Field session will be continued next week.

Neela's pronounced inner tension is palpable. Equally clear is her traumatization, which manifests in the shooting motions of her arms and in the lack of fulfilling sensory feedback. She reaches out, but without the belief to receive something in return, hence not even giving herself the time to receive. Neela is overwhelmed when she experiences contact, which points toward a not surprising existential deficit, given her refugee status, while her lack of trust is indicative of missing care.

Moving forward, the aim is to establish dual polarity and reciprocity to strengthen the sensorimotor feedback loop. She needs sensory experiences to be able to absorb the haptic invitation to explore the field with motor impulses. Initially Neela works mainly with clay and is supplied with only small amounts of water to avoid overstimulation. However, the therapist spends much time with her when she washes her hands at the end of the session. When she comes into contact with the flow of the pure tap water, she is visibly internally touched in a manageable and supported way. She begins to seek eye contact with the therapist of her own accord. The following sessions are scenarios of fights and caregiving, acted out with a toy bear and a crocodile. The process of establishing mutuality and of finding congruency has begun.

Neela enjoys the Clay Field sessions. She is alert and absorbs information well. She has started school and continues with her therapy, for which the public health department has arranged financial support for one year.

Marie

Marie, age eleven, is increasingly dissatisfied at school. Although she copes well with the curriculum, she is terrified of exams and even suffers from insomnia and severe headaches when they are looming. Her relationship with her mother is characterized by quarrels and rejection. The mother is afraid of losing touch with her daughter and at the same time is overwhelmed by her daughter's rebelliousness. Following the recommendation of an acquaintance, she makes an appointment for Marie. Marie is skeptical upon her first arrival and has her reservations, neither of which she is slow to hide: "You don't understand what I'm doing here anyway." Her haptic intention

is to find her own position in the world, a self-concept that in her case is vitally connected to her identity as a female. Both are aligned with her developmental age.

The first few sessions at the Clay Field consist of building the relationship between the therapist and Marie by providing her with the experience that she is given her own space, which is respected and valued. This is achieved, among other ways, by the fact that the therapist turns away so that the Clay Field is no longer in her view. This achieves a duality of presence for the girl, the therapist being simultaneously present and absent, while giving her discretional space to determine her own actions. But then she exclaims: "You'll never guess what I am doing here." The therapist is aware of the age-related haptic situation and makes suggestions about what might be going on behind her back. She expresses ideas and offers interpretations. The subsequent dialogue between girl and therapist centers on the topic of concealment. The ideas of the therapist have awakened something in the girl that in Clay Field Therapy is referred to as *intention to act*. Marie begins to reveal her age-related prepubescent need to discover what is hidden and to simultaneously hide herself. In her approach of the unknown and in what could be perceived as threatening events, Marie creates images of flowing water systems in the Clay Field, which mirror her inner life force (fig. 24.4). She fills the canals with plenty of water. Eventually she covers those water systems up again with clay (fig. 24.5). She gradually occupies her space.

As dialogue flows, Marie experiences that sustaining a relationship and focusing on her own actions need not contradict each other. Staying connected is possible for her in this process. By repeating this, this new experience is consolidated over

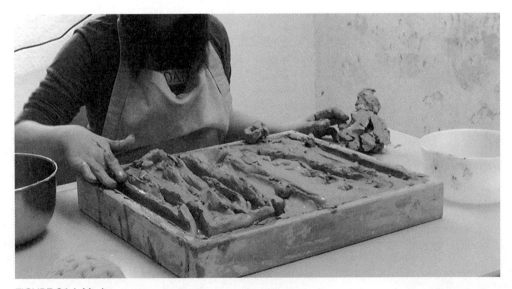

FIGURE 24.4. Marie.

the next few sessions. Marie's experience of being able to occupy space on her own terms, and the experience of being appreciated for it, gives her the opportunity to test this in other parts of daily life with inner resolve and confidence. She is able to apply this newly acquired skill for herself away from the "laboratory setting" at the Clay Field. Nearing the end of the sessions, Marie invites the therapist to cover up the flowing water systems with clay, and they proceed to do this together.

Her experience of her own vital yet still hidden body-soul developmental process finds fulfillment in the shared complicity with the therapist. She has gained sufficient confidence to be able to enter a relational dialogue. At home as well as at school, she continues to develop her independence with vitality. On the one hand she shows more tolerance, for example when frustrated, and on the other hand she displays strength in her convictions. This does not necessarily make things easier for her environment, but as things become negotiable, there is greater flexibility. Marie can play a more constructive role using her self-awareness. At the Clay Field she demonstrates the beginnings of puberty; her menstruation cycle begins.

About a year later the mother contacts the therapist. It is important to her to convey Marie's ongoing journey of self-confidence and happiness since completing the sessions. At school she shows herself fearless and active. Her change in attitude toward herself, "This is who I am," also affects her whole classroom. In this atmosphere of increasing self-acceptance, her year's group develops a new culture of debating, to the astonishment of the teachers. The mother is relieved by Marie's successfully growing independence and can thus constructively accompany her daughter's sustained growth into becoming herself.

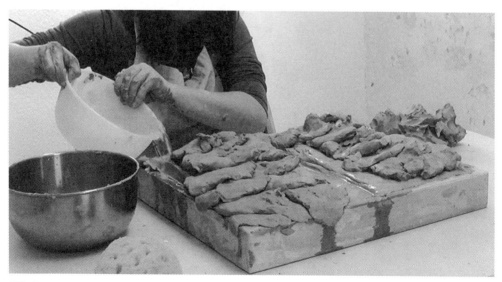

FIGURE 24.5. Marie.

Christopher

Christopher, age eleven, has been diagnosed with autism spectrum disorder. He is one of triplets, and neither his two brothers nor his older sister have any diagnosis. Christopher is well supported at home; his mother is proactive and at ease with his disability. She is looking for ways to direct Christopher's intrinsically motivated motor impulses toward connecting with his environment, and books him in for sessions. She is made aware of the option of Clay Field Therapy through a medical colleague. Christopher is open and curious at the first session and dips his hands into the bowl of warm water, which stands ready. He begins playing with the water by alternately dipping his hands into the bowl and lifting them up into the air. Christopher listens to the flow of the water; he experiences the sensations with his whole body. He stands on his toes, apparently in a juxtaposing stance, and dances.

He is obviously used to constantly adjusting his inner experience within his body. The Clay Field is set up and visibly ready. Christopher perceives this. In the first few sessions, the game with the water is repeated, and he now also uses the smaller bowl from the Clay Field table together with the sponge lying next to it for watering. He

FIGURE 24.6. Christopher.

fetches both items. He still will not touch the Clay Field. Christopher explores how he can actively control the flow of water by squeezing the sponge.

For the following sessions, the toy bear appears at the initiative of the therapist as a possible representation of "I." The bear awaits Christopher at the edge of the table. Christopher carries the big water bowl from the other table to the Clay Field table. He changes, and in the process expands the setting, and occasionally refers to the Clay Field by looking at it, but he still will not actively use it.

Next come several sessions in which Christopher insists that the bear participates from the beginning, and positions him at the edge of the Clay Field. Again, more sessions follow in this rhythm, and with these cycles of repetition comes safety. Suddenly, he interrupts his water games and lets the toy bear run across the Clay Field for a short time. He comments on all this with laughter and other expressions of joy. He always uses the therapist as his reference point. She is supposed to stand at his side but not sit opposite him. He himself stands at the table the whole time. When the bear is due to be cleaned of clay in one session, Christopher sits down and carefully dips the toy into the water of his bowl. He is intimately focused on the object. Here too, processes are repeated in subsequent sessions.

FIGURE 24.7. Christopher.

The structure of the sessions is always the same—as Christopher draws the water from the bowl, he tunes in to the experience of himself. When this is fulfilled, Christopher goes to the toilet. Upon returning, he carries the bowl next to the Clay Field. He is ready for a new experience to expand on his reference points. Christopher now realizes that it is he himself who is involved in his perception: "This is *me*."

The intimate experience of his own body transfers his awareness onto an object, even if it is not yet perceived as an object itself, as an occasion for an expanded self-awareness: "There is something in my hands; that is not me, but I am holding it."

The feedback from school is that an increase in clarity of his own impulses can be observed. Christopher takes initiative and sets demands, which otherwise would not happen without his commitment. His end-of-year report states that:

> Christopher's ability to make eye contact with conversational partners has increased more and more.... He was able to improve his communication from using three to five words in sentences. He independently expresses his needs and wishes to the teachers, and his communication with his classmates has become stronger. As a result, his tolerance (for example, when frustrated) has increased in comparison to the beginning of the school year. His progress is reflected in his German lessons, German reading course, and speech therapy.

Christopher expands on his awareness of inner flow, which he first initiated through his contact with water, in the course of the Clay Field Therapy by finding new spatial reference points. He discovers objects as an option to increase his self-awareness. By tapping on the spatula, he experiences himself through his actions, and in the process receives haptic feedback. This presents itself in several variations: for instance, by throwing sponges up in the air and catching them again. He discovers the moistened clay in a storage box as a source of material, and can put it to use. All this demonstrates his increasing ability to connect with his environment through his own impulses. Christopher has succeeded in taking these decisive developmental steps within the framework of Clay Field Therapy, even though the box filled with clay has not yet become the focus of his attention.

Paul

Paul, age thirteen, has been recommended for sessions by a friend of his family. He struggles at school, experiences bullying, and suffers from stomach cramps, which are so severe they can prevent him from attending school at all. The doctor cannot find any medical reason for the pain. The parents are worried and feel helpless. For the first three sessions, he arrives with his mother, until he gradually succeeds in explaining to her that he would prefer to attend the Clay Field appointments independently,

without her. In his relationship with the therapist, he appears as competent, friendly, and organized. For example, he questions the therapist about the general conditions for Clay Field Therapy. He is striving to securely position himself in the relationship with the therapist, as well as within the setting. Additionally, he signals a developmental need: to be encountered at eye level as an adolescent in an adult world. His lower body tension and the lax tonus in both hands, which look like the hands of a younger child, are particularly noticeable.

Sitting at the Clay Field, he starts to reposition the chair farther left, which happens to place him exactly opposite the therapist. She encourages him, in turn, to find *his* space from where he is sitting. Paul then develops a specific routine: at the beginning of each session, he pushes the Clay Field straight ahead, away from him, with both hands, and in this way frees space up between him and the Clay Field. This allows him to use the Clay Field as a "reservoir" for the building materials, and he takes the desired clay from there with outstretched arms, keeping his hands parallel, and occasionally alternating his hands. Using the clay, he proceeds to build in the interspace in front of him, a space he has established for himself (fig. 24.8).

Buildings, figures, and symbols arise in detail from the computer game *Minecraft*. Through repetition in the course of the following sessions and through the exact use of the *Minecraft* designs, he establishes reliability and safety (fig. 24.9). In addition, he craves the acknowledgment of the therapist appreciating his achievements. On that basis he is able to venture into creating a connection to the Clay Field. Paul starts landscaping in the actual Clay Field: a mountain with a mine. The entrance of the mine is located outside of the field's frame, in the interspace between him and the Clay Field. He builds lakes, another mountain, a lonely island, and a castle surrounded by a moat.

FIGURE 24.8. Paul.

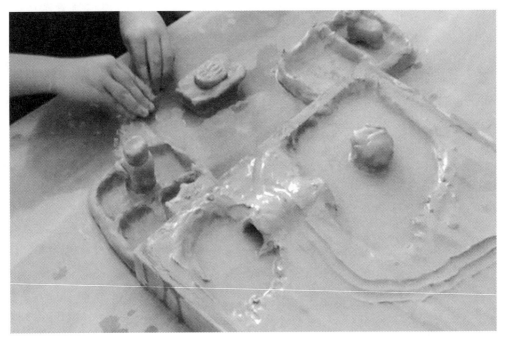

FIGURE 24.9. Paul.

The therapist encourages him to transfer "would-be constructions" into real-term shapes, which his felt sense intention is palpably longing for. For instance, he has built a tunnel linking two lakes, which at first are merely marked at both ends. After completion of the full tunneling action with both hands, Paul seems a little surprised, yet very satisfied (fig. 24.10).

His desire for directed motor impulses becomes more pronounced. His lack of depth sensibility, such as his low body tonus, demonstrated in his initial inability to connect the lakes, might refer to developmental deficits he has experienced in relationships with others and the world when he was age four, according to the stages of haptic development. At the Clay Field he experiences that he is able to complete his intentional motor impulses and that he feels relieved and fulfilled afterward.

Paul is on his way to integrating the multitude of new internal impulses stemming from puberty in order to prove himself on the journey from the safety of his home toward the external world. School in this context represents his external world. The stomachache on the journey from home to school might be interpreted as an expression of fear of the unknown within him as well as the loss of self as soon as he leaves the protected family home, his spatial reference point.

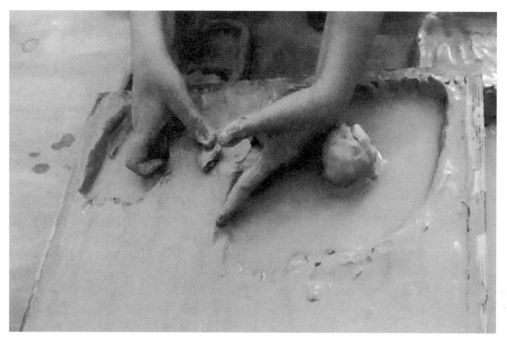

FIGURE 24.10. Paul.

Paul's need for safety and his implicit knowledge of self-coherence help him manage his inner transformation: "I continue to be myself, even if I change myself. I am allowed to go through changes." This corresponds with the age-appropriate task of development in adolescence, the development of identity.

These cases may open a small window to showcase children's and adolescents' journeys of haptic development. At the Clay Field we do preventive work.[3] We are delighted to experience the joyful independence children, teenagers, and adults gain in these processes. For us, this is where human freedom lies. We are deeply convinced that this freedom—rooted simultaneously in the knowledge of and experience with our connectivity to the world—can form the basis for responsible human existence and activity. That is why it is important to us to implement and communicate the work in all its complexity.

25

Developmental Trauma in the Psychiatric Hospital Setting

ROSAMUND MORTIMORE

The rare opportunity to offer Clay Field Therapy in a psychiatric hospital has been a profound gift of learning for me as an art therapist, and I write this in acknowledgment of the courage and trust of those patients who have been willing to dive into the unknown with me in participating in this work.

I am one of a team of five creative art therapists working in an inner-city private mental health facility where we provide open studio groups and day program groups. The hospital has two well-stocked art rooms: one for inpatients and another for outpatients.

Inpatients are visited daily by their psychiatrists and have access to allied health professionals who offer group sessions in various cognitive therapies, such as cognitive behavioral therapy (CBT) and dialectical behavioral therapy (DBT), schema therapy, mindfulness-meditation, and diet and exercise. Art therapy, occupational therapy, and craft are also available. This hospital also provides transcranial magnetic stimulation (TMS) of the brain for depression.

Many find quiet sanctuary in the containment of the art therapy setting away from the intensity of what can be confronting cognitive therapies. Patients often say that

the art therapy room is the most healing place in the hospital, and art therapy the most therapeutic aspect of their treatment.

Group schema therapy for complex trauma is an inpatient program at this hospital for individuals who present with borderline personality disorder or complex post–traumatic stress disorder (CPTSD). It is an intensive specialized therapy aiming to teach cognitive strategies for individuals to learn to self-regulate. Many have found it helpful, but there are often casualties, who, despite being considered strong enough to undertake this program, have been retraumatized and had to leave. There are no somatic therapies offered in this program.

In this context, I include the definition of CPTSD according to Courtois and Ford:

> Complex psychological trauma is defined as traumatic stressors that are: (1) repetitive and prolonged; (2) involve direct harm and/or neglect and abandonment by caregivers or ostensibly responsible adults; (3) occur at developmentally vulnerable times in the victim's life, such as early childhood; (4) have great potential to compromise severely a child's development, [the results of which can include] problems with emotional dys-regulation, identity, dissociation, somatic distress, and relational disturbance.[1]

This chapter will include a case history of a patient who, having completed a series of individual sessions of sensorimotor art therapies with me, returned to the hospital to undertake schema therapy. I also give a brief account of her outcome.

Many patients appear to be shut down and resistant to change. They identify strongly with their diagnoses and their history of mental illness. They can be defensive, dismissive, fearful, and seemingly unwilling or unable to consider the possibility of change or recovery. Such patients often utilize the art room for distraction rather than an intention to face their trauma through creative expression. They will "color in," make cards for friends, or look through magazines, but if highly medicated, they will only stay for a short time due to poor concentration. Nevertheless, they gain solace from these activities that we may perceive as superficial.

Those individuals who are willing to immerse themselves in deeper creative expression usually stay for the entire session and will come to the art room every day, describing it as their "therapy." Over time these patients build up a strong connection and trust in the therapists. They are open to developing an understanding and ownership of their process, taking risks and gaining insight into their mental health through creative work.

Van Der Kolk writes that "the only thing that makes it possible to do the work of healing trauma is awe at the dedication to survival that enabled my patients to endure their abuse and then to endure the dark nights of the soul that inevitably occur on the road to recovery."[2]

I developed a keen intuition about what was safe to offer. Nevertheless, there were times during a Clay Field session when I had to search my mind for answers, engaging my own bodily feelings and intuition for what to do next. At no time could I risk leaving a patient in a precipitous situation such as trauma activation or freeze. Feelings of helplessness and defeat would sometimes manifest in my body, alerting me to the danger of the client becoming overwhelmed. Or, if my mind wandered or became distracted, it alerted me that they could be at risk of dissociation.

A strong faith in the elements of the Clay Field—the constancy of the material, the solidity of the container, the haptic sense of touch, and wisdom of the hands—was ultimately my anchor that prepared me throughout my training to be a very present witness and companion on the journey.

Case History

In working with severe trauma, the therapist must be open to the potential of accompanying the traumatized individual to the darkest and most terrifying places in the psyche.

—NANCY R. GOODMAN AND MARILYN B. MEYERS

Diana is one such client who has come back from the depths of depression and debilitating trauma to the extent that, at the time of writing, she has successfully avoided hospitalization for the last eighteen months during which she has miraculously remained well and functioning.

I include parts of Diana's written account of her history, her experience with art therapy, and specifically with the Clay Field, along with my explanations and interventions:

I am a fifty-five-year-old with a long history of complex trauma, post–traumatic stress disorder, and major depression. I was diagnosed in 1993 when I met both my current psychiatrist and clinical psychologist after several years of secondary trauma caused by misdiagnosis. My first suicide attempt was in 1984, and I have had many since. I have a history of self-harm and have had a number of psychotic episodes.

I was repeatedly sexually abused by my maternal grandfather between the ages of four and eleven, and once by my paternal uncle at age four. The abuse by my grandfather was by far the more influential for me, and it has had the most significant effects on my mental health. He called me his "little princess."

Having successfully undergone several years of psychoanalytic treatment in my late twenties, I began to dream of a box that I could not open. I also dreamed of a book

with the title *So Much to Tell You.* Then, during a therapy session, I had a full body memory on the couch. Neither my therapist nor I had any idea what was happening. This was the start of my somatic flashbacks, which continue today. These flashbacks are extremely physical, my body reenacting scenes of abuse as if they are happening in the present. Sometimes I don't have a cognitive reference for the flashback; at other times I suffer from very disturbing memories of the abuse and terrible nightmares.

Despite the support of my therapist at the time, psychoanalytic work was now no longer helpful in me going forward. I was referred to several different psychiatrists, who either didn't believe me or wanted to treat me for psychosis. I was labeled with borderline personality disorder and treated accordingly. I was told I was "attention seeking" and "putting it on." My original trauma was greatly impacted by this secondary trauma.

When I began working with my present psychiatrist and her psychologist colleague, my world changed dramatically. They not only believed me but set about medical and psychological treatment based on my trauma. Having a correct diagnosis made an enormous difference to me. I began eye movement desensitization reprocessing (EMDR), a cognitive and somatic therapy, which was both distressing and extremely helpful. This was my first experience of a somatic therapy, and as someone who "lives in her head," it was a great change for the better for me, helping me to process my memories, flashbacks, and nightmares in a physically safe environment. I was on increasing doses of medication: sedatives, antidepressants, mood stabilizers, antipsychotic drugs, antiepileptic drugs for medication-induced seizures, and drugs to control nightmares. I also tried a schema program based on a CBT dialectical approach. I lasted four days of a four-week course and had my first psychotic break. An intensely intellectual process, it wasn't a safe environment for me.

Diana's experience of schema therapy left her severely and precariously unwell. She became high-risk and was hospitalized for six more weeks.

Her first engagement with art therapy as an inpatient was to create small handmade books using collage, stitching, and "found poetry" in the form of cut-out and reassembled words from old books. The following weeks and months of work within these precious and private containers resulted in incredibly beautiful but extremely confronting depictions of her story, written to herself and not to be seen by others. I had the privilege to share in and bear witness to her process and the resulting small books.

The Art Therapy program allowed me to explore my darkness and light without judgment. I felt supported at a time when I didn't feel safe. The therapeutic interventions assisted me when I was terribly depressed, and art-making gave me something to do outside of the horror inside my head. When my therapist offered me the Clay Field, I trusted her enough to give it a try.

The regressive nature of clay has the potential to trigger a trauma response. The accompanying therapist must be sensitive to the possibility of retraumatization and trained to support the client with appropriate interventions to keep them safe in their process. Different from children, adults work with their eyes closed at the Clay Field. Flashback procedure is to ask the client to open their eyes and reorient—for example, to look around the room, name three things you can see, feel your body weight on the chair and your feet on the ground, and feel the boundaries of your body and notice how it responds. The client needs reassurance that she is safe.

> My first experience of the Clay Field was extremely challenging. I struggled most with the consistency of the wet clay, and as a result had to limit my experience by opening my eyes, as I found it unbearable.

A bowl of warm water is most often used to add water to the field. It's also a resource to move the hands to in order to slow down a trauma response. The client might be invited to bathe their hands in the bowl and experience how that feels, to rest their hands there, sometimes smoothing wrists and arms with the liquid clay, all of which can be calming. However, Diana found the warm water abhorrent, as it triggered memories of abuse. At one point she recoiled in horror when water splashed into her face, so the offer to soothe her hands in the warm water was unacceptable to her.

> I had somatic flashbacks while working with the clay and water, and this went on for several sessions, but my therapist offered solutions that made it much better.

Diana was able to clean her hands using the sponge, or go to the sink and wash her hands. She was also reassured that she could open her eyes at any time to reorient to the present. Other interventions were offered as Diana progressed through the sessions. In her early sessions, Diana experienced her hands as not being her own, but rather the hands of the perpetrator, saying, "They are his hands, not mine. I am the clay, and the hands are his." In another session she reported she could feel his hands around her head. Her hands sometimes stopped moving, indicating that Diana was experiencing a trauma response; her fingers would be frozen, gripping deep into the clay. She said, "If I dig in, they're mine. I'm holding me down." Yet on another occasion she described her hands digging into the clay and holding on as a feeling of being "anchored and safe."

While the hands are moving, the client is still able to deal with the material, but in the event of freeze, it is necessary to find an active response.[3] An appropriate intervention here might have been to remind her that this is a memory and to encourage her to move her hands and experience them as her own.

At times Diana seemed to be identifying with the perpetrator. She would often say that she felt that she had "no skin." Her boundaries had been so violated that she could not separate herself from the sense that the body of the grandfather was inside her own. She reminded me of a quote she "once read" that refers to the survivor of abuse as being three entities at once: victim, perpetrator, and witness: "There is an 'I' present." These are conscious memories, but they tend to be unintegrated.[4]

> Initially the clay and water were impossible for me to manage. My therapist guided me with several techniques that made a big difference. She covered my hands during one session, which felt very safe and contained. I felt the clay was actually protecting me, not forcing me to touch it. Even though it was inanimate, that's how it felt (fig. 25.1).

I offered to try covering her hands with the clay on two occasions. This was done with extreme care so as not to touch her skin as well as to avoid the squelching sounds made by the clay, which she found extremely triggering. Diana described her enclosed hands as a comforting feeling of being held.

The containment of the clay can also offer an experience of the boundary of the skin, as can the client smoothing liquid clay over the hands, wrists, and arms. Diana described it as having protective gloves to soften the gripping, and in her words, to "stop them getting to me." She felt relaxed and was now able to cry and allow release. This was an emotional moment, and very moving for me to accompany her.

> During one session I grabbed all the clay and threw it onto the table next to me. I felt angry, naughty, and deeply satisfied. In another session I cleaned out the entire box, down to the tiniest fragment. The box was "clean" and free from "dirt." It felt very calming and peaceful—freeing (fig. 25.2)!

Diana cleaned with great energy and purpose, saying it felt good and that she was "clearing away all the shit," all the while needing to stop to clean her hands with the

FIGURE 25.1. Covering the hands.

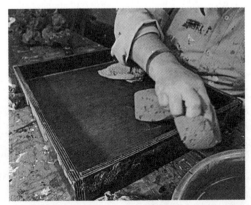

FIGURE 25.2. Cleaning the box.

sponge. I offered her a scraper as well as a cloth to remove the material, as she still found it repugnant. I noted the courage it took for her to continue despite the horror of the clay ("shit") on her hands. She remarked at one stage: "I wasn't the one who cleaned me up; he did. He used to call me dirty a lot. 'Dirty little girl.'"

Diana removed every trace of clay from the box, focusing especially on the corners. She was fully focused on this process, and when finally she was satisfied that the box was clean inside and out, I encouraged her to place her hands inside the field and tell me how the ground felt. Mostly the client experiences the empty box as liberating, solid, and supportive. They may spend time playfully exploring the ground, perhaps with a little water. This space is claimed as theirs. "It is that which survived it all,"[5] and it may be the first time they have felt so free.

Diane did not feel supported yet, though, remarking that she could still feel the perpetrators hands around her head. I suggested she place her elbows in the box, and she rested that way, eyes open, on her forearms, "and I felt the relief of that moment in my own body." The elbows represent the infant stage of crawling, prior to learning to become upright, and arms resting in the field give the experience of solid ground. "The body reconnects with the vital impulse of that age, the impulse to get up and walk and 'stand up for myself.'"[6]

Diana then felt that the box was safe and contained, and she picked it up and hugged it to her chest. "I'm hugging her to myself." Then she placed the box down vertically on the table like a shield and said, "It felt better that way," and again rested her

FIGURE 25.3. "I'm hugging her to myself."

head down on her forearms, and picked it up, hugging it for a second time. Elbrecht writes: "To reconnect with this inner resource is empowering. Once the bottom [of the box] has been reached and claimed, it is undoubtedly a new beginning, a reconnection with the source from which life, sustenance, safety, and spirit flow."

At her next session, Diana emptied out the left side and began to cover the top edge of the box down to the table around it, then the right side, the left, and finally the lower edge. All were covered and reinforced by clay. She checked all the boundaries to see that they were strong and in touch with the ground outside the box. The boundaries of the box represent safety and containment, so they must be solid.

She proceeded to build constructions that encroached inward from all sides toward a small ball in the center, which she had identified as herself. But she then squashed this self flat in an act of hopelessness that, no matter how many times she cleaned, "all the shit will come back" and "I am obliterated." Diana had only been using her right hand. I questioned what was happening with her left hand, and she said, "It's hanging on for dear life. I'm bracing myself." She described having to hold on to the bed.

At this point I was desperately searching for what to do, as the feeling was of utter hopelessness, and I needed to help Diana through this. None of the usual resources were acceptable to her, so I asked her if she could think about her safe place and tell me about it. Diana closed her eyes and soon relaxed a little. She began to tell me about a memory of walking along the Thames in spring, and how happy she'd felt then. I asked her if she could make this safe place in the Clay Field. She began to roll the material into tiny balls with which she filled the box, lining them up like little soldiers. These were reminiscent of the small round shapes that had first appeared in Diana's guided drawings. Diana likened them to cells of the body and to recovered memories.

For me, these tiny balls felt hugely significant, the "soul retrieval" of the lost and dissociated parts of herself. It felt like a breakthrough moment in Diana's process, and it opened up a way to move forward. Diana asked if I would keep the tiny balls as they were, in the box, until her next session. Just as she finished, the sun shone through the window onto the Clay Field, the little balls casting *big* shadows in the warmth of the sun (fig. 25.4). This was an auspicious moment—it felt almost sacred.

> The balls I made became objects of meaning in themselves. I dyed three of them with natural red ocher, three with white ocher, and three with black charcoal. These are the three colors of the goddess in the Western mystery tradition. I made a small leather pouch and gave them to my art therapist.

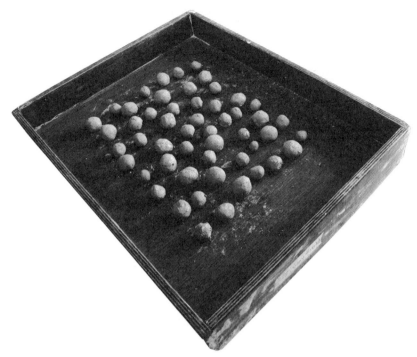

FIGURE 25.4. An auspicious moment.

Diana progressed through several more sessions, building trust in the material and the process:

> My last session was very important to me. The clay felt so right, and the slickness was lovely and cool on my hands and fingers as I worked. I made a bowl shape in the middle of the Clay Field and smoothed the edges gently and carefully. Next, I made many small balls from the side that I had removed, taking time to make these as uniform and smooth as possible. Then placing them into the bowl, I was finished…. It made me think of the cupped hands and the womb of the mythic Mother, holding life and creation in her body. It was a powerful moment in my healing. I felt beautifully serene.

Diana had found integration. The empty bowl at the beginning was now filled with the previously lost fragments of her self.

Diana had one more Clay Field session, which involved the small balls and talking about what they meant while sorting them into sizes. She said, "I love circles, balls, and spirals. They represent the goddess, the divine feminine for me." The Clay Field that day felt safe for her, and she noticed the shapes and images that appeared were "more feminine than masculine."

She was able to use the water freely, commenting that it felt completely different this time. More tiny balls appeared and were much more playful in their engagement.

She felt in control and free to move, uninhibited in the field, "enjoying the stillness in my head and being." At the end, Diana was delighted to notice that she had not washed her hands once during the entire session.

"My experiences with Clay Field and EMDR have helped me to understand that, for me, somatic therapies are highly successful for those of us experiencing physical responses to trauma." Diana stated that her experience of being witnessed and "the sense of being held and protected by the therapist didn't leave me feeling alone with my trauma." She affirmed the role of the team approach while being in the hospital setting: "At no time did I feel as if I was abandoned at the end of a Clay Field, as the sessions were discussed and followed up by my therapist and other health professionals. This interconnectivity allowed me to feel very protected and supported."

In time, Diana completed two more Clay Fields after becoming stable. These have strengthened a connection with her deeply spiritual core and a new feeling of hope. Through her courage and commitment, and a team of dedicated professionals, Diana has built resilience and strategies to manage her mental health. I consider it a privilege to have been part of her journey.

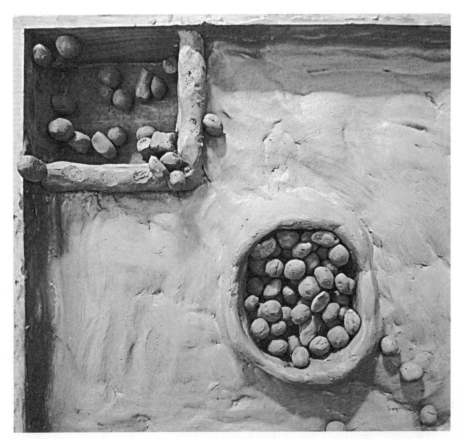

FIGURE 25.5. The divine feminine.

26

The Healing Journey

The setting seems to be so simple, and many beginners think it will be sufficient just to provide a box filled with clay, and the child will have fun and learn something in the process. I would hope that as a reader by now you have realized that it is not quite that easy. It takes more than just clay and water and a box to repair a bruised and hurting soul, and yet, it takes just that.

Just as much as children, adults connect with the developmental stages I have described whenever they touch on issues from their childhood. You have read in Rosamund Mortimore's "Case History" in chapter 25 how implicit memories of sexual abuse stay alive, in the case she shares for sixty years, until they can be put to rest. Adults will work with their outstretched arms and round soft baby hands if they connect with their attachment trauma. They will hold onto the box when something destabilized them as if they are still two or three years old. Children are easier to work with because they have not spent the past decades consolidating their overcompensating, asynchronous postures and belief systems due to the terrible things that happened to them when they were little.

In order to be a human individual in a particular family, community, and society we all undergo a profound and often damaging socialization process, but even while we are being shaped by this school of life, each unique personality shines through. Children in the same family, including twins, show their distinct character and personality from an early age onward. Each child has a different pregnancy, a different birth, even though the parents and the setting are the same as for all the others. At around age nine or ten, their spirit stirs into action. Children now begin to compare and make choices of their own. They will spend the next ten years intensely and confusingly waking up to themselves. And in their twenties, they will consolidate their positioning in the world.

You may dismiss this next statement as my personal belief system, but in my experience, each individual has a unique spirit soul. We come into being with what Caroline Myss calls a *soul contract:*[1] a contract that each soul makes before incarnating concerning which lessons he or she wants to learn in this lifetime. Such lessons are usually painful and scarring. Jung makes a clear distinction between the ego and the self. According to Jung, this self is our transpersonal essence. It gives birth to the ego as its agent in the world, but it is not identical with the ego. While the ego almost inevitably gets damaged, the self remains intact as our immortal spirit. Jung defines the self throughout his works as a core that cannot be hurt and broken because it is not of this world.[2]

In a very different context, it is this core onto which Levine bases his concept of a counter or healing vortex. For Levine it is an essential part of the nervous system. As long as we are alive, this healing vortex is somewhere. Among all the chaos and overwhelm, which Levine calls the trauma vortex, a healing vortex can be accessed. This healing vortex might initially be weak and barely perceptible, but it can be nursed into strength in the therapeutic process. Levine's work is centered *around* accessing the healing vortex through what he calls *pendulation,* virtually asking the self to help repair and restore the ego. If clients cannot access their healing vortex, the entire therapeutic process will focus on building and strengthening this connection. It is there, maybe initially just as a fantasy place or an imaginary friend. No trauma exploration, however, can safely take place without being able to access at least one aspect that does not hurt. This can be a felt sense, an image, a song, a movement, a teddy bear, or a crystal, but it needs to be something that a child can reliably connect with whenever a stressful situation occurs.

In my role as a therapist, I can strengthen this core through my trust. My ego may also despair, in empathy with the child's desperation, but my self will be able to connect to the child's core and wake up its healing potential. I believe this is what shamans do: they create a setting in which the adepts are encouraged to communicate with their higher self. Through this connection, clients come in contact with their innermost knowing and become able to heal themselves.

In less esoteric terms, there is always a life movement. If it wasn't there, we would be dead. This life movement is quite intangible, yet it powerfully drives our development forward. Even Jung defined the mysterious self at its core as an instinct. I have watched Levine in many sessions simply reminding clients that they were still alive.[3] Part of their dissociated PTSD stance was locked in the belief they were dead. This simple reminder enabled those clients to come back to movement.

Both Deuser and Levine agree that the essence of their work is to find an active response to what happened. To be safe enough is the basis, but then it is necessary

in the process to come out of acquired bracing patterns into movement, and where perception has been shut down to avoid pain, to allow the sensed life movement to rekindle the spirit. Both also agree that the story of what happened is not necessary for healing to occur, as I believe the many case histories have vividly illustrated.

This work could not be done without the box. The clay is pliable, sticky, smooth, rock-hard or a sloppy bog, as changeable and at times unpredictable as life itself. The box, on the other hand, is solid. It does not change; it does not move. If the life movement has been unmanageable, the box becomes the part that has survived it all. In this book you have witnessed several girls cleaning their field with utter dedication of the abuse they suffered. You have also witnessed adolescents who moved out of the box, taking the clay with them but leaving the confines of their chaotic, unsupportive families behind. The firm box and the forever changeable clay offer two polarities in which each individual can find answers. Some need the boundary of the box to crash into to be able to find a hold; others need to leave exactly this confinement and take possession of the entire table.

As a therapist I have learned that as long as a client feels safe and accepted, they know what they need. They know what feels right and good. Goodness is implicit. Goodness happens in our gut, in our heart. It makes us feel light, as if all our cells are moving, singing, and dancing. We feel alive as we are meant to be. Good therapy can connect us to this felt sense of being whole and complete. It is what some call a spiritual experience. Others refer to this state as happiness: not the giddy, exuberant excitement of a child who has just had a treat but the deeply fulfilling state of being alive.

It is mostly the ego that gets hurt when we grow up. It distorts the lens through which we perceive ourselves and others. If, as a therapist, I can keep the focus on the spiritual core rather than the ego, I speak to the part in each individual, no matter what age, that is unharmed. This attitude becomes an extraordinary healing agent. In simple terms, I call it trust. As a therapist I trust that my client knows. I do not need to know; I do not need to provide the answers. But being open is important: being authentic, being connected to my own core of being. This attitude allows the child to trust as well. It is what Perry calls a calm and regulated adult, necessary to support a dysregulated child. If I do not engage in the drama, the drama will stop. If I stay calm, the child can calm down. If I can trust the child will come up with the answers, the child will. When I feel afraid in a therapy session, I can almost be certain the child is afraid, too. The most useful intervention I can offer my client is to calm down myself. Whatever helps me will help the child.

Suzuki called the essence of Zen the *beginner's mind*.[4] It is a spontaneous, authentic attitude of being fully present. From my twenties onward, I studied with the Zen masters Yuho Seki *roshi* and later his successor Daichi Bunryo Yamada *roshi*. Both

were abbots of the famed Eigen-ji monastery in Kobe, Japan. We hosted their visits to Germany, and I cooked for them and spent days on end in meditation with other participants and the monks. Layer by layer the many facets of ego and convention fell to the wayside. The *roshi* was himself, be it as the Zen master in a koan session or drinking champagne and loving vanilla ice cream. He could laugh so fully and infectiously that he could fall off his seat and roll on the floor. I had never in my life seen an eighty-year-old man do this. The thousands of *shoulds* that were programmed into my impressionable child-self became confused and eventually fell off me like ill-fitting clothes. The beginner's mind of children makes their layers of ego still fresh and flexible. They are ready to drop the pretense if they are allowed to.

These life lessons as a young therapist have stayed with me. My supervisor Huib van Schelven was adamant that I had to learn more than anything else to be comfortable with *not doing* in the therapy dyad, that no technique would heal a client as such. His teachings were all about being present and trusting that the clients would know what to do. To be present with a child, to be fully there, is the most important therapeutic intervention I have ever learned. Yes, there are decisions made in a session, based on our client's behaviors and needs for safety or practicalities. But underneath the veil of doing, of skillful interventions, is the core belief that with the right support, clients will heal themselves.

The Clay Field is testament to this attitude. Once children have settled and gained trust in the therapeutic setting, built a connection with the therapist, and are feeling safe enough in the environment, they will unerringly focus on those developmental needs that require strengthening and repair. They know. They know what is missing and when they have completed their inner process. Fulfillment of the inner movement in the clay allows children to become their own potent healers.

ACKNOWLEDGMENTS

Heinz Deuser has generously supported the writing of this book. We have spent many hours discussing developmental aspects and how to best support clients. I consider him not only a dear friend but also a genius in what he has developed. I am deeply grateful for his unique, lifelong friendship spanning by now close to fifty years, and his ongoing generous support.

The case histories in the last part of this book aim to underpin the therapeutic scope this work has. In this context, I would like to thank Pip (Philippa) Rose, Chris Storm, Monica Finch, Katharina Kramer, Ina Schott, and Ros (Rosamund) Mortimore for contributing chapters, which illustrate their particular lens and expertise. All of them are pioneers and dedicated therapists who have supported and furthered this modality.

Several others have shared case vignettes of sessions; my particular gratitude goes to Mia (Erasmia) Vaux, Jo (Joanne) Meijer, Lyn Duffton, and Jocelyn Campbell. Others have given their permission to share their photographs; thank you to Alyson Byrnes, Emma Templeton, Judy Rosson, Brittney Merrylees, Maree Gaukrodger, Alyssa Grenkiewicz, Jessica Leung, Denise Kay, Dakhylina Madkhul, Brianna Marchbank, and Leeza Stratford.

I am particularly grateful for the lively discussion concerning the continued updating of the Clay Field Therapy curriculum, a never-ending learning curve I share with the Institute of Sensorimotor Art Therapy faculty members Chris, Ina, and Katharina, whom I have already mentioned, as well as Clare Jerdan, and, of course, Heinz Deuser, whose life work is the theme of this book.

A special thank-you goes to my inspiring friend Cathy Malchiodi for writing the foreword and for understanding how much wrestling it takes to fit all these ideas into words, and then into chapters, and for adding laughter, color, and female empowerment to every Zoom chat.

My beautiful friend Arleen Hanks has supported me at critical moments during the writing process in her unique and special way, which was invaluable.

The team at North Atlantic Books has again been exceptional. The designers, who wrestled two hundred images into place. Christopher Church, you must have the patience of an angel. Shayna Keyles, I really appreciated your critical eye throughout the process. Janelle Ludowise, you were a patient guide through the book's interior design and proofreading phases. And lastly Tim McKee, thank you for believing the book to be an essential resource.

INTERNET RESOURCES

Cornelia Elbrecht, Institute for Sensorimotor Art Therapy: www.sensorimotorarttherapy.com. The institute offers supervision and online training in Clay Field Therapy.

Beacon House, a collection of information and advice for children, families, and schools: https://beaconhouse.org.uk

ChildTrauma Academy: www.childtrauma.org

Cathy Malchiodi, Trauma-Informed Practices and Expressive Art Therapy Institute: www.trauma-informedpractice.com

Ruby Jo Walker, Polyvagal Theory: www.rubyjowalker.com

Sensory Attachment Intervention: www.sensoryattachmentintervention.com

Pediatric occupational therapy aspects of child development: https://mamaot.com and www.candokiddo.com

Excellent YouTube videos can be found on the following subjects:

- Somatic Experiencing
- mirror neurons
- Bruce Perry
- the still face experiment
- "Code Red *(tzeva adom)* Song—Helping Children Deal with Terror," https://youtu.be/FJ4WKHKu-_w

NOTES

Foreword

1 Joshua K. M. Nan and Rainbow T. H. Ho, "Effects of Clay Art Therapy on Adults Outpatients with Major Depressive Disorder: A Randomized Controlled Trial." *Journal of Affect Disorders* 217 (2017), 237–245, doi:10.1016/j.jad.2017.04.013.

2 Margaret Atwood, *The Blind Assassin* (Toronto: McClelland & Stewart, 2000).

3 Cathy A. Malchiodi, *Trauma and Expressive Arts Therapy: Brain, Body, and Imagination in the Healing Process* (New York: Guilford Press, 2020).

4 Cathy A. Malchiodi, "Expressive Arts Therapy Is a Culturally Relevant Practice," *Psychology Today,* September 24, 2019, https://tinyurl.com/1dc8eska.

5 Sigmund Freud, "Beyond the Pleasure Principle," in *Complete Psychological Works,* vol. 3, ed. J. Strachey (London: Hogarth Press, 1954).

6 Thich Nhat Hanh, *The Heart of Buddha's Teaching: Transforming Suffering* (New York: Harmony, 2015), 131.

7 David J. Linden, *Touch: The Science of Hand, Heart and Mind* (New York: Penguin, 2015), 26.

Introduction

8 Bruce D. Perry and Cathy A. Malchiodi, "Rhythm and Regulation: Innovative Approaches to Brain and Body During a Time of Immobilization," audio recording, May 30, 2020, www.besselvanderkolk.com.

9 Frank Wilson, *The Hand: How Its Use Shapes the Brain, Language and Human Culture* (New York: Vintage, 1998).

10 Peter Levine, *Trauma and Memory: Brain and Body in Search of the Living Past* (Berkeley, CA: North Atlantic Books, 2015), 17.

11 Australian Childhood Foundation, personal communication, February 9, 2018.

12 Bruce Perry, "Applying Principles of Neurodevelopment to Clinical Work with Maltreated and Traumatized Children: The Neurosequential Model of Therapeutics," in *Working with Traumatized Youth in Child Welfare,* ed. Nancy Boyd Webb, 27–53 (New York: Guilford Press, 2005); Bessel Van der Kolk, *The Body Keeps the Score* (New York: Viking, 2014); Lawrence Heller and Aline LaPierre, *Healing Developmental Trauma: How Early Trauma Affects Self-Regulation, Self-Image, and the Capacity for Relationship* (Berkeley, CA: North Atlantic Books, 2012).

13 Karlfried Graf Dürkheim, *Hara: The Vital Center of Man* (London: Unwin Books, 1988), plus about twenty other publications.

14 Heinz Deuser, *Lebendige Haptik: Handbuch zur Arbeit am Tonfeld* (Norderstedt, Germany: Books on Demand, 2020); Heinz Deuser, *Bewegung wird Gestalt* (Bremen, Germany: Edition Doering, 2004); Heinz Deuser, *Arbeit am Tonfeld, der Haptische Weg zu uns selbst* (Giessen, Germany: Psychosozial Verlag, 2018).

15 Cornelia Elbrecht, *Healing Trauma with Guided Drawing: A Sensorimotor Art Therapy Approach to Bilateral Body Mapping* (Berkeley, CA: North Atlantic Books, 2018).

16 Peter Levine, *In an Unspoken Voice: How the Body Releases Trauma and Restores Goodness* (Berkeley, CA: North Atlantic Books, 2010; Levine, *Trauma and Memory;* Peter Levine, *Waking the Tiger: Healing Trauma* (Berkeley CA: North Atlantic Books, 1997); Peter Levine and Maggie Kline, *Trauma through a Child's Eyes: Awakening the Ordinary Miracle of Life* (Berkley, CA: North Atlantic Books, 2007).

17 Daniel Hughes, "Dyadic Developmental Psychotherapy: Toward a Comprehensive Trauma Informed Treatment for Developmental Trauma Disorder," DDP Network, February 18, 2014, https://tinyurl.com/h8767khq.

18 Bruce D. Perry, "Examining Child Maltreatment through a Neurodevelopmental Lens: Clinical Applications of the Neurosequential Model of Therapeutics," *Journal of Loss and Trauma,* June 23, 2009, 242, doi:10.1080/15325020903004350.

19 Van der Kolk, *The Body Keeps the Score.*

20 Hughes, "Dyadic Developmental Psychotherapy: Toward a Comprehensive Trauma Informed Treatment."

21 Perry, "Examining Child Maltreatment"; Perry, "Applying Principles"; Bruce D. Perry, *The Boy Who Was Raised as a Dog: What Traumatized Children Can Teach Us about Loss, Love, and Healing* (New York: Basic Books, 2006).

22 Van der Kolk, *The Body Keeps the Score;* Robin Karr-Morse and Meredith S. Wiley, *Scared Sick: The Role of Childhood Trauma in Adult Disease* (New York: Basic Books, 2012).

23 Cornelia Elbrecht, *Trauma Healing at the Clay Field: A Sensorimotor Art Therapy Approach.* (London and Philadelphia: Jessica Kingsley, 2013).

24 Begga Hölz-Lindau, *Arbeit am Tonfeld bei ADHS: Pädagogische und psychodynamische Aspekte der Affektregulierung* (Giessen, Germany: Psychosozial Verlag, 2020).

Chapter 1

1 Sabina Spielrein, "Destruction as the Cause of Coming into Being," *Journal of Analytical Psychology* 39 (April 1994), 155–186, doi:10.1111/j.1465-5922.1994.00155.x.

2 Maria Montessori, *The Montessori Method* (Mineola, NY: Dover, 2002).

3 I use the Stokke Tripp Trapp chair (www.stokke.com), which can be quickly height-adjusted from babies up to adults.

4 Malchiodi, *Trauma and Expressive Arts Therapy,* 250.

5 Sheila Dorothy Smith, *Sandtray Play and Storymaking: A Hands-On Approach to Build Academic, Social, and Emotional Skills in Mainstream and Special Education* (Philadelphia: Jessica Kingsley, 2012).

6 Malchiodi, *Trauma and Expressive Arts Therapy,* 250.

7 Caroline Case and Tessa Dalley, *The Handbook of Art Therapy* (New York: Routledge, 1992), 97.

8 Joy Schaverien, *The Revealing Image: Analytical Art Psychotherapy in Theory and Practice* (New York: Tavistock/Routledge, 1992), 13.

9 Bruce D. Perry, "The Three R's: Reaching the Learning Brain," Boston: Beacon House, 2019, https://tinyurl.com/1okftmz4; Perry, "Applying Principles."

Chapter 2

1 Deuser, *Lebendige Haptik.*

2 Hölz-Lindau, *Arbeit am Tonfeld,* 27.

3 Ibid., 30.

4 Perry and Malchiodi, "Rhythm and Regulation."

5 Van der Kolk in Perry and Malchiodi, "Rhythm and Regulation."

6 Heller and LaPierre, *Healing Developmental Trauma,* 134.

7 Karr-Morse and Wiley, *Scared Sick.*

8 Van der Kolk, *The Body Keeps the Score.*

9 Kristin Moe, "Breaking the Chain: Healing Racial Trauma in the Body; an Interview with Resmaa Menakem," Medium, May 14, 2020, https://tinyurl.com/1ixztnz9.

10 Resmaa Menakem, *My Grandmother's Hands: Racialized Trauma and the Pathway to Mending Our Hearts and Bodies* (Las Vegas: Central Recovery Press, 2017), 9.

11 Perry and Malchiodi, "Rhythm and Regulation."

12 Ibid.

13 Jean Ayres, *Sensory Integration and the Child: Understanding Hidden Sensory Challenges,* 6th ed. (Los Angeles: Western Psychological Services, 2015), 6.

14 Ibid., 5.

15 Ibid., 7.

16 Ibid., 15.

17 Heller and LaPierre, *Healing Developmental Trauma*, 134.

18 Edward Tronick, "Still Face Experiment: Dr. Edward Tronick," YouTube, video, November 30, 2009, https://youtu.be/apzXGEbZht0.

19 Vilayanur S. Ramachandran, *The Tell-Tale Brain: A Neuroscientist's Quest for What Makes Us Human* (New York: W. W. Norton, 2011).

20 Hughes, "Dyadic Developmental Psychotherapy: Toward a Comprehensive Trauma Informed Treatment"; Daniel Hughes, *Attachment-Focused Family Therapy Workbook* (New York: W. W. Norton, 2011); Pat Ogden and Janina Fisher, *Sensorimotor Psychotherapy: Interventions for Trauma and Attachment* (New York: W. W. Norton, 2015).

21 Deuser, *Arbeit am Tonfeld*.

22 Hölz-Lindau, *Arbeit am Tonfeld*, 28.

23 Deuser, *Arbeit am Tonfeld*, 27.

24 Ayres, *Sensory Integration*, 15.

25 Levine, *In an Unspoken Voice*.

26 Deuser, *Arbeit am Tonfeld*, 27.

Chapter 3

1 Deuser, *Lebendige Haptik*.

2 Elbrecht, *Trauma Healing at the Clay Field*, 140.

3 Perry, "Applying Principles"; Van der Kolk, *The Body Keeps the Score*.

4 Ayres, *Sensory Integration*, 14.

5 Deuser, *Lebendige Haptik*.

6 Ibid., 64.

Chapter 4

1 Martin Grunwald, *Human Haptic Perception: Basics and Application* (Berlin and Boston: Birkhäuser Verlag, 2008).

2 Linden, *Touch*, 7.

3 Ibid., 27.

4 Ibid., 143.

5 Ibid., 48.

6 Ibid., 56.

7 Ibid., 78.

8 Babette Rothschild, *The Body Remembers* (New York: W. W. Norton, 2000), 41.

9 Linden, *Touch,* 80.

10 Ibid., 44.

11 Thomas W. Myers, *Anatomy Trains: Myofascial Meridians for Manual and Movement Therapists* (New York: Churchill Livingstone Elsevier, 2014), 33.

12 Ibid., 28.

13 Ibid.

14 Ibid., 34.

15 Karr-Morse and Wiley, *Scared Sick.*

16 Perry, "Examining Child Maltreatment," 81.

17 Wilson, *The Hand,* 35.

18 Ibid., 49.

19 Ibid., 147.

20 Jill Bolte Taylor, "My Stroke of Insight," TED Talks, video, 2008, https://tinyurl.com/1kceyvx0.

21 Margaret Emory, "The Divided Brain: An Interview with Dr. Iain McGilchrist," *Brain World,* December 23, 2018, https://tinyurl.com/omtb4waz.

22 Wilson, *The Hand,* 147.

23 Ibid., 49.

24 Ibid., 182.

25 Ibid., 190.

26 Ibid., 15.

27 Wilder Penfield and Theodore Rasmussen, *The Cerebral Cortex of Man* (New York: Macmillan, 1950); Brian Resnick, "Wilder Penfield Redrew the Map of the Brain—by Opening the Heads of Living Patients," Vox, January 26, 2018, https://tinyurl.com/1ez2e277.

28 Linden, *Touch,* 62.

29 Ayres, *Sensory Integration,* 31.

30 Wilson, *The Hand,* 195.

31 Christiane Kiese-Himmel, "Haptic Perception in Infancy and First Acquisition of Object Words: Developmental and Clinical Approach," in *Human Haptic Perception: Basics and Applications,* edited by Martin Grunwald, 321–334 (Boston and Berlin: Birkhäuser, 2008), 331.

32 Wataru Ohashi, *Do-It-Yourself Shiatsu* (New York: Dutton and Co., 1976).

33 Kid Sense, "Fine Motor Development Chart," ChildDevelopment.com.au, n.d., https://tinyurl.com/guecdxyn.

Chapter 5

1 Levine, *Waking the Tiger.*

2 Van der Kolk, *The Body Keeps the Score;* Karr-Morse and Wiley, *Scared Sick;* Sue Gerhard, *Why Love Matters: How Affection Shapes a Baby's Brain* (London and New York: Routledge, 2004).

3 Perry and Malchiodi, "Rhythm and Regulation."

4 Levine, *Waking the Tiger;* Levine, *In an Unspoken Voice.*

5 DNA Learning Center, *3D Brain,* software application, 2015, https://tinyurl.com/yk48p7rn.

6 Joseph Cesario, David J. Johnson, and Heather L. Eisthen, "Your Brain Is Not an Onion with a Tiny Reptile Inside," *Current Directions in Psychological Science* 29:3 (May 8, 2020), 255–260, doi:10.1177/0963721420917687.

7 Ibid.

8 Sarah McKay, "Rethinking the Reptilian Brain," DrSarahMcKay.com, June 24, 2020, https://tinyurl.com/ynd42pyf.

9 Stephen W. Porges, "Neuroception: A Subconscious System for Detecting Threats and Safety." *Zero to Three* 24 (January 2004).

10 Perry, "The Three R's."

11 Daniel J. Siegel, *The Whole-Brain Child: 12 Revolutionary Strategies to Nurture Your Child's Developing Mind* (New York: Bantam, 2011).

12 Gerhard, *Why Love Matters;* Karr-Morse and Wiley, *Scared Sick.*

13 Perry, "Examining Child Maltreatment," 245.

14 Perry and Malchiodi, "Rhythm and Regulation"; Perry, "Examining Child Maltreatment."

15 Daniel Hughes, "Dyadic Developmental Psychotherapy (DDP): An Attachment-Focused Family Treatment for Developmental Trauma," *Australian and New Zealand Journal of Family Therapy* 38:4 (December 2017), 595–605, doi:10.1002/anzf.1273.

16 Perry, "Examining Child Maltreatment," 245.

17 Elbrecht, *Trauma Healing at the Clay Field;* Elbrecht, *Healing Trauma with Guided Drawing;* Gerhard, *Why Love Matters;* Karr-Morse and Wiley, *Scared Sick;* Levine, *In an Unspoken Voice;* Perry, "Examining Child Maltreatment"; Perry, *The Boy Who Was Raised as a Dog;* Van der Kolk, *The Body Keeps the Score.*

18 Levine, *Trauma and Memory,* 17.

19 Ibid., 38.

20 McKay, "Rethinking the Reptilian Brain."

21 Stephen W. Porges, *The Polyvagal Theory: Neurophysiological Foundations of Emotions, Attachment, Communication, and Self-Regulation* (New York: W. W. Norton, 2011).

22 Based on written notes from Porges's master class at the Australian Childhood Foundation Trauma Conference, 2014.

23 Siegel, *Whole-Brain Child*, 46.

24 Bert Hellinger, *Love's Hidden Symmetry: What Makes Love Work in Relationships* (Williston, VT: Zeig, Tucker and Theisen, 1998).

25 Ogden and Fisher, *Sensorimotor Psychotherapy*.

26 Ayres, *Sensory Integration*, 14.

27 Siegel, *Whole-Brain Child*, 46.

Chapter 6

1 Van der Kolk, *The Body Keeps the Score*, 348.

2 Levine and Kline, *Trauma through a Child's Eyes*, 41.

3 Van der6Kolk, *The Body Keeps the Score*, 162.

4 Levine and Kline, *Trauma through a Child's Eyes*, 41.

5 Inner World Work, "What Survival Looks Like in Primary School," 2019, https://tinyurl.com/dtk9ek2k.

6 Malchiodi, *Trauma and Expressive Arts Therapy*, 373.

7 Cathy A. Malchiodi, *Understanding Children's Drawings* (New York: Guilford Press, 1998), 171.

8 Shirley Riley, "Illustrating the Family Story: Art Therapy, a Lens for Viewing the Family's Reality," *The Arts in Psychotherapy* 20:3 (1993), 253–264, doi:10.1016/0197-4556(93)90020-3.

9 Levine and Kline, *Trauma through a Child's Eyes*, 41.

10 Perry, *The Boy Who Was Raised as a Dog*.

11 Levine and Kline, *Trauma through a Child's Eyes*, 62.

12 Ibid.

13 Ibid., 63.

14 Mark Thorley and Helen Townsend, "What Survival Looks Like in Secondary School," 2017, https://tinyurl.com/2krkeefs.

15 Foster Care 2.0, "Unacceptable Facts and Statistics: Research and Statistics," n.d., https://tinyurl.com/3jvmdut3.

16 Van der Kolk, *The Body Keeps the Score*.

17 Ibid., 145.

18 Deuser, *Bewegung wird Gestalt*.

19 Bessel van der Kolk in Levine, *Trauma and Memory*, xviii.

Chapter 7

1 Van der Kolk, *The Body Keeps the Score.*

2 Levine and Kline, *Trauma through a Child's Eyes.*

3 Van der Kolk, *The Body Keeps the Score.*

4 Ibid., 162.

5 Ibid.

6 Levine, *In an Unspoken Voice.*

7 Perry, "Applying Principles"; Perry, *The Boy Who Was Raised as a Dog.*

8 Ibid.

9 Ibid., 40–43.

10 Heller and LaPierre, *Healing Developmental Trauma,* 96.

11 Rothschild, *The Body Remembers;* Babette Rothschild, "Trauma Specialist Babette Rothschild: Description of Dual Awareness for Treating PTSD," YouTube, video, November 16, 2011, https://youtu.be/HlM8XV7vIFs.

12 Deborah Green, "Quake Destruction/Arts Creation: Arts Therapy and the Canterbury Earthquakes," *Australian and New Zealand Journal of Arts Therapy* 2017, 40–46, https://tinyurl.com/4pfwxhxp.

13 Rothschild, *The Body Remembers,* 66.

14 Ibid., 68.

15 Ibid., 70.

16 Levine and Kline, *Trauma through a Child's Eyes,* 139.

17 Ibid., 145.

18 Unpublished Somatic Experiencing training video. See also www.youtube.com/somaticexperiencing.

19 Ibid.

20 Sass Video, "Code Red *(tzeva adom)* Song—Helping Children Deal with Terror," YouTube, video, November 21, 2012. https://youtu.be/SoB1AjVCueU; "Rocket Alert Song in Israel Goes Viral," *Haaretz,* July 11, 2014, https://www.haaretz.com/.premium-rocket-alert-song-in-israel-goes-viral-1.5255184.

Chapter 8

1 Perry, "Examining Child Maltreatment," 244.

2 Perry, *The Boy Who Was Raised as a Dog,* 24.

3 Ibid., 25.

4 Wilson, *The Hand,* 190.

5 Ayres, *Sensory Integration,* 13.

6 Jean Piaget, "Piaget's Stages of Development," YouTube, video, April 26, 2011, https://www.youtube.com/watch?v=TRF27F2bn-A.

7 Ayres, *Sensory Integration,* 13.

8 Perry, "Examining Child Maltreatment," 242.

9 Ibid.

10 Beacon House, n.d., https://beaconhouse.org.uk.

11 Sarah Lloyd, *Building Sensorimotor Systems in Children with Developmental Trauma: A Model for Practice* (Philadelphia: Jessica Kingsley, 2020), 26.

12 Ibid.

13 Bruce D. Perry, "Childhood Experience and the Expression of Genetic Potential: What Childhood Neglect Tells Us About Nature and Nurture," *Brain and Mind* 3 (2002), 79–100. doi:10.1023/A:1016557824657. https://tinyurl.com/yny9csav.

14 Perry, *The Boy Who Was Raised as a Dog,* 27.

Chapter 9

1 Sandra L. Kagin and Vija B. Lusebrink, "The Expressive Therapies Continuum," *Art Psychotherapy* 5:4 (1978), 171–180. doi:10.1016/0090-9092(78)90031-5; Vija B. Lusebrink, "Assessment and Therapeutic Application of the Expressive Therapies Continuum: Implications for Brain Structures and Functions," *Journal of the American Art Therapy Association* 27 (2010), 168–177; Lisa D. Hinz, *Expressive Therapies Continuum: A Framework for Using Art in Therapy* (New York: Routledge, Taylor and Francis, 2009).

2 Levine, *In an Unspoken Voice;* Levine, *Waking the Tiger.*

3 Bessel van der Kolk in Levine, *Trauma and Memory,* xviii.

4 Ayres, *Sensory Integration,* 15.

5 Perry, "Examining Child Maltreatment," 242.

Chapter 10

1 Perry and Malchiodi, "Rhythm and Regulation."

2 Gerhard, *Why Love Matters;* Heller and LaPierre, *Healing Developmental Trauma;* Karr-Morse and Wiley, *Scared Sick.*

3 Noman Doidge, *The Brain That Changes Itself* (Carlton North, Australia: Scribe, 2007), 74.

4 Vilayanur S. Ramachandran and Lindsay M. Oberman, "Broken Mirrors," *Scientific American* 295:5 (2006), 62–69.

5 Candida Peterson, "Theory of Mind Understanding and Empathic Behavior in Children with Autism Spectrum Disorders," *International Journal of Developmental Neuroscience* 39 (2014), 16–21, doi:10.1016/j.ijdevneu.2014.05.002.

6 Lloyd, *Building Sensorimotor Systems.*

7 Anna Brockmann and Marie-Louise Geiss, *Sprechende Hände: Haptik und Haptischer Sinn als Entwicklungspotential* (Berlin: Pro Business, 2011).

8 Lloyd, *Building Sensorimotor Systems,* 150.

9 Brockmann and Geiss, *Sprechende Hände.*

10 Ibid., 72.

11 Frances O'Brien, "The Making of Mess in Art Therapy: Attachment, Trauma and the Brain," *Inscape* 9:1 (2008), 2–13, doi:10.1080/02647140408405670.

Chapter 11

1 Brockmann and Geiss, *Sprechende Hände,* 117.

2 Ayres, *Sensory Integration,* 22.

3 Brockmann and Geiss, *Sprechende Hände,* 119.

4 Donald Woods Winnicott, *The Child, the Family and the Outside World* (Cambridge, MA: Perseus, 1957), 170.

5 Brockmann and Geiss, *Sprechende Hände,* 151.

Chapter 12

1 Margaret S. Mahler, "On Human Symbiosis and the Vicissitudes of Individuation," *Journal of the American Psychoanalytic Association* 15:4 (1967), 740–763, doi:10.1177 /000306516701500401.

2 Ernest L. Abelin, "The Role of the Father in the Separation-Individuation Process," in *Separation-Individuation Essays in Honor of Margaret S. Mahler,* edited by John McDevitt and Calvin F. Settlage, 229–252 (New York: International Universities Press, 1971).

3 Hölz-Lindau, *Arbeit am Tonfeld,* 183.

4 Lloyd, *Building Sensorimotor Systems,* 29.

5 Ibid., 118.

6 Ibid., 119.

7 Levine and Kline, *Trauma through a Child's Eyes,* 50.

8 Hölz-Lindau, *Arbeit am Tonfeld,* 151.

9 Ibid., 202.

10 Deuser, *Arbeit am Tonfeld;* Levine, *In an Unspoken Voice;* Hölz-Lindau, *Arbeit am Tonfeld.*

11 DNA Learning Center, *3D Brain.*

12 Lloyd, *Building Sensorimotor Systems,* 152.

13 Ayres, *Sensory Integration.*

14 Deuser, *Arbeit am Tonfeld;* Deuser, *Lebendige Haptik.*

15 Brockmann and Geiss, *Sprechende Hände,* 181.

16 Van der Kolk, *The Body Keeps the Score.*

17 Ogden and Fisher, *Sensorimotor Psychotherapy.*

18 Perry, "Examining Child Maltreatment"; Perry, *The Boy Who Was Raised as a Dog;* Van der Kolk, *The Body Keeps the Score;* Levine, *In an Unspoken Voice;* Levine and Kline, *Trauma through a Child's Eyes.*

19 Deuser, *Arbeit am Tonfeld.*

Chapter 13

 1 Ibid., 244.

 2 Spielrein, "Destruction."

 3 Ibid., 156.

 4 Deuser, *Arbeit am Tonfeld,* 218.

 5 Levine, *Trauma and Memory,* 22.

 6 Ibid.

 7 Ibid., 24.

 8 Deuser, *Arbeit am Tonfeld,* 234.

 9 Deuser, *Arbeit am Tonfeld,* 235.

10 Ibid., 240.

11 Ibid., 237.

12 Ibid., 238.

13 Levine, *In an Unspoken Voice;* Levine and Kline, *Trauma through a Child's Eyes.*

14 Hinz, *Expressive Therapies Continuum;* Vija B. Lusebrink, "Art Therapy and the Brain: An Attempt to Understand the Underlying Processes of Art Expression in Therapy," *Journal of the American Art Therapy Association* 21:3 (September 2004), 125–135, doi:10.1080/07421656.2004.10129496; Lusebrink, "Assessment and Therapeutic Application"; Vija B. Lusebrink, "A Systems Oriented Approach to the Expressive Therapies: The Expressive Therapies Continuum," *The Arts in Psychotherapy* 18:5 (1991), 395–403, doi:10.1016/0197-4556(91)90051-B.

Chapter 14

1 Jean Piaget, Bärbel Inhelder, and Helen Weaver, *The Psychology of the Child* (New York: Basic, 1969).

2 Siegel, *Whole-Brain Child*, 45.

3 Ibid., 46.

4 Deuser, *Arbeit am Tonfeld*, 261.

5 Ibid., 238.

6 Deuser, *Lebendige Haptik*, 239.

7 Case history supplied by Erasmia Vaux.

8 Ayres, *Sensory Integration*.

Chapter 15

1 Deuser, *Arbeit am Tonfeld*, 269.

2 Ibid., 265.

3 Ibid., 266.

4 C. G. Jung, "The Structure and Dynamics of the Psyche," in *Collected Works of C. G. Jung, Vol. 6,* ed. R. F. C. Hull (Princeton, NJ: Princeton University Press, 1968); C. G. Jung, "Approaching the Unconscious," in *Man and His Symbols* (New York: Doubleday, 1964); Joseph Campbell, *The Hero with a Thousand Faces* (1949, repr. London: Fontana Press, 1993); Erich Neumann, *The Origins and History of Consciousness* (Princeton, NJ: Princeton University Press, 2014).

Chapter 16

1 Daniel J. Siegel, *Brainstorm: The Power and Purpose of the Teenage Brain* (New York: Tarcher Perigee, 2013).

2 Deuser, *Arbeit am Tonfeld*, 265.

Chapter 17

1 Siegel, *Brainstorm*.

2 Van der Kolk, *The Body Keeps the Score*.

3 Siegel, *Brainstorm*, 4.

Chapter 18

1 Ibid., 305.

2 Jacob Grimm and Wilhelm Grimm, *The Complete Grimm's Fairy Tales* (London: Routledge and Kegan Paul, 1983).

3 Selma Lagerlöf, *The Wonderful Adventures of Nils* (1907, repr. Copenhagen: Saga Egmont, 2017).

4 Deuser, *Arbeit am Tonfeld,* 294.

5 Siegel, *Brainstorm,* 4.

Chapter 19

1 Elbrecht, *Trauma Healing at the Clay Field,* 198.

2 Ayres, *Sensory Integration,* 25.

3 Deuser, *Arbeit am Tonfeld,* 180.

4 Ibid., 178.

5 Ibid., 190.

6 Levine, *In an Unspoken Voice.*

7 Donald Woods Winnicott, *Playing and Reality* (Milton Park, UK: Routledge, 1971).

8 Verbal communication; Elbrecht, *Healing Trauma with Guided Drawing,* 140.

9 Perry and Malchiodi, "Rhythm and Regulation."

10 Deuser, video conversation, June 15, 2020.

Chapter 20

1 Written contribution by Lyn Duffton for this publication.

Chapter 21

1 Heinz Deuser, "Work at the Clay Field," in *Dictionary of Analytical Psychology,* ed. Lutz Mueller and Anette Mueller (Olten, Switzerland: Walter Verlag, 2003).

2 Elbrecht, *Trauma Healing at the Clay Field,* 100.

3 Cornelia Elbrecht and Liz R. Antcliff, "Being Touched through Touch. Trauma Treatment through Haptic Perception at the Clay Field: A Sensorimotor Art Therapy," *International Journal of Art Therapy* 19:1 (2014), 26, doi:10.1080/17454832.2014.880932.

4 Deuser, "Work at the Clay Field."

Chapter 22

1 Bessel A. Van der Kolk, "Developmental Trauma Disorder: Toward a Rational Diagnosis for Children with Complex Trauma Histories," *Psychiatric Annals* 35:5 (May 2005), 401–408, doi:10.3928/00485713-20050501-06.

2 V. J. Felitti, R. F. Anda, D. Nordenberg, D. F. Williamson, A. M. Spitz, V. Edwards, M. P. Koss, and J. S. Marks, "Relationship of Childhood Abuse and Household Dysfunction to Many of the Leading Causes of Death in Adults. The Adverse Childhood Experiences (ACE) Study," *American Journal of Preventive Medicine* 14:4 (May 1998), 245–258, doi:10.1016/s0749-3797(98)00017-8.

3 Daniel J. Siegel, "An Interpersonal Neurobiology of Psychotherapy: The Developing Mind and Resolution of Trauma," in *Healing Trauma: Attachment, Mind, Body, and Brain,* ed. Marion F. Solomon and Daniel J. Siegel (New York: W. W. Norton, 2003); Allan N. Schore, *Affect Dysregulation and Disorders of the Self* (New York: W. W. Norton, 2003); Stephen W. Porges, "Social Engagement and Attachment: A Phylogenetic Perspective," *Annals of the New York Academy of Sciences* 1008:1 (December 2003), 31–47, doi:10.1196/annals.1301.004; John Bowlby, *Attachment and Loss. 1: Attachment,* 2nd ed. (New York: Basic Books, 1982).

4 Elbrecht, *Trauma Healing at the Clay Field.*

5 Elbrecht, *Trauma Healing at the Clay Field.*

Chapter 23

1 Ibid., 288.

2 Circle of Security International, "What Is the Circle of Security?" 2009. https://tinyurl.com/19eljpa6.

3 Lucille Proulx, *Strengthening Emotional Ties Through Parent-Child-Dyad Art Therapy: Interventions with Infants and Preschoolers* (Philadelphia: Jessica Kingsley, 2003), 69.

4 Circle of Security International, "What Is the Circle of Security?"

5 Elbrecht, *Trauma Healing at the Clay Field.*

6 Mark Pearson and Patricia Nolan, *Emotional Release for Children: Repairing the Past, Preparing the Future* (Camberwell, Australia: Australian Council for Educational Research, 1995), 24.

7 Stanislav Grof, *The Holotropic Mind: The Three Levels of Human Consciousness and How They Shape Our Lives* (New York: HarperCollins, 1992), 29.

8 Noah Hass-Cohen and Richard Carr, eds., *Art Therapy and Clinical Neuroscience* (Philadelphia: Jessica Kingsley, 2008), 288.

9 Lowenfeld, *The Nature of Creative Activity.*

10 Elbrecht, *Trauma Healing at the Clay Field,* 124.

11 Barbara Labovitz Boik and E. Anna Goodwin, *Sandplay Therapy: A Step-by-Step Manual for Psychotherapists of Diverse Orientations* (New York: W. W. Norton, 2000), 42.

12 Hinz, *Expressive Therapies Continuum,* 32.

13 Ibid., 56.

Chapter 24

1 Deuser, *Lebendige Haptik,* 46.

2 Deuser, *Arbeit am Tonfeld,* 82–85.

3 Marianne Bentzen and Susan Hart, *Through Windows of Opportunity: A Neuroaffective Approach to Child Psychotherapy* (London: Karnac Books, 2015), 11–13.

Chapter 25

1 Christine A. Courtois and Julian D. Ford, eds., *Treating Complex Traumatic Stress Disorders: An Evidence-Based Guide* (New York: Guilford Press, 2014).

2 Van der Kolk, *The Body Keeps the Score.*

3 Courtois and Ford, *Treating Complex Traumatic Stress Disorders;* Nancy R. Goodman and Marilyn B. Meyers, *The Power of Witnessing: Reflections, Reverberations, and Traces of the Holocaust: Trauma, Psychoanalysis, and the Living Mind* (London: Routledge, 2012); Dori Laub and Nanette C. Auerhahn, "Knowing and Not Knowing Massive Psychic Trauma: Forms of Traumatic Memory," *International Journal of Psychoanalysis* 74:2 (April 1993), 287–302; C. G. Jung, *Psychology and Alchemy: Collected Works of C. G.Jung, Vol. 12,* ed. R. F. C. Hull (Princeton, NJ: Princeton University Press, 1968).

4 Goodman and Meyers, *The Power of Witnessing;* Laub and Auerhahn, "Knowing and Not Knowing."

5 Elbrecht, *Trauma Healing at the Clay Field.*

6 Ibid.

Chapter 26

1 Caroline Myss, *Anatomy of the Spirit: The Seven Stages of Power and Healing* (New York: Bantam, 1997).

2 Jung, *Collected Works.*

3 Levine training videos, not publicly available.

4 Shunryu Suzuki, *Zen Mind, Beginner's Mind* (Boston: Weatherhill, 1970).

BIBLIOGRAPHY

Abelin, Ernest L. "The Role of the Father in the Separation-Individuation Process." In *Separation-Individuation Essays in Honor of Margaret S. Mahler,* edited by John McDevitt and Calvin F. Settlage, 229–252. New York: International Universities Press, 1971.

Andersen, Hans Christian. "The Emperor's New Clothes." 1837. Reprinted in *The Complete Andersen.* New York: The Hans Christian Andersen Centre, 1987.

Atwood, Margaret. *The Blind Assassin.* Toronto: McClelland & Stewart, 2000.

Ayres, Jean. *Sensory Integration and the Child: Understanding Hidden Sensory Challenges.* 6th Edition. Los Angeles: Western Psychological Services, 2015.

Bentzen, Marianne, and Susan Hart. *Through Windows of Opportunity: A Neuroaffective Approach to Child Psychotherapy.* London: Karnac Books, 2015.

Boik, Barbara Labovitz, and E. Anna Goodwin. *Sandplay Therapy: A Step-by-Step Manual for Psychotherapists of Diverse Orientations.* New York: W. W. Norton, 2000.

Bowlby, John. *Attachment and Loss. 1: Attachment.* 2nd edition. New York: Basic Books, 1982.

Brockmann, Anna, and Marie-Louise Geiss. *Sprechende Hände: Haptik und Haptischer Sinn als Entwicklungspotential.* Berlin: Pro Business, 2011.

Case, Caroline, and Tessa Dalley. *The Handbook of Art Therapy.* New York: Routledge, 1992.

Cesario, Joseph, David J. Johnson, and Heather L. Eisthen. "Your Brain Is Not an Onion with a Tiny Reptile Inside." *Current Directions in Psychological Science* 29:3 (May 8, 2020), 255–260. doi:10.1177/0963721420917687.

Circle of Security International. "What Is the Circle of Security?" 2009. https://tinyurl.com/19eljpa6.

Courtois, Christine A., and Julian D. Ford, editors. *Treating Complex Traumatic Stress Disorders: An Evidence-Based Guide.* New York: Guilford Press, 2014.

De Domenico, Gisela Schubach. "Group Sandtray-Wordplay: New Dimensions in Sandplay Therapy." In *The Handbook of Group Play Therapy: How to Do It, How It Works, Whom It's Best For,* edited by Daniel S. Sweeney and Linda E. Homeyer, 215–233. San Francisco: Jossey-Bass, 1999.

Deuser, Heinz. *Arbeit am Tonfeld, der Haptische Weg zu uns selbst.* Giessen, Germany: Psychosozial Verlag, 2018.

Deuser, Heinz. *Bewegung wird Gestalt.* Bremen, Germany: Doering, 2004.

Deuser, Heinz. *Lebendige Haptik: Handbuch zur Arbeit am Tonfeld.* Norderstedt, Germany: Books on Demand, 2020.

Deuser, Heinz. *Work at the Clay Field.* Hinterzarten: Institut für Haptische Gestaltbildung, 1972.

Deuser, Heinz. "Work at the Clay Field." In *Dictionary of Analytical Psychology,* edited by Lutz Mueller and Anette Mueller. Olten, Switzerland: Walter Verlag, 2003.

DNA Learning Center. *3D Brain.* Software application. 2015. https://tinyurl.com/yk48p7rn.

Doidge, Noman. *The Brain That Changes Itself.* Carlton North, Australia: Scribe, 2007.

Dürkheim, Karlfried Graf. *Hara: The Vital Center of Man.* London: Unwin Books, 1988.

Elbrecht, Cornelia. "The Clay Field and Developmental Trauma in Children." In *Creative Interventions with Traumatized Children,* 2nd ed., edited by Cathy A. Malchiodi, 191–213. New York: Guilford Press, 2015.

Elbrecht, Cornelia. *Healing Trauma with Guided Drawing: A Sensorimotor Art Therapy Approach to Bilateral Body Mapping.* Berkeley, CA: North Atlantic Books, 2018.

Elbrecht, Cornelia. *The Transformation Journey.* Todtmoos-Rütte, Germany: Johanna Nordländer Verlag, 2006.

Elbrecht, Cornelia. *Trauma Healing at the Clay Field: A Sensorimotor Art Therapy Approach.* London and Philadelphia: Jessica Kingsley, 2013.

Elbrecht, Cornelia, and Liz Antcliff. "Being in Touch: Healing Developmental and Attachment Trauma at the Clay Field." *Children Australia,* 40:3 (September 2015), 209–220. doi:10.1017/cha.2015.30.

Elbrecht, Cornelia, and Liz R. Antcliff. "Being Touched through Touch. Trauma Treatment through Haptic Perception at the Clay Field: A Sensorimotor Art Therapy." *International Journal of Art Therapy* 19:1 (2014), 19–30. doi:10.1080/17454832.2014.880932.

Emory, Margaret. "The Divided Brain: An Interview with Dr. Iain McGilchrist." *Brain World,* December 23, 2018. https://tinyurl.com/omtb4waz.

Felitti, V. J., R. F. Anda, D. Nordenberg, D. F. Williamson, A. M. Spitz, V. Edwards, M. P. Koss, and J. S. Marks. "Relationship of Childhood Abuse and Household Dysfunction to Many of the Leading Causes of Death in Adults. The Adverse Childhood Experiences (ACE) Study." *American Journal of Preventive Medicine* 14:4 (May 1998), 245–258. doi:10.1016/s0749-3797(98)00017-8.

Foster Care 2.0. "Unacceptable Facts and Statistics: Research and Statistics." n.d. https://tinyurl.com/3jvmdut3.

Freud, Sigmund. "Beyond the Pleasure Principle." In *Complete Psychological Works, Volume 3,* edited by J. Strachey. London: Hogarth Press, 1954.

Gendlin, Eugene T. *Focusing.* New York: Bantam Books, 1981.

Gerhard, Sue. *Why Love Matters: How Affection Shapes a Baby's Brain.* London and New York: Routledge, 2004.

Goodman, Nancy R., and Marilyn B. Meyers. *The Power of Witnessing: Reflections, Reverberations, and Traces of the Holocaust: Trauma, Psychoanalysis, and the Living Mind.* London: Routledge, 2012.

Green, Deborah. "Quake Destruction/Arts Creation: Arts Therapy and the Canterbury Earthquakes." *Australian and New Zealand Journal of Arts Therapy* 2017. https://tinyurl.com/4pfwxhxp.

Grimm, Jacob, and Wilhelm Grimm. *The Complete Grimm's Fairy Tales.* London: Routledge and Kegan Paul, 1983.

Grof, Stanislav. *The Holotropic Mind: The Three Levels of Human Consciousness and How They Shape Our Lives.* New York: HarperCollins, 1992.

Grunwald, Martin. *Human Haptic Perception: Basics and Application.* Berlin and Boston: Birkhäuser Verlag, 2008.

Harris, K. *Learning through the Senses.* Bloomington, MN: NCS Pearson, 2001.

Hass-Cohen, Noah, and Richard Carr, editors. *Art Therapy and Clinical Neuroscience.* Philadelphia: Jessica Kingsley, 2008.

Heller, Lawrence, and Aline LaPierre. *Healing Developmental Trauma: How Early Trauma Affects Self-Regulation, Self-Image, and the Capacity for Relationship.* Berkeley, CA: North Atlantic Books, 2012.

Hellinger, Bert. *Love's Hidden Symmetry: What Makes Love Work in Relationships.* Williston, VT: Zeig, Tucker and Theisen, 1998.

Hinz, Lisa D. *Expressive Therapies Continuum: A Framework for Using Art in Therapy.* New York: Routledge, Taylor and Francis, 2009.

Hölz-Lindau, Begga. *Arbeit am Tonfeld bei ADHS: Pädagogische und psychodynamische Aspekte der Affektregulierung.* Giessen, Germany: Psychosozial Verlag, 2020.

Hughes, Daniel. *Attachment-Focused Family Therapy Workbook.* New York: W. W. Norton, 2011.

Hughes, Daniel. "Dyadic Developmental Psychotherapy (DDP): An Attachment-Focused Family Treatment for Developmental Trauma." *Australian and New Zealand Journal of Family Therapy* 38:4 (December 2017), 595–605. doi:10.1002/anzf.1273.

Hughes, Daniel. "Dyadic Developmental Psychotherapy: Toward a Comprehensive Trauma Informed Treatment for Developmental Trauma Disorder." DDP Network. February 18, 2014. https://tinyurl.com/h8767khq.

Inner World Work. "What Survival Looks Like in Primary School." 2019. https://tinyurl.com/dtk9ek2k.

Jung, C. G. "Approaching the Unconscious." In *Man and His Symbols.* New York: Doubleday, 1964.

Jung, C. G. "The Structure and Dynamics of the Psyche." In *Collected Works of C. G. Jung, Vol. 6.* Edited by R. F. C. Hull. Princeton, NJ: Princeton University Press, 1968.

Jung, C. G. "Two Essays on Analytical Psychology." In *Collected Work of C. G. Jung s, Vol. 7.* Edited by R. F. C. Hull. Princeton, NJ: Princeton University Press, 1968.

Kagin, Sandra L., and Vija B. Lusebrink. "The Expressive Therapies Continuum." *Art Psychotherapy* 5:4 (1978), 171–180. doi:10.1016/0090-9092(78)90031-5.

Kalff, Dora M. *Sandplay: A Psychotherapeutic Approach to the Psyche.* Santa Monica CA: Sigo Press, 1980.

Karr-Morse, Robin, and Meredith S. Wiley. *Scared Sick: The Role of Childhood Trauma in Adult Disease.* New York: Basic Books, 2012.

Kid Sense. "Fine Motor Development Chart." ChildDevelopment.com.au. n.d. https://tinyurl.com/guecdxyn.

Kiese-Himmel, Christiane. "Haptic Perception in Infancy and First Acquisition of Object Words: Developmental and Clinical Approach." In *Human Haptic Perception: Basics and Applications,* edited by Martin Grunwald, 321–334. Boston and Berlin: Birkhäuser, 2008.

Lagerlöf, Selma. *The Wonderful Adventures of Nils.* 1907. Reprinted Copenhagen: Saga Egmont, 2017.

Laub, Dori, and Nanette C. Auerhahn. "Knowing and Not Knowing Massive Psychic Trauma: Forms of Traumatic Memory." *International Journal of Psychoanalysis* 74:2 (April 1993), 287–302.

Levine, Peter. *In an Unspoken Voice: How the Body Releases Trauma and Restores Goodness.* Berkeley, CA: North Atlantic Books, 2010.

Levine, Peter. *Trauma and Memory: Brain and Body in Search of the Living Past.* Berkeley, CA: North Atlantic Books, 2015.

Levine, Peter. *Waking the Tiger: Healing Trauma.* Berkeley CA: North Atlantic Books, 1997.

Levine, Peter, and Maggie Kline. *Trauma through a Child's Eyes: Awakening the Ordinary Miracle of Healing.* Berkeley, CA: North Atlantic Books, 2007.

Lewis, C. S. *The Chronicles of Narnia.* London: HarperCollins, 2008.

Linden, David J. *Touch: The Science of Hand, Heart and Mind.* New York: Penguin, 2015.

Lloyd, Sarah. *Building Sensorimotor Systems in Children with Developmental Trauma: A Model for Practice.* Philadelphia: Jessica Kingsley, 2020.

Lowenfeld, Viktor. *The Nature of Creative Activity.* New York: Harcourt, Brace, and Co., 1939.

Lusebrink, Vija B. "Art Therapy and the Brain: An Attempt to Understand the Underlying Processes of Art Expression in Therapy." *Journal of the American Art Therapy Association* 21:3 (September 2004), 125–135. doi:10.1080/07421656.2004.10129496.

Lusebrink, Vija B. "Assessment and Therapeutic Application of the Expressive Therapies Continuum: Implications for Brain Structures and Functions." *Journal of the American Art Therapy Association* 27 (2010), 168–177.

Lusebrink, Vija B. "A Systems Oriented Approach to the Expressive Therapies: The Expressive Therapies Continuum." *The Arts in Psychotherapy* 18:5 (1991), 395–403. doi:10.1016/0197-4556(91)90051-B.

MacLean, Paul D. *The Triune Brain in Evolution: Role in Paleocerebral Functions.* New York: Plenum, 1990.

Mahler, Margaret S. "On Human Symbiosis and the Vicissitudes of Individuation." *Journal of the American Psychoanalytic Association* 15:4 (1967), 740–763. doi:10.1177/000306516701500401.

Malchiodi, Cathy A. "Bilateral Drawing: Self-Regulation for Trauma Reparation." *Psychology Today.* September 29, 2015. https://tinyurl.com/vxjdmtwj.

Malchiodi, Cathy A. "Expressive Arts Therapy: The Original Psychotherapy." *Psychology Today.* December 11, 2020. https://tinyurl.com/ykdewv72.

Malchiodi, Cathy A. "Expressive Arts Therapy Is a Culturally Relevant Practice." *Psychology Today.* September 24, 2019. https://tinyurl.com/1dc8eska.

Malchiodi, Cathy A. *Expressive Therapies.* New York: Guilford Press, 2005.

Malchiodi, Cathy A. *Trauma and Expressive Arts Therapy: Brain, Body, and Imagination in the Healing Process.* New York: Guilford Press, 2020.

Malchiodi, Cathy A. *Understanding Children's Drawings.* New York: Guilford Press, 1998.

McKay, Sarah. "Rethinking the Reptilian Brain." DrSarahMcKay.com. June 24, 2020. https://tinyurl.com/ynd42pyf.

McNiff, Shaun. *The Arts and Psychotherapy.* Springfield, IL: Charles C. Thomas, 1981.

Menakem, Resmaa. *My Grandmother's Hands: Racialized Trauma and the Pathway to Mending Our Hearts and Bodies.* Las Vegas: Central Recovery Press, 2017.

Michael, Deborah. "Understanding Sensory Processing Disorder." North Shore Pediatric Therapy. 2015. https://www.nspt4kids.com.

Moe, Kristin. "Breaking the Chain: Healing Racial Trauma in the Body; an Interview with Resmaa Menakem." Medium, May 14, 2020. https://tinyurl.com/1ixztnz9.

Montessori, Maria. *The Montessori Method.* Mineola, NY: Dover, 2002.

Myers, Thomas W. *Anatomy Trains: Myofascial Meridians for Manual and Movement Therapists.* New York: Churchill Livingstone Elsevier, 2014.

Myers, Thomas W. "Fascia 101." YouTube. Video. November 20, 2014. https://youtu.be/-uzQMn87Hg0.

Myss, Caroline. *Anatomy of the Spirit: The Seven Stages of Power and Healing.* New York: Bantam, 1997.

Nan, Joshua K. M., and Rainbow T. H. Ho. "Effects of Clay Art Therapy on Adults Outpatients with Major Depressive Disorder: A Randomized Controlled Trial." *Journal of Affect Disorders* 217 (2017), 237–245. doi:10.1016/j.jad.2017.04.013.

Nhat Hanh, Thich. *The Heart of Buddha's Teaching: Transforming Suffering.* New York: Harmony, 2015.

O'Brien, Frances. "The Making of Mess in Art Therapy: Attachment, Trauma and the Brain." *Inscape* 9:1 (2008), 2–13. doi:10.1080/02647140408405670.

Ogden, Pat. *Trauma and the Body: A Sensorimotor Approach to Psychotherapy.* New York: W. W. Norton, 2006.

Ogden, Pat, and Janina Fisher. *Sensorimotor Psychotherapy: Interventions for Trauma and Attachment.* New York: W. W. Norton, 2015.

Ohashi, Wataru. *Do-It-Yourself Shiatsu.* New York: Dutton and Co., 1976.

Orbach, Susie. *Bodies.* London: Profile Books, 2009.

Osterwald, Barbara. 2016. "If You Touch, You Are Touched." Work at the Clay Field. https://tinyurl.com/4d7nffs3.

Pearson, Mark, and Patricia Nolan. *Emotional Release for Children: Repairing the Past, Preparing the Future.* Camberwell, Australia: Australian Council for Educational Research, 1995.

Penfield, Wilder, and Theodore Rasmussen. *The Cerebral Cortex of Man.* New York: Macmillan, 1950.

Penfield, Wilder, and Theodore Rasmussen. "The Cerebral Cortex of Man: A Clinical Study of Localization of Function." *Journal of American Medical Association* 144:16 (December 16, 1950), 1412. doi:10.1001/jama.1950.02920160086033.

Perry, Bruce D. "Applying Principles of Neurodevelopment to Clinical Work with Maltreated and Traumatized Children: The Neurosequential Model of Therapeutics." In *Working with Traumatized Youth in Child Welfare,* edited by Nancy Boyd Webb, 27–53. New York: Guilford Press, 2005.

Perry, Bruce D. *The Boy Who Was Raised as a Dog: What Traumatized Children Can Teach Us about Loss, Love, and Healing.* New York: Basic Books, 2006.

Perry, Bruce D. "Childhood Experience and the Expression of Genetic Potential: What Childhood Neglect Tells Us About Nature and Nurture." *Brain and Mind* 3 (2002), 79–100. doi:10.1023/A:1016557824657. https://tinyurl.com/yny9csav.

Perry, Bruce D. "Examining Child Maltreatment through a Neurodevelopmental Lens: Clinical Applications of the Neurosequential Model of Therapeutics." *Journal of Loss and Trauma,* June 23, 2009, 240–255. doi:10.1080/15325020903004350.

Perry, Bruce D. "The Three R's: Reaching the Learning Brain." Boston: Beacon House. 2019. https://tinyurl.com/1okftmz4.

Perry, Bruce D., and Cathy A. Malchiodi. "Rhythm and Regulation: Innovative Approaches to Brain and Body During a Time of Immobilization." Audio recording. May 30, 2020. www.besselvanderkolk.com.

Peterson, Candida. "Theory of Mind Understanding and Empathic Behavior in Children with Autism Spectrum Disorders." *International Journal of Developmental Neuroscience* 39 (2014), 16–21. doi:10.1016/j.ijdevneu.2014.05.002.

Piaget, Jean. "Piaget's Stages of Development." YouTube. Video. April 26, 2011. https://youtu.be/TRF27F2bn-A.

Piaget, Jean, Bärbel Inhelder, and Helen Weaver. *The Psychology of the Child.* New York: Basic, 1969.

Porges, Stephen W. "Neuroception: A Subconscious System for Detecting Threats and Safety." *Zero to Three* 24 (January 2004).

Porges, Stephen W. *The Polyvagal Theory: Neurophysiological Foundations of Emotions, Attachment, Communication, and Self-Regulation.* New York: W. W. Norton, 2011.

Porges, Stephen W. "Social Engagement and Attachment: A Phylogenetic Perspective." *Annals of the New York Academy of Sciences* 1008:1 (December 2003), 31–47. doi:10.1196/annals.1301.004.

Proulx, Lucille. *Strengthening Emotional Ties Through Parent-Child-Dyad Art Therapy: Interventions with Infants and Preschoolers.* Philadelphia: Jessica Kingsley, 2003.

Ramachandran, Vilayanur S. *The Tell-Tale Brain: A Neuroscientist's Quest for What Makes Us Human.* New York: W. W. Norton, 2011.

Ramachandran, Vilayanur S., and Lindsay M. Oberman. "Broken Mirrors." *Scientific American* 295:5 (2006), 62–69.

Resnick, Brian. "Wilder Penfield Redrew the Map of the Brain—by Opening the Heads of Living Patients." Vox. January 26, 2018. https://tinyurl.com/1ez2e277.

Richards, M. C. "Centering." The Sun. October 1983. https://tinyurl.com/ya22cmnr.

Riley, Shirley. "Illustrating the Family Story: Art Therapy, a Lens for Viewing the Family's Reality." *The Arts in Psychotherapy* 20:3 (1993), 253–264. doi:10.1016/0197-4556(93)90020-3.

Rothschild, Babette. *The Body Remembers.* New York: W. W. Norton, 2000.

Rothschild, Babette. "Trauma Specialist Babette Rothschild: Description of Dual Awareness for Treating PTSD." YouTube. Video. November 16, 2011. https://youtu.be/HlM8XV7vIFs.

Sass Video. "Code Red *(tzeva adom)* Song—Helping Children Deal with Terror." YouTube. Video. November 21, 2012. https://youtu.be/SoB1AjVCueU.

Schaverien, Joy. *The Revealing Image: Analytical Art Psychotherapy in Theory and Practice.* New York: Tavistock/Routledge, 1992.

Schore, Allan N. *Affect Dysregulation and Disorders of the Self.* New York: W. W. Norton, 2003.

Schore, Allan N. "Effects of a secure attachment relationship on right brain development, affect regulation, and infant mental health." *Infant Mental Health Journal* 22:1–2 (2001), 7–67. doi:10.1002/1097-0355(200101/04)22:13.0.CO;2-N.

Shapiro, Francine. *Eye Movement Desensitization and Reprocessing (EMDR): Basic Principles, Protocols and Procedures.* New York: Guilford Press, 2001.

Siegel, Daniel J. *Brainstorm: The Power and Purpose of the Teenage Brain.* New York: Tarcher Perigee, 2013.

Siegel, Daniel J. *The Developing Mind: How Relationships and the Brain Interact to Shape Who We Are.* 2nd edition. New York: Guilford Press, 2012.

Siegel, Daniel J. "An Interpersonal Neurobiology of Psychotherapy: The Developing Mind and Resolution of Trauma." In *Healing Trauma: Attachment, Mind, Body, and Brain,* edited by Marion F. Solomon and Daniel J. Siegel. New York: W. W. Norton, 2003.

Siegel, Daniel J. *The Whole-Brain Child: 12 Revolutionary Strategies to Nurture Your Child's Developing Mind.* New York: Bantam, 2011.

Smith, Sheila Dorothy. *Sandtray Play and Storymaking: A Hands-On Approach to Build Academic, Social, and Emotional Skills in Mainstream and Special Education.* Philadelphia: Jessica Kingsley, 2012.

Spielrein, Sabina. "Destruction as the Cause of Coming into Being." *Journal of Analytical Psychology* 39 (April 1994), 155–186. doi:10.1111/j.1465-5922.1994.00155.x.

Suzuki, Shunryu. *Zen Mind, Beginner's Mind.* Boston: Weatherhill, 1970.

Taylor, Jill Bolte. "My Stroke of Insight." TED Talks. Video. 2008. https://tinyurl.com/1kceyvx0.

Thorley, Mark, and Helen Townsend. "What Survival Looks Like in Secondary School." 2017. https://tinyurl.com/2krkeefs.

Tolkien, J. R. R. *The Lord of the Rings.* 1954. Reprinted London: Harper Collins, 1968.

Tronick, Edward. "Still Face Experiment: Dr. Edward Tronick." YouTube. Video. November 30, 2009. https://youtu.be/apzXGEbZht0.

Van der Kolk, Bessel A. *The Body Keeps the Score.* New York: Viking, 2014.

Van der Kolk, Bessel A. "Developmental Trauma Disorder: Toward a Rational Diagnosis for Children with Complex Trauma Histories." *Psychiatric Annals* 35:5 (May 2005), 401–408. doi:10.3928/00485713-20050501-06.

Wiener, Daniel J. *Beyond Talk Therapy: Using Movement and Expressive Techniques in Clinical Practice.* Washington, DC: American Psychological Association, 1999.

Wilson, Frank. *The Hand: How Its Use Shapes the Brain, Language and Human Culture.* New York: Vintage, 1998.

Winnicott, Donald Woods. *The Child, the Family and the Outside World.* Cambridge, MA: Perseus, 1957.

Winnicott, Donald Woods. *Playing and Reality.* Milton Park, UK: Routledge, 1971.

INDEX

italic page numbers indicate figures

0–12 months development, 149
6–12 months development, 161–164
1–2 years development, 165–172
 constancy, 168–172
 fencing position, 166
 gravitational security, 168
 separation anxiety, 168
 spatial order, 172
2–4 years development, 173–182
4–6 years development, 185–188
6–9 years development, 205–208
9–11 years development, 235–243
 balance as triangulation, 236–237
 felt sense of, 238
 telling stories, 241–242
 trickster figures, 239–241
11–13 years development, 245–251
 permanence, 248–249
13–16 years development, 253–259
16–18 years development, 261–262

A

abduction, 41
Abelin, Ernest, 175
A-beta fibers, 52
Aboriginal children in Australia, 94, 309
Aceh, Indonesia tsunami, 124–125
"acting in," 105, 108
action figures, 15
active sensors, 51
acupressure map of hand, 59–61, *60*

ADHD (attention deficit–hyperactivity disorder), 27–28, *40,* 106, *128,* 176, 178, 181, *281, 284,* 307
 perinatal trauma, 91
 pressure, *127,* 128
 primary school children in sympathetic arousal, 89–91
 self-nurture, 307–309
adolescents
 11–13 years development, 245–251
 13–16 years development, 253–259
 16–18 years development, 261–262
 complex trauma, 95
 fingertips, 62
 peer pressure, 256
 search for own base. See centering as search for own base
 sexual identity, 255
 shutdown, 92–93
 sympathetic arousal, 93–97
affect
 emergence of, 186
 in relation to Clay Field, 188–190
 stimulation, 138–139
afferent sensory division of peripheral nervous system, 109–111, *110*
 creating safe places, 114–115
 encasing hands or feet, 117–121
 exteroceptors and interoceptors, 111–113
 stimulating the five senses, 113–114
 trauma-informed interventions to strengthen the sensory division, 113–121
 warm water, 115–117

aggression, 100, 185, 189, 192–193, 195, 198, 226, 229

aikido, 123

alcohol, reaction to smell, 113

alcohol and drug abuse, 262, 263, 267
 link to childhood trauma and neglect, 95–96
 self-medicating, 92

anal (possessive) acquisition, 191–193

anger, 100

animal figurines, 19, *20,* 23, 38, 43, *44, 45–50, 46–48,* 114, *129, 223, 230, 232, 250,* 327, 328, 339, 345
 big mountain case history, 342–344, *343–344*
 courage to make contact, 279
 dealing with sexual abuse trauma, 221–224
 footprints, *37,* 38, 88, 126, 128, 181, 248, 279, 301
 mother and father archetype, 171–172, 215–221
 pressure, 99, 100
 safe places, 114, *115*
 safe zoo, 304–307, *306*
 separate homes for duck and bear, 301–303, *302–303*
 unicorn queen, 224–233

animals in the wild, 124
 completing fight-or-flight response, 124
 coping with life-threatening stress, 71
 songs/stories about, 123–124

animals, creating, 39, 41, *41,* 82, 304
 monsters/dinosaurs, 299–301, *300–301,* 316
 unicorn queen, 224–233

anorexia, 92, *180,* 262–263

Antcliff, Elizabeth "Liz," 8, 310

anthropogenic drive, 33

anthropogenic vs. individual development, 27

anxiety, 307, 323
 attachment trauma, 172
 bedwetting, 285
 creative destruction, 286
 destruction at the Clay Field, 186
 exam anxiety (Marie case history), 353–355
 panic attacks, 122–123
 pubert, 255
 self-nurture, 307–309
 separation anxiety. See separation anxiety
 sirens and rocket fire, 125
 spontaneous, unconventional responses, 275
 starting school, 170

archetypes, animal figurines, 171–172, 215–221

arms
 balance, 167
 balancing through elbows, 198–199, *198, 208, 208*
 covering with liquid clay, *283,* 286, *286*
 fencing position, 166, *166*
 lack of coordination with legs, 175–176
 packing. See packing hands/arms
 parallel arms, 158, *158*

art therapy
 circular chart, 89
 combining with Clay Field, 327–333, 345–346
 drawing, 89–90
 ETC. See Expressive Therapies Continuum (ETC), 137
 Institute for Sensorimotor Art Therapy, 379
 perceptual skills, 138
 psychiatric hospital, 366
 unsupported environments, 291–292

Art Therapy Star, 294, *295,* 323–325, *324*

asthma, 8

attachment, 3
 parents staying in the room, 328–329

attachment needs, 156

attachment trauma, 161, 373
 object constancy, 170–172

attention deficit–hyperactivity disorder. See ADHD (attention deficit–hyperactivity disorder)

Atwood, Margaret, xii

Australian Childhood Foundation Trauma Conference, 79

autistic children, 151–153, *150*
 case history (Christopher), 356–358
 perinatal trauma, 151

sensorimotor base deficits, 183
water, 151
autobiographical episodic memory, 79
autonomic nervous system, 111–112, *110*
 brains, 71–79, *72*
 fear and excitement, 74
 impact of traumatic events on a child,
 76–77
 learning stress regulation, 76
 memory systems, 77–79, *77–78*
 neuroception, 74
 polyvagal theory, 79–83, *80*
 stress responses, 71–73
 three R's, 75, *75*
 upstairs and downstairs brains, 75, 81,
 83, 207
Ayres, Jean, 83, 132, 273
 brain hand connection, 59
 central programming, 177
 developmental building blocks, 132–133,
 144–145
 inner drive, 33
 sensorimotor foundation, 30
 sensory integration, 29–30, 45, 166
 standing up, 166

B

balance, 165–172, *166*
 constancy, 168–172
 elbows, 198–199, *198*, 208, *208*
 fencing position, 166, *166*
 gravitational security, 168
 haptic question, 278, 279
 kinesthetic experience, 138
 parallel arms, 158, *158*
 perception and vital relationship, 198–199
 secondary sense of balance, 183
 separation anxiety, 168
 spatial order, 172
 triangulation, 236–237, *236*
balance in relational field of parents, 205–233
 6–9 years, 205–208
 developmental trauma, 211–212
 embodied balance, 208–211

 hyperactivation and hypoactivation,
 212–214
 parental conflict, 214–218
 roleplaying and story-telling, 208–211
 role-playing scenarios, 207
 tantrums, 207–208
 trauma, 218–224
 unicorn queen, 224–233
balls, 100, *100*, 180, *250*
 eggs, *231*
 snowman, 218, *227*, 239–242, *239*
 soul retrieval of lost and dissociated parts,
 370–372, *371–372*
base in the world (situation 5), 287
 centering as search for own base (16–18
 years), 261–271
Basoglu, Saba, 8
Beacon House, 379
bedwetting, 43, 285
birthing experience trauma, 331
blankets, 21, 23, 81, 82, 87, 114, 151, *151*
blueprint of human potential, 33
The Body Keeps the Score (van der Kolk), 29, 95
body mapping, 138
 hand, 59–65, *60*
body-based trauma responses, 124
bottom-up approach, self-perception as
 intentionally feeling, 287
Bowlby, John, 320
bowls, creating, 371, *372*
box, 13–15, *13*
 cleaning, *368*. *See also* cleaning the field
 hugging, 369–370, *369*
 mobile Clay Field Therapy, 311
The Boy Who Was Raised as a Dog (Perry), 92
braced children
 hyperarousal, 87
 working with pressure, 88
brain, 71–79
 anatomy, *72*
 divided brain, 56
 hand-brain-language connection, 55–59
 midbrain/cerebellum, 73
 neocortex, 72, 73
 prefrontal cortex, 74

brain *(continued)*
 sequential development, 133–134
 social brain (social engagement system), 73
brain stem, 71–72, *78*
 autism, 153
 memory system, *77*
 need for body-based trauma responses, 124
 polyvagal theory, 79
 regulate function, 75
breathing exercises, 87
building confidence, 318–319
bullying
 case history (Paul), 358–361
 social media, 92

C

cameras, 16, 32, 310
 mobile environment, 312
Campbell, Jocelyn, 50
CanDo Kiddo website, 379
caregiver support, 85
caress system, 53
caressing skin with sponge, *117*
caretaker abuse, 81, 96, 107
case histories
 combining Clay Field with expressive art
 therapies, 328–346
 developmental trauma. *See* developmental
 trauma case study
 parental separation: "I love the clay and
 the clay loves me," 297–299
 parental separation: safe zoo, 304–307
 parental separation: self-nurture, 307–309
 parental separation: separate homes for
 duck and bear, 301–303
 phenomenological observation. *See*
 phenomenological observation
 preschool. *See* preschool case histories
cause and effect, 201, *201*
caves, *47, 48, 115*, 213, 232, 329
 creating safe places, 114–115
 for hands/arms, 318, *318*, 320, *320*. *See also*
 encasing hands/arms
Center for Existential Psychology, 4

centering, 246–247, *247*
centering as discovery of the inner world
 (11–13 years), 245–251
centering as search for identity (13–16 years),
 253–259
centering as search for own base (16–18 years),
 261–271
 entities, 265–270
 homeland, 263–265
 nurturing the developing identity/healing
 old wounds, 262–263
 soul retrieval, 270–271
central nervous system, *109–111*, 110
central programming, 177
cerebellum, 71–73, *72*
C-fibers, 53
chair, 18
"chewing" the clay, 102, *103*, 163, *190*
 hungry acquisition, 189–191
child abuse, hidden epidemic, 85–86
children
 five situations. *See* five situations
 primary school children in shutdown,
 86–88
 primary school children in sympathetic
 arousal, 89–92
ChildTrauma Academy, 379
"chocolate milk," 43–50, *45*
Christchurch, New Zealand earthquake, 114
Christmas tree, 317, *317*
chronic trauma, adjustments to, 106–107
clay, 2, 15–17
 amount, 13, 16
 color, 16
 malleability, xiii–xiv
 mobile Clay Field Therapy, 311
 owning and taking possession of, 191–193
 processing wet clay for reuse, 312
Clay Field, 15–19
 affect in relation to Clay Field, 188–189
 as a self-generating experience, 42–43, 49
 as an interspace, 36, 49
 as an opposite, 36–42
 combining with expressive art therapies,
 327–333, 345–346

combining with Sand Tray, 22, 275

completion of fight action, 73

facing the Clay Field (situation 2), 276–278

gaining trust in relationship with, 30

hands' relationship with Clay Field, 5

origin of, 4

setting, 13–25, *13*

size, 4, 14, 23

Clay Field Therapy, 1–9

complementary to Somatic
 Experiencing, 219

developmental stages, 140, *141*

growing interest in, 8

cleaning the field, 18, 192–193, *193*, 241, 262,
 287, 368, 375

clearing away the "shit," 368–369

clothing, 21

"Code Red" song, 125–126, 379

cognitive integration, 138–139, 287

cognitive–symbolic level, ETC, 139

collapsed children, 81, 88

color of clay, 16

combining Clay Field

with expressive art therapies, 327–333,
 345–346

with Sand Tray, 22, 275

comforting with blankets, cushions, etc., 21,
 23, 81, 82, 87, 114, 151, *151*

complex post–traumatic stress disorder
 (CPTSD), 364

complex trauma, 7, 86

adolescents, 95

definition of, 364

schema therapy, 364

computers, 9

pornography, 92, 248

social media bullying, 92

constancy, 168–171

object constancy, 170–171, 284

contact, 32–33

core stability, pressure exercises, 177

corrections, 32

coregulating nervous systems, 29

cortex, 71

evolution, 55

sensorimotor cortex. *See* sensorimotor
 cortex

somatosensory cortex, 57

counter vortex, 374

COVID-19 pandemic, xiv, 8–9

hygiene and health safety, 312

CPTSD (complex post–traumatic stress
 disorder), 364

creaming the skin, *118*, 138, 144, 154, *155*, 183,
 190, 248–249, 262, 271, 308–309, 316, *316*,
 321, *321*, 342

creation and destruction cycles, 16

credit cards, 312

crunchy food, 88–89, 112, 114

crystals, 19, 163, 248

cubby houses, 21, 23, 87, 114, 183, 291

cushions, 23, 81, 87, 291

cycles of creation and destruction, 16

D

danger, yellow traffic light (polyvagal theory),
 81–83, *80*

declarative memory system, 79

dedication to survival and recovery, 364

departure from relational field of parents,
 235–243

9–11 years development, 235

balance as triangulation, 236–237

felt sense of, 238

telling stories, 241–242

trickster figures, 239–241

depression, 267, 307

adolescents in sympathetic arousal, 93

case history, treatment in psychiatric
 hospital, 365–372

transcranial magnetic stimulation
 (TMS), 363

depth sensibility, 173–184, 194, 300

2–4 years development, 173–182

haptic question, 279

primary and secondary sensorimotor base,
 182–184

secondary depth sensibility, 183

destruction and creation cycles, 16

destruction at the Clay Field, necessity of, 185–188

destructive explanation compulsion, 97

Deuser, Heinz, xvii–xviii, 4, 5, 7, 24, 32, 42, 189, 193, 236, 377
 anal acquisition, 191
 anthropogenic vs. individual development, 27
 centering, 246
 dual polarity, 35
 echo, 286
 education of the senses, 33, 97
 emergence of affect, 186
 encasing hands, 118
 finding active response to what happened, 374
 five situations, 273
 haptic aggression, 185
 intention toward ourselves, 50
 liberation of emotionality, 217
 movement fantasies, 50, 177
 oedipal acquisition, 226, 232
 oedipal aggression, 196–197
 oral acquisition, 189
 postnurturing, 144
 reality principle of haptics, 189, 276
 rebuilding underdeveloped or collapsed action patterns in sensorimotor cortex, 176
 sensorimotor base, 182
 space-related identity, 271
 therapist's role for adolescents, 254
 we touch, and we are touched, 298

development milestones, 65–69, 140, *141*
 fine motor development, 65–69

developmental building blocks, 132–133, 144–145
 postnurturing, 144

developmental building block 1: skin sense, 149–164
 0–12 months, 149
 6–12 months, 161–164
 first months, 154–161
 womb, 149–154

developmental building block 2: balance, 165–172
 1–2 years, 165–172

constancy, 168–172
fencing position, 166
gravitational security, 168
separation anxiety, 168
spatial order, 172

developmental building block 3: depth sensibility, 173–184
 2–4 years, 173–182
 primary and secondary sensorimotor base, 182–184

developmental building block 4: vital relationship and perception, 185–203
 4–6 years, 185–188
 affect in relation to Clay Field, 188–189
 balance, 198–199
 hungry acquisition, 189–191
 investigating acquisition, 196–198
 oppositional acquisition, 193–196
 orientation in space through perception, 199–203
 possessive acquisition, 191–193

developmental building block 5: balance in relational field of parents, 205–233
 6–9 years, 205–208
 developmental trauma, 211–212
 embodied balance, 208–211
 hyperactivation and hypoactivation, 212–214
 parental conflict, 214–218
 roleplaying and story-telling, 207–211
 tantrums, 207–208
 trauma, 218–224
 unicorn queen, 224–233

developmental building block 6: departure from relational field of parents, 235–243
 9–11 years, 235
 balance as triangulation, 236–237
 felt sense, 238
 telling stories, 241–242
 trickster figures, 239–241

developmental building block 7: centering as discovery of the inner world, 245–251
 11–13 years, 245–251

developmental building block 8: centering as search for identity, 253–259
 13–16 years, 253–259

developmental building block 9: centering as search for own base, 261–271
 16–18 years, 261–262
 entities, 265–270
 homeland, 263–265
 nurturing the developing identity/healing old wounds, 262–263
 soul retrieval, 270–271
developmental trauma, 6, 71, 95, 105, 140, 176, 211–212, 256–257
 drug and alcohol abuse, 262
 girls who don't fit in, 256
 hopelessness of untreated trauma, 106
 physiological indicators, 175
 treatment in psychiatric hospitals, 363–372
developmental trauma case study, 313–326
 genogram, 314
 session 1: finding safety, 315–317
 session 2: finding meaning, 317
 session 3: building confidence, 318–319
 session 5: symbolic birthing, 319–321
 session 6: full engagement with material, 321
 session 10: working on supports, 322–323
 session 11: review with star chart, 323–325
 session 13: age-appropriate landscaping, 325–326
diagonal movement patterns, 168
differentiation, 180
dinosaurs, 299–301, *300–301*, 316
disabled children, 292–293
dissociated sensory function, 107–108
dissociation, 122–123
 adolescents in sympathetic arousal, 93
 collapsed children, 88
 emergence from, 98
 from red to green in forty minutes, 97–103
 red traffic light, 80–81
 SIBAM model, 122
 soul retrieval of lost and dissociated parts, 370–372, *371–372*
 violent homes, 105
dissociative identity disorder (DID), 265
divided brain, 56
dividing, *179*

divorce, 82, 97, 248. *See also* parental separation
 dealing with parental conflict, 214–218
 restoring balance in relational field of parents, 208
 story-telling, 209–211
 teenagers, 95
Donald, Merlin, 55
downstairs and upstairs brains, 75, 81, 83, 207
downstairs emotions, hyperactivation and hypoactivation, 212
downward pressure, 174. *See also* pressure
 embodied identity, *237*
drawing, 89–90
 circular chart, 89
 landscapes, 138
drilling, 65, 126, 128, 138, 162, 173, 179, 226, *226*, 228, 232, *232*
 elbows, 181
 experimenting with high and low, 200
 haptic aggression, 185
 investigating acquisition, 196–198, *196*
drooling, 43
drug and alcohol abuse, 262, 263, 267
 link to childhood trauma and neglect, 95–96
 self-medicating, 92
dual awareness, 112
dual polarity, 32, 35–36, 107, 138, 159, 160, 173, 176, 187, 256, 276, 279, 283, 353
 "chocolate milk" lake, 43–50, *45*
 Clay Field as a self-generating experience, 42–43, 49
 Clay Field as an interspace, 36, 49
 Clay Field as an opposite, 36–42
 intention toward ourselves, 50
dual-diagnosis, 263
Duffton, Lyn, 153, 293
Dürckheim, Karlfried Graf, 4
dyadic developmental psychotherapy, 76
dysregulated nervous system, 22, 29–30
 self-medicating with drugs and alcohol, 92

E

early triangulation, 175
earthquake in Christchurch, New Zealand, 114

eating crunchy food, 88–89, 112
eating disorders, 92, 95, *180*, 262–263
echo, 286
echolalia, 152–153
education of the senses, 33, 97
efferent motor division, 109–111, *110,* 122
 movement, 123–126
 pressure, 126–130
 SIBAM model, 122
 somatic nervous system and autonomic
 nervous system, 111–112
 trauma-informed interventions to
 strengthen the motor division,
 122–130
elbows, 88, 181, 369
 balancing through elbows, 198–199, *198,*
 208, *208*
 packing, *63*
Elbrecht, Cornelia, 298, 310, 370, 379
embodied experience, 81
EMDR (eye movement desensitization
 reprocessing), 366, 372
emotional abuse, 96
 developmental trauma case study,
 313–326
emotions, 188
encasing hands/arms, 40, *40, 46, 48, 64,* 65,
 117–121, *118–120,* 156–158, *157, 251,* 318, *318,*
 320, *320*
 creating a "womb," 156, 157
 elbows, *63*
 sexual abuse victim, 368
entities, 265–270
epigenetics, 28–29
episodic memory system, 79
equine therapy, 96
essential oils, 88, 112, 114
ETC. *See* Expressive Therapies Continuum
 (ETC)
evil, 267
evolution of hand-brain-language connection,
 55–59
exam anxiety (Marie case history), 353–355
excitement, relationship with fear, 74
expression of love for the clay, 297–299

expressive art therapies, 8, 22, 96, 137, 138
 combining with Clay Field, 327–333,
 345–346
Expressive Therapies Continuum (ETC),
 137–145
 bottom-up approach, 138–139
 developmental stages in Clay Field, 140, *141*
 levels, 137, 139
exteroceptors, 111–113
eye movement desensitization reprocessing
 (EMDR), 366, 372

F

facial twitch, 43
facing the Clay Field (situation 2), 276–278
fairy tales, 138, 214, 216–217
family violence, developmental trauma case
 study, 313–326
fascia, 53–55
fear, 187
 Elizabeth case history, 350–352
 from red to green in forty minutes, 97–103
 of being seen, 40
 of being touched, 39
 of water, 280
 red traffic light, polyvagal theory, 80–81,
 80. See also polyvagal theory
 relationship with excitement, 74
feet
 encasing, 117–121, *118*
 standing in the box, 108
felt sense, 153
 felt sense relationship with the
 material, 194
 felt-sense identity of early preverbal years,
 181–182
 symbolic landscapes, 209–211
 "This is me," 238
fencing position, 166, *166*
fetus development. *See also* developmental
 building block 1: skin sense
 Global High Intensity Activation
 (GHIA), 28
 trauma. *See* perinatal trauma

fight-flight response, 79, 124
 adolescents in sympathetic arousal, 94
 animals in the wild, 124
 completion of fight action in Clay Field, 73
 songs, 123–126
figurines, 19, *20*, 23, *37*, 38, 43, *44*, 45–50,
 46–48, 114, 232, 275, 327, 328, 339, 345
 big mountain case history, 342–344,
 343–344
 courage to make contact, 279
 dealing with sexual abuse trauma, 221–224
 mother and father archetype, 215–221
 mountain of treasures, 351
 roleplaying and story-telling, 211, *211*
 unicorn queen, 224–233
Finch, Monica, 327
finding a hold, 42
finding meaning, 317
fine motor development chart, 67–69
fine motor development milestones, 66–69
fingertips, 62
five situations, 273–288
 1: Finding a Safe Base, 274–276
 2: Facing the Clay Field, 276–278
 3: Haptic Questions, 278–283
 4: Haptic Answers, 283–286
 5: Building My Own Base in the
 World, 287
 echo, 286
 self-perception as intentionally feeling,
 287–288
flashbacks, 366
flat hands, 61–62, *61*
flight response, sympathetic arousal, 94
footprints, *37*, 38, 88, 126, 128, 181, 248,
 279, 301
forearms, 62, *63*
forensic psychology, 8
foster care, 95, 129, *157, 283, 286*
framework, 21–23
freeze response, 81
Freud, Sigmund, xiii, 189
 oedipal phase, 217
 pleasure principle, 189
full body memory, 366

G

gay teen, *254*
gender identity, 197
genogram, 314
gifted children, 257
girls who don't fit in, 256
Global High Intensity Activation (GHIA), 28
Goodman, Nancy R., 365
goodness, 375
Goth culture, 268
gravitational security, 168
 pressure exercises, 177
green traffic light, polyvagal theory, *80*, 83
 from red to green in forty minutes,
 97–103
Grof, Stanislav, 331
groups, 293
Grunwald, Martin, 51
Guided Drawing, 4

H

hairy skin, 53
The Hand (Wilson), 132
hands, *63*
 acupressure map, 59–61, *60*
 balance, *166*, 167
 body map of the hand, 59–65, *60*
 creaming. *See* creaming the skin
 encasing. *See* encasing hands/arms
 evolution of hand-brain-language
 connection, 55–59
 felt sense of "This is me," 238
 inner stability, 236
 making imprints, 181
 mechanoreceptors, 65–66
 mirror of body, 63
 packing. *See* encasing hands/arms
 relationship with Clay Field, 5
 soft and round, *153*, 159
 squeezing sponge over frozen hands,
 116, *116*
 tonus, 159, *160*, 181, 359
hands-brain-language connection, 132

haptic aggression, 100, 185, 189, 192, 193, 195
 drilling with one finger, 226
 integrating, 198
 tunneling, 229
haptic answers, 283–286
haptic developmental building blocks. *See* developmental building blocks
haptic diagnosis, 280
Haptic Institute, 51, 59
haptic perception, xii, 2
haptic questions (situation 3), 278–283
haptics, xii
 development milestones, 65–69
 language of haptics, 65–69
 reality principle of haptics, 189, 276
healing journey, 373–376
healing old wounds (16–18 years), 262–263
healing vortex, 374
Hellinger, Bert, 82
hero myths, 266–267
hidden epidemic of child abuse, 85, 86
hiding marbles in clay, 36, 43, *44*, 90, 345
high and low, 200
"high global," 28
Hippius, Maria, 4
historical context, xiii
hitting the field, *237*
Ho, Rainbow T. H., xi
Hölz-Lindau, Begga, 8, 27–28
 corrections, 32
 implicit resonance, 28
 triangulation, 175
homeland, 263–265
homunculus models, 57–59, *58*, 65, 109
hugging the box, 369–370, *369*
Hughes, Dan, 32, 76
hungry acquisition, 189–191
hunted animals, 124
hyperactivated nervous systems, 37
hyperactivation and hypoactivation, 212–214
hyperactivity
 ADHD. *See* ADHD (attention deficit–hyperactivity disorder)
 primary school children in sympathetic arousal, 89

hyperarousal
 dissociated sensory division, 107–108
 fingers and knuckles, 159
 shut down motor division, 108
hypoarousal, 106, 214
 shutdown, 87
 trauma-informed interventions to strengthen the sensory division, 113–121

I

"I love the clay and the clay loves me," 297–299
iceberg illustration of memory systems, 78–79, *78*, 112, 203
identity, 32–33
 centering as search for identity (13–16 years), 253–259
 nurturing the developing identity (16–18 years), 262–263
 sexual identity, teenagers, 255
implicit resonance, 28
imprints with hands, 181
In an Unspoken Voice (Levine), 30, 123
Indigenous children, 291–292, 309
 trauma therapy, 97
individual vs. anthropogenic development, 27
infants. *See also* developmental building block 1: skin sense
 developmental trauma, 6
 "kangaroo care," 52
 Still Face Experiment, 30–31
inner backbone, 271
inner drive, 33
inner stability, 236
Institut für Haptische Gestaltbildung, xvii
Institute for Sensorimotor Art Therapy, xvii, 379
integration, art therapy, 345–346
intention
 to act, 354
 toward ourselves, 50
interoceptors, 111–113
interspace, 36, 49
interventions
 overwhlem, 202
 packing clay around child's hands. *See* packing hands/arms

suggestion to apply pressure, 37, 38

trauma-informed interventions to strengthen the motor division, 122–130

trauma-informed interventions to strengthen the sensory division, 113–121

water, 98

investigating acquisition, 196–198

islands, *217*

K

Kagin, Sandra L., 137

"kangaroo care," 52

Karr-Morse, Robin, 28

Kiese-Himmel, Christiane, 59

kinesthetic experience, 138

kinesthetic–sensory level, ETC, 139

kinship care

developmental trauma case study, 313–326

genogram, 314

Kline, Maggie, 123, 124

Kramer, Katharina, 347

L

lakes, 47, 195, 195, 250, 360–361

"chocolate milk" lake, 43–45, *44–45, 285*

landscaping, 40–41, *41,* 138, 197, 200–201, *200,* 239–241, 325–326, *325,* 359–360, *360*

roleplaying and story-telling, 207, 209–211

language

hand-brain-language connection, 55–59

language barrier, case history (Neela), 352–353

language of haptics, 65–69

left- and right-brain connection, 56

legs, lack of coordination with arms, 175–176

Levine, Peter, 5, 7, 30, 79, 85, 86, 105, 144

"acting in," 86, 105

animal studies, 124

body-based songs and plays, 123–124

counter/healing vortex, 374

destructive explanation compulsion, 97

different reactions to trauma, 74

fight-flight response, 79, 124

finding active response to what happened, 374

mammalian universal emotions, 188

memory systems, 77, *77,* 79, 139, *141–143*

pendulation, 108–109, 374

re-membering, 34

SIBAM model, 122

stress responses, 71–73

using up survival energy from infant trauma, 91

life movement, 374

limbic memory system, 71, 78, *77, 78*

relate function, 75

Linden, David J., 109

A-beta fibers and C-fibers, 52–53

fascia, 54

skin, 51

touch map, 57

Lloyd, Sarah, 134, 175, 177

Lowenfeld, Viktor, xii, 332

Lusebrink, Vija, 137, 199

M

"The Making of Mess in Art Therapy" (O'Brien), 164

Malchiodi, Cathy A., xi–xv, 22, 87, 89, 96

Trauma-Informed Practices website, 379

malleability of clay, xiii–xiv

Mama OT website, 379

mammalian universal emotions, 188

mandala, 264, 265, 269

marbles, 19, 163–164, *230, 231,* 286

hiding, 36, 43, *44,* 90, 345

mountain of treasures, 351

sense of being in charge, 279

martial arts, 123

masked hyperaroused state, 93

McGilchrist, Iain, 56

McKay, Sarah, 74, 79

mechanoreceptors, 52, 65–66

Meissner system, 53

memory, 131

episodic memory, 79

full body, 366

processing, 366

memory systems, 3, 77–79, *77*, 139
 iceberg illustration, 78–79, *78, 141*
Menakem, Resmaa, 29
meridians, 62
Meyers, Marilyn B., 365
midbrain, 71, 73
 memory system, *77*
 regulate function, 75
milestones. *See also* developmental building
 blocks
 fine motor development, 65–69, 140, *141*
 motor milestones, 56–57
Minecraft designs, 359–360, *360*
mirror neurons, 31–32
 autistic children, 152
 disabled children, 292–293
 YouTube videos, 379
mirroring, hands as mirror of body, 63
mobile Clay Field Therapy, 311, 312
monster, 299–301, *300–301*
morbid fantasies, 268
Mortimore, Rosamund, 363
mother archetype, animal figurines, 171–172,
 215–221
motor division, 109–111, *110,* 122
 hyperarousal with shut down motor
 division, 108
 movement, 123–126
 pressure, 126–130
 SIBAM model, 122
 somatic nervous system and autonomic
 nervous system, 111–112
 trauma-informed interventions to
 strengthen the motor division,
 122–130
Motor Homunculus, 57, *58*
motor milestones, 56–57
mountains, 331–345, *336–338, 340–341,* 351
movement, 123–126
 fantasies, 50, 177
 importance of, 116
 patterns, 177
mutism, 179. *See also* nonverbal
Myers, Thomas, 53
myofascial web, 53–54
Myss, Caroline, 374

N

Nan, Joshua K. M., xi
Nasr, Cynthia, 8
natural disasters
 earthquake in Christchurch, New
 Zealand, 114
 tsunami in Aceh, Indonesia, 124–125
The Nature of Creative Activity (Lowenfeld), xii
neocortex, 55, 72–73, 78, 78
 memory system, *77*
 reason function, 75
nervous system, *110*
neural pathways, 52
neurobiology of touch, 53
neuroception, 74
Neurosequential Model of Therapeutics, 75,
 133–135, *134*
 ETC levels, 137. *See also* Expressive
 Therapies Continuum (ETC)
nonverbal, 14, 152–153, 159, 179
novelty, 132
nurturing the developing identity (16–18
 years), 262–263

O

O'Brien, Frances, 164
object constancy, 170–171, 284
object creation, 180
obsession with death, 268
occupational therapy websites, 379
oedipal acquisition, 196, 226, 232
oedipal aggression (investigating acquisition),
 196–198
oedipal phase, 217
Ogden, Pat, 32, 288
 riding the edge, 82
opposite, Clay Field as an opposite, 36–42
oppositional acquisition, 193–196
oppositional defiant disorder (ODD), *219,*
 220–221
oral (hungry) acquisition, 189–191
orientation in space through perception,
 199–203
orienting in the room, 328

origin of the Clay Field, 4
overwhlem, 202
 stimulating senses, 112
owning the clay, 191–193

P

packing hands/arms, 40, *40, 46, 48, 64,* 65,
 117–121, *118–120,* 156–158, *157, 251,* 318, *318,*
 320, *320*
 creating a "womb," 156, 157
 elbows, *63*
 sexual abuse victim, 368
Paediatric Occupational Therapy
 Association, 66
pain (physical), 52
pandemic, xiv, 8–9
panic attacks, 122–123
parallel arms, 158, *158*
parasympathetic branch of autonomic nervous
 system, *110*
parasympathetic settling, yellow traffic light,
 81–83
parental conflict, 214–218
 story-telling, 219–221
parental separation. *See also* divorce
 "I love the clay and the clay loves me,"
 297–299
 safe zoo, 304–307
 self-nurture, 307–309
 separate homes for duck and bear,
 301–303
parents
 balance in relational field of parents. *See*
 developmental building block 5
 departure from relational field of parents.
 See developmental building block 6
 early triangulation, 175
 staying in the room, 328–329
passive sensors, 51
patterns, 131
 rhythmic repetition patterns, 138
peekaboo, 170–172
peer pressure, 256
pendulation, 108–109, 278, 374
Penfield, Wilder, 57

penis-like shapes, 17, 21
perceiving what has been accomplished,
 287–288
perception and vital relationship, 185–203
 4–6 years, 185–188
 affect in relation to Clay Field, 188–189
 balance, 198–199
 hungry acquisition, 189–191
 investigating acquisition, 196–198
 oppositional acquisition, 193–196
 orientation in space through perception,
 199–203
 possessive acquisition, 191–193
perceptual–affective level, ETC, 139
perinatal trauma, 28, 331
 ADHD, 91
 autism, 151–152
 water, 18, 150–151
peripheral nervous system, 109–113, *110*
permanence (11–13 years), 248–249
Perry, Bruce, 2, 6, 25, 28, 30, 76
 The Boy Who Was Raised as a Dog, 92
 calm and regulated adults, 375
 impact of traumatic events on a child, 76
 memory, 131
 myofascial web, 54
 nervous system regulation, 71
 Neurosequential Model of Therapeutics,
 75, 133–135, *134,* 137
 novelty, 132
 pregancy, 149
 reason-driven memory systems, 78–79
 sensorimotor cortex as a foundation of a
 house, 109
 sequential development, 131
 three R's, 75, *75,* 78, 139, *141*
 YouTube videos, 379
phallic (oppositional) acquisition, 193–196
phenomenological observation, 347, 348
 autism spectrum disorder (Christopher),
 356–358
 bullying and stomach cramps (Paul),
 358–361
 exam anxiety (Marie), 353–355
 immigrant, language barrier (Neela),
 352, 353

phenomenological observation *(continued)*
 shyness and fear (Elizabeth), 350–352
 voice issues due to palatine cleft
 (Matthias), 348–350
photographs, 16, 310
 mobile environment, 312
physical abuse, 87, 96, 267–268
physical pain, 52
Piaget, Jean, 132, 205, 246
pillows, 21. *See also* comforting with blankets,
 cushions, etc.
pizzas
 4-6 years, 200–201
 6–9 years, 206–207
play therapy, 22
pleasure principle, 189
pointy sticks, 19
poking/prodding, 267–268
polyvagal theory, 79–83, *80*
 adolescents in shutdown, 92–93
 adolescents in sympathetic arousal, 93–97
 from red to green in forty minutes,
 97–103
 green traffic light, 83
 primary school children in shutdown,
 86–88
 primary school children in sympathetic
 arousal, 89–92
 red traffic light, 80–81
 yellow traffic light, 81–83
Polyvagal Theory website, 379
Porges, Stephen, 79
 human attachment, 320
 traffic lights, 79–83, *80*
pornography, 92, 248
portable art therapy kit, 329
possessive acquisition, 191–193
postnurturing, 144
post–traumatic stress
 complex post–traumatic stress disorder
 (CPTSD), 364
 post–traumatic stress disorder (PTSD),
 112, 374
prefrontal cortex, 74, 83
pregnancy, 149–150
 trauma. *See* perinatal trauma

preschool, 309–311
 "I love the clay and the clay loves me"
 (parental separation), 297–299
 monster/dinosaur, 299–301
 orientation in space through perception,
 199–203
 separate homes for duck and bear
 (parental separation), 301–303
pressure, 32–33, 38, *99*, 126–130, *126–129, 155,*
 173, *174,* 176–177, *282, 285*
 ADHD, *127,* 128
 animal figurines, 99, 100
 collapsed and braced children, 88
 embodied identity, 237
 packing hands. *See* packing hands/arms
 pulling/pushing, 173, *178,* 198, *198,* 241–242
 questioning parental authority figures, 237
 rhythmic pressure, 164
 suggestion to apply pressure, 37, 38
 transitional objects, 38
 uncoupling trauma from physiology, 177
primary caregivers, external stress
 regulation, 76
primary school children
 shutdown, 86–88
 sympathetic arousal, 89–92
primary sensorimotor base, 182–184
processing wet clay for reuse, 312
proprioception, 133
 definition of, xii
 kinesthetic experience, 138
 pressure exercises, 177
props, 18–21, *20. See also* toy figurines
 transitional objects, 38
prostitution, 16–17
protective clothing, 21
psychiatric hospital developmental trauma
 treatment, 363–372
PTSD (post–traumatic stress disorder)
 complex post–traumatic stress disorder
 (CPTSD), 364
 exteroceptors and interoceptors, 112
 life movement, 374
pulse diagnosis, 62
pushing/pulling, 173, *178,* 198, *198,* 241–242
 questioning parental authority figures, 237

R

racial trauma, 29
Rainbow T. H. Ho, xi
Ramachandran, Vilayanur S., 31
Rasmussen, Theodore, 57
reality principle of haptics, 189, 276
"reason" function, 75, 78–79
reason-driven memory systems, 78
rebellious children, 242
recording sessions, 16
red traffic light, polyvagal theory,
 80–81, *80*
 adolescents in shutdown, 92–93
 primary school children in shutdown,
 86–88
 red to green in forty minutes, 97–103
"regulate" function, 75–77
 polyvagal theory, 79
"relate" function, 75, 78
relational contagion, 29
relational field of parents
 balance in. *See* developmental building
 block 5
 departure from. *See* developmental
 building block 6
re-membering, 34
rhythmic drumming, 96
rhythmic pressure, 164
rhythmic repetition, 138, 162
rhythmic stimulation, 87–88
Richards, M. C., xi
riding the edge, 82–83
right- and left-brain connection, 56
Riley, Shirley, 89
Ritalin, 106
ritual mandala, *264, 265*
role of therapist, 23–25
roleplaying, 208–211
role-playing, 138
role-playing scenarios, 207
Rose, Philippa, 297
Rothschild, Babette, 52, 122
 dissociation, 122
 dual awareness, 112
rules for groups, 293

S

safe places, 114–115, *115*
 recreating in the Clay Field, 370
 song about, 124
safe zoo, 304–305, *306*
safety, 42, *318*
 developmental trauma, 315–317
 embodied experience, 81
 engagement of social brain, 73
 felt-sense identity of early preverbal years,
 181–182
 finding a safe base (situation 1), 274–276
 from red to green in forty minutes, 97–103
 green traffic light, polyvagal theory, *80*, 83
 trauma-informed interventions to
 strengthen the motor division, 122–130
 trauma-informed interventions to
 strengthen the sensory division, 113–121
Sand Tray, 22, 291, 328–329
 combining with Clay Field, 22, 275
 figurines, 19
sawing movement, *179*
schema therapy, 363–364
 case history, treatment in psychiatric
 hospital, 365–372
school sessions, 22, 292, 309–311, 329
 framework, 21–22
 protective clothing, 21
Schore, Allan, 320
Schott, Ina, 347
secondary depth sensibility, 183
secondary sense of balance, 183
secondary sensorimotor base, 182–184
secondary skin sense, 182–183
selective mutism, 179
self-care and nurturing
 developmental trauma, 316–317, *316,*
 321, 321
 parental separation, 307–309
self-generating experience, 42–43, 49
self-harming, 107, 256, 268
self-nurturing, 307–309
 creaming the skin. *See* creaming the skin
self-perception as intentionally feeling,
 287–288

senses. *See also* sensory division of peripheral
nervous system
 reaction to smell of alcohol, 113
 stimulating, 88, 112–114
sensorimotor approaches, 23
sensorimotor base, 182–184
sensorimotor cortex, 57, 105–113
 adjustsments to chronic trauma, 106–107
 dissociated sensory function, 107–108
 dual awareness, 112
 pendulation, 108–109
 peripheral nervous system, 109–113, *110*
 trauma-informed interventions to
 strengthen the motor division, 122–130
 trauma-informed interventions to
 strengthen the sensory division,
 113–121
sensorimotor feedback loop, 2, 32, 50, 353
sensorimotor foundation, 30
sensorimotor psychotherapies, 30
Sensory Attachment Intervention website, 379
sensory division of peripheral nervous system,
 109–111, *110*
 creating safe places, 114–115
 dissociated sensory function, 107–108
 encasing hands or feet, 117–121
 exteroceptors and interoceptors, 111–113
 stimulating the five senses, 113–114
 trauma-informed interventions to
 strengthen the sensory division, 113–121
 warm water, 115–117
sensory feedback, dual polarity, 35–36
Sensory Homunculus, 57, *58*
sensory integration, 29–30, 45, 166
 developmental building blocks, 132
sensory recall, 113
sensual vs. sexual, 16–17, 232–233
separation anxiety, 168, 202–203
separation of parents. *See* parental separation;
 divorce
sequential development, 131–135
 brain, 133–134
 developmental building blocks, 132–133
 memory, 131
 Neurosequential Model of Therapeutics,
 133–135, *134*

setting, 13–25, *13*
 box, 13–15
 clay, 15–17
 framework, 21–23
 props, 18–21, *20*
 therapist, 23–25
 water, 17, 18
sexual abuse, 17, 21, 96, 126, 181, 267–268
 adverse reaction to warm water, 367
 creating stories, 241–242
 dealing with trauma, 221–224
 dissociated states, 81
 enclosed hands, 368
 flashbacks, 366–367
 gender identity, 197
 treatment in psychiatric hospital, 365–372
sexual identity, adolescents, 255
shame, fear of being seen, 40
shutdown
 adolescents, 92–93
 primary school children, 86–88
 red to green in forty minutes, 97–103
 red traffic light, 80–81
 trauma-informed interventions to
 strengthen the motor division,
 122–130
shyness, 192
 case history (Elizabeth), 350–352
SIBAM model, 122
Siegel, Dan
 adolescence, 259
 human attachment, 320
 inner backbone, 271
 upstairs and downstairs brains, 75, 81,
 83, 207
situations. *See* five situations
size of the box, 4, 14
skin
 caressing with sponge, *117*
 creaming, *118*, 138, 144, 154, *155*, 183, 190,
 248–249, 262, 271, 308–309, 316, *316*,
 321, *321*, 342
skin sense, 149–164
 0–12 months, 149
 6–12 months, 161–164
 first months, 154–161

haptic question, 278
secondary skin sense, 182
womb, 149–154
snowman, 218, *227*, 239–242, *239*
social brain (social engagement system), 73
social distancing, 9
social engagement
 green traffic light, *80,* 83
 red to green in forty minutes, 97–103
social media bullying, 92
"Somatic Experiencing" (Levine), 5
Somatic Experiencing, 30, 32, 144, 151
 ADHD, 176
 body-based trauma responses, 124–125
 complementary to Clay Field
 Therapy, 219
 Global High Intensity Activation
 (GHIA), 28
 pendulation, 108–109
 reactions to client behavior, 25
 YouTube videos, 379
somatic nervous system, 111
somatic (somesthetic) senses, xii
somatosensory cortex, 57
somatosensory foundation, 27–34
 anthropogenic drive, 33
 mirror neurons, 31–32
 pressure, contact, and identity, 32–33
 re-membering, 34
 sensory integration, 29–30
 Still Face Experiment, 30–31, 379
somatosensory touch, 51–53
 body map of the hand, 59–65, *60*
 evolution of hand-brain-language
 connection, 55–59
 fascia, 53–55
 fine motor development chart, 67–69
 language of haptics, 65–69
sensory and motor homunculus models,
 57–59, *58*, 65, 109
songs, 123–126
soul contract, 374
soul retrieval, 270–271, 370–372, *371–372*
space, finding/occupying, 354–355, 359
space-related identity, 271
spatulas and spoons, 19

special needs children, 292–293
Spielrein, Sabina, 16, 186
spirit self, 214
spirituality
 entities, 265–270
 homeland, 263–265
 ritual mandala, *264–265*
 soul contract, 374
 soul retrieval, 270–271
 Zen, 375–376
sponge, 18, *98*, 99, *99*
 caressing skin (photo), 117
 squeezing motion, 116
 squeezing over frozen hands, 116, *116*
Stages of Artistic Graphic Development, 332
standing in the box, 108
standing up, balance, 166
sticks, 19
Still Face Experiment, 30–31, 379
stimulating the senses, 88, 112–114
stomach cramps, Paul case history, 358–361
Storm, Chris, 294, 313
story-telling, 22, 208–211, 241–242,
 325–326
 big mountain, 342
 death and revival stories, 216–217
 dealing with trauma, 218–224
 developmental trauma, 316
 hyperactivation and hypoactivation, 213
 parental conflict, 220–221
 role-playing scenarios, 207
 unicorn queen, 224–233
stress
 learning stress regulation from primary
 caregivers, 76
 stress responses, 71–73
suicide/suicidal ideation, 256, 267–268
symbolic birthing, 319–321, *319*
symbolic understanding of the world,
 138–139
sympathetic arousal
 adolescents, 93–97
 primary school children, 89–92
 yellow traffic light, *80,* 81–83
sympathetic branch of autonomic nervous
 system, *110*

T

table, 18
taking possession of clay, 191–193
tantrums, 207–208
tea tree oil, 16
teddy bears, 23, 82, 114
teenagers
 11–13 years development, 245–251
 13–16 years development, 253–259
 16–18 years development, 261–262
 complex trauma, 95
 fingertips, 62
 peer pressure, 256
 search for own base. *See* centering as
 search for own base
 sexual identity, 255
 shutdown, 92–93
 sympathetic arousal, 93–97
therapists
 Clay Field as an interspace, 36, 49
 Clay Field as an opposite, 36–38
 encasing hands/feet, 40, *40*, 117–121, *118–
 120*. *See also* encasing hands/arms
 haptic diagnosis, 280
 positioning, 278
 role of, 23–25, 254
 supporting situation 3, 279
 trusting that client knows, 375
 unsupported environments, 291, 292
 work in different settings, 291–295, 309–
 312, 363
"This is me," 238
three R's (Perry), 75, *75,* 78, 139, *141*
tonus in hands/wrists, 181, 359
tools, sense of being in charge, 279
toothpicks, 19, *20*
touch
 active sensors, 51
 fear of being touched, 39
 neurobiology, 53
 passive sensors, 51
 somatosensory touch. *See* somatosensory
 touch
touch map, 57
touch screen, 9

touch therapies, need for, 9
Touch: The Science of Hand, Heart and Mind
 (Linden), 51–53
toy figurines, 19, *20,* 23, 38, 43, *44,* 45–50,
 46–48, 114, *129,* 213, 232, *250,* 275, 327, 328,
 339, 345
 big mountain case history, 342–344,
 343–344
 courage to make contact, 279
 dealing with sexual abuse trauma,
 221–224
 footprints, *37,* 38, 88, 126, 128, 181, 248,
 279, 301
 mother and father archetype, 215–221
 roleplaying and story-telling, 211, *211*
 safe places, 114, *115*
 safe zoo, 304–307, *306*
 separate homes for duck and bear,
 301–303, *302–303*
 unicorn queen, 224–233
traffic lights, polyvagal theory, 79–83, *80*–*80*
transcranial magnetic stimulation (TMS),
 363
transgenders, 265
transgenerational racial trauma, 29
transitional objects, 38
trauma, 5–7
 autonomic nervous system. *See* autonomic
 nervous system
 children who have experienced traumatic
 events, 218–224
 complex trauma, 86
 dedication to survival and recovery, 364
 fetus development, 28
 impact of traumatic events on a child,
 76–77
 shutdown response. *See* shutdown
 sympathetic arousal. *See* sympathetic
 arousal
 transgenerational racial trauma, 29
 uncoupling from physiology using pressure
 exercises, 177
Trauma and Expressive Arts Therapy
 (Malchiodi), 22, 96
Trauma and Memory (Levine), 77
Trauma Healing at the Clay Field (Elbrecht), 7

trauma-informed interventions to strengthen the motor division, 122–130
 movement, 123–126
 pressure, 126–130
 SIBAM model, 122
trauma-informed interventions to strengthen the sensory division, 113–121
 creating safe places, 114–115
 encasing hands or feet, 117–121
 stimulating the five senses, 113–114
 warm water, 115–117
Trauma-Informed Practices and Expressive Art Therapy Institute, 379
traumatic retention, 29
traumatized children, 85, 86
 adolescents in shutdown, 92–93
 adolescents in sympathetic arousal, 93–97
 primary school children in shutdown, 86–88
 primary school children in sympathetic arousal, 89–92
 red to green in forty minutes, 97–103
triangulation, 175, 236–237, 236
trickster figures, 239–241, 239
Tronick, Edward, 30
trust, 3, 33
 therapists, 375
tsunami in Aceh, Indonesia, 124–125
tunneling, 173, 250
 haptic aggression, 229
 phallic acquisition, 194

U

unicorn queen, 206, 224–233, 282, 285
unsupported environments, 291–292
upstairs and downstairs brains, 75, 81, 83, 207

V

van der Kolk, Bessel
 adjustments to chronic trauma, 107
 The Body Keeps the Score, 29, 95
 dedication to survival and recovery, 364
 developmental trauma, 105
 exteroceptors and interoceptors, 112
 healing attachment trauma, 96
 hidden epidemic of child abuse, 85–86
 hopelessness of untreated developmental trauma, 106
 sensorimotor foundation, 30
 trauma-informed yoga, 123
van Schelven, Huib, 376
Vaux, Erasmia, 215, 224
vertical structures, 18, 257–258, 258, 266, 268
 Christmas tree, 317, 317
 mountains, 331–345, 336–341
videotaping sessions, 16, 32, 310
 mobile environment, 312
videos on YouTube, 125–126, 379
violent homes, 15, 37, 39, 40
 dissociation, 105
visual perception orientation, xii
vital autonomy, 194
vital relationship and perception, 185–203
 4–6 years development, 185–188
 affect in relation to Clay Field, 188–189
 balance, 198–199
 hungry acquisition, 189–191
 investigating acquisition, 196–198
 oppositional acquisition, 193–196
 orientation in space through perception, 199–203
 possessive acquisition, 191–193
voice issues due to palatine cleft (Matthias), 348–350
voiding dysfunction, 224–233
vortices, pendulation from trauma vortex toward healing vortex, 108–109, 278, 374

W

wabi-sabi, xiv
Walker, Ruby Jo, 379
warm water, 107–108, 115–117, 116–117
 adverse reaction to, 367
 nurturing relaxation, 279
 perinatal trauma, 150–151
water, 17–18, 150, 155, 354–355
 adverse reaction to, 367

water *(continued)*
 autism spectrum, 151, 356–357, *356–357*
 boggy clay, 257
 bogs, 248
 "chocolate milk," 43–50, *45*
 creating a "womb," 156
 fear of, 280
 intervention, 98
 perinatal trauma, 18, 150–151
 ponds and lakes, 43–45, *44–45*, 47, 195, *195, 250, 360–361*
 pools, 302–303
 squeezing over frozen hands, 116, *116*
 symbolic libido, adolescents, 258
 temperature. *See* warm water
 vertical structures, 18, 257–258, *258*
 warm water. *See* warm water
websites, 379
weighted blankets, 81
Wiley, Meredith S., 28
Wilson, Frank, 55
 hands-brain-language connection, 132
 left- and right-brain connection, 56
 motor milestones, 56–57
Wilson, Julie, 262

Winnicott, Donald Woods
 object constancy, 284
 soothing separation anxiety, 168
womb, creating a "womb," 156–157
Work at the Clay Field, xvii, 2, 8, 133
 developmental stages, 140
 education of the senses, 33, 97
wrists, 62, *63*
 angle, 159, *180*
 brakes, *160*
 inner stability, 236
 tonus, 181

Y

yellow traffic light, polyvagal theory, *80,* 81–83
 adolescents in sympathetic arousal, 93–97
 primary school children in sympathetic arousal, 89–92
yoga, 123
YouTube videos, 125–126, 379

Z

Zen, 375–376

ABOUT THE AUTHOR

CORNELIA ELBRECHT is a leader in ground-breaking art therapy techniques with a particular focus on healing trauma. An art therapist with over forty years' experience, she is a renowned author and educator, and the founder and director of the Institute for Sensorimotor Art Therapy. Elbrecht studied at the School for Initiatic Therapy in the Black Forest, Germany, and holds degrees in fine arts and arts education along with extensive postgraduate training in Jungian and Gestalt Therapy, bioenergetics, and Somatic Experiencing at the Somatic Experiencing Training Institute. Best known for her cutting-edge work with Guided Drawing and Clay Field Therapy, she holds regular workshops around the world and at Claerwen Retreat in Apollo Bay, Australia, an internationally respected arts therapy education facility. An author of numerous books, she runs accredited online courses for art therapists, educators, and mental health professionals looking to understand a body-focused art therapy approach to trauma therapy (www.sensorimotorarttherapy.com).

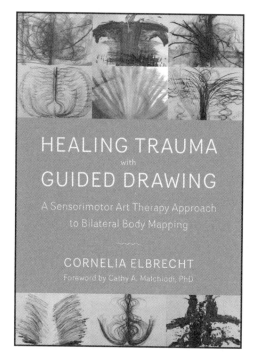

About North Atlantic Books

North Atlantic Books (NAB) is a 501(c)(3) nonprofit publisher committed to a bold exploration of the relationships between mind, body, spirit, culture, and nature. Founded in 1974, NAB aims to nurture a holistic view of the arts, sciences, humanities, and healing. To make a donation or to learn more about our books, authors, events, and newsletter, please visit www.northatlanticbooks.com.